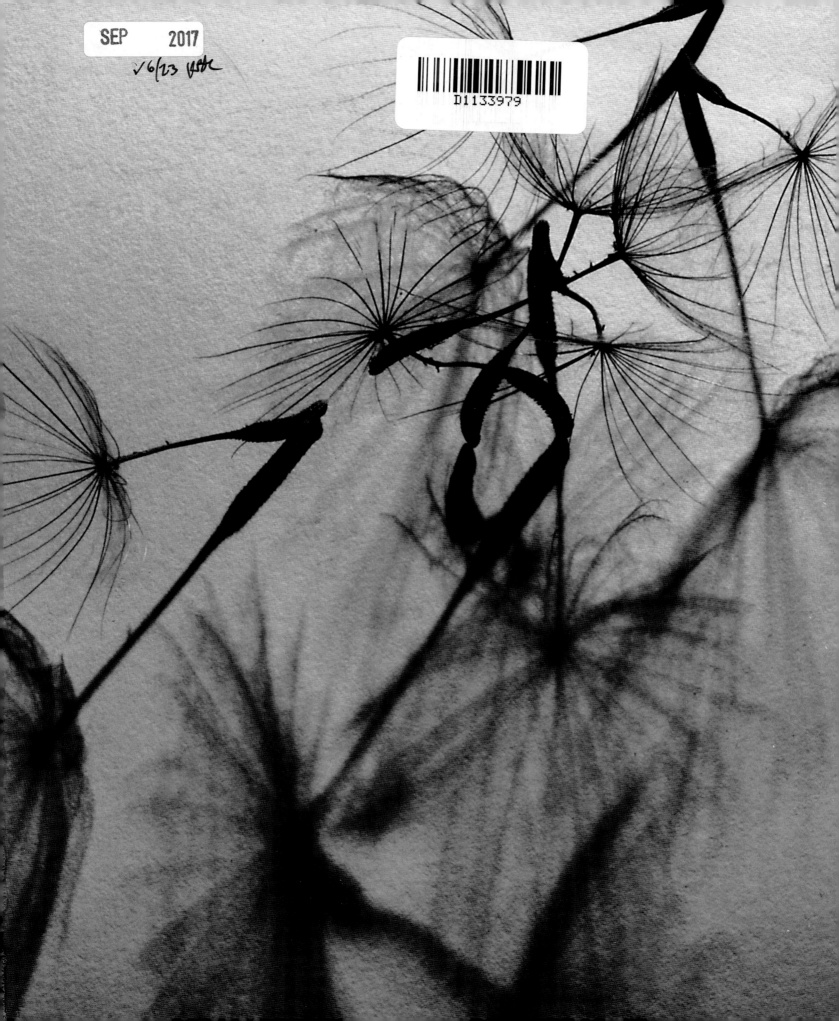

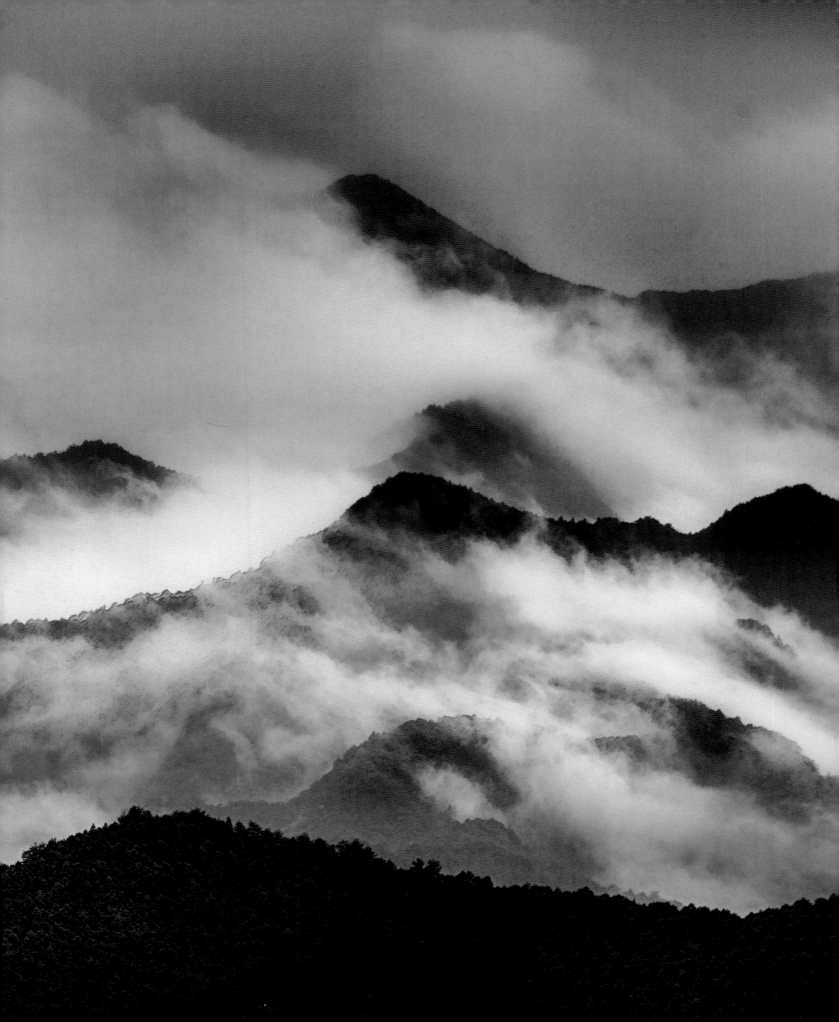

THE PHOTOGRAPHER'S
BLACK & WHITE HANDBOOK

MAKING AND PROCESSING STUNNING
DIGITAL BLACK AND WHITE PHOTOS

HAROLD DAVIS

MONACELLI STUDIO

DEDICATION

For our kids—Julian, Nicholas, Mathew, and
Katie Rose.

Published in the United States by Monacelli Studio,
an imprint of The Monacelli Press

Library of Congress Cataloging-in-Publication Data
Names: Davis, Harold, 1953- author.
Title: The photographer's black and white handbook :
 making and processing stunning digital black and white
 photos / Harold Davis.
Description: New York : Monacelli Studio, 2017.
Identifiers: LCCN 2016026175 | ISBN 9781580934787
 (paperback)
Subjects: LCSH: Black-and-white photography--
 Handbooks, manuals, etc. |BISAC: PHOTOGRAPHY /
 Techniques / General. | PHOTOGRAPHY /
 Techniques / Digital (see also COMPUTERS /
 Digital Media / Photography). | PHOTOGRAPHY /
 Techniques / Equipment.
Classification: LCC TR146 .D27 2017 | DDC 778.3--dc23
LC record available at https://lccn.loc.gov/2016026175

ISBN 978-1-58093-478-7
eISBN 978-1-58093-479-4

Printed in China

Interior design and layout by Phyllis Davis
Copy editing by Nancy Bell
Cover design by Jennifer K. Beal Davis
Cover photographs by Harold Davis

10 9 8 7 6 5 4 3 2 1

First Edition

MONACELLI STUDIO
THE MONACELLI PRESS
236 West 27th Street
New York, New York 10001
www.monacellipress.com

PHOTOS

Page 1: *Dandelion Seeds*
Pages 2–3: *Panorama, Kii Peninsula, Japan*
Right: *Beneath the Berkeley Pier, California*
Page 9: *Engine Room*
Pages 10–11: *Reflections in a Maine Pond*

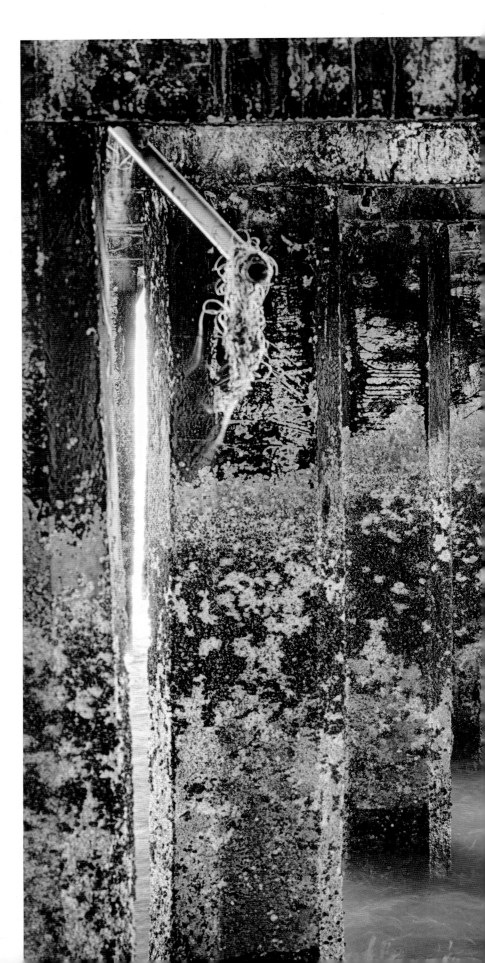

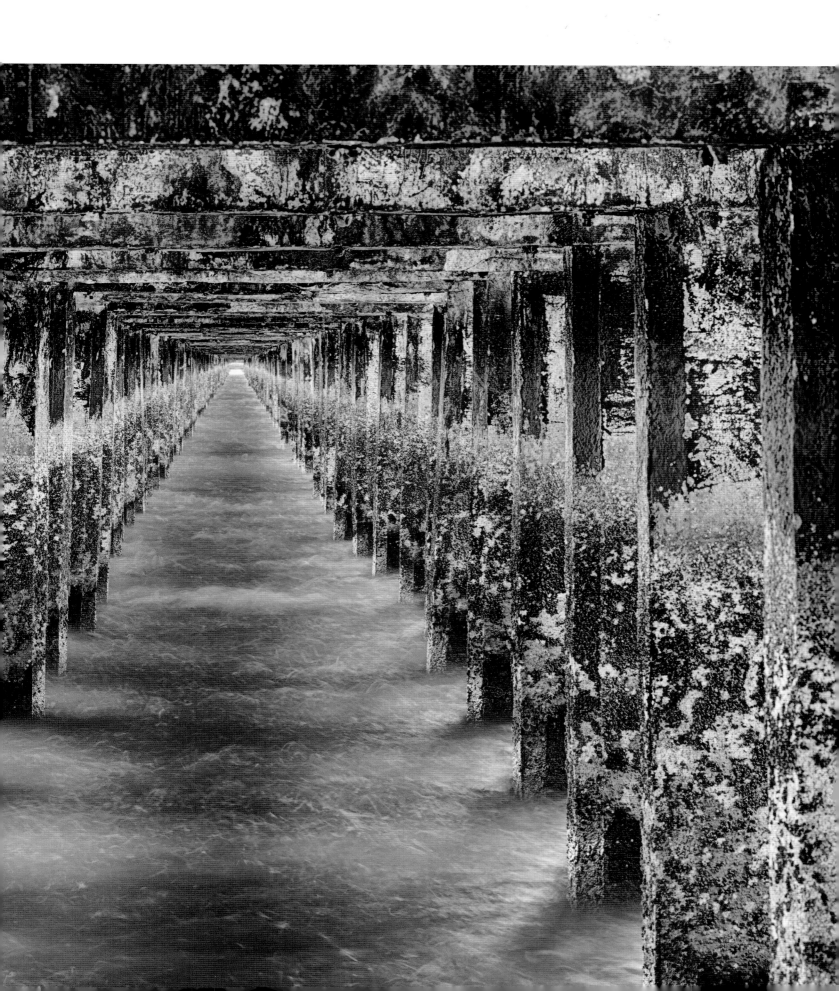

CONTENTS

8 *Preface*

1: SEEING IN BLACK & WHITE

14 Why Black and White?

17 Storm over Sainte-Croix-de-Beaumont

18 Contemplating a Cloudy Sky

23 Pre-visualizing

26 Workflow: From Color to Black and White

28 Content Management System (CMS)
 Overview

30 Color to Black and White Workflow

2: FINDING BLACK & WHITE

38 Your Path to Black and White

42 The American West

45 Pre-visualizing Black and White Using
 the Camera

46 The Black and White Composition

53 Using Negative Space

55 Framing

56 Patterns

60 High Key and Low Key

68 Contrast and Shades of Gray

74 Black and White at Night

78 People in Black and White

3: CONVERTING TO B&W

84 Your Black and White Workflow

86 Dispatches from the Land of the Rising Sun

94 Black and White Conversion: Effort vs Quality

91 JPEG vs RAW

92 Effort vs Quality

98 Black and White Conversion in Adobe Camera
 RAW (ACR)

102 Black and White in Lightroom

105 Lightroom: Basic Black & White Treatment

105 Lightroom: HSL/Color/B&W Tab

109 Lightroom: Black & White Presets

110 Black and White in Photoshop

110 Photoshop: Basic Conversions

116 Photoshop: Using the Channel Mixer

118 Photoshop: Black & White Adjustments

123 Nik Silver Efex Pro

124 Topaz B&W Effects

128 Perfect B&W

132 Onward and Upward

4: EXTENDING TONAL RANGE

136 From Color to Black and White

140 Multi-RAW Processing via Lightroom

142 Multi-RAW Processing with Adobe Camera RAW

149 Multiple Layers and Masking in Photoshop

154 Extending Contrast and Range in Photoshop

157 Blending modes

158 LAB Color for Contrast Enhancement

161 Bracketed Sequence Photography

166 Monochromatic HDR Presets

168 The Photoshop Layer Stack as Gold Standard for Black and White Conversion

5: CREATIVE B&W EFFECTS

174 Finishing the Image

176 Lighting and Monochromatic Photos

180 High Key

186 Low Key

190 Toning, Tinting, and Split Toning

193 Tinting Using a Photoshop Black & White Adjustment Layer

193 Toning and Split Toning Using Nik, On1, and Topaz

194 Split Toning Using Color Range Selection in Photoshop

200 Selective Color and Hand Painting

202 Soft and Selective Focus

207 Pinhole Camera Effect

210 LAB Inversions

214 Solarization

214 Solarizing Using Double LAB Inversions

216 Solarizing Using Curve Adjustments

216 Photoshop Solarize Filter

217 Nik Color Efex Pro Solarization Filter

220 Simulated Infrared

220 Simulated IR Using a Photoshop Black & White Adjustment Layer

220 IR Simulation with Nik Color Efex Pro

224 Artful Black and White Effects with Topaz

226 Antique, Vintage, and Film Effects

230 Borders

234 *Making Black and White Prints*

236 *Resources and Software*

237 *Glossary*

238 *Index*

239 *Photo Locations*

PREFACE

For much of the history of photography, practitioners were limited to black and white. Since the world around us is seen in color, to some this limitation seemed truly limiting. But as color photography became available, the orthodox position became that black and white was the only true expression of the art of photography.

In modern times with the rise of digital photography, this orthodoxy became irrelevant. Digital cameras allow you to choose on a frame-by-frame basis whether you are creating a color or black and white image. Furthermore, most digital workflow incorporates the possibility of creating color and black and white versions of a single image. You can then put the two versions side by side, to see which works best.

Whatever the era, the structural underpinnings of any book about black and white photography must emphasize learning to see without color so the photographer can pre-visualize black and white imagery.

Seeing in black and white and pre-visualizing effective black and white imagery involve special considerations. With the absence of color, formal compositional elements assume greater importance. Color can be regarded as an attractive distraction. Without the "eye candy," the compositional "bones" of the image must be strong. It's possible to create high-key and low-key images in black and white that are compelling, while the same exposures in

color would be seen as simply over-the-top, blown-out, or too dark.

So black and white involves significant pre-visualization skills, and a different style of image composition than color photography. There's also a conscious artistic choice to limit the tools of engagement to the shades and tones from black to white. This free choice to be restrained can lead to more powerful imagery than is often the case in the anything-goes world of color photography.

Whether consciously or unconsciously, photography involves narrative. This narrative can be sequential and tell a story, or it can be poetic and consist mainly of visual metaphor. Whichever is the case, I am firmly committed to the proposition that telling a story via photographic narrative is a crucial component of creating compelling black and white images.

The Photographer's Black & White Handbook aims to echo the structural importance of narrative in photography by presenting technical information within the context of stories. Often these stories will be located in specific geography, and sometimes they will relate to particular kinds of photography. Within the narrative arc of the stories I tell, *The Photographer's Black & White Handbook* details the range of black and white conversion and enhancement approaches that are available. But of course the world of technology never stands still—so I've included new hardware and

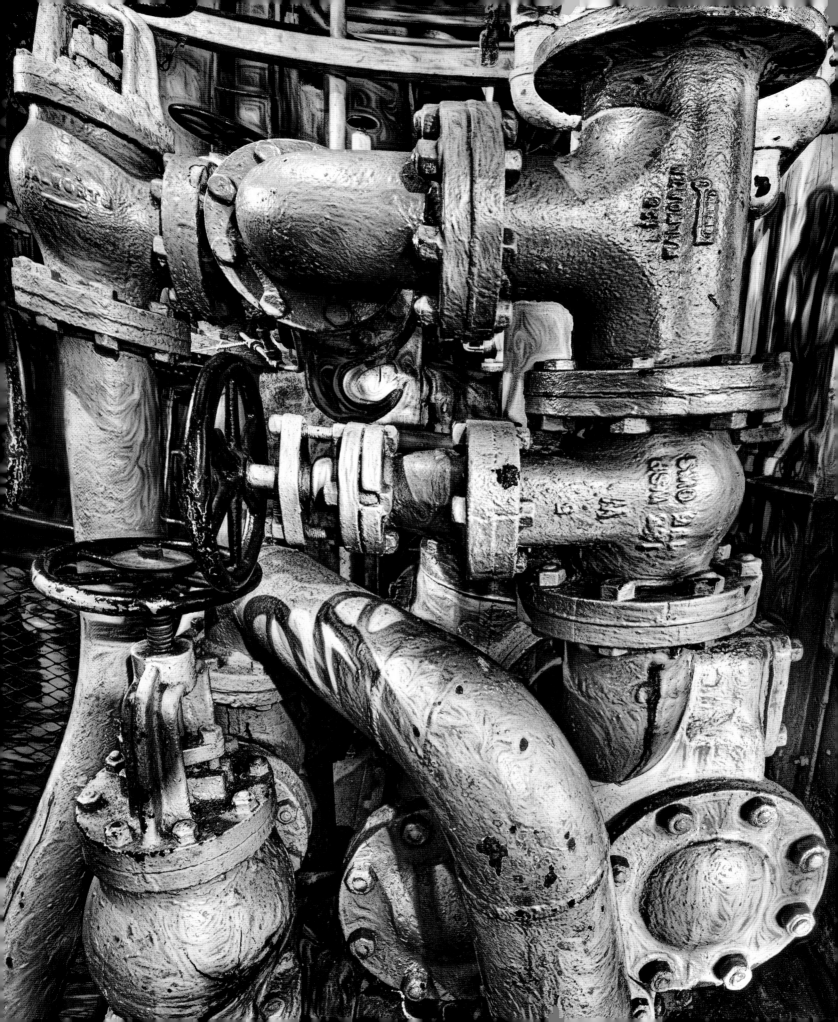

software along with more traditional photographic approaches.

Therefore, iPhone captures and monochromatic conversions have a place in this book as examples, along with best workflow practices when the original is a high-megapixel full-frame DSLR. Software keeps getting better, and the advances of products such as Lightroom, Photoshop, and Nik Silver Efex Pro are explained.

Since I believe that the image isn't done until it has been printed, I've added summary material on how to get the best prints from your black and white photos using today's high-end inkjet printers.

Black and white photography is a great art form with a significant historical context. The rise of digital photography has greatly enhanced what it is possible to do within this medium.

The Photographer's Black & White Handbook presents relevant workflow and creative opportunities in sufficient detail to be comprehensible, without elevating the technical side over the creative side. This information is presented in a context that tells the stories of actual photographic practice in the field.

If you are looking for up-to-date and thorough information about the tools of digital black and white photography, while also teasing your senses with a glimpse at what is possible using this magical artistic medium, then *The Photographer's Black & White Handbook* is for you.

Harold Davis

Berkeley, California

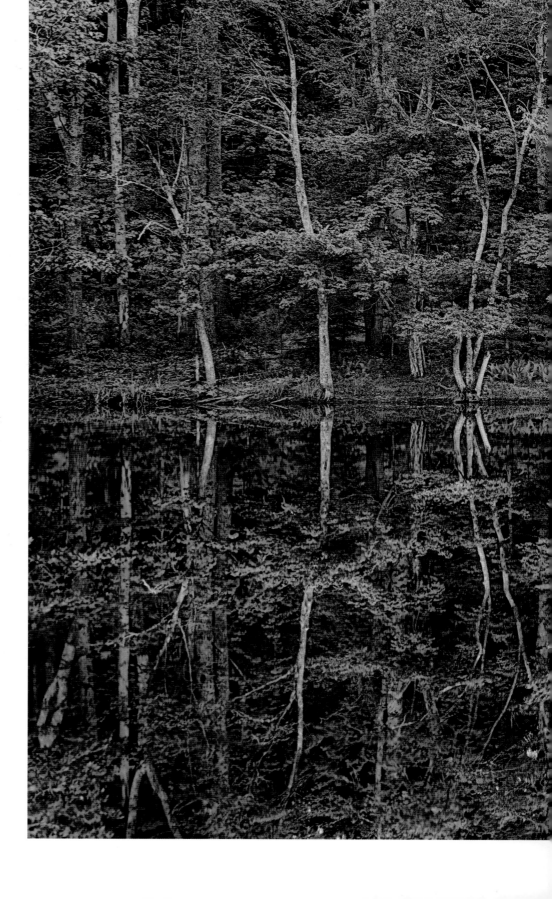

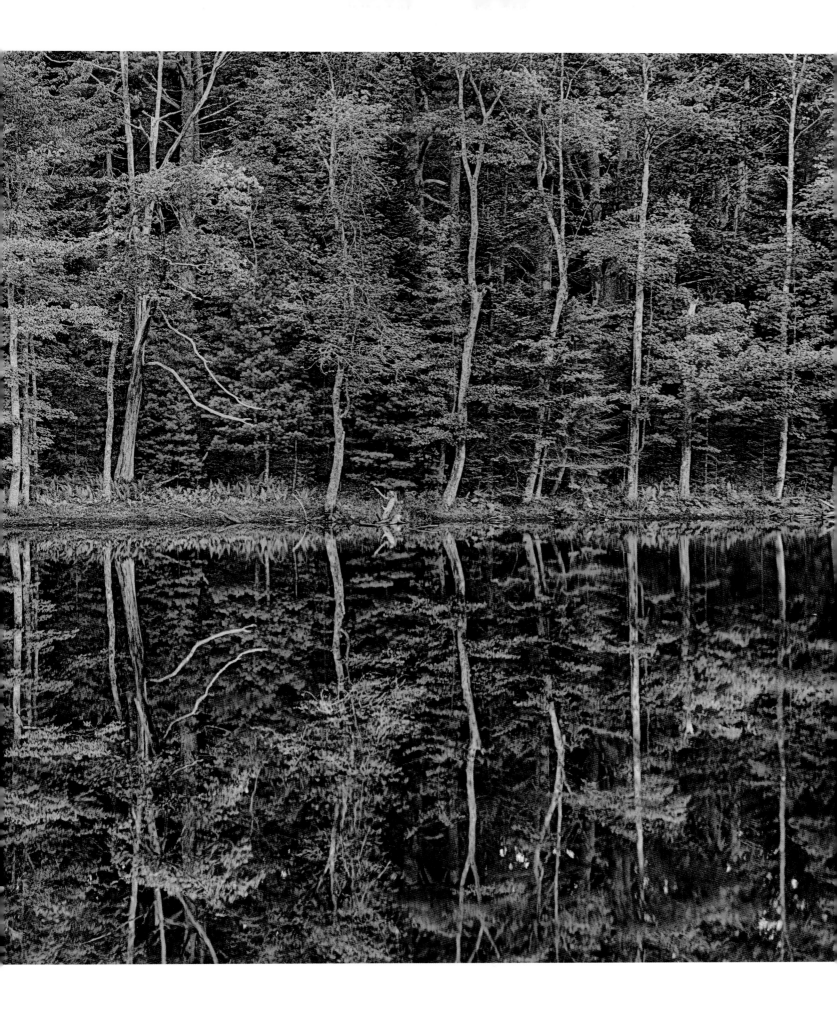

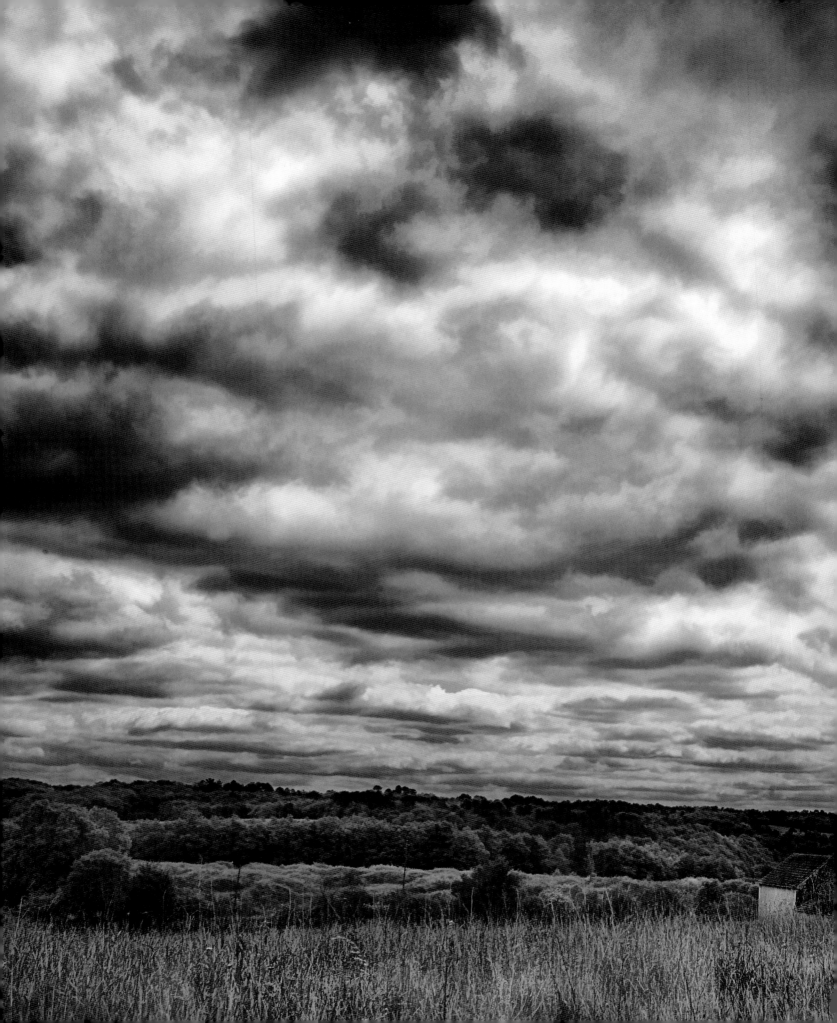

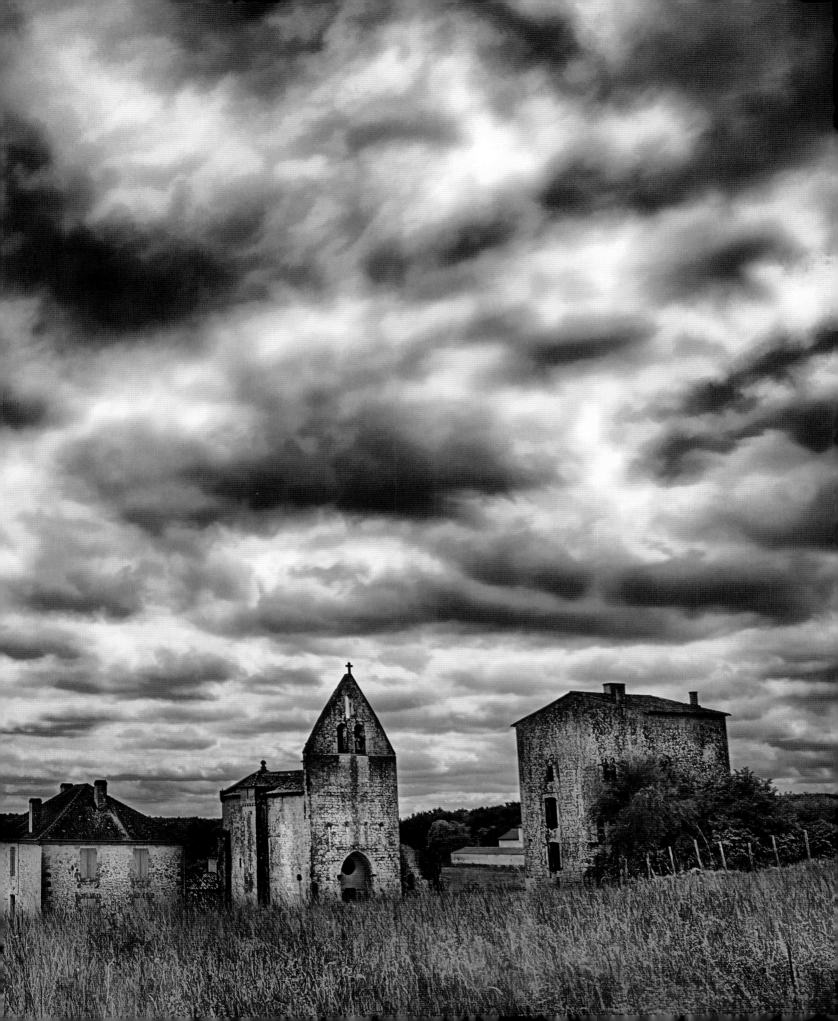

1: SEEING IN BLACK & WHITE

WHY BLACK AND WHITE?

The world around us is for the most part a world in color—hopefully bright, vibrant, and exciting colors, except when our mood is dour, in which case the colors should be appropriately muted and gray. Why then photograph in black and white?

The answer to this question was, of course, trivial when black and white was the only option earlier in the history of photography. To some degree, the choice to represent the world monochromatically carried on as a kind of "default option" during the reign of the film photography era.

In today's digital photography world, the choice to render a black and white image is entirely a *choice*—one that can be made on an individual basis. Making this choice is consciously choosing a kind of creative and anachronistic view of the world. In order to make the choice and to understand when it will be effective, you must learn to see in black and white.

This chapter provides the basis for learning to see in black and white, along with tips and techniques that will make it easier for you to both pre-visualize in black and white and capture great images.

▲ PAGES 12–13 AND ABOVE: The ancient church at Sainte-Croix-de-Beaumont is on the French approach to the famous pilgrimage trail to Santiago de Compostela. The complex belonged to the Knights Templar and is almost entirely abandoned. The ancient granite stonework in the interior of the church has been maintained. But otherwise, the complex is quickly heading for ruin.

All morning it had been gray and threatening to rain, leading me to think about black and white. I wandered through empty fields with my camera on tripod and got a stunning view of Sainte-Croix-de-Beaumont before the storm broke. As it started to pour, I took shelter in an abandoned building and waited for the storm to pass.

28mm lens, eight bracketed exposures with shutter speeds ranging from 1/500 of a second to 1/8 second at f/22 and ISO 100, tripod mounted; processed using Adobe Camera RAW, Photoshop, and Nik HDR Efex Pro, and then converted to black and white using Nik Silver Efex Pro.

▶ From the outside, the rural communities in southwestern France known as *bastides* seem organized for mutual defense. Alone in the French countryside, a sturdy wall surrounds each town. The thick stone wall is pierced with gates leading to main thoroughfares that divide the town into *insulae* or blocks. Within each bastide is a central square that is the locus of the market activity. The square is surrounded by covered arched walkways, called *couverts*, that connect the thoroughfares to the marketplace. For this photo of the Montpazier bastide, I added a light sepia tint to the black and white image to give a feeling of antiquity.

28mm, 4 seconds at f/22 and ISO 200, tripod mounted; processed using Adobe Camera RAW and Photoshop, and converted to black and white with sepia tint added using Photoshop.

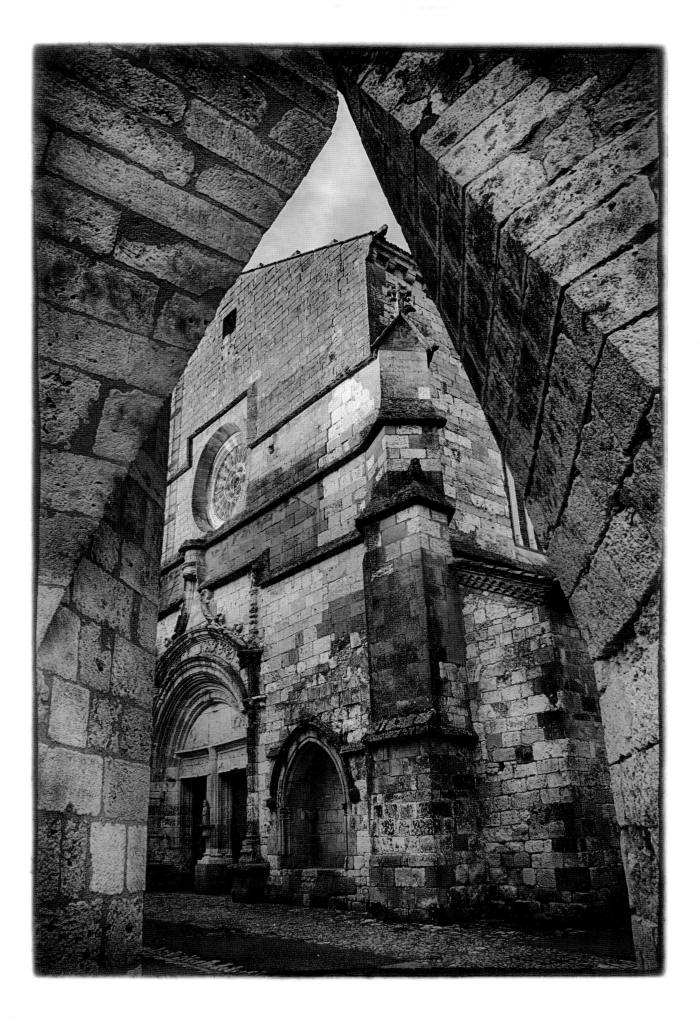

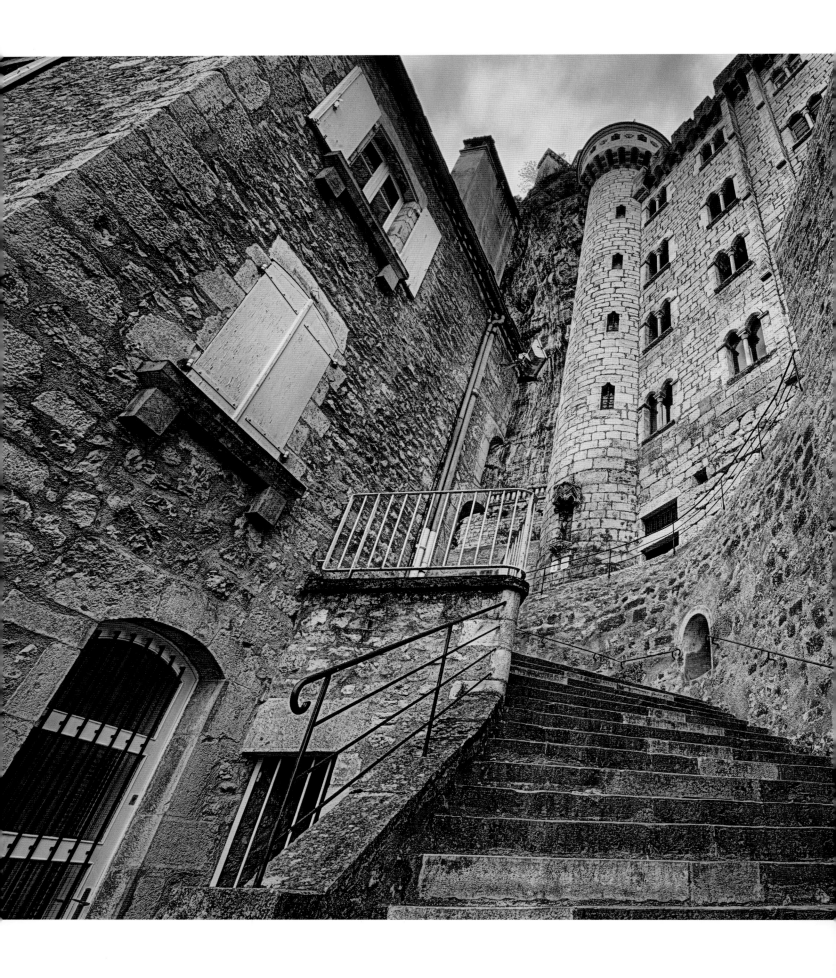

STORM OVER SAINTE-CROIX-DE-BEAUMONT

The fractured high plateau in the southwest of France between the Dordogne and Lot Rivers has been inhabited for millennia. Some of the oldest known art in the world is found in this region in prehistoric caves such as the Caves of Lascaux. Estimates place these wonderful and evocative cave paintings back about 17,000 years, give or take a couple of centuries.

This land has long been home to human beings. In Roman times, cities and colonies were established here, and great trading stations grew up. In somewhat more recent times, crusaders used this area as a base before heading off to the Middle East. Pilgrims journeyed over centuries to the holy citadel of Rocamadour, and headed south on the feeder trails to the great pilgrimage route to Santiago de Compostella in Spain. Robber barons fortified remote crags and barricaded the passageways along the canyon bottoms, demanding tolls or ransoms. Walled cities called *bastides* sprang up, eventually becoming the basis for the French ideal of the commune, or city made up of citizens.

◄ On a gray morning, I had my croissant and café au lait on a terrace overlooking the craggy valleys of southwestern France. My hotel was located along the ancient cobblestone street that bisected the medieval town of Rocamadour. Stepping out the front door of the hotel, it seemed as if I had passed back through time. In front of me, a long curving flight of stairs led up to the religious citadel of Rocamadour.

Modern visitors can ride an elevator up to view the holy relics in this location, but pilgrims, who have visited in droves for at least a millennia, have not had it so easy. Part of the tradition of the pilgrimage to Rocamadour was to climb this stair—known as the "Grand Escalier"—on one's knees. So these stone stairs have been polished by the knees of princes both secular and sacred, not to mention common folk as well.

15mm, eight bracketed exposures with shutter speeds ranging from 1/30 of a second to 8 seconds at f/22 and ISO 100, tripod mounted; processed using Adobe Camera RAW, Photoshop, and Nik HDR Efex Pro; then converted to black and white using Nik Silver Efex Pro.

In the 1300s and 1400s, the Hundred Years' War was fought back and forth between the English and the French, decimating cities that were then rebuilt and decimated all over again.

In modern times, the underlying topography, structure, and fertility of the land holds sway. Barren and wind-swept plains abruptly lead to great fissures, where ancient villages cling to the side of cliffs, protected from enemies since ancient times. The picturesque habitations, and the wild landscape, makes this a natural area to delight photographers.

On a spring day in early May, I woke at a bed and break-fast in Monpazier, France. Monpazier is a classic *bastide*, or walled city that protected itself without the aid of a nearby robber baron (otherwise known as the nobility). Monpazier is considered by architects such as Le Corbusier to be an inspiration and model for the modern town square, and to have the finest central town square of any of the ancient *bastides* of southwestern France.

I sipped my café au lait, and nibbled the croissant-au-beurre that the mistress of my accommodations had provided. The croissant was still warm from the bakery oven and crunchy on the outside but moist within—perfectly *croustillant*.

Outside an impetuous spring storm had brought driving rain. While I am always mindful of Ansel Adams' dictum that "unless you are out in the rain, you can't photograph a clearing storm," photographing in wet weather can be a challenge, particularly when navigating via back roads in an unfamiliar country.

I finished breakfast, packed my bags, and said farewell to my hosts, making sure to keep out the shower cap I use to protect my camera on the tripod in wet weather. It wasn't cold, but I did need a raincoat.

Then I set out in my small car, taking the smallest roads I could find using my detailed Michelin map, happily planning to get lost without turning on my GPS. The high alluvial plains of southwestern France, criss-crossed with pilgrimage routes and the battlements of ancient conflicts, have a pristine sense that lend themselves to compositional photographs that emphasize black and white elements.

CONTEMPLATING A CLOUDY SKY

As I explored small hamlets and abandoned churches on the road from Monpazier to Cadouin, the rain lessened. But the sky was still cloudy and gray, and I began to consider what kind of imagery I could make in the stormy weather. It seemed to me that conditions were perfect for black and white photography.

In today's world of digital photography, black and white is about more than a choice of film, or the absence of color. In fact, on an image-by-image basis, black and white is a choice, and is specifically chosen for visual impact and to make a statement.

What makes an image effective in black and white? When I am thinking in black and white, I look first, but not necessarily foremost, for subject matter where color is not

▶ On one of the major trails for the pilgrimage of the Camino de Santiago, the village of Saint-Cirq-Lapopie in southwestern France is not all that well known to international tourists. But in France, it is widely considered to be one of the most beautiful small French villages and is a destination for many French tourists. Nestled more than 1,000 feet above the Lot River on top of a granite dome, the village is closed to car traffic, and while there are some really excellent restaurants within the medieval boundaries of the town, there are no formal hotels.

I had no fixed plans to where I would stay that night, so I decided to let my feet wander and take things as they came along. After walking the ancient stone streets and passageways for a while, I turned a corner and found a lovely little restaurant that also had one room available for the night. Grabbing this little piece of serendipity, I rented the room, and then enjoyed a delicious meal of local specialities before retiring to bed.

In the morning before the tourists arrived, I took my camera and tripod in search of stonework and arches. The street shown in this photo was right behind my bedroom window.

40mm, six bracketed exposures with shutter speeds ranging from 1/60 of a second to 4 seconds at f/22 and ISO 100, tripod mounted; processed using Adobe Camera RAW, Photoshop, and Nik HDR Efex Pro, then converted to black and white with a sepia tint and custom border using Nik Silver Efex Pro.

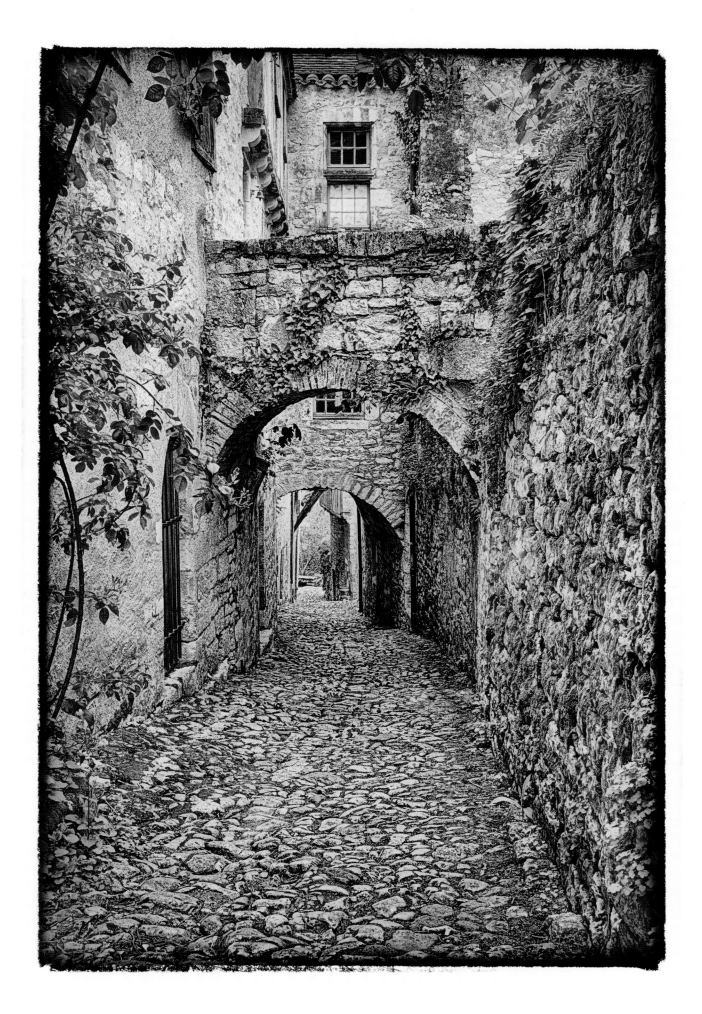

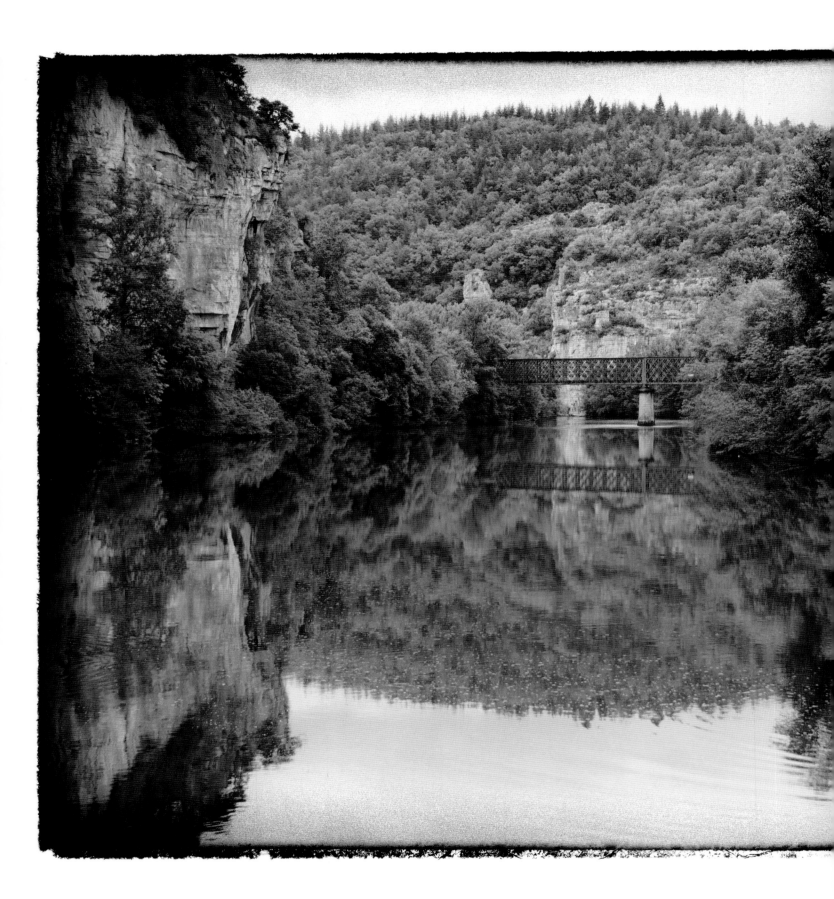

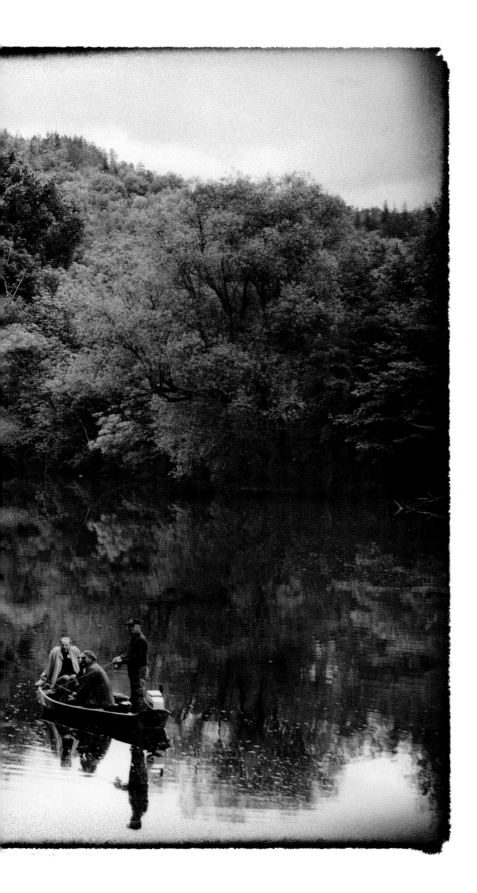

a crucial element of the composition. For landscape photography this often has to do with the weather: A sunny day may lend itself to bright colors, but a gray, rainy day in the southwest of France may tend toward the grayscale.

Beyond the absence of color as a crucial element, to make great black and white images:

- Look for contrast. This may be created by strong shadows that create a hard line between light and dark, or also may be the result of extreme range between bright and darkness in a subject that doesn't have to do with shadows; for example, a light-toned foreground subject against a very dark or black background. Contrast can often be enhanced or exaggerated by camera position and angle, and by over- or under-exposing the subject. An extreme range between light and dark may be problematic in a color image but work well in black and white.

◄ The southwest of France consists of massive limestone uplands bisected by rivers in deep gorges. The greatest rivers are the Lot and the Dordogne. River valleys are fertile and predictable. This country is home to some of the earliest known manifestations of man, such as the art on the walls in the Caves of Lascaux. The Romans settled it, and the British and French fought over it in the Hundred Years' War.

After leaving the village of Saint-Cirq-Lapopie (see pages 18–19) on a gray morning, I made my way in my small rental car down hair-raising curves to a trailhead beside the Lot River. Pilgrims, farmers, and soldiers have trekked this route since before recorded history. About a mile down the trail along the river, I came upon this scene of fishing in a serene stretch of water.

68mm, 1/125 of a second at f/6.3 and ISO 400, hand held; processed using Adobe Camera RAW and Photoshop, and then converted to black and white with a custom border using Nik Silver Efex Pro.

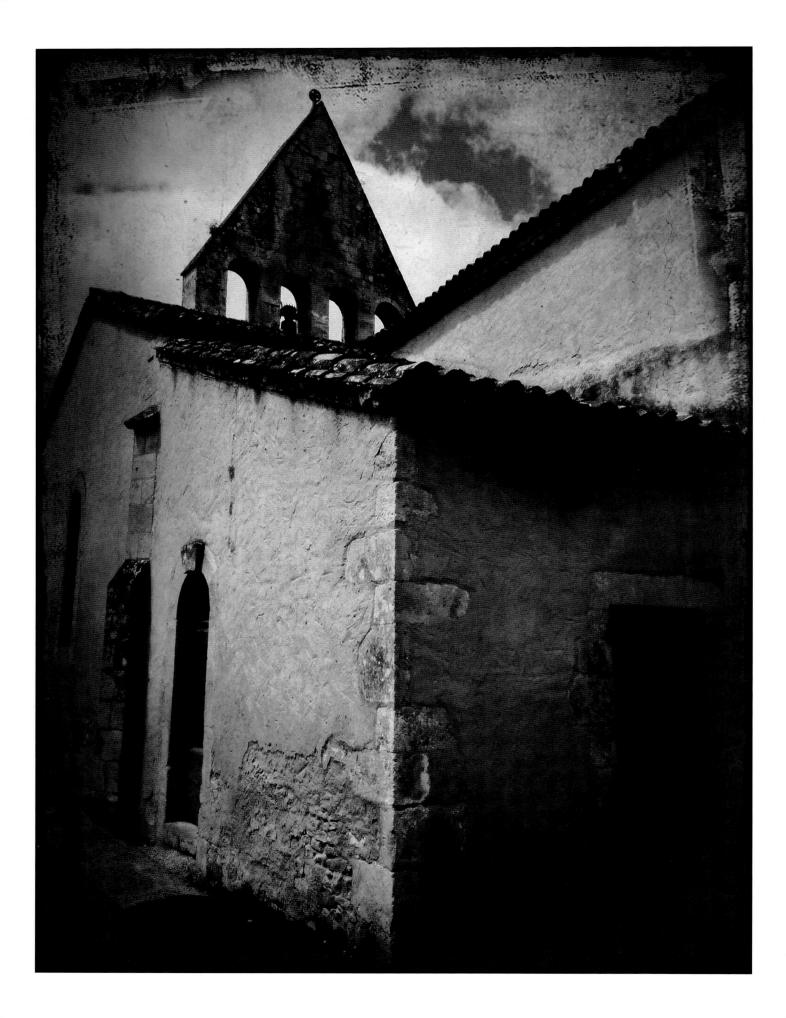

- Use color by implication. Color may not be a crucial element of the composition, but good black and white images work by allowing color to be inferred, or implied, by the viewer. The imagination of the viewer is a powerful thing. Color that is inferred or imagined based on the black and white content can ultimately be more powerful than actual color content.

- Think about the elements of formal composition. Photographs that are graphically powerful tend to work well in black and white, because they are not "about" the color, and are effective as a matter of graphic design. In fact, color can be a distraction. Without it, design elements have to work better, and you can see the bare bones of your composition with more clarity. If you are interested in graphical expression, then black and white may work well for you.

- Patterns are often graphical in presentation, and can work well—because their outline is clearer—in black and white.

- Finally, presenting a photo in black and white is an intentional act with artistic and anachronistic tendencies. Black and white photography is linked to the history of photography. The world is color, not monochromatic, so by presenting an image in black and white you are essentially accepting an artifice that denotes your work as art, meaning that it should be viewed as apart from the realm of the snapshot.

◀ Part of what I like doing best is exploring the countryside in as much detail as possible. Modern electronic maps don't work very well for this, and in fact, there's nothing like a geological survey map or a detailed Michelin map, such as the ones that cover all of France.

Between Montpazier and Cadouin, I followed my intricate Michelin map and piloted my little rental car down a dirt road in the French countryside. Turning right onto another dirt road with vague markings and no official signposts, I came upon this abandoned chapel under brooding, stormy skies. I stopped for photography, because who could resist?

iPhone camera app, processed and converted to black and white using Plastic Bullet, Lo-Mob, Filterstorm, and Snapseed.

PRE-VISUALIZING

Photographs, as they say, should be made, not taken—meaning that if you care enough about your photography to be studying how to be better photographer, you should invest some energy into planning your photos and not just expect them to randomly pop into being, like Athena bursting forth from Zeus's head.

To effectively plan requires the ability to pre-visualize. If there is a chain of work involved in creating a modern photo—sometimes referred to as a "digital workflow"—to get to the end of this chain you need to be able to understand the visual impact of the choices you make.

As the rain eased in the plains of the Dordogne in France, I eased my car into the small hamlet of Sainte-Croix (photo on pages 12–13). While the drops of rain were now sporadic, and taking out my camera without getting it soaking wet was a real possibility, the landscape was still gray, with fast-moving clouds scudding across the sky.

Sainte-Croix was mostly abandoned with buildings that had last been truly occupied by the Knights Templar in the time of the crusades. Looking out over the fields at the partially ruined structures, I saw a stormy black and white landscape that reminded me a little of *Christina's World*, the painting by Andrew Wyeth, with overtones of the long history of the southwest of France.

As I pre-visualized the landscape image I wanted to make, I had two thoughts—one related to the old craft of analog film photography and one based on the new craft of digital photography:

- To bring out the drama in a cloudy and moody black and white landscape, a red filter was used when making prints in the chemical darkroom. As I pre-visualized my image of the landscape of Sainte-Croix (pages 12–13), I knew that I would need to use a "virtual" red filter when I processed the image in the digital darkroom toward the end of my workflow process.

- Photography is about both time and place. It's also about what happens to motion when time passes. As I pre-visualized the clouds in the sky in the landscape of Sainte-Croix, I wanted to render the motion of the clouds attractively. My tool for this rendering was to

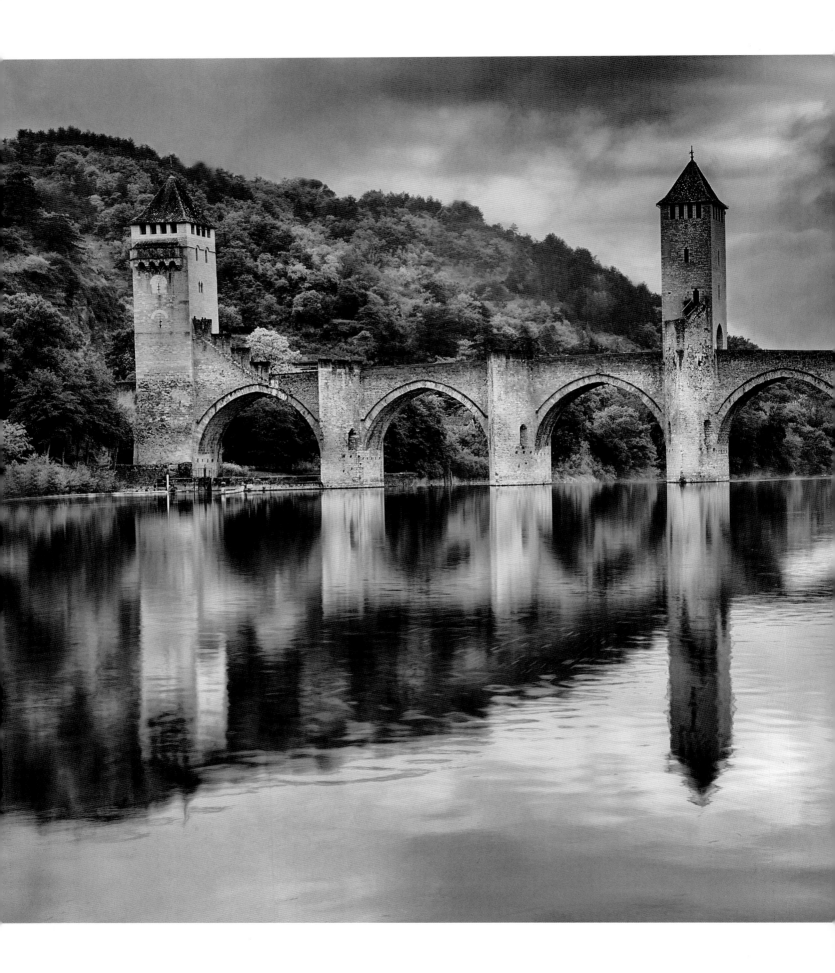

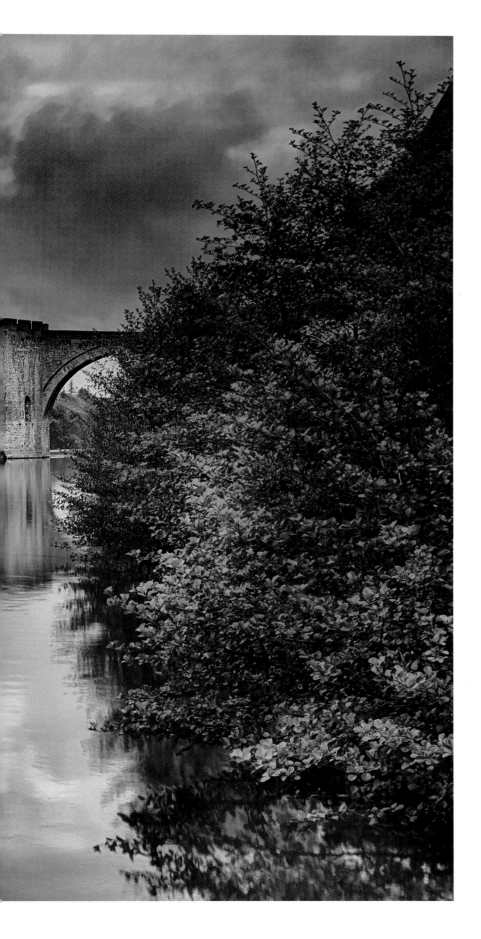

shoot a bracketed sequence of photos with my camera on a tripod, and to use software later to combine the sequence without aligning the clouds, thus creating an attractive effect of clouds flowing.

The point of both these observations is to indicate that you can't really pre-visualize in the digital photography world without a sense of the tools available in both photography and in post-production. Best-practices black and white conversion involves conceptualizing an image in monochrome in the first place. But it also involves understanding where the image can be taken in the Photoshop darkroom, and the steps along the way toward that destination.

With this key principle in mind, let's see how the concepts of black and white photography and post-production fit within the construction of a typical high-end black and white workflow.

◀ In the Middle Ages, the city of Cahors in southwestern France was fabulously wealthy. Protected on three sides by the Lot River, Cahors was nevertheless sacked, abandoned, and rebuilt during the convoluted battles that made up the Hundred Years' War. The city may have fallen, but the Pont Valentré, shown here, was rightly regarded as impregnable.

On a overcast day, I made my way down to the banks of the Lot River upstream from the Pont Valentré. Despite the bloodthirsty history of this fortified bridge, the waterscape seemed calm and serene. As drops of rain began to fall, I used a low ISO and an ND filter to make a bracketed sequence of long exposures, with the idea of emphasizing the tranquillity of the scene.

56mm, +4 neutral density filter, eight brack-eted exposures with shutter speeds ranging from 1 to 30 seconds at f/22 and ISO 50, tripod mounted; processed using Adobe Camera RAW, Photoshop, and Nik HDR Efex Pro, and then converted to black and white using Photoshop and Nik Silver Efex Pro.

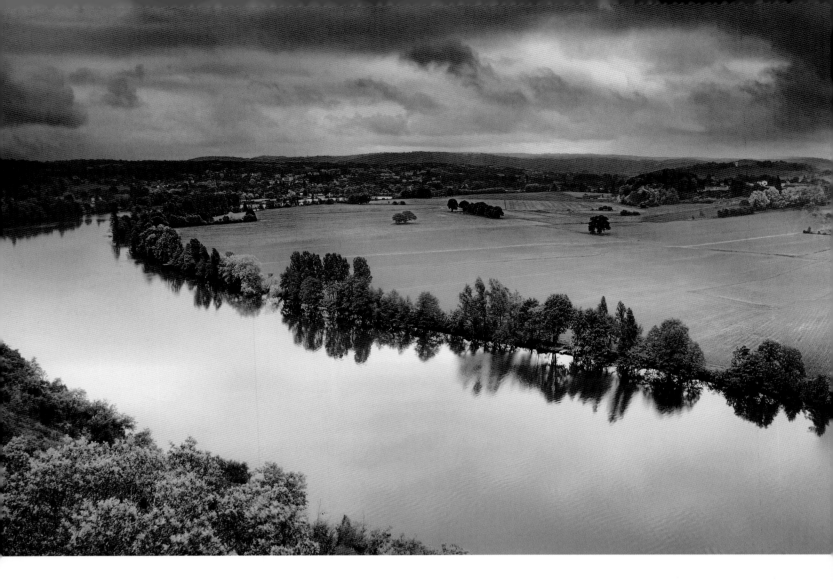

WORKFLOW: FROM COLOR TO BLACK AND WHITE

Exploring the countryside of southwestern France is, of course, a great deal of fun, both gastronomically and photographically. But lest you think that I had not a care in the world, I do want you to know that issues of black and white workflow were on my mind much of the time I was visiting there.

In the field, I used my high-performance, full-frame DSLR with images saved in the RAW format on memory cards. Each evening, whether I was in a medieval village, a pilgrimage location, or a room above a delightful res-taurant, I used a card reader to copy the RAW files onto both my laptop and a military-grade, crash-proof backup hard drive. No matter how tired I was, I made sure that I followed this protocol each night. This elementary field

workflow was enough to protect my imagery until I got back to my studio, but only the very beginning of my digital workflow.

There is literal travel in the real world and then there is digital travel in the virtual world. Workflow is the unsexy foundation and scaffolding that keeps digital image creation alive, and should always be considered even as early as image capture.

When you do ponder the issue of a digital black and white workflow, it's really important to keep in mind that high-quality black and white files are really color files. A good black and white photo should be saved as an RGB or CMYK image, just like a color file. Any additional treat-ment of the black and white photo, such as tinting and toning, merely modifies the underlying file by changing the color values. Note that the terminology that is often used

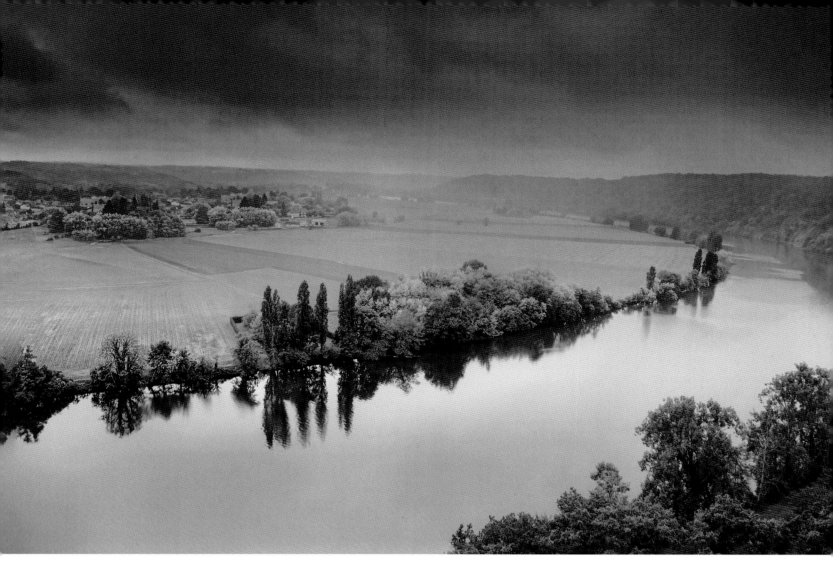

▲ My experience is that there is no better way to find off the beaten track photographic locations than to make friends with folks who live in a place. I got to talking about photography with the nice couple who ran the bed and breakfast where I was staying in the ancient monastery town of Cadouin. When not hosting peripatetic photographers, these friendly people operated an organic strawberry farm—and I can attest that their strawberries were out of this world!

My new friends suggested that I take a look at one of their favorite locations—a spot overlooking the Dordogne River—a bit above the ancient medieval village of Tremolat. This is not a location that can be found in any guidebooks.

I drove to the spot they had told me about, through intermittent rain and into the face of ominous oncoming clouds. There was a dirt parking lot in the forest above the river near an abandoned resort hotel and a little unmarked path. I took the path from the parking area that led to the top of the cliffs overlooking a bend in the Dordogne River.

By the time I got there, the rain was moving in, and while the sky to the southwest was diffuse and soft, the clouds to the northeast (the direction of the incoming weather) were dark and brooding.

I ignored the oncoming storm and mounted my camera on the tripod. My plan was to create an HDR panorama, which meant shooting bracketed sequences in order across the horizon. I did my best to take my time and shoot the sequences carefully despite the large raindrops splattering my gear.

28mm, three sets each of five bracketed exposures, each bracketed set with shutter speeds ranging from 1/8 of a second to 1/125 of a second, each exposure at f/11 and ISO 100, tripod mounted; each bracketed set combined using Nik HDR Efex Pro, the three bracketed sets combined into a panorama using Photoshop Automerge, and then converted to black and white using Photoshop Adjustment layers.

for these black and white modifications tends to be derived from the chemical processes used in the film darkroom. Don't let this mislead you. These are actually simulated processes applied to a "normal" color file, and the use of the anachronistic terminology is merely an aid for communication.

In a nutshell, my workflow from color to black and white, with pre-visualization of the entirety of the impact of these steps a goal to strive for, is:

- Photography. I suggest saving an image in RAW format for best quality black and white. In some situations, in order to capture the entire range from light to dark, or to render motion in a particular way, shooting a sequence of images is also indicated (see Chapter 2, "Finding Black & White").

- Initial image conversion. The first step in creating a good black and white image is somewhat paradoxically to convert it to color, using software such as Adobe camera RAW or Lightroom (see Chapter 3, "Converting to B&W").

- If a sequence of images was shot, then the sequence needs to be processed and combined appropriately using software such as Photoshop, or Nik HDR Efex Pro (see Chapter 4, "Extending Tonal Range").

- Optimization of the color image for a black and white future in Lightroom and Photoshop (see Chapter 4, "Extending Tonal Range").

- Converting the color image to black and white (see Chapter 3, "Converting to B&W").

- Applying special effects to a black and white image, such as a border, toning, adding grain, or creating a virtually solarized image (see Chapter 5, "Creative B&W Effects").

- Doing something with my photo, such as archiving, making prints (pages 234–235), and preparing for presentation on the Web.

You can see these steps in the "Color to Black and White Workflow" diagram on pages 30–31.

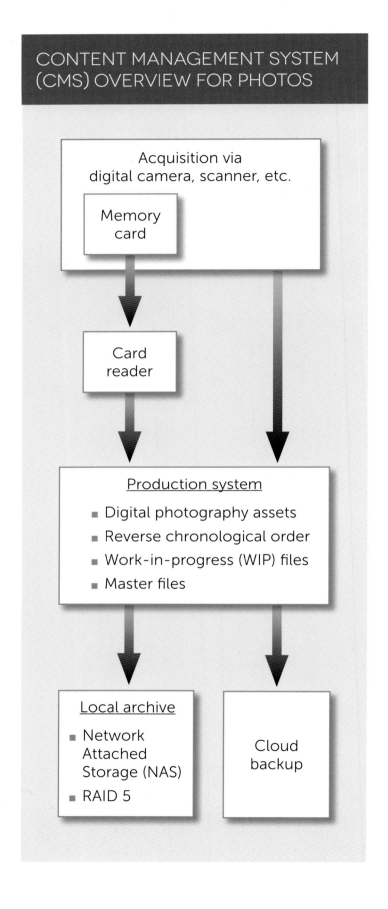

CONTENT MANAGEMENT SYSTEM (CMS) OVERVIEW FOR PHOTOS

Acquisition via digital camera, scanner, etc.

Memory card

Card reader

Production system
- Digital photography assets
- Reverse chronological order
- Work-in-progress (WIP) files
- Master files

Local archive
- Network Attached Storage (NAS)
- RAID 5

Cloud backup

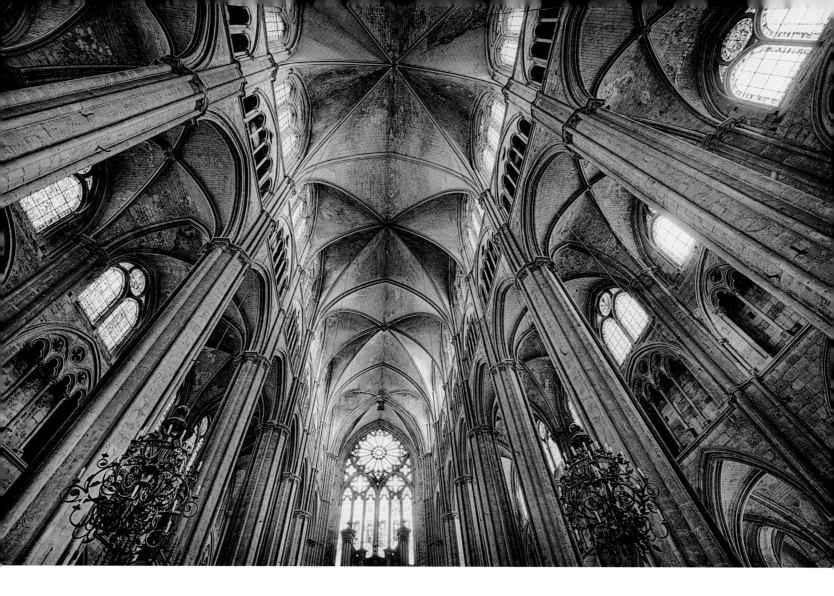

▲ The cathedral in Bourges, France, is a World Heritage Site that was begun in the 12th century and has never been entirely completed (they are still working on it!). Roughly contemporary with the great cathedral in Chartres to the northwest, the Bourges Cathedral is one of the largest Roman Catholic churches in the world and built to emphasize the status and independent stature of the southwestern French duchies relative to the northern parts of France.

Inside this huge space, I decided to capture as much volume as possible using an extreme wide-angle lens (15mm). It also occurred to me that this solemn space was far less decorative than the ornate interiors of many cathedrals, even though grander in size. In addition, the day I visited the cathedral in Bourges was gray and drizzling.

What little light there was outside came in dimly through the high windows of the cathedral. I knew I would have to make the best of this low-light, low-color situation.

The gray light, sharp architectural details, and grayish stone all seemed to come together to create an image that would work well in black and white. I thought that the best approach was to create a monochromatic image that emphasized the vastness of the spacial relationships, the height of the ceiling, and the massive nature of the buttresses needed to hold the roof aloft. Even though I knew I was going to create a black and white image, I was careful to create a bracketed set of nine color captures for later processing. That way, I would have the tonal palette I needed to create an image with the widest tonal range possible in post-production.

15mm, nine exposures with shutter speeds ranging from 8 seconds to a 1/15 of a second, each exposure at f/2.8 and ISO 200, tripod mounted; exposures combined using Nik HDR Efex Pro, Adobe Camera RAW, and Photoshop; with post-production and black and white conversion using Photoshop, Nik Silver Efex Pro, and Topaz Simplify.

COLOR TO BLACK AND WHITE WORKFLOW

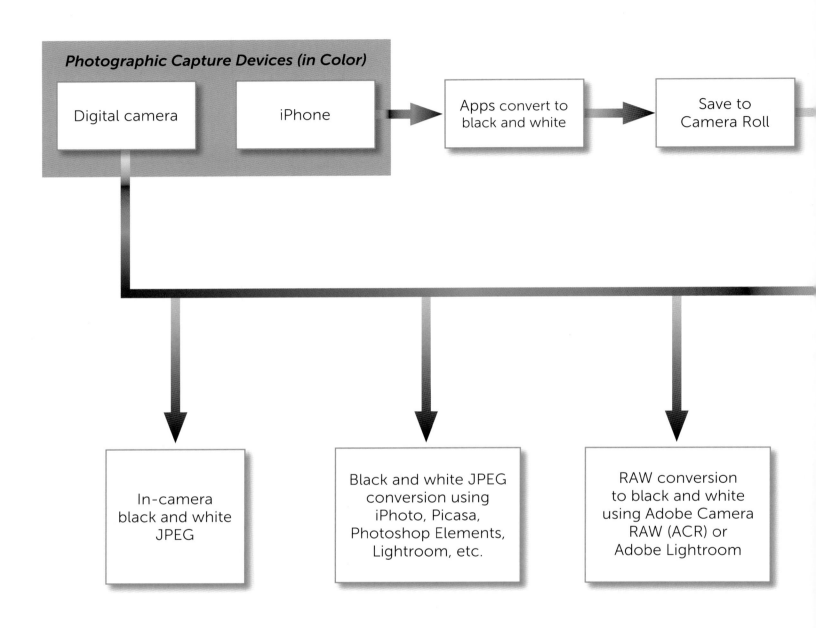

Photographic Capture Devices (in Color)

Digital camera

iPhone

Apps convert to black and white

Save to Camera Roll

In-camera black and white JPEG

Black and white JPEG conversion using iPhoto, Picasa, Photoshop Elements, Lightroom, etc.

RAW conversion to black and white using Adobe Camera RAW (ACR) or Adobe Lightroom

Effort

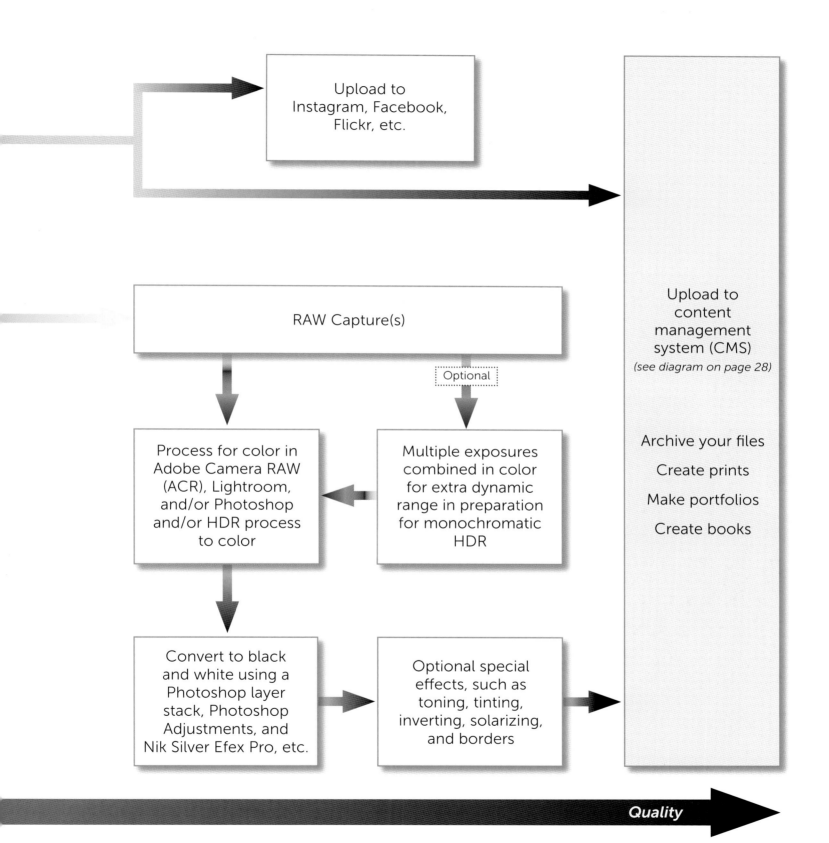

Upload to
Instagram, Facebook,
Flickr, etc.

RAW Capture(s)

Optional

Process for color in
Adobe Camera RAW
(ACR), Lightroom,
and/or Photoshop
and/or HDR process
to color

Multiple exposures
combined in color
for extra dynamic
range in preparation
for monochromatic
HDR

Upload to
content
management
system (CMS)
(see diagram on page 28)

Archive your files

Create prints

Make portfolios

Create books

Convert to black
and white using a
Photoshop layer
stack, Photoshop
Adjustments, and
Nik Silver Efex Pro, etc.

Optional special
effects, such as
toning, tinting,
inverting, solarizing,
and borders

Quality

Not all the steps involved in my pre-visualization sequence are required for all images. Indeed, in some cases the decision to create black and white imagery is after the fact. I see a color image file, and I say, "Hey, this would look cool in black and white." So I try a conversion to see what happens.

Keep in mind that a workflow for processing black and white images is only one part of the larger system of how one manages, retrieves, and archives photographs. Software such as Adobe Lightroom can help with this content management. There are many different ways to organize content management, and different photographers have their own preferences and ways of working with this.

One possible approach to a content management system (CMS) for managing photographic assets is shown in the diagram on page 28.

This isn't the only scheme for protecting and deploying photographic assets, but it is one that works for me. The topic of digital asset management (DAM) is a

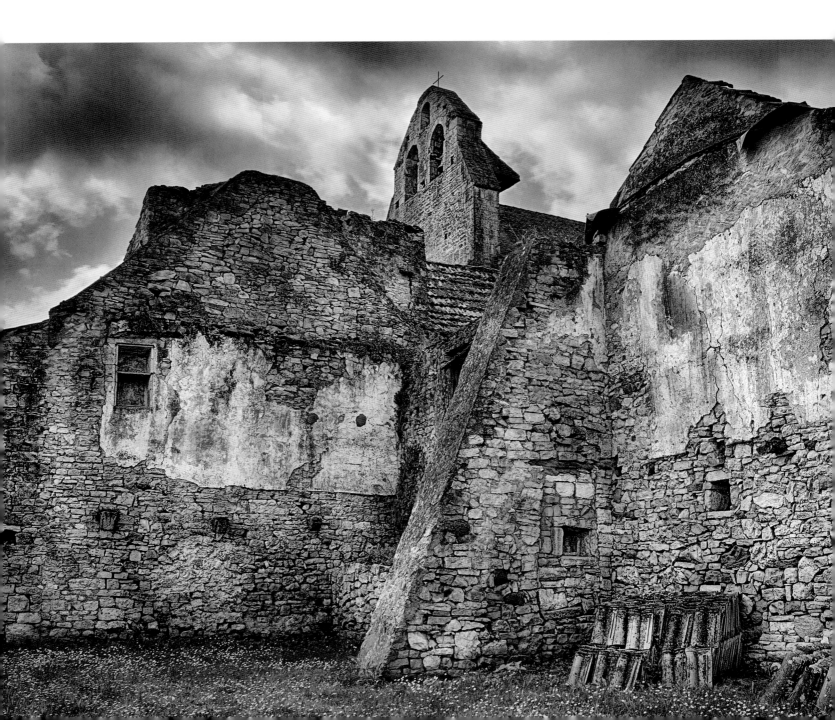

large one, and to some degree beyond the scope of this book—it takes a whole book to do the topic justice. But the important thing to keep in mind is that you do need an organized system that works for you that you can use to:

- Store and save photographic assets with sufficient backups.

- Be able to find and retrieve the photographs you need.

- Maintain photographic files in the formats you need to be able to make specific prints and reproductions.

There's nothing wrong with experimentation. In fact, allowing for the possibility of serendipity and the unexpected is very important to the creative process. But assuming you want to be the best digital black and white craftsperson you can be, then mastering the steps in a complete and consistent workflow will give you a method that you can use and get used to—there's nothing like being familiar with the steps you need to take to create a black and white image. Knowing these steps in advance will help you realize your images in post-production, speeding you along your grand journey in black and white.

◀ I like to explore off the grid and as off the map as I can get. Usually, this turns out pretty well and I don't get into *too* much trouble. Sometimes, however, I do get into slightly awkward situations that are a bit difficult to explain.

One day, on my way from Cahors to Montpazier, I saw an extremely intriguing dirt road branching off the highway. Without further ado, I put my foot on the brake and made a screeching left turn off the highway and into the dirt. Before I knew it, my dirt road had branched into two dirt roads and I took the right fork (perhaps because it was the road less traveled that I am always seeking).

Before long, my fork branched again and I made another impulsive choice, this one to the left. By now the road had dwindled into a cattle track with grass growing between two ruts on either side. It was pretty clear to me that I was lost, but I continued to barrel on, bumping along in my little car.

The next thing I knew, the track, such as it was, ended right next to an extended French family having an elaborate picnic in their backyard. There was a red-checked tablecloth, many bottles of wine, and numerous farm animals—mostly

pigs—wandering around. Of course, my hope was that I would be invited to the picnic, but this is one case in which my lack of language skills did not work in my favor. The patriarch of the family seemed outraged that I would drive up to their private party and didn't speak their language. And in no uncertain terms, he stood up, pointed a commanding finger in the direction I had come, and ordered me out.

I wasn't able to precisely retrace my route, but usually there are compensations for getting lost. In this case, I backtracked, took a different turn, and found the abandoned monastery shown here. Of course, I stopped for photography. The good news also was that I had my own picnic—fresh baguette, tomatoes, and paté de campagne. What could be better than a great photographic subject and a yummy picnic, discovered while one was busy getting lost?

28mm, eight bracketed exposures with shutter speeds ranging from 1/500 of a second to 1/2 second at f/22 and ISO 100, tripod mounted; processed using Adobe Camera RAW, Photoshop, and Nik HDR Efex Pro, and then converted to black and white using Nik Silver Efex Pro.

▶ In the surprising uplands of Dordogne and Lot in the southwest of France, high alkaline plateaus are bisected by deep river valleys. You'll find medieval towns and castles, with markers from the history of the bloody Hundred Years' War, home to crusaders, Knights Templar, robber barons, and pilgrims.

Exploring the back country and looking for the smallest hamlets I could find, I discovered abandoned farms and picturesque ruined buildings, some dating from medieval times.

As I photographed the compound in Sainte-Croix (see pages 12–13), I found an ancient graveyard behind the church. While antique, many of the graves and markers were comparatively recent and well maintained with fresh flowers.

From the vantage point of this cemetery, ahead of an incoming storm, I made this image of an abandoned farmhouse, intricate in its construction and picturesque in its decay. The wind whistled through the grass in the fields, with a sound as desolate as the abandoned buildings. The grass in the foreground of the scene reminded me of Andrew Wyeth's famous painting *Christina's World*. The only thing missing was a French Christina, I thought, disassembling my camera and tripod and turning away as the wind whistled and rain began to fall heavily.

When looking at this scene, I was struck by the drama of the lowering clouds in the sky. My idea was to give this the kind of classical black and white treatment that could be obtained in the chemical darkroom by using a red filter over the enlarger lens. Fortunately, a simulated version of this effect is available for black and white conversions in Photoshop and other software.

40mm, six bracketed exposures with shutter speeds ranging from 1/1000 of a second to 1/30 of a second at f/25 and ISO 100, tripod mounted; processed using Adobe Camera RAW, Photoshop, and Nik HDR Efex Pro, and then converted to black and white using a simulated red filter as a Photoshop Black & White Adjustment layer.

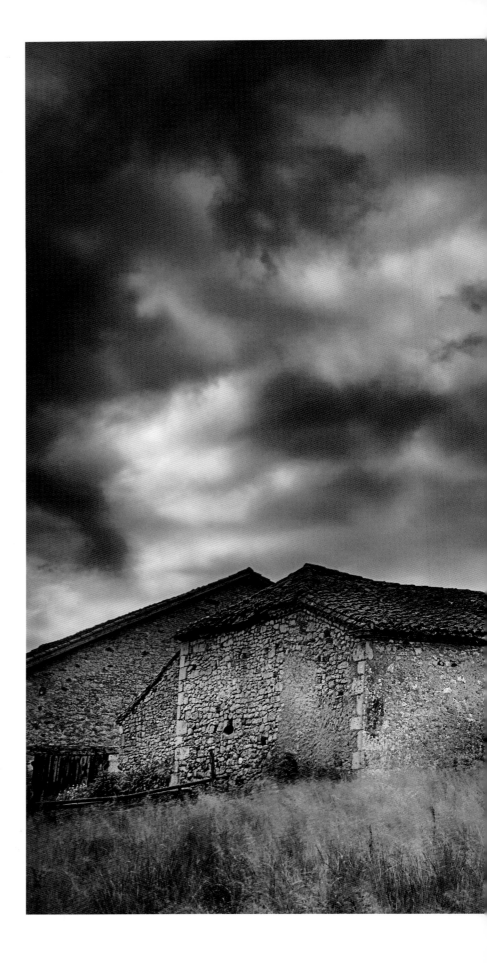

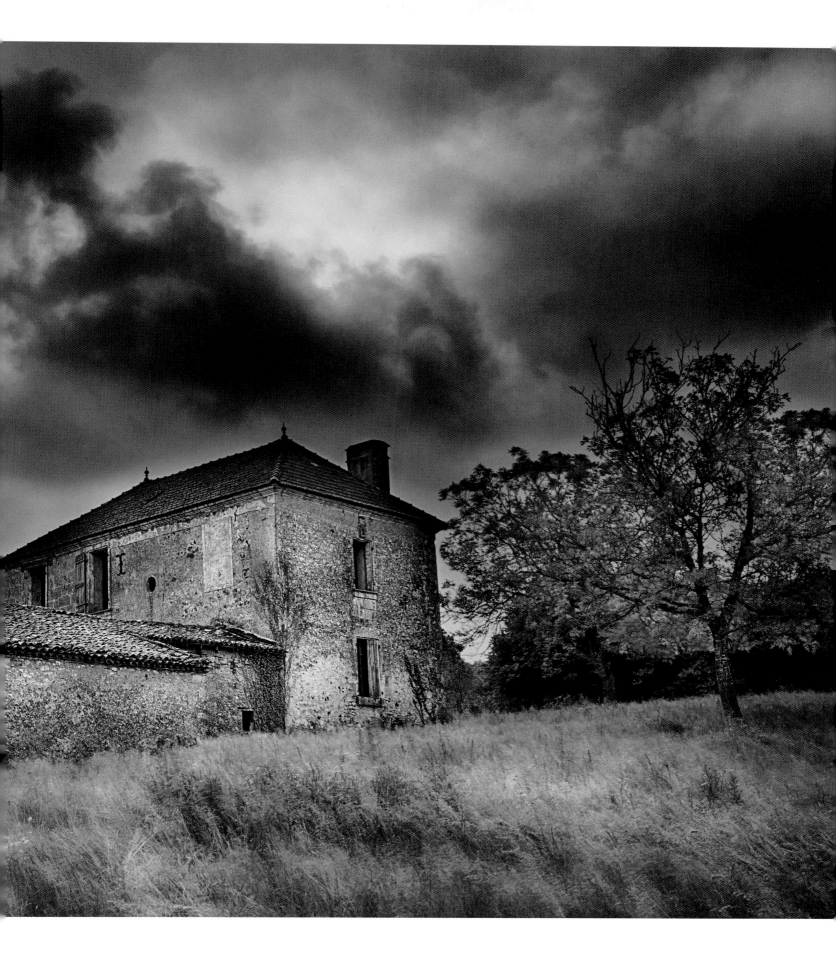

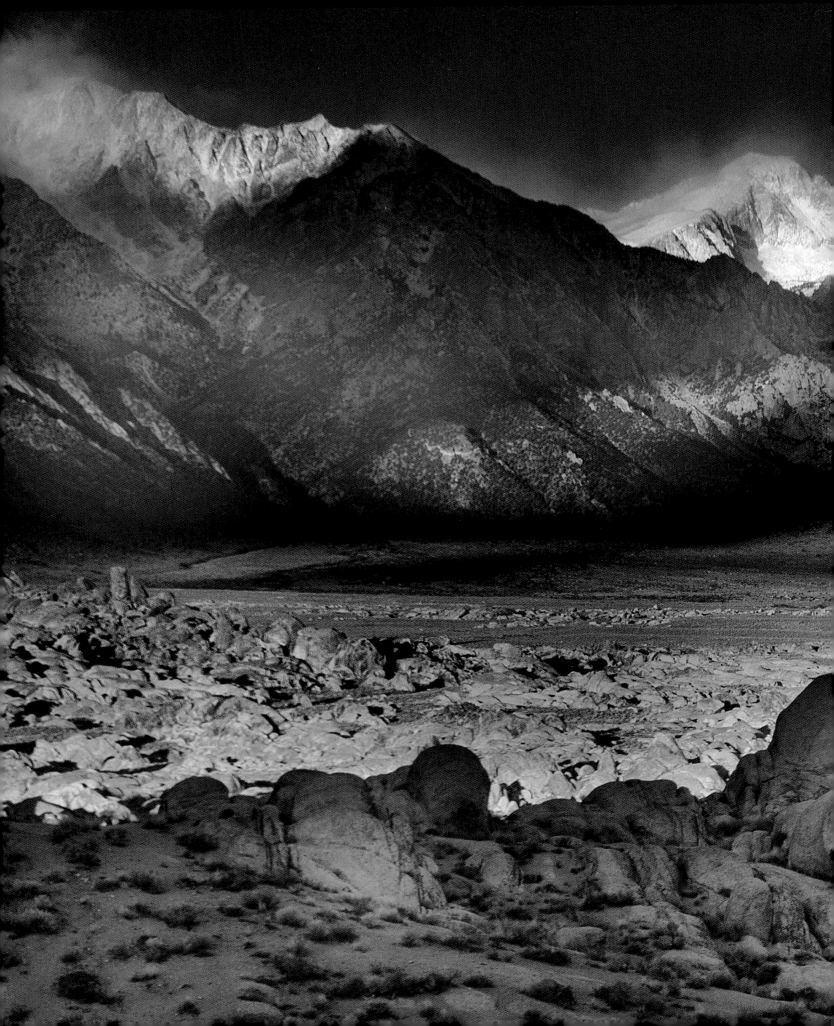

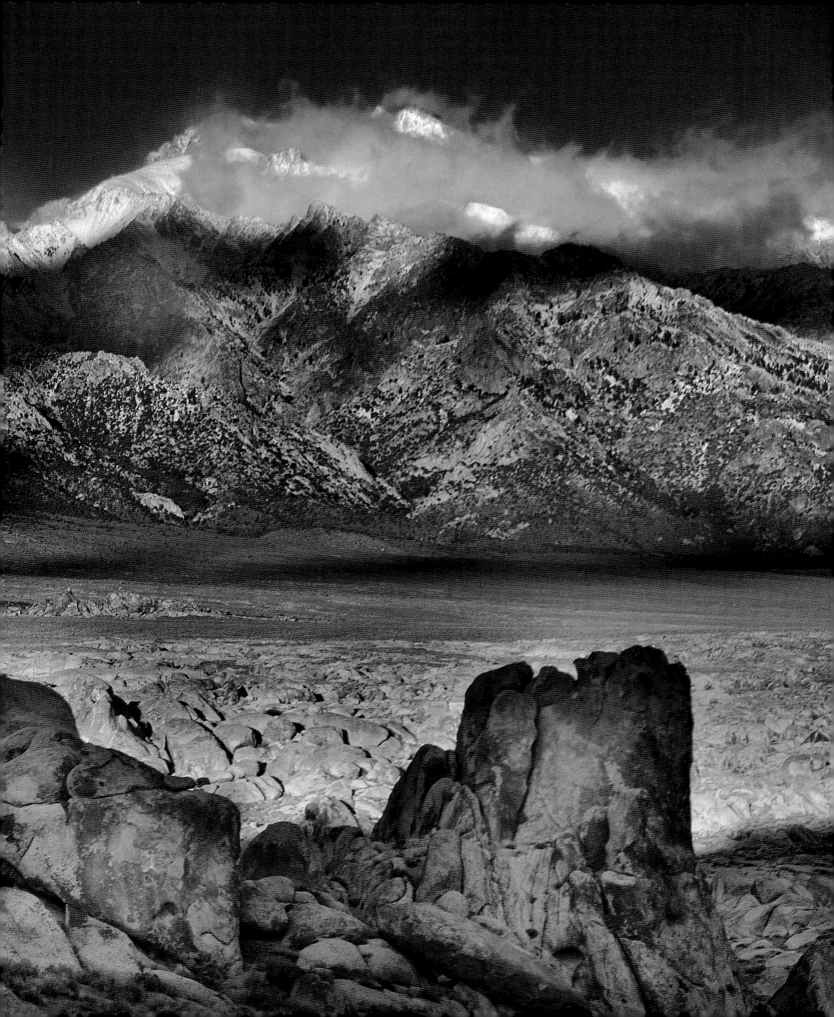

2: FINDING BLACK & WHITE

YOUR PATH TO BLACK AND WHITE

If you want to make more interesting photos, you should put yourself and your camera in front of more interesting things. Making more interesting black and white photographs means knowing how to find interesting and appropriate subject matter that works well in the grayscale tonality of black and white.

This is a little more complicated than meets the eye because the absence of color does not mean the obliteration of color. In other words, black and white is an affirmative choice that can paradoxically call attention to the color inherent in an apparently monochromatic image.

This chapter provides you with a road map to discovering the heart of what works as black and white imagery. A good starting place is to look for high-contrast images, because these often make for starting demarcations between the areas that are dark and the areas that are light.

Thinking in black and white means understanding—as is true for all photography—that you cannot capture an actual object that is in front of the camera. The only thing that the camera sensor will record is light reflected or emitted by the subject. So looking for black and white photographic subject matter means looking for light that will be spectacular and interesting when rendered in the black, gray, and white of monochrome.

▲ PAGES 36–37 AND ABOVE: The Alabama Hills are a rocky maze lying at about 4,000 feet above sea level between the town of Lone Pine, California, and the highest portion of the crest of the Sierra Nevada Mountain range. After a night of photographing star trails, I decided to stay for sunrise. As I watched the first light of dawn hit the high mountain peaks and portions of the distant vista, the light made the rock formations nearest me appear in silhouette, leaving me for a few brief moments in darkness until the sun struck fully and the landscape became a blazing furnace with the rising sun.

Looking carefully at the scene, I decided that a black and white rendition was the best way to convey the experience of standing in the cold shade of pre-dawn as the rising sun lit the world around me.

52mm, 1/400 of a second at f/8 and ISO 100, tripod mounted; converted to black and white in Photoshop using the High Contrast Red preset Black & White Adjustment layer.

▶ U.S. Route 66, sometimes known as the "Mother Road," was one of the original highways in the United States, and a major migration route during the great Dust Bowl of the 1930s. Today, Route 66 near the western Arizona border is a backwater, with tourist services that are intentionally anachronistic, and mimic the look-and-feel of the past.

iPhone camera app, processed and converted to black and white using Lo-Mob.

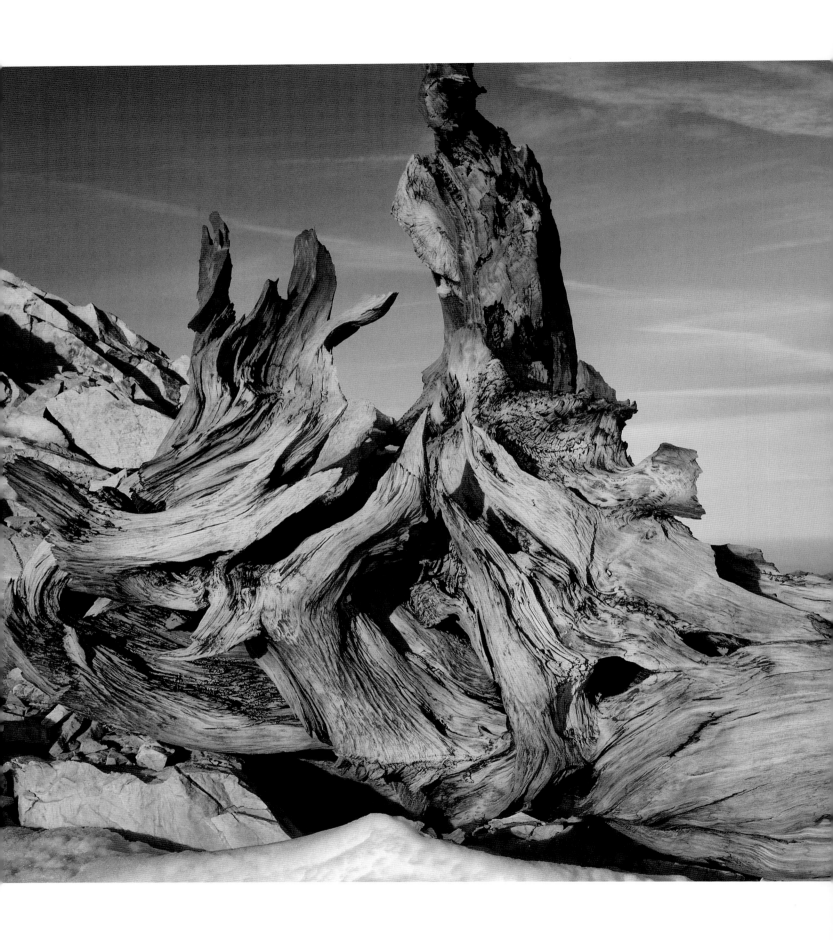

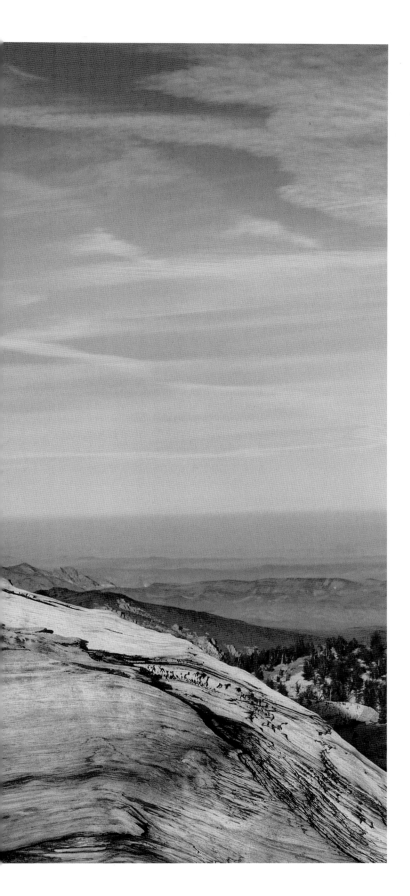

A starting place for beginning this search is to consider the elements that work best in black and white compositions (see pages 46–52). I often find that considering an image from the context of the "negative spaces" in the image is a great way to quickly evaluate black and white compositions (see pages 53–54).

The way a photograph is framed—the relationship of the image to the surrounding edges, and the internal relationships within those edges—is crucial to almost all aspects of fine photography. Take away the color and you have fewer elements left; therefore, framing becomes even more important in black and white photography (see page 55).

As I noted, a black and white photograph intentionally is simpler than one where the color can distract and mislead the viewer. In the context of this simpler universe, patterns become much more important. Many good black and white compositions rely on a strong underlying pattern, because the pattern defines the nature of what is shown in the photo (see pages 56–59).

High-key and low-key photography—photography that emphasizes light or dark in a composition—can be very problematic in color photography because colors get blown out and details get lost. But in black and white photography, these kinds of special effects play to the strength of the medium (see pages 60–67 and 180–189). When my camera and I are in a high- or low-key situation, I always start to think in black and white.

◄ The ancient bristlecone pines of eastern California and Nevada grow in isolated groves at elevations up to 11,200 feet above sea level. They are believed to be the world's oldest living things—a few trees are more than 5,000 years old. Because they live in a dry, cold environment with a short growing season, the trees grow very slowly. As these trees grow older, they grow more gnarled until they almost no longer seem to be alive.

As I walked among these ancient beings, I thought about their great age and solitude. I decided to frame this photo showing this tree's lonely perch high above the great ranges of the American West.

46mm, 1/15 of a second at f/22 and ISO 100, tripod mounted; converted to black and white in Photoshop.

THE AMERICAN WEST

From the Rocky Mountains along the continental divide at the heart of North America nearly a thousand miles west to the great wall of the Sierra Nevada range that rises up in a second Pacific divide, you'll find a great country of basins and ranges. This is a stark land of contrasts that is sparsely populated, freezing cold in the winter, among the hottest places on Earth in the summer. Early pioneers from Europe left their bones on the trails of the American Southwest, and it remains a region for travelers to be wary of hazards such as venomous snakes and running out of water in the desert heat.

Perhaps paradoxically, the very harshness of this spectacular landscape means that it lends itself to black and white photography. Strong sunlight and harsh shadows increase the contrast between lights and darks, and means that the photographer who is able to recognize subject matter that works in black and white can create compelling imagery.

> ▶ Located in a remote, northern section of Death Valley National Park, the Eureka Valley Sand Dunes are the tallest sand dunes in the United States, topping out at about 680 feet. Located at the end of a long, desert valley, these sand dunes are notable for a nearly constant wind. This wind creates whistling, throbbing sound harmonics that are reminiscent of a Philip Glass composition.
>
> Carrying my gear bag and tripod, I climbed to the top of the dunes in a sandstorm, the sand whirling around me, stinging the exposed skin of my face and hands. Lifting one foot in front of the other to the steady throb and hum of the dune music, I made it to the top, but was forced to turn back by the unrelenting wind storm. On my way back down, the blowing sand cleared for a little as the sun started to set. I set my tripod down in the shifting sand, quickly set up my camera, and underexposed this photo by about 3 EVs so the details in the brightly sunlit areas wouldn't blow out. Included with these details is the path I made to the top of the dunes. My exposure strategy meant that the shadowed areas in the photo became very dark.
>
> *95mm, 1/30 of a second at f/9 and ISO 200, tripod mounted; converted to black and white using Photoshop.*

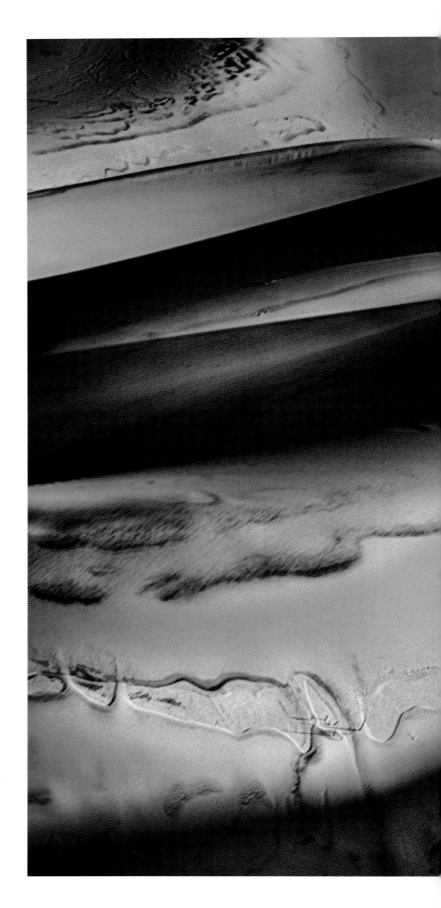

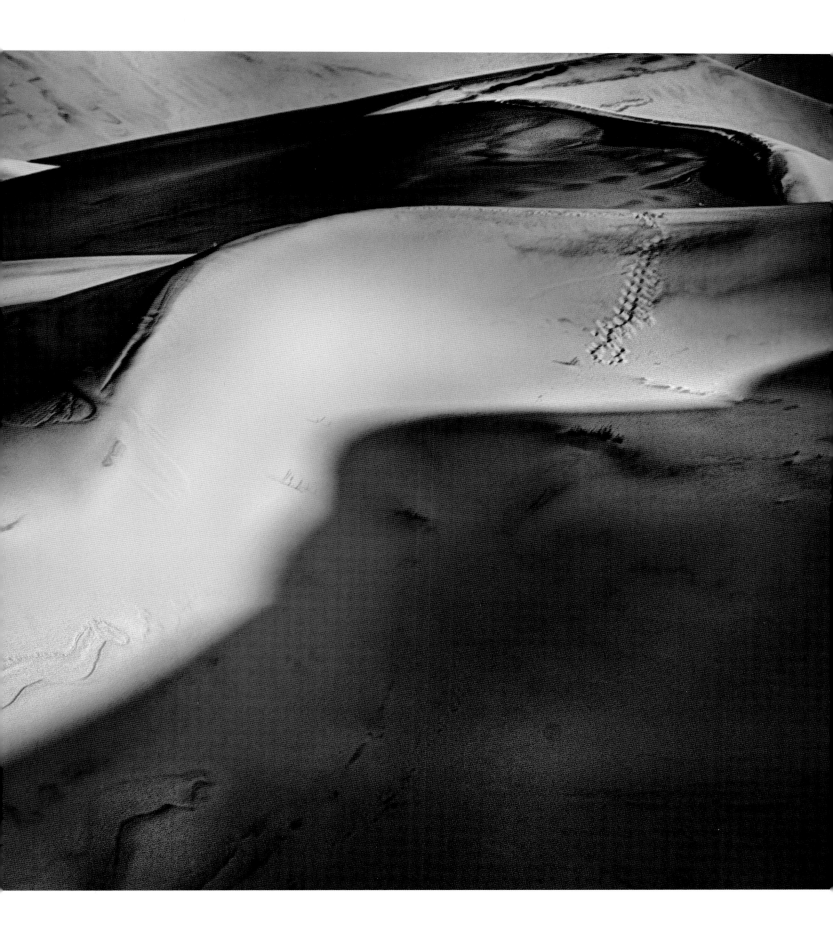

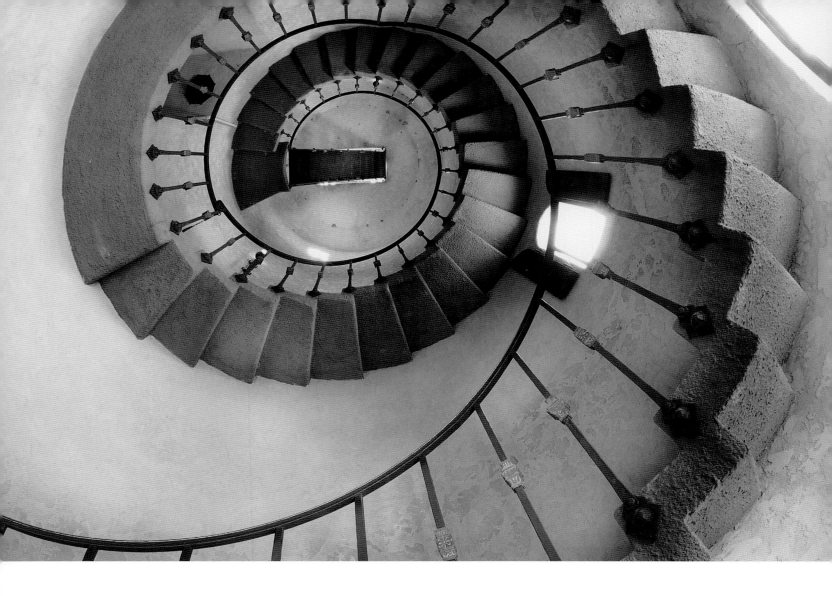

Like pioneers of old searching for routes through impenetrable canyon lands, modern photographic wanderers in this desert land need to know how best to prepare for the adventure of finding black and white subject matter, and for taking advantage of it once it is recognized.

The process of making compelling black and white photos involves a number of loosely related sequential steps:

■ *Finding subject matter that works in black and white.* Like a traveler in a desert land, you will never reach your destination without first understanding the terrain and map.

■ *Mastering photographic composition, particularly as it applies to elements that work well in black and white.* If you would cross a desert and find the paths across trackless mountains, you need to know how to survive in the sand dunes, and the basics of mountaineering.

▲ The spiral stair shown in this photo is in the interior of Scotty's Castle, located in the Grapevine Mountains of Death Valley National Park, California. Gold prospector and con man Walter Scotty persuaded a Chicago millionaire friend to build this folly—actually more like a villa than a castle—as a vacation home and informal tuberculosis sanatorium.

It is surely an exotic experience coming upon Scotty's Castle in the midst of a bleak, dry desert canyon. After the blazing heat and bright sunlight of the hot day, I felt dazzled when I entered the darkened tower. The cool stone felt good on my back as I lay face up on the floor. With my camera on a tripod photographing this somewhat stark staircase, the dark outlines contrasted nicely with the white interior stucco.

10.5mm fisheye lens, 1.6 seconds at f/22 and ISO 200, tripod mounted; converted to black and white using Photoshop and Nik Silver Efex Pro.

- *Understanding the best ways to process black and white photos.* This can be considered analogous to living symbiotically in the environment you have selected.

While all three subjects are tackled in *The Photographer's Black & White Handbook*, this chapter takes aim at the first two: finding monochromatic subject matter, and using this subject matter to create striking black and white compositions. This often comes down to the ability to think in black and white.

Normal human vision sees the world in color. To see well in black and white means to note *implied* colors. Implicative color is color that is not present in a black and white image—by definition—but remember the technical caveat that a black and white photo is usually contained in a file that has color values in the channels.

So the color is absent, but implied when the viewer is looking at a black and white rendition of the image, such as a print or one of the photos in this book.

Can you predict in advance when an image you make, and then convert to black and white, will imply the color story that was present when you made the photo? This is an essential pre-visualization skill for the black-and-white photographer.

Beyond implicative color, you should look for subject matter that has an extended and subtle range of grayscale values, and also has elements of extreme contrast. These goals involve a number of characteristics:

- The *dynamic range* from lights to dark. Generally the greater the dynamic, or tonal, range in the subject the better. The best black and white subjects generally extend from completely white white to completely black black. How often can you see this range in the world around you? It is rarer than you may think.

- The number of *tonal gradations*. Essentially, with some exceptions, the more different gray tonal values that can be separately rendered to appear in a black and white image, the more effective a monochromatic image is likely to be. The reasons for this are fairly clear: Without tonal separation you'll lose apparent detail, and the image will likely become mushy and boring.

- Extreme contrast means that the juxtaposition of black and white are important to the photo, just as shade on a brilliantly hot desert summer day matters more than a similar patch of cover in temperate weather.

Of course, as in all photography, composition matters (see "The Black and White Composition," starting on page 46). But in some ways color photographers have it easy. A compositionally conscious color photographer knows that the eyes of the viewer will first go to bright and distinctive colors, and then follow where the color leads.

The black and white photographer has no such crutch, and must rely on the skills of the indigenous native who understands the ways of the desert. This photographer walks rather than drives when possible and works with the landscape.

PRE-VISUALIZING BLACK AND WHITE USING THE CAMERA

Your camera can help you with you with the task of pre-visualization, or at least help get you up and running to the point where you no longer need to rely on an electronic crutch to see the world around you. Camera capabilities differ in this regard, so please check your camera manual to see if these visualization techniques are available to you, and to learn how to use them with your specific camera.

There are two basic ideas, again depending upon your camera's functionality:

- You can use the post-processing features in your camera to make a black and white copy of an image you just made. This facility will usually be called a "preset," or a "filter." Once you have made the black and white copy, check it out in your LCD to see whether it works in monochromatic. Maybe an adjustment of the composition would improve it in black and white? This can be a good way to find out.

- With some cameras, a "Live View" can be used to turn the LCD into a real-time digital video-based viewfinder. If your camera has this facility, you can probably add a black and white preset to view your composition in black and white on the LCD before making the exposure.

The idea is to look and really see: to take advantage of the absence of color, to learn to recognize the world of grayscale, and to enjoy the high-contrast image. In the light of such wonders, the facile joys of the color composition pale in comparison to the joys of black and white.

THE BLACK AND WHITE COMPOSITION

Photography is applied design, and according to classical design theory the principal building blocks of two-dimensional design are:

- Making the best use of both external and internal boundaries

- Acknowledging and working with the underlying shape in the image

- Constructing and depicting exciting and dynamic forms

As opposed to color photography, the boundaries in a photo are not obscured by an attractive color palette that can distract the viewer's eye. This means that getting your composition right is even more important with black and white photography than with color.

The concept of a boundary speaks to areas in a photo that are bordered in some way. In a photograph, the most important boundary of all is the visual frame for the photo—how the photo is cropped, how the content of the photo relates to the frame, and how the edges of the frame are treated. (Note that this does not refer to a picture frame, which is an entirely different issue.)

As an example of the frame edge treatment, a photo can go straight to the edge without a break (so the break is the edge), it can be bounded with a black retaining line, or it can be surrounded with a regular white area. These possibilities can be combined, and of course there are other possibilities as well.

Within the image itself, boundaries help shape the building blocks that are the shapes that make up a composition. Boundaries work best with defined edges, and when an edge is used appropriately in a black and white composition, an image can be created that uses the interplay of positive and negative spaces (see "Using Negative Space," starting on page 53). The ability to effectively contrast positive and negative

space in this way is an element that is simply not present in most color compositions.

Finding the edges that frame spaces within a monochromatic composition does require experience and an affinity for seeing in black and white. Becoming edge and frame conscious is essential, but otherwise there really are no hard and fast rules. But once you get the hang of it you'll be well on your way toward creating great black and white compositions.

Keep in mind when choosing your black and white subject matter that you cannot actually photograph an object. This sounds counter-intuitive, but it is true whether you are working in color or black and white. To restate this idea, you cannot make a photo of a given subject; the only thing you can capture is the light reflected or emitted by the subject.

While true across the domain of photography, this idea is particularly helpful to keep in mind when considering black and white photography, because the absence of

▶ This form of aloe is well known to plant lovers for the intricate spiral that it forms over time. It is an *Aloe polyphylla*, commonly called "the gem of the Drakensberg," named for its native mountain range in the Kingdom of Lesotho, near South Africa.

Interestingly, these spirals, which grow either clockwise or counterclockwise, grow very slowly. Some of the larger gems are literally hundreds of years old. The one shown here is probably quite venerable. By the time they get big, they are considered quite valuable and command high prices at horticultural nurseries.

One thing that always catches my eye when I am wandering about is an interesting spiral, whether natural or man-made. So I was delighted to come across this beauty as I wandered in the late afternoon through some lonely California hills. Who planted this lone specimen so long ago, and why here?

I was really glad that I had my iPhone with me. The late afternoon light was shining right on the center of the plant as I snapped this shot.

iPhone camera app, processed and converted to black and white using Lo-Mob.

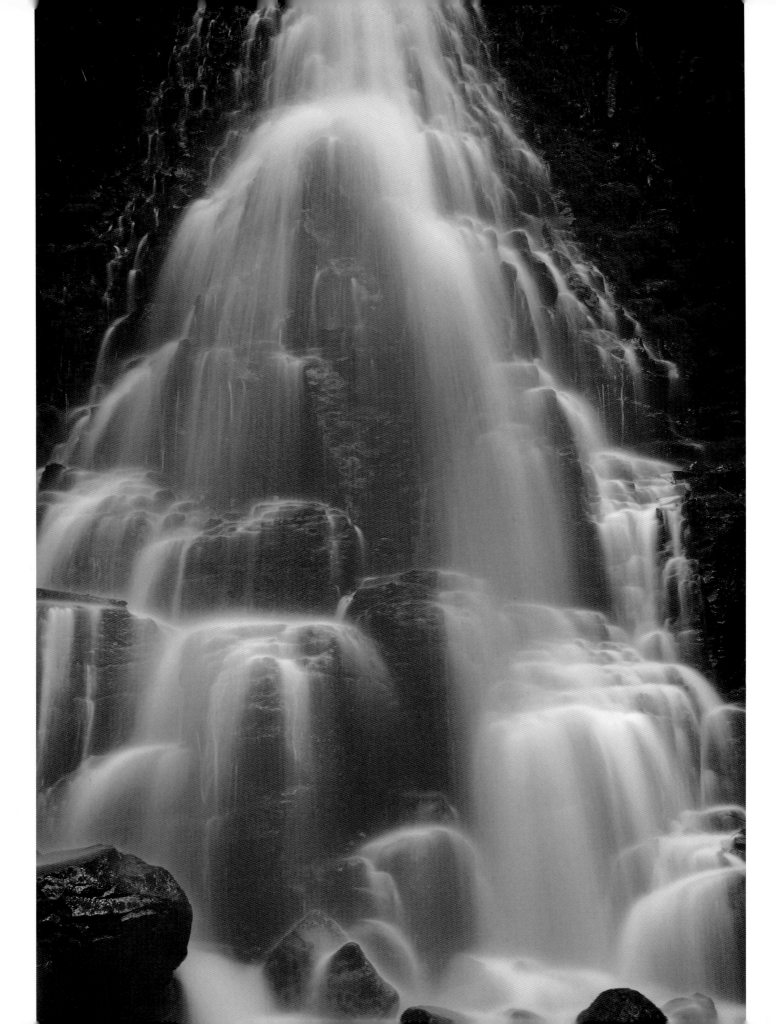

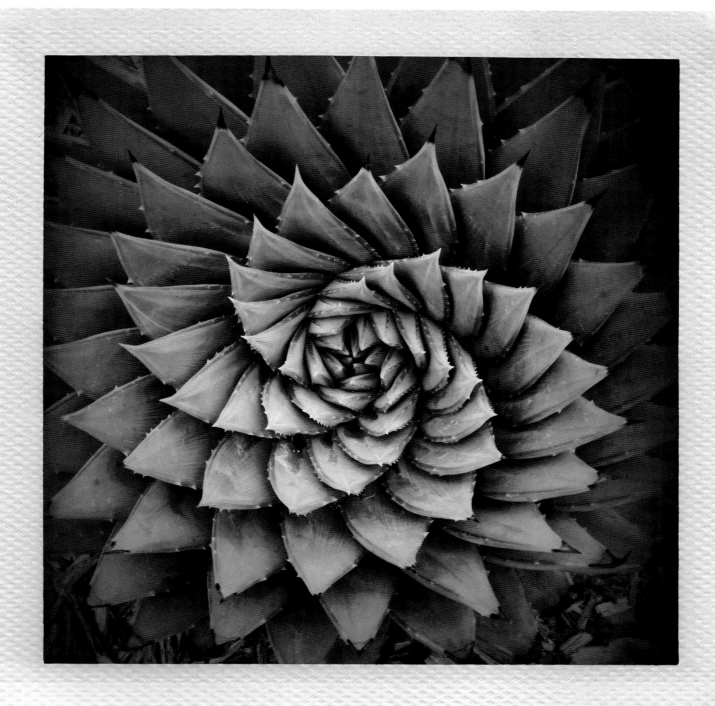

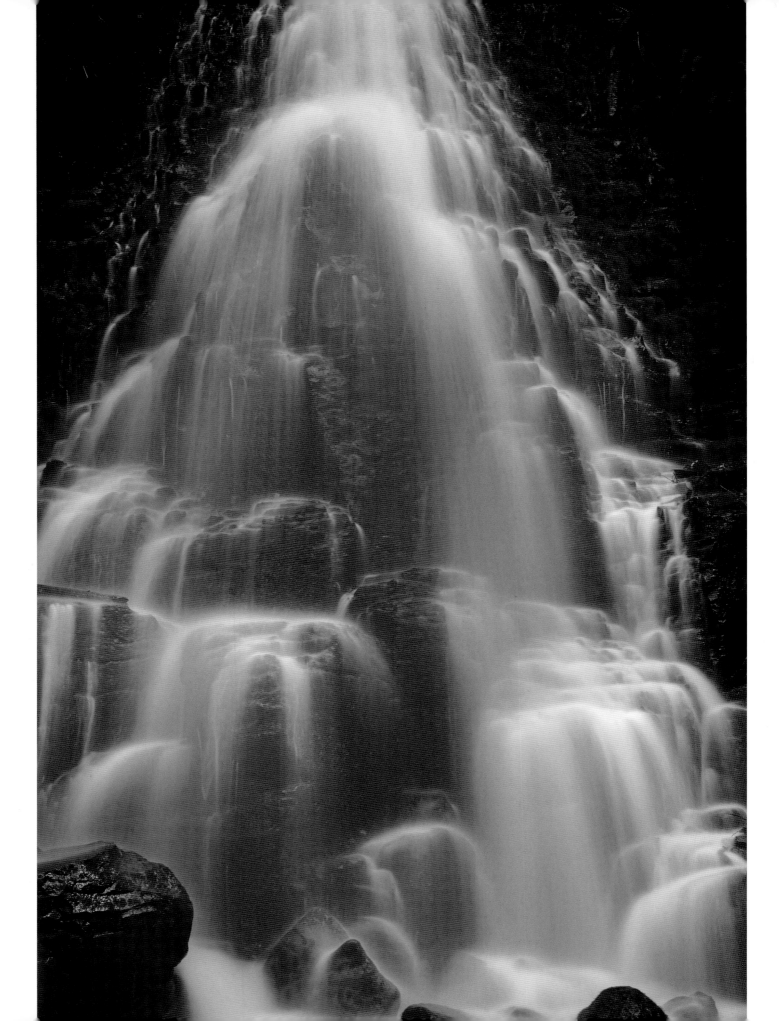

color reduces the composition to its minimal elements, meaning it is more closely tied to the way the light that is captured behaves.

Photos that are primarily about light, in as pure a form as possible, almost always lend themselves to black and white compositions.

Within the image itself, and in addition to being aware of the importance of light and edges, here are some of the remaining significant compositional issues to keep in mind when you are looking to make a black and white photo:

- *Look for the dark side:* Strong and compelling shadows often don't work well in color, but can be a hallmark of great black and white photography.

- *The absence of color is, well, the absence of color:* Compositions that are otherwise interesting but only have a little in the way of color variations, or are mostly presented in a single color, can work very well in black and white, as they are almost always not about color.

- *Ramp up the range:* In the Western desert we are home on the range, and much good black and white photography also shows a strong range between lights and darks. If there is little variation between the lightest lights and the darkest darks in an image, this may be a sign that it is not inherently workable in black and white.

- *Intentionality about graphic design:* Omitting color is an act of abstraction in the sense is that it is creating something artificial in relationship to the way that most of us see. Therefore, subject matter with abstract characteristics—that might work well if you didn't know what in the world you were looking at—can make great black and white imagery.

- *Keep it simple:* An image without color is an image with an important and complex element removed. Therefore, you want to look for imagery where there is at least the appearance of simplicity, and where keeping things simple is an important aspect of the composition.

- *Watch dem bones:* Black and white photos don't disguise the underlying structure, or bones, of their compositions as much as color images do. It's therefore important to work toward black and white imagery where the compositional elements are striking.

- *Patterns are the best:* Many black and white images take advantage of patterns to create striking and highly abstract compositions.

- *Shades of gray:* Since black and white images are by definition in shades of gray, look for compositions that feature a subtle range of gray layers, like sand on sand, clouds, mountains in the desert, and many other kinds of subject matter.

◀ The great Columbia River rolls between the states of Oregon and California, out to the Columbia Bar, graveyard of ships, in the stormy Pacific. Once a massive and fiercely independent torrent, the Columbia has been tamed with a series of hydroelectric dams that allow spawning salmon to swim upstream via fish ladders.

About 50 miles east of Portland, Oregon, the Columbia River Gorge allows this mighty river to cut through the Cascade Mountain Range. Numerous side waterfalls flow over the brink of the precipices into the Columbia River.

Exploring the scenic Columbia River Gorge area, I took a trail up to the top of the cliffs. From a vertiginous overlook, I peered down the rushing waters to the floor of the Columbia River Gorge.

From this cliff-top vantage point I continued up the trail past numerous waterfalls with names like Dutchman Falls, Weisendanger Falls, and Ecola Falls.

As I hiked, morning turned to afternoon, and the shadows in the lee of the Columbia River Gorge cliffs lengthened. On my way down, I passed Fairy Falls, shown here. As I started photographing the falls, I was struck by the way the light funneled from the top of the falls, almost as if the arc of light were flowing on purpose with the water. This seemed to be a perfect subject for a low-key black and white image. I also wanted to lengthen the exposure time so that the water appeared soft and blurred.

I wanted to convey a spiritual effect in this image, and it was accomplished technically by both intentional underexposure and intentional lengthening of the exposure. I lengthened the exposure by adding a 4x neutral density filter and by lowering the ISO to 31. By way of comparison, an overall average exposure for the scene would probably have been 4–8 EV brighter.

50mm, 0.6 seconds at f/22 and ISO 31, 4x ND filter, tripod mounted; converted to monochrome in Nik Silver Efex Pro.

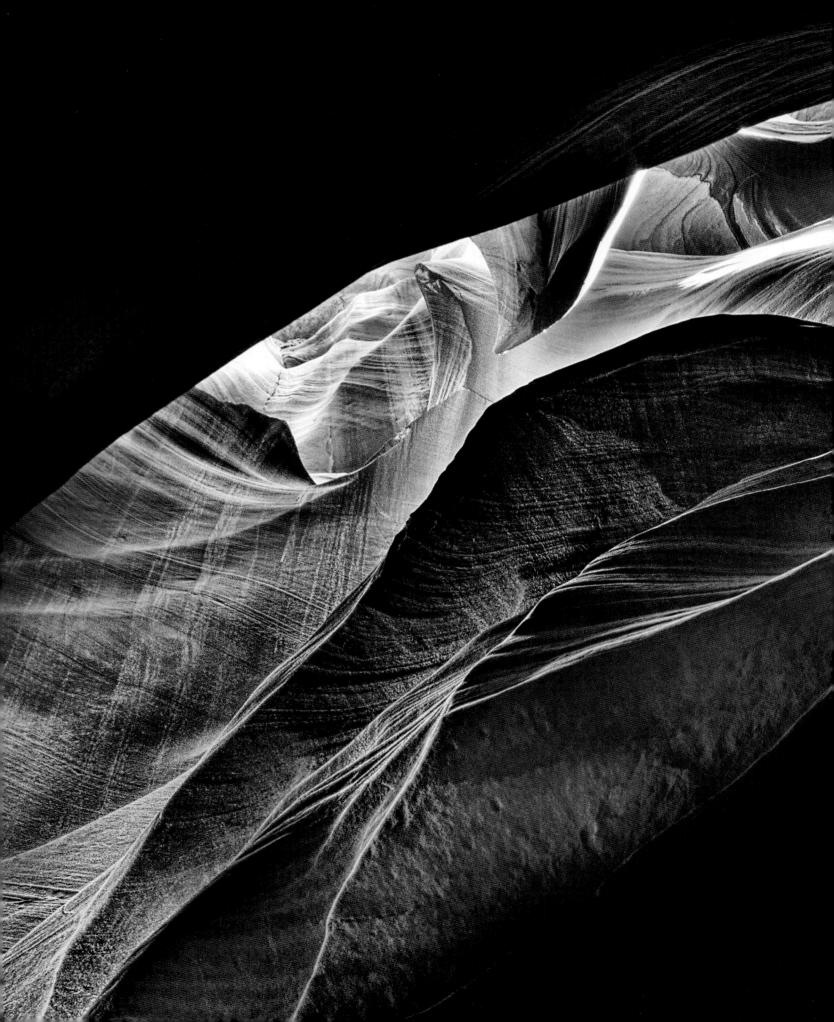

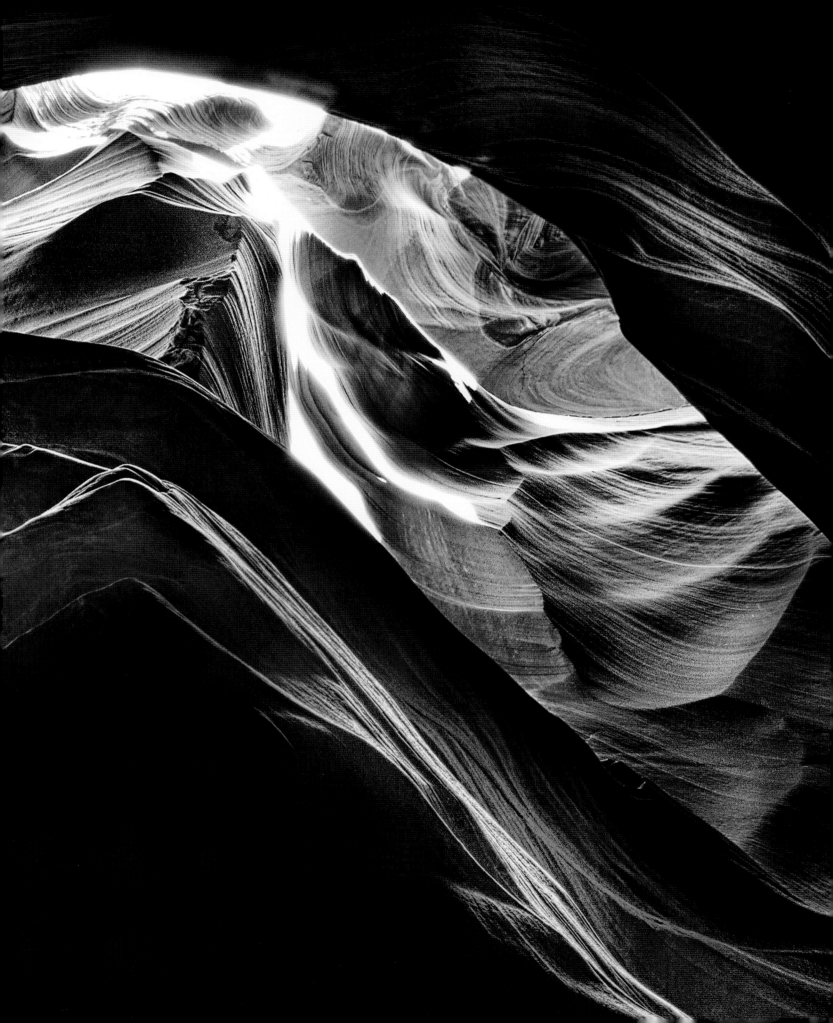

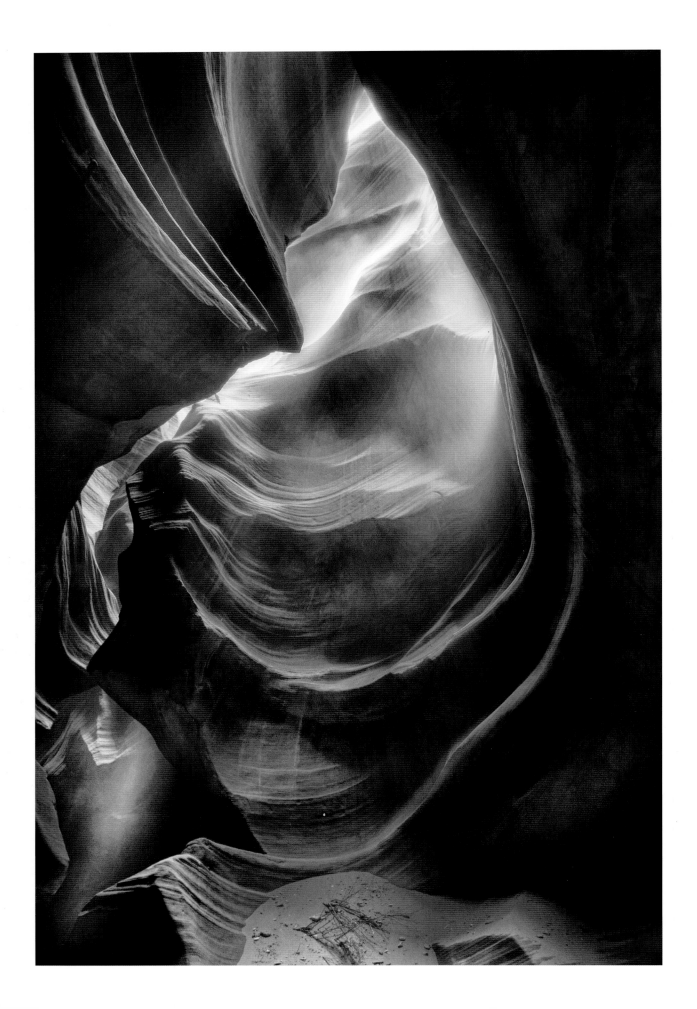

▲ PAGES 50–51: Looking up through the layers of rock viewed from the bottom of Upper Antelope Canyon near Page, Arizona, made me feel that I could see the structure of time moving at a geological pace.

This is an exposure blend of five on-tripod bracketed captures, giving me plenty of exposure range to capture the detail within the dark areas as well as the lighter sunlit band at the top of the image. But back in my studio at my computer when I saw the individual frames, I decided I actually wanted to make an image with outer bands of blackness, even though I had plenty of exposure information to also show the detail in the dark areas if I had chosen to do so.

From a formal viewpoint, this meant that the image's narrative was there to tell the story about the contrast between the dark area—which is the negative space— and the light areas—which is the primary subject. Put another way, it is visually about the interplay between the negative spaces—the dark upper and lower bands—and the detailed ribbon of light in the center of the image.

26mm, five exposures with shutter speeds ranging from 3/5 of a second to 20 seconds, at f/25 and ISO 200, tripod mounted; exposures combined and processed in Photoshop, and then converted to black and white using Nik Silver Efex Pro.

◀ When the wind comes up in the afternoon in Antelope Canyon, the sand blows down the canyon walls where it is caught in drifts at the bottom. In this photo, a shaft of sunlight caught the motion of the sand, which as smoothed by the long duration of the 20-second exposure.

Besides the framing of light and dark areas in an image, negative space can also be seen when the area around a subject forms an interesting shape that the eye can trace. Negative space can give the eye a place to rest, letting the viewer take their time when appreciating an image. The word *ma* (間) is a Japanese term that is often used to designate negative space—the word can be translated to mean "gap" or "pause."

This photograph of Antelope Canyon is interesting to think about in terms the shapes that form the negative space. The large oval shape gives the eye something to trace, before moving in to look at the other curves in the image. The light at the top also draws the eye upward from the darker areas at the bottom.

18mm, 20 seconds at f/15 and ISO 200, tripod mounted; converted to black and white using Photoshop.

USING NEGATIVE SPACE

Negative space is one of those elusive concepts that is hard to wrap your brain around, but once you get it you will understand exactly what is involved.

In theory, the idea of negative space is quite simple, but it is perhaps best explained in the context of an example. Think of it this way: Suppose you have a very dark figure on a white snow field. The subject of the photo is the dark figure. The negative space is the white snow field.

In a normal compositional process, one would probably focus on the subject matter of the photo, namely the dark figure. Becoming conscious of the negative space in an image means inverting the compositional thinking, and concentrating on the "empty" space around the subject.

Note that in my example I described a dark figure on a very white background. Since black and white photography operates to create images that do not explicitly convey color, considering issues of negative space is a particularly effective technique for approaching monochromatic composition.

What I do is use the contemplation of the negative spaces within an image as a way to shift my understanding of the underlying compositional structure. So, supposing I come across a dark canyon with a ribbon of light partially illuminating the cliff falls far above (see photo pages 50–51) the obvious place my eye is drawn is the bright areas of sunlight. But I will learn more about creating an effective composition around the subject if I learn to concentrate on the dark, comparatively uninteresting negative space areas.

In another example, suppose I find myself in an abandoned ranch where there is something of interest through a window in an almost blank white wall, as in the photo on page 54. The issues are visually complex in this image, because it is not entirely clear which space is negative and which is positive—but there is no doubt that to achieve an interesting composition I needed to focus on the relationships between the negative and positive spaces, leaving aside the question of which was which.

So, when you are thinking about black and white composition, I suggest you contemplate the concept of negative

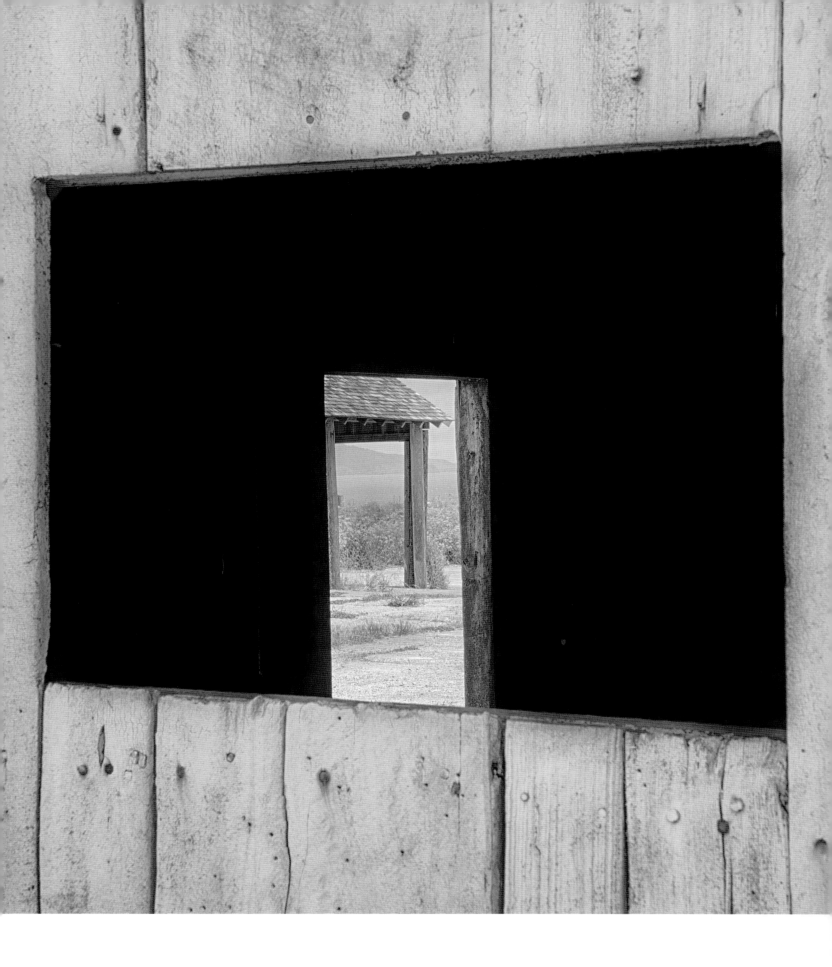

space in your photos. Using this concept you can enrich your imagery, and also shift your thinking away from a too conventional approach.

FRAMING

Framing a photo means the relationship of the subject within a photo to the edges of the photo, and also, secondarily, how the border of the photo is treated. Just to be very clear, let me repeat that I am not talking about picture framing, which is an entirely different issue.

When you are composing a photo, its framing is one of the key elements of how successful the composition will be—depending upon the photo perhaps *the* key to compositional success.

Sure, some photos depict a subject with sufficient impact or emotional appeal that they will stand no matter how badly they are framed. But absent this kind of circumstance, good framing adds logical integrity and coherence to an image, and makes it the kind of photo one might want to come back to and do more than just glance at. Since black and white photos tend to be more about formalism than color photography—because creating a digital black and white photo is inherently an act of creative anachronism with artistic intent compared to simply firing off a selfie with a point-and-shoot or phone camera. Think of it this way: The best photographs bring a sense of order out of the chaos that is the world. All may be a jumble around one, but by choosing a great frame for your photo you are saying to the viewer that there is a coherent and logical reason for your compositional choice of framing.

In other words, your choice of framing is an important element of your image design. So consider the frame from the viewpoint of formal design: The frame should complement rather than detract from the image, and it should visually answer the question of why you decided to show this particular slice of the world.

Consideration should be given to the elements within the frame as they approach the frame. There should be a visual reason these elements either come to a stop before the frame, or apparently continue past the frame. The more the subject matter seems confused and tangled (the bristlecone pine studies shown on pages 70 and 71 are good examples), the more important is pinpoint compositional framing.

In a broader sense, you want the viewer, either consciously or unconsciously, to come away from your image with a sense that the framing is interesting and presents a plausible view of the importance of the subject you have captured.

Paying attention to the frame when making a black and white photo will pay dividends in terms of the quality of your compositions.

◀ Parking my car beside the road, I scrambled down a steep bank, crossed through a tunnel under the road, and found myself in the abandoned out-buildings of an old ranch. The scene shown in the image—a door within a door within a window—with stark contrasts between light exterior wood and dark interior, was too good to pass up, so I stopped to make this monochromatic image with my camera on my tripod.

In this image, the negative space of the exterior wall serves as contrast with the interior darkness, which itself frames the negative space of the lighter door seen through the outermost window and interior door. So, from a formal point of view, this image is about the interplay of several levels of negative space, all interacting with each other and with the positive space areas as well.

62mm, five exposures with shutter speeds ranging from 1/100 of a second to 2 seconds, each exposure at f/22 and ISO 64, tripod mounted; exposures processed and combined using Nik HDR Efex 2, and then converted to black and white using Photoshop and Nik Silver Efex Pro.

PATTERNS

Black and white photography tends to reduce things to an absolute irreducible minimum. In the absence of color, it is easy to see at a glance whether an image is structurally sound or not. This means that recognizing strong patterns is extremely important to creating effective black and white compositions.

Formally speaking, a pattern consists of repetition of one or more identical or very similar shapes. Hopefully, the repetition forms an aggregate whole that is attractive.

In black and white photography, contrast plays a particularly important role in pattern building, as does the recognition of negative space. The elements of the pattern are usually created using contrast between dark and light lines and shapes. Put another way, the pattern is built up by placing negative spaces next to positive spaces in a progression or a repetitive sequence.

To be truly effective, a compositional pattern needs to work out if and how the pattern ends, which usually means that the pattern has to interact with the framing of the image.

▶ Different species of agave, a desert succulent, dot the American southwest. Each rosette of an agave flowers only once and then dies. During the development of the flower, the sap that agave syrup is made from runs to the bottom of the flower stalk. The sap is also used to make tequila.

I photographed this clump of agaves to maximize the patterned nature of the plants and to emphasize the outlines of the thick leaves. My idea was to create an image more akin to an etching or a lithograph than to a photo.

40mm macro lens, four exposures at shutter speeds ranging from 2.5 seconds to 1/6 of a second, each exposure at f/22 and ISO 100, tripod mounted; exposures combined and processed using Photoshop, Nik HDR Efex Pro, Topaz Adjust, Topaz Simplify, and Nik Silver Efex Pro.

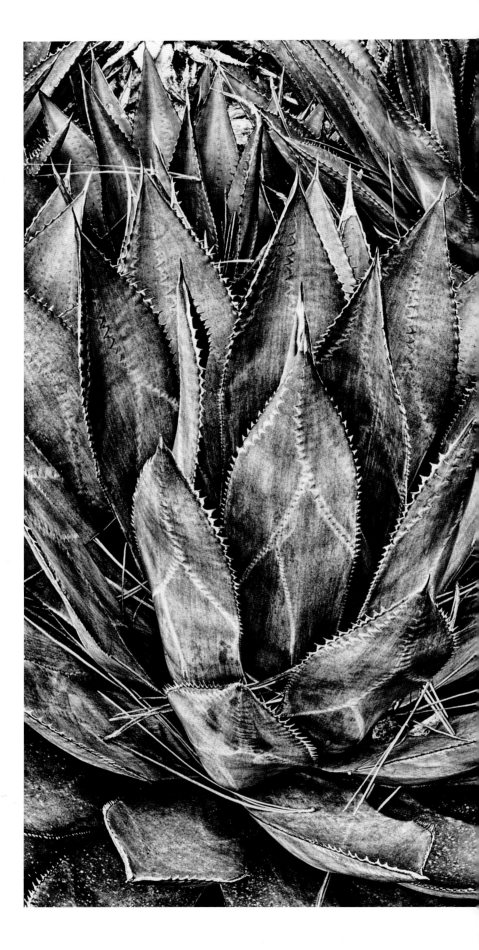

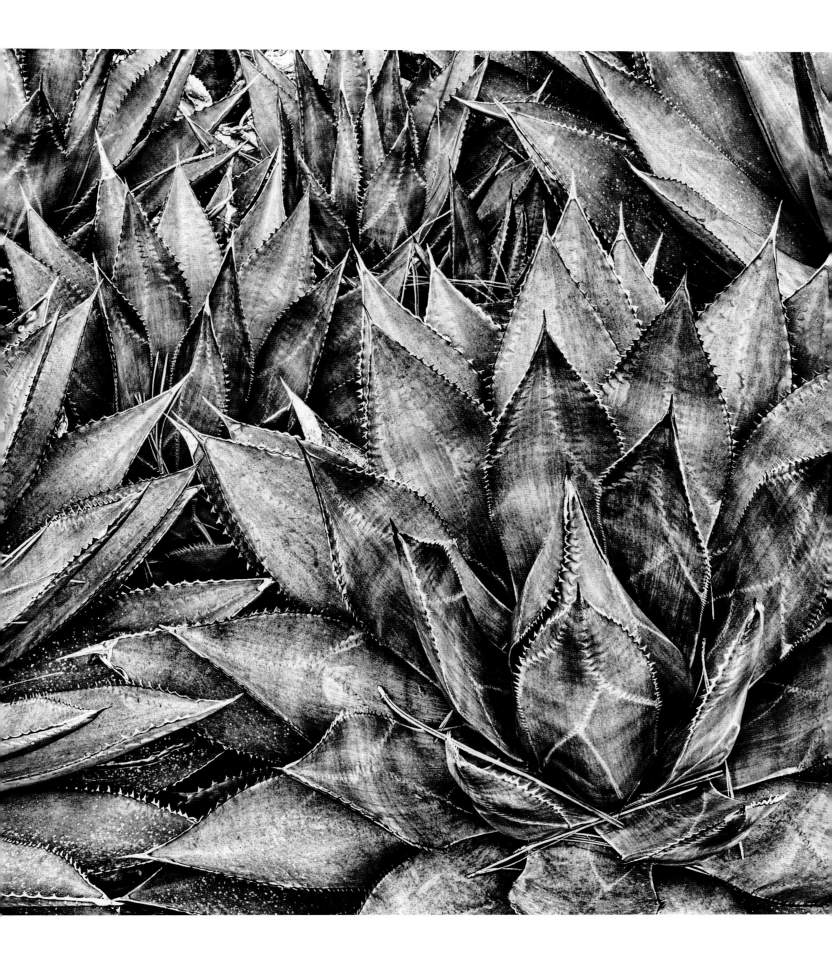

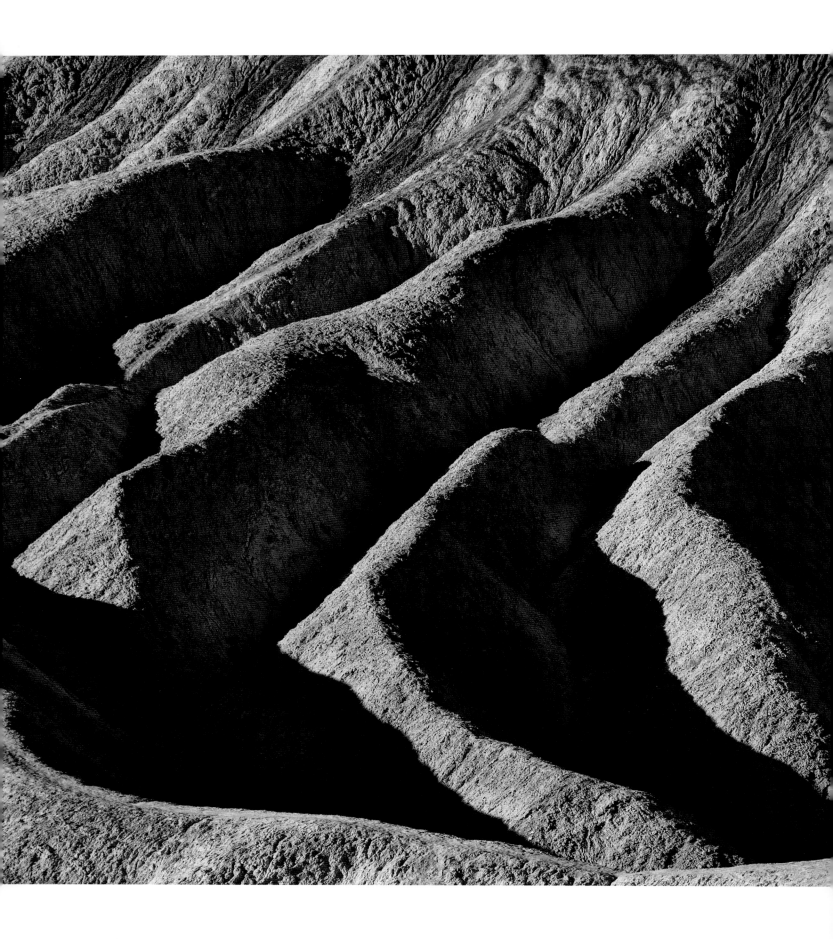

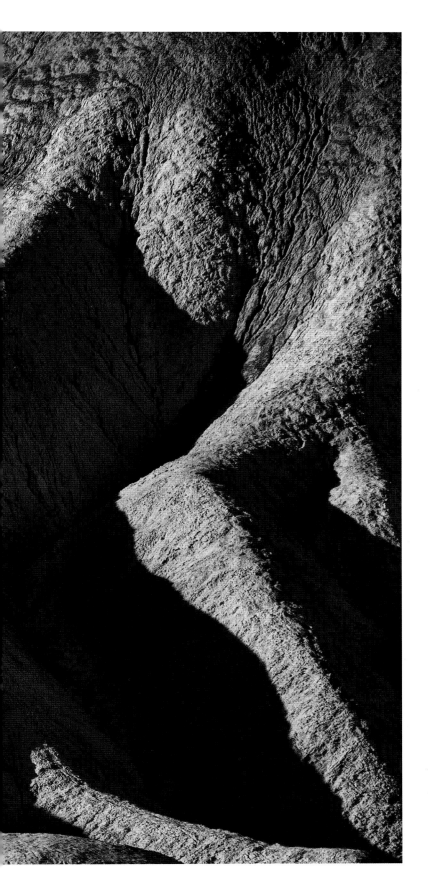

Showing where a pattern begins and ends can help to create visual interest in the pattern. In addition, the endpoints of the pattern can hopefully work well with the image boundaries and framing. For example, in the image of desert agaves shown on pages 56–57, the clear visual implication is that the pattern ends just outside the framing of the image.

In the image of Death Valley's vast badlands in deep shade shown to the left, the pattern ends in the right in a triangular shape that is pointing into the photo, with the visual implication that the depth of the valleys in the badlands is lessening toward the right.

When composing black and white photos, look for patterns that involve contrast. The best pattern photos also explore the relationship of negative spaces to the subject of the image (the interior of the agave leaves to the leaf edges on pages 56–57, the contrast between the black valleys and bright ridge tops to the left).

Consider carefully how the pattern begins and ends, and pay particular attention to how the pattern relates to the image framing.

If you consider the patterns in your image, and make sure there is a tonal logic and cohesion related to them, you will certainly create stronger black and white pattern-based imagery—and patterns are the basic stuff of life!

◄ Zabriskie Point is located at the east end of Death Valley National Park in California. Composed of sediment from Furnace Creek Lake (which dried up more than five million years ago), the eroded badlands form an interesting pattern created by the bright ridge-tops and dark canyons. Many ill-fated Forty-Niners, who traveled to California with word of the Gold Rush, blundered into this parched land and perished in these hills.

Standing well above the badlands at a high vantage point, I wanted to create an image that emphasized the stark quality of the landscape with its light and dark pattern. As I made a series of exposures, I intentionally underexposed the images to capture the darkest areas. After returning to my studio, I darkened the blacks and lightened the whites in post-production.

135mm, 1/500 of a second at f/11, hand held; converted to black and white in Photoshop.

HIGH KEY AND LOW KEY

A brightly lit, predominantly light, or white image is called *high key*. In some cases, high-key imagery is created via intentional overexposure.

Low-light, dimly lit photos that are predominantly dark or black are called *low key*. Low-key images are often intentionally underexposed from a technical perspective.

Both high-key and low-key subject matter can work very well in black and white. The "gotchas" are that good high-key and low-key subject matter can be hard to find, and these types of imagery can be harder to pull off from a technical view point than more straightforward imagery.

One thing to consider: Sometimes, a single image can involve both high-key and low-key elements, possibly arranged in a regular pattern, for example when sunlight alternates with shadows in a geometric arrangement.

Good high-key subjects are usually bright without much contrast, except perhaps in specific areas. In some cases, the subject matter is not inherently bright but can be processed to make it look attractively light. In other words, not all high-key subject matter starts that way in nature—some high-key (and low-key) effects are generated in post-production.

Within a high-key photo, or within the high-key areas of a mixed-key photo, make sure you look for dark areas that are defined with detail, because these must contrast with areas that have lost detail. Note that losing detail in bright, overexposed areas is an inherent and expected feature of high-key imagery.

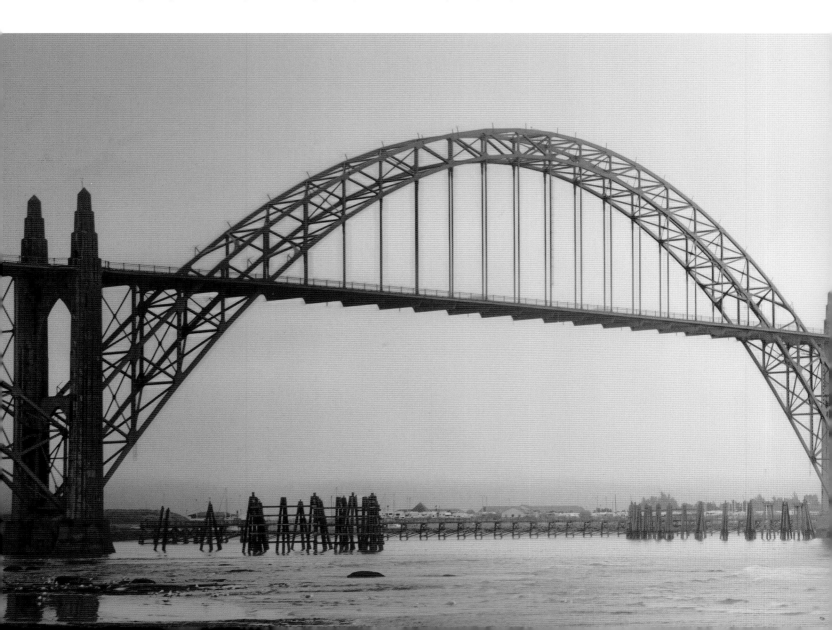

▼ It was a long day driving. By the time I reached Astoria, Oregon, on the Pacific Coast, it was pitch black. I checked into the first hotel I could find, went out to the hotel restaurant for a tasty seafood dinner, and fell into bed not knowing exactly where I was or what things would look like in the morning.

I woke to the sound of foghorns in the distance, and opened the shades in my room to see fog and drizzle rolling in, and the distant outline of the Yaquina Bay Bridge silhouetted against the bright gray sky (for a photo showing the underpinnings of the Yaquina Bay Bridge, see page 72).

Looking at the elegant structure of the art deco bridge, I realized that the interesting bright but foggy weather really lent itself to creating a high-key black and white image.

In my mind's eye, this image would use the fog and the bridge structure to make the image seem to stretch on forever. In this context, the far end of the bridge needed to appear to disappear smoothly into the distance without ever actually ending.

Before the weather could change, I grabbed my gear, jumped in the car, and went in search of a location where I could photograph the length of the bridge with as few visual distractions as possible. I calibrated my exposure so that it was slightly overexposed (by about 1 EV), without being so overexposed that I would lose detail. When it came time to process this image, I made sure to overexpose the right side (where the bridge disappears) compared to the left side (where the bridge starts). I also cropped the final image to emphasize the long horizontal form of the bridge.

48mm, 1/25 of a second at f/11 and ISO 64, tripod mounted; processed in and converted to black and white in Photoshop.

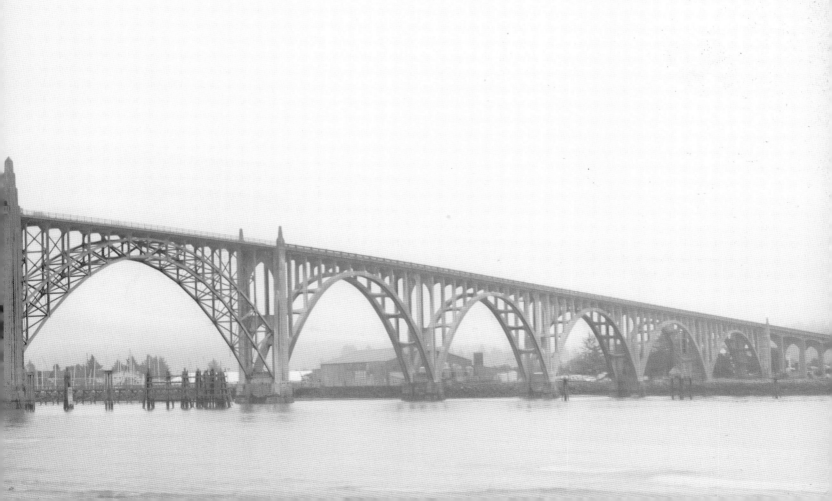

When you are contemplating creating either a high-key or low-key photograph, I recommend that you strongly consider bracketing exposures. There are several good reasons for this. Most important, it is hard to know in advance how far you will need to overexpose or underexpose to get the high- or low-key effect you want. Also, if you've bracketed with the camera on a tripod, you can use elements from more than one exposure in post-production, which is often desirable in high-key and low-key photography.

Remember, if you don't bracket exposures when you are in the field, you will not be able to generate them when you are working in post-production. So why not take a few moments to make some additional exposures when it is easy to do so?

High-key images involve predominantly bright or light subjects. If you are looking to create a low-key image, the quest is for dark subject matter that is very dark and perhaps only intermittently lit at all.

In low-key photography, the high-key elements take on greater importance because they contrast to the

◄ The Oakland 16th Street Station was built in the early 1900s as a grand terminus for the Southern Pacific Railway. In service until 1994, the station served as a transportation hub and a gateway to the West.

The station is now disconnected from all train tracks, and it is fenced and locked. Located in what has become a mixed neighborhood with light industry, residence hotels, expensive gated condo communities, and ad hoc homeless villages filled with shopping carts and tents, the future of this historic structure is unclear.

Lucky to gain access to the station for a few hours, I wanted to show its grandeur and mystery. With this photo of the main waiting room, I shot two exposures and combined them in Photoshop to capture the intense, low-key tonal range. Each exposure was lit through the doorway and windows with remote strobes.

15mm, two exposures with shutter speeds of 30 seconds and 60 seconds, each exposure at f/10 and ISO 200, tripod mounted; converted to black and white using Photoshop.

low-key background, there are fewer of them, and they are the only elements that really are noticeable.

It's a good idea to take some care when exposing low-key images, because your in-camera light meter is almost always likely to lead you astray. An average reading across a dark subject will illuminate a dark background and overexpose the lit elements, which is not what you want. Your plan should be to underexpose dark elements, allow the dark subject matter to go very black, and exposing properly for the all-important high-key element within the image.

I suggest paying special attention to the possibility of creating high-key, low-key, or mixed high-low-key imagery when you are working in black and white, because this approach can be tremendously effective in creating striking monochromatic compositions.

▶ The great Southwestern country of basin and range ends abruptly on the western side in the impenetrable wall of the Sierra Nevada mountain range of California. Rising 8,000 feet from the deepest valley on the North American continent, the mountain stillness is unbroken by roads for more than two hundred miles. When winter comes early, fierce winds howl down from these great heights, blasting the lands below with icy, frigid air.

Slowly driving along the base of the mountains on a back country dirt road in my minivan, I watched numbers on the van's external thermometer quickly plummet 10 degrees in 5 minutes. Seeing the contrast of misty, snowy, mountain-top cloud with the foothills' desert jumble, I decided to stop to try to capture the majesty of the scene. As I parked, wind whipped past the van, rocking it. When I opened the door, cold air rushed past my face, making my eyes sting. Grabbing my gear, I set up my tripod and stabilized it by piling rocks around the tripod legs. I used the van as a windbreak while I took several photos.

120mm, 1/800 of a second at f/8 and ISO 100, hand held; converted to black and white using Photoshop.

▼ PAGES 66–67: The scene looking through this memorable tunnel of trees was a starkly contrasted mixture of lights and darks. I exposed and processed the image to empha-size the lighter tones and created a high-key photo for greater impact.

92mm, six exposures at shutter speeds ranging from 2.5 seconds to 1/20 of a second, each exposure at f/22 and ISO 64, tripod mounted; exposures processed in Photo-shop and Nik Silver Efex Pro.

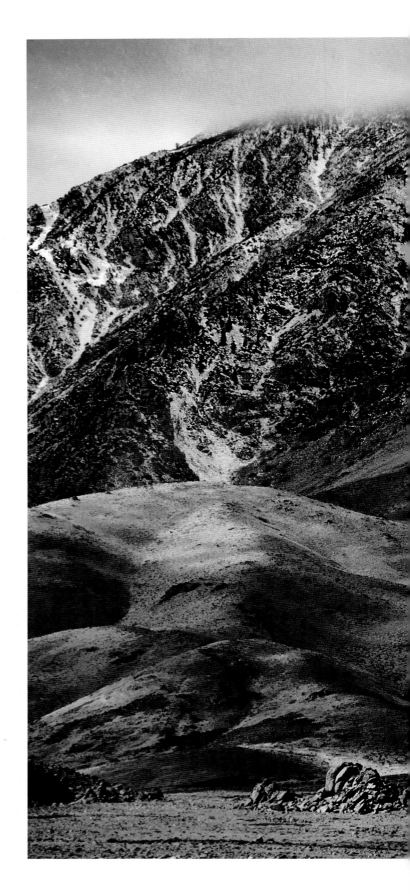

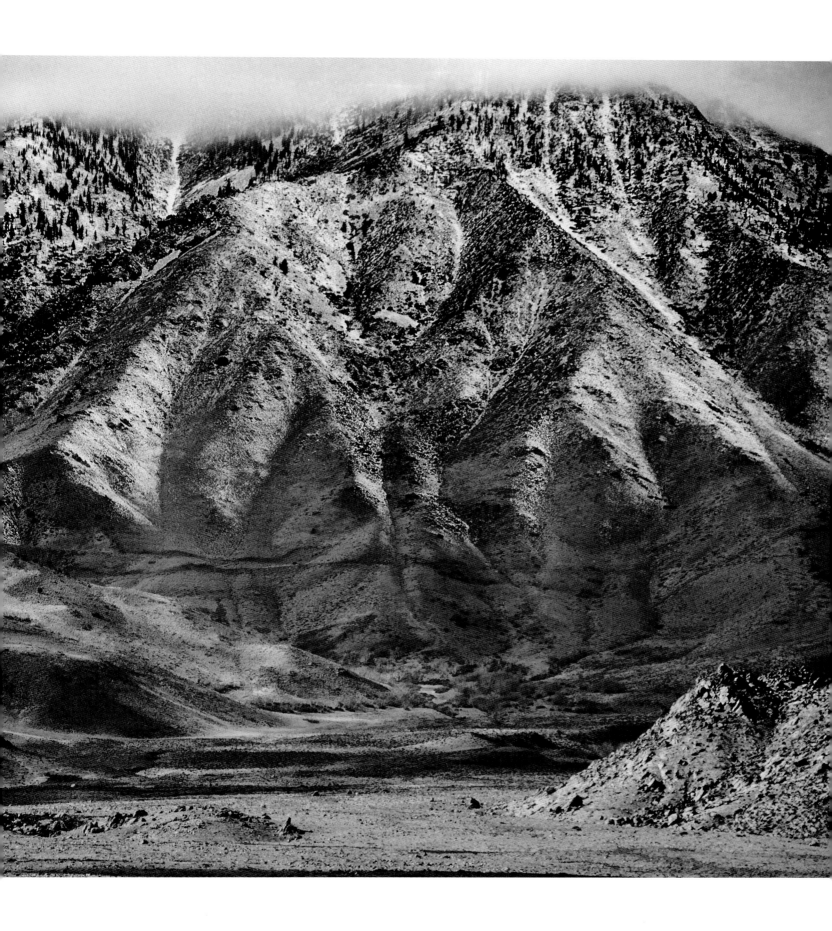

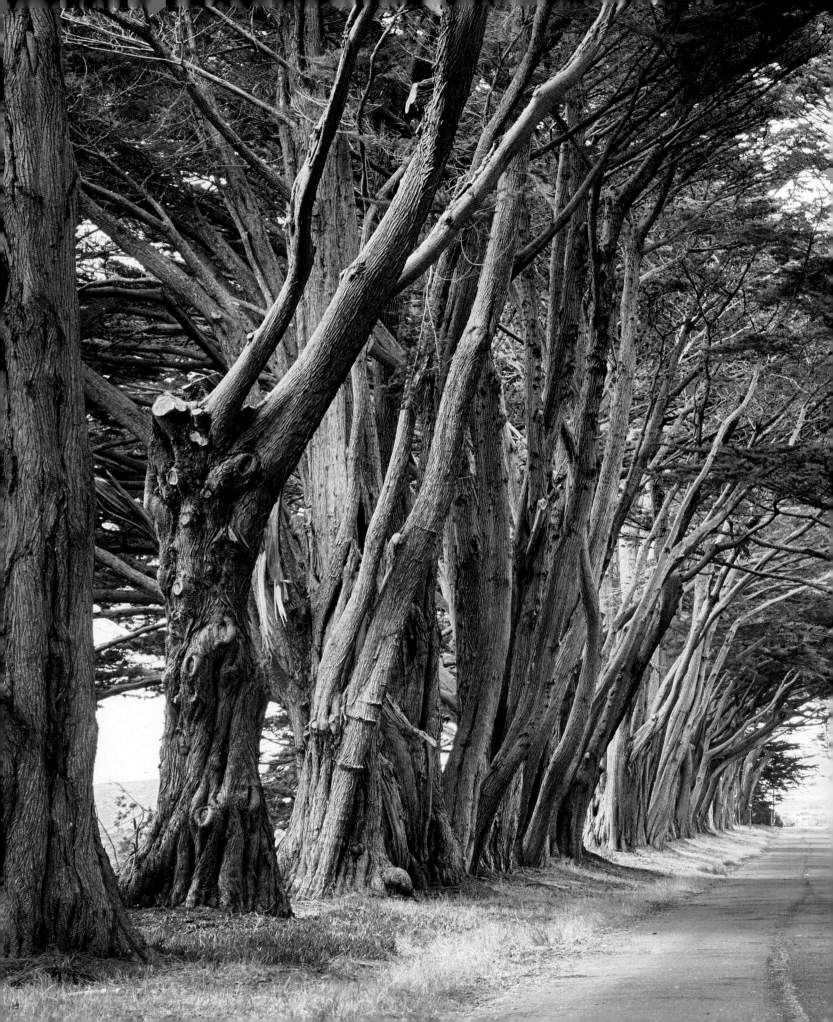

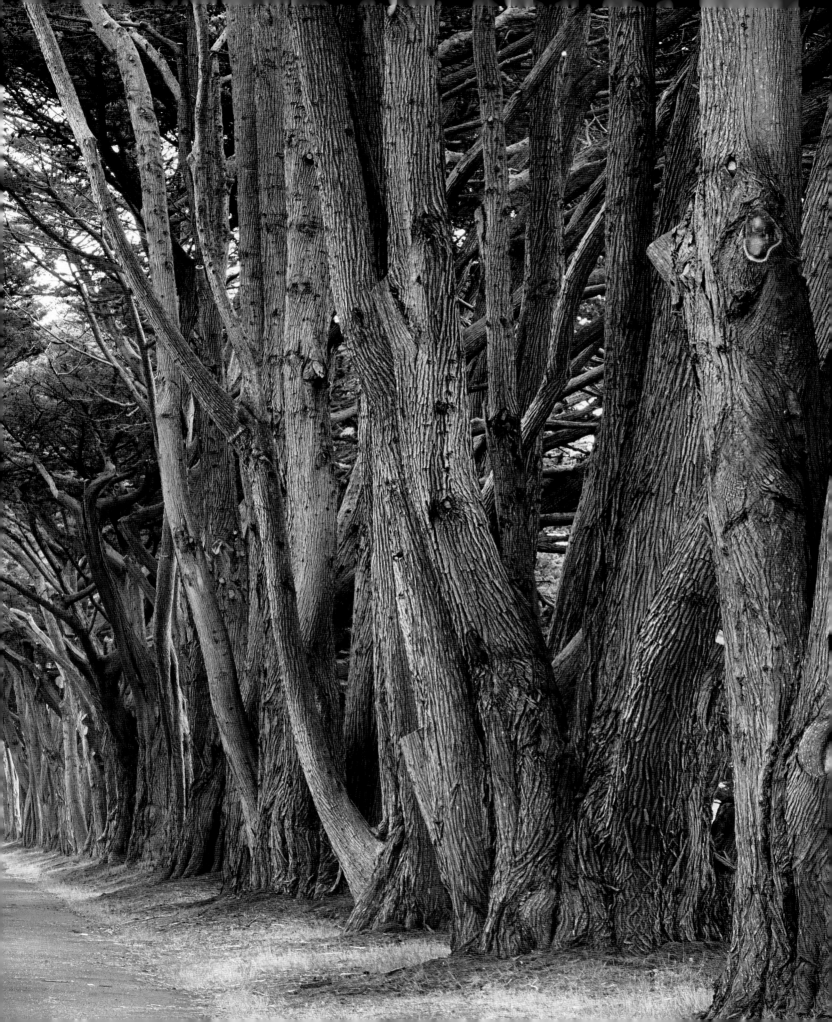

CONTRAST AND SHADES OF GRAY

Notwithstanding the importance of high-key and low-key imagery to black and white, and bearing in mind that considering the relationship of negative space to positive space is an important tool for improving black and white compositions, the truth is that for many images these concepts will not apply.

In other words, gray rules!

For the most part, the world is less stark than we think, and the rendition of a perceptually colored universe into shades of gray creates imagery with fascinating layers of subtle contrast. It's our job as photographers to learn to employ these gray layers with one another—even when the difference in tonality between the gray layers might not be what one would like for an inherently dramatic image. As photographers, we need to learn to decode the colors that are in front of us, and understand how they translate into grayscale values.

In other words, an image with stark, dramatic shadows and highlights—as is often found in the American Southwest desert—makes for easy black and white rendition. But most often in life we don't get this kind of thing handed to us on a silver platter. In fact, sometimes "hard," meaning

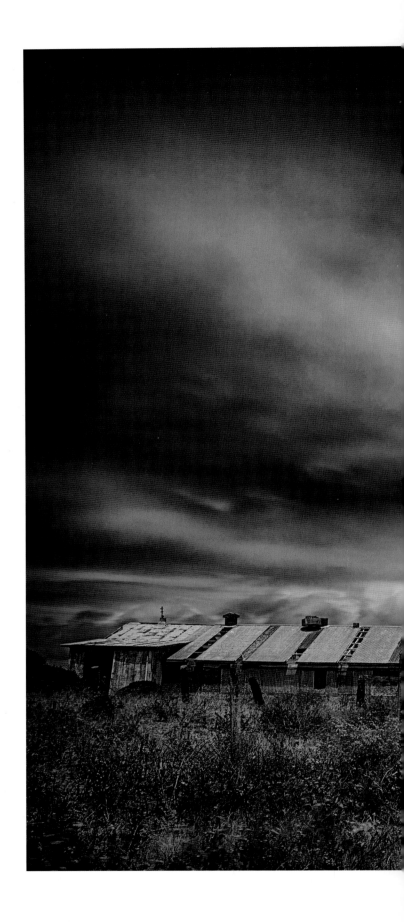

▶ On Point Reyes, California, one day in the spring, I walked around the deteriorating buildings in the abandoned, historic D Ranch, photographing various details and interesting features (see page 54).

As I was walking back toward my car, I turned and saw the ranch buildings standing tall against a dramatic, stormy sky. There was no choice: I had to pull out my camera and tripod again. The ominous appearance of the clouds was exaggerated by adding a circular polarizing filter to some of the exposures, and by extending the exposure time using a neutral density filter on some of the other exposures.

28mm, 12 exposures with shutter speeds ranging from 1/640 of a second to 5 seconds, and apertures ranging from f/10 to f/22, all exposures at ISO 64, tripod mounted, some exposures with polarizer and/or +4 ND filter; processed in Photoshop and Nik HDR Efex Pro, and converted to black and white using Photoshop and Nik Silver Efex Pro.

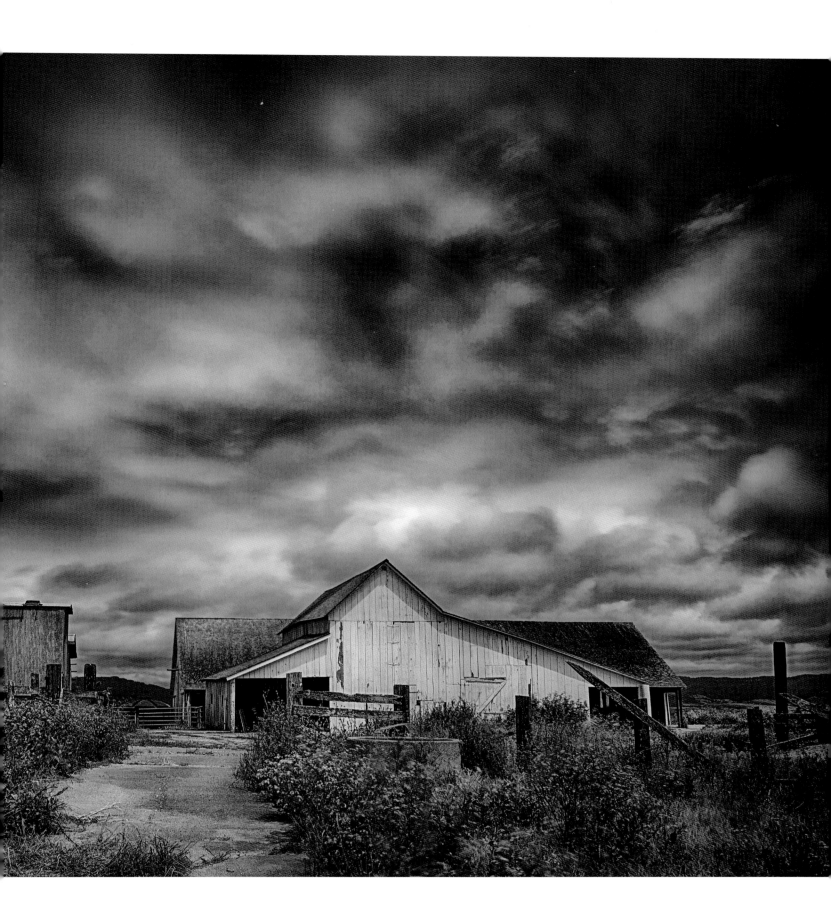

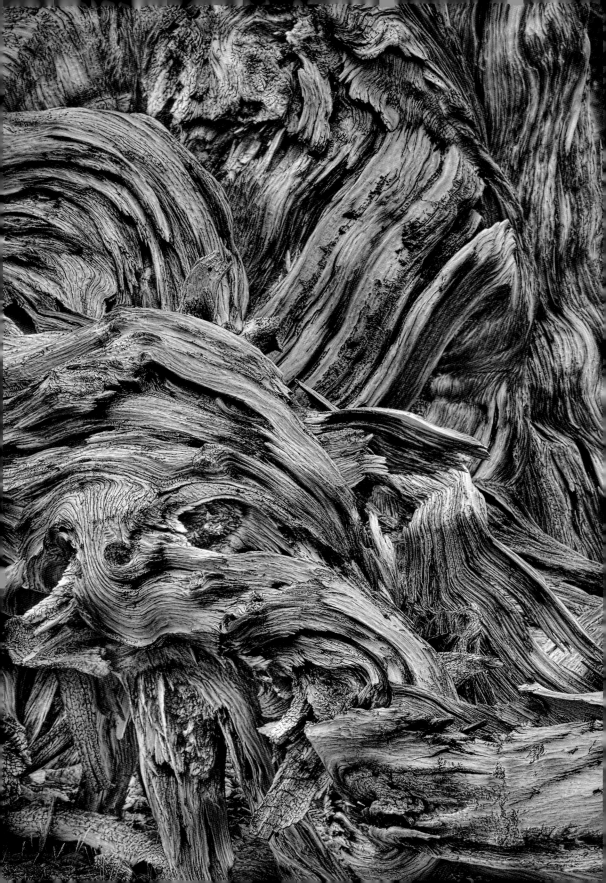

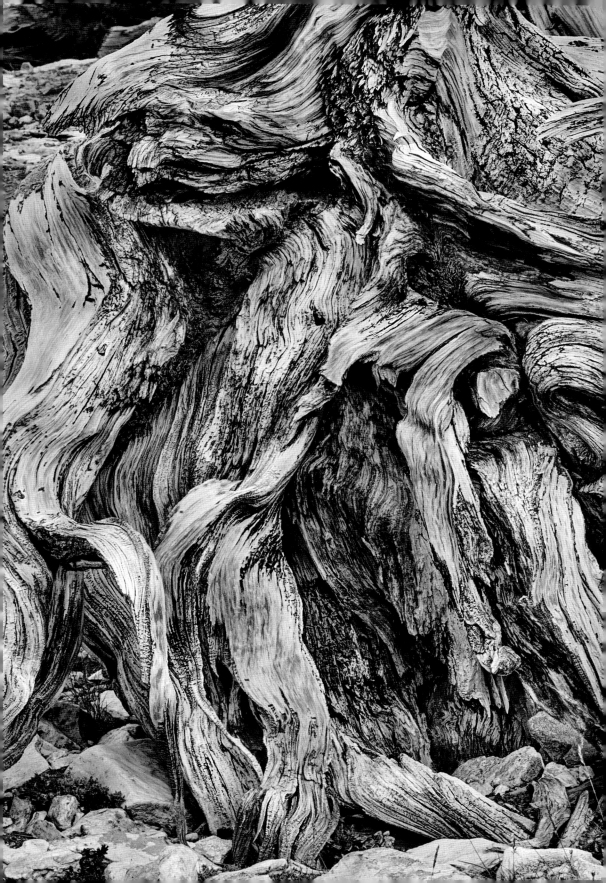

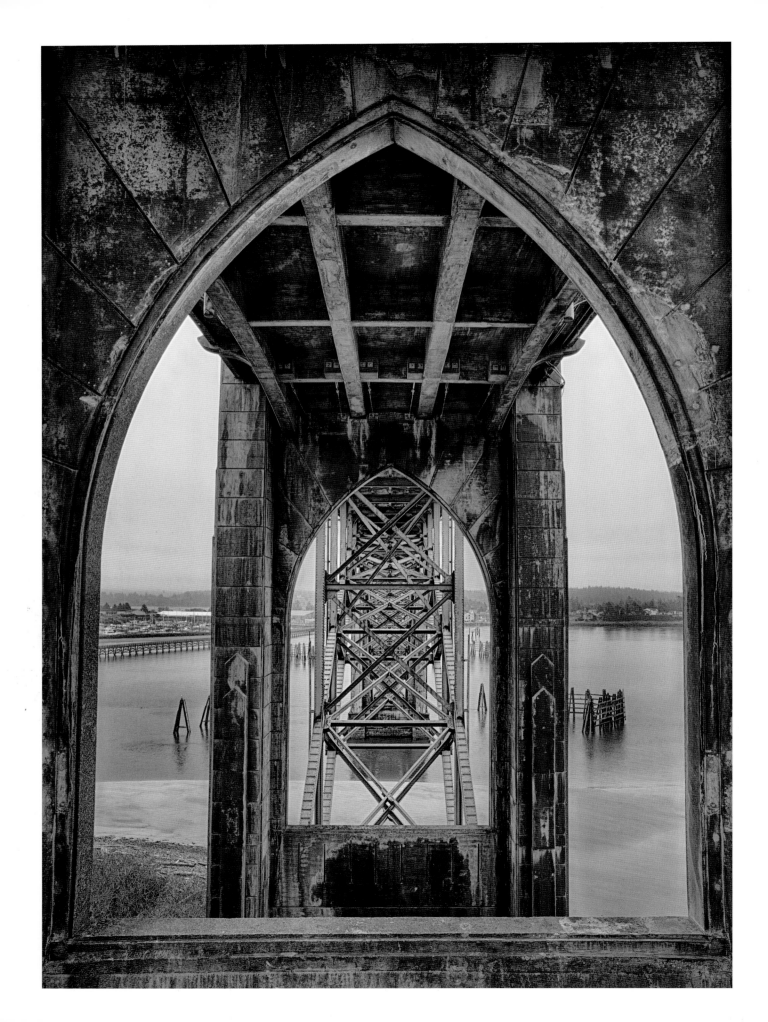

▲ PAGES 70–71: 10,000 feet above sea level in the arid, windswept White Mountains of eastern California, ancient bristlecone pines have lived and thrived for millennia. These ancient trees exist in only a few isolated groves around the world and grow very slowly—the pine needle leaves can stay green on a tree for up to 45 years.

In this extreme environment wood decomposes very slowly, and these trees can look more dead than alive. In this state a tree can live on for centuries, the spark of life embedded within the enduring structure of the reddish-brown bark.

Coming upon the apparently dead wood formed by a living bristlecone pine, I could see the contrast of lights and darks made by the deeply fissured bark. As I imagined images of the tree bark in black and white, I knew that the contrast possibilities inherent in black and white photography would show the spectacular patterns and different shading of the wood grain.

The next question of how to capture the entire range of lights and darks—to create an entire range of resonating, deep grays in each photo—was answered by shooting several exposures of each image at different shutter speeds, creating a set of images that captured the lightest and darkest grays. After returning to my studio, I combined these different exposures using Nik HDR Efex Pro.

Both photographs: 200mm macro lens, six exposures at shutter speeds ranging from 1/500 of a second to 7/10 of a second, each exposure at f/32 and ISO 200, tripod mounted; RAW files processed in Adobe Camera RAW and Nik HDR Efex Pro with post-production in Photoshop, black and white conversion using Photoshop and Nik Silver Efex Pro.

◄ The Oregon coast is dotted with inlets, bays, and exotic-seeming marine formations. One of the largest bays, near Astoria, Oregon, is Yaquina Bay. The coastal highway, U.S. 1, crosses Yaquina Bay on a massive deck arch bridge that was built in the 1930s.

As a photographer, I always enjoy walking across bridges because the view from above can be surprising and unusual. However, it is also worth checking out what's going on under the bridge, as shown here in this image (for another view of the Yaquina Bay Bridge, see pages 60–61).

21mm, seven exposures at shutter speeds ranging from 1/10 of a second to 6 seconds, each exposure at f/22 and ISO 64, tripod mounted; exposures combined using Photoshop and Nik HDR Efex Pro, and converted to black and white using Photoshop, Nik Silver Efex Pro, and On1 Perfect B&W.

a landscape or subject that is composed of relatively similar grayscale tones, makes for the kind of monochromatic image that stays with us longer. Black, and white, are great, but gray is the dominant theme when converting the world of color to black and white.

While I enjoy creating images where the formal composition is primarily about shades of gray, the trade-off is that an image composed of shades of gray can be less dramatic than one with stark contrasts of tonality. On the other hand, the many closely related layers can make up for the lack of contrast and create a subtle effect that lasts with impact in the viewer's visual memory far longer than a starker image.

What's important is to recognize a primarily grayscale image when you see it. A good, sharp lens is particularly important for this kind of photography. As much as possible, you'll want to expose the image evenly to pick up all the tonal values, preferably at the native ISO of your camera. The native ISO is a low-ISO setting below which you have no further gains in noise reduction. Check your camera's manual to find out what the native ISO is for your model, and also how to set the camera so it will expose at its native ISO using manual exposure.

The deal with the ISO is that you want to capture as much detail as possible. Normally, the lower the ISO, the less interference from noise there is with the content of the image. But there is no point in going lower than the native ISO of your camera because there are no further gains in clarity.

Often, if you are creating a hand-held image, there is a good reason for raising the ISO: so you can also expose at a faster shutter speed to avoid camera movement (the image to the left was shot at ISO 500 just for this reason). On the other hand, if your camera is on a sturdy tripod, there is seldom a reason to boost the ISO above the native ISO.

As you pre-visualize this kind of image, bear in mind that you will want to work in post-production to keep the layered shades of gray close to each other in tonal value while respecting their individuality. Use of light while photographing can help keep grays distinct—highlights and shadows can add subtle shaping.

BLACK AND WHITE AT NIGHT

Humans lose their color vision at night long before their cameras do. Properly exposed, a sensor will pick up vibrant colors for several hours after darkness from the lingering light left behind by the setting sun, which is beyond the spectrum our eyes can see. And starlight is colorful to a camera sensor all night long.

That said, we do tend to think of nighttime as being relatively colorless. While this isn't true, as I've noted from a technical perspective, it does mean that black and white photography of subject matter at night has visual plausibility.

Remember, as I noted earlier, that photography is about capturing emitted or reflected light, and that you can't capture subjects directly without this reflection or emission. The interesting implication for black and white photography at night is that light sources and reflection work rather differently than in the daytime. Starlight and car headlights (as shown in the photo to the right) are not light sources you'll see during the day.

I recommend night photography generally as a great field that hasn't been fully exploited by contemporary photographers. Specifically, if you are interested in black and white, get out there, and whether you are in a city or the countryside, see how light changes everything!

Many subjects that seem mundane or bleak during the day take on new life at night, becoming exciting and mysterious in black and white.

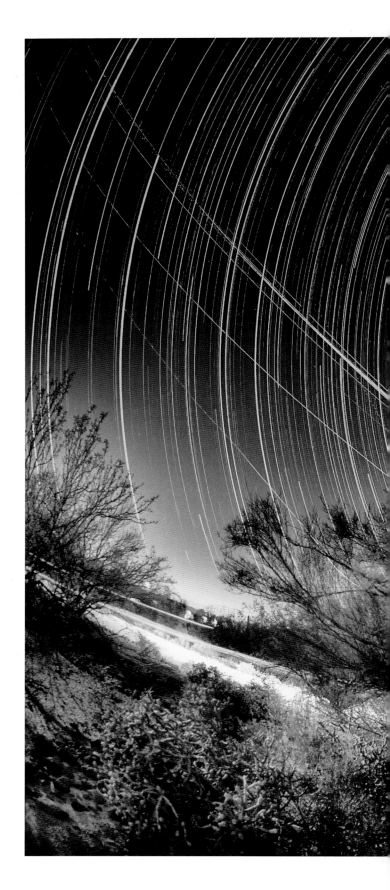

▶ On the outskirts of Phoenix, Arizona, I set my tripod up for an all-night sequence of exposures. The idea was to capture stars circling in the sky behind a desert shrub and a saguaro cactus. As my camera made exposure after exposure—each photo was four minutes—powered by an external lithium battery and triggered by an intervalometer (programmable interval timer), I dozed on a lawn chair, wrapped in my sleeping bag.

I was truly surprised in the morning when I looked at the photos to see the extent of traffic—the headlights driving by—on this remote country road at night.

10.5mm fisheye lens, ninety-five stacked 4-minute exposures for a total composite exposure time of 380 minutes (6 hours and 20 minutes), each exposure taken at f/2.8 and ISO 200, tripod mounted; stacked in Photoshop, and then converted to black and white using Photoshop, Topaz, and Nik Silver Efex Pro.

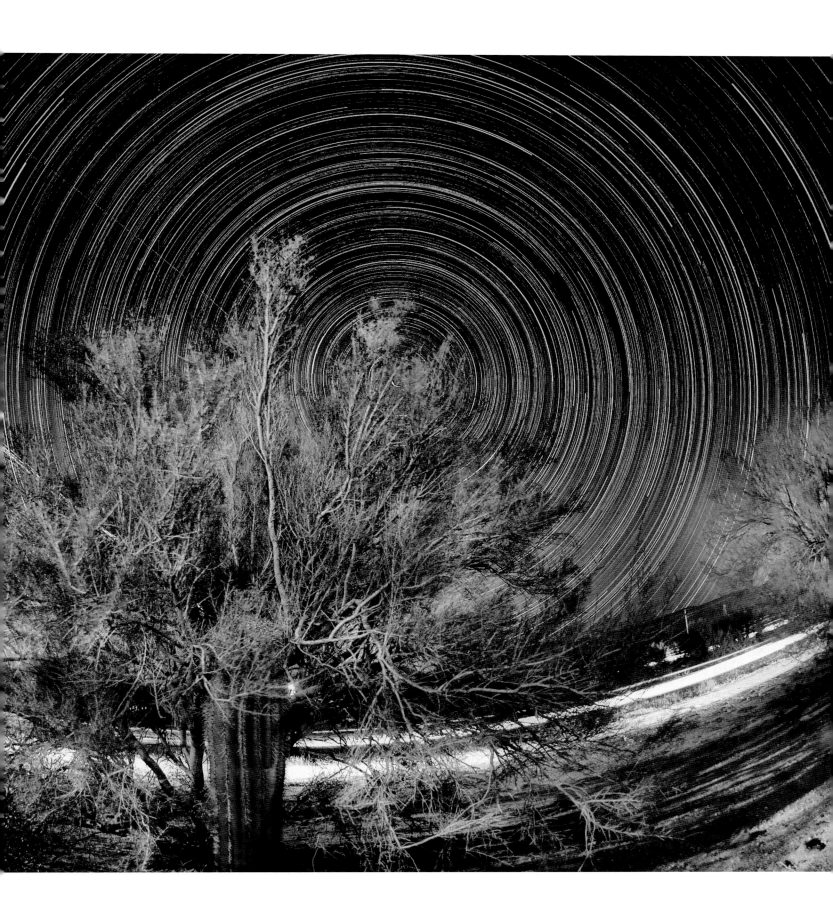

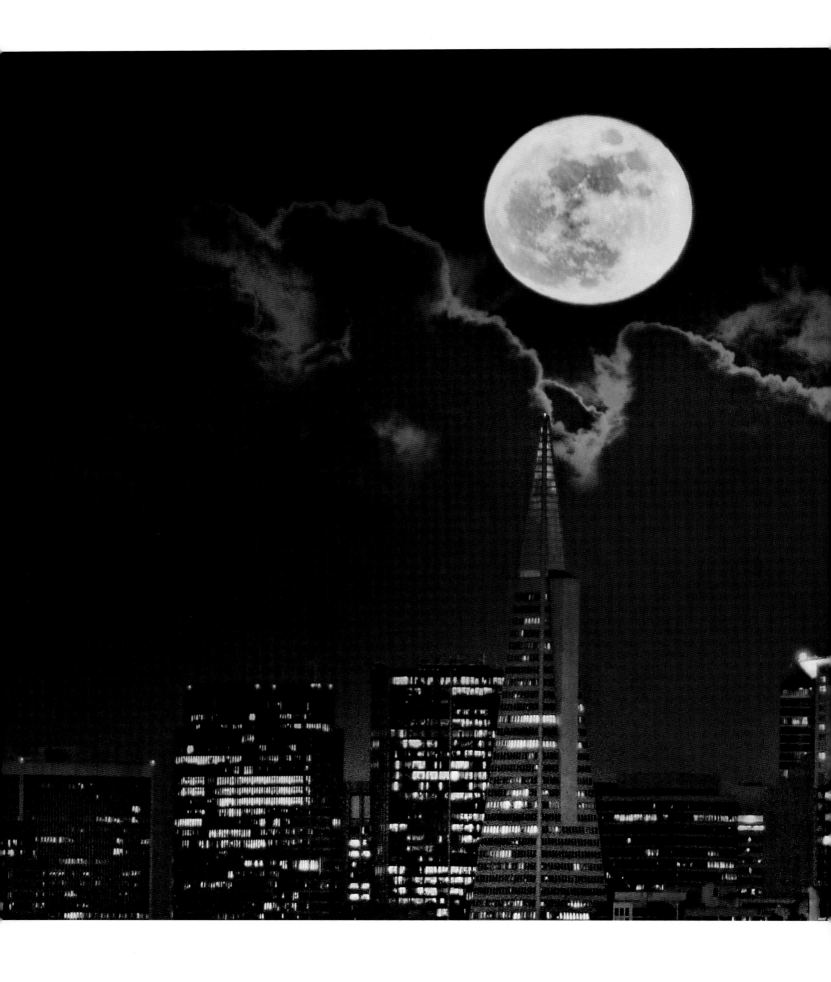

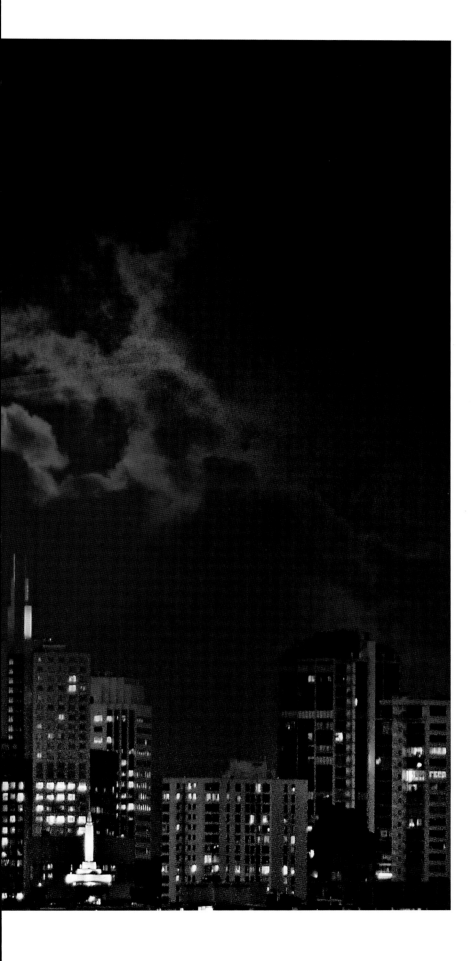

◀ The so-called super moon is larger in appearance than a normal full moon—probably by at least 10 percent—due to the moon's location closer to the Earth in its elliptical orbit. When a super moon rises early in the night sky, it clearly creates a photographic opportunity.

With an upcoming super moon, rising just after sunset, and clear skies in the San Francisco Bay Area, I wanted to take advantage of this extraordinary opportunity.

The Photographer's Ephemeris, sometimes called TPE for short, is planning software that combines Google maps with directional rays showing the path of the moon and sun at moonrise, moonset, sunrise, and sunset, respectively. I used TPE to determine that the super moon would be rising over the Trans America Tower in the San Francisco skyline when viewed from across San Francisco Bay on the ramparts of an old military fortification in Sausalito, California.

The software and my calculations proved to be correct, although the image required a telephoto lens to get close to the moon and skylight action. I used a 400mm lens on a 1.5 crop factor camera, so in 35mm terms, this was effectively equivalent to a 600mm lens.

The exposure problem when photographing a landscape or cityscape with a moon is that the moon is a lot brighter than the Earth at night. In fact, we see the moon because it is reflecting sunlight, and the moon is approximately 10 EV brighter than the Earth at night, even when the Earth is partly brightened by city lights.

There is no way that a single exposure can capture details in both the moon and the night landscape because of the disparity in brightness. This can be okay if you want your moon to be a bright featureless disk.

But if you want to see details in both the moon and the Earth, the only solution is to shoot two exposures—one for the moon, and one for the Earth—as I did here, and combine the exposures in post-production.

400mm, two combined exposures at 1/30 of a second and 1/2 of a second, each exposure at f/5.6 and ISO 400, tripod mounted; converted to black and white using Nik SilverEfex Pro.

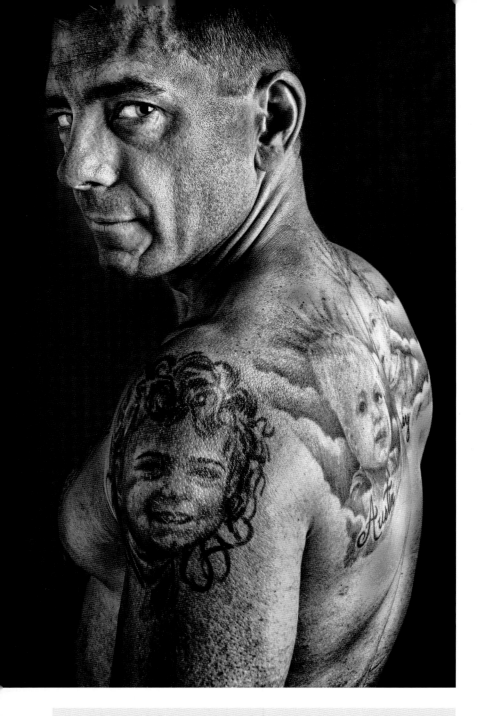

PEOPLE IN BLACK AND WHITE

When black and white photography is done right, it reduces visual clutter to an absolute minimum. The irreducible minimum when it comes to the inner person is character, and when it comes to the outer manifestations of people it is their bodies. Therefore, the best black and white photography of people tends to either reveal character or to work as a figure study along somewhat classical lines.

When I am photographing people in black and white, I like to isolate them as foreground subjects so they stand out against a dark background. From this perspective, most of my photographs of people in black and white are low-key images, where the negative space of a dark or black background plays against the person in the photo. As with any low-key image, you must be sure to create an overall underexposure, so your subject is properly exposed even though you've allowed the background to go black.

Creating this kind of image in the studio means using a black background and lighting with strobes.

For environmental portraiture, I recommend paying attention to the lighting that is specifically directed at the person, while positioning them against a dark background. Remember that the eyes are indeed the windows to the soul, so that in any portrait the most important area of focus is the eyes.

A photographic portrait is a record of an interaction between the subject and the photographer, and this interaction can be deep, or it can be shallow. For compelling black and white images of people, make sure you engage with your subjects, and follow some of the guidelines I've given in this chapter for considering framing, low-key image making, and the formal relationship between negative space and the rest of the image.

▲ You can use black and white to emphasize a gritty, masculine feeling. This emergency room nurse, while appearing tough, obviously has a tender side as shown by the tattoos of his four children.

36mm, 1/160 of a second at f/8 and ISO 100, hand held; converted to black and white using Photoshop Black & White Adjustment layers and masking.

▶ Character will out, and the inner character can be made more manifest by stripping away the distraction of color. Black and white reveals bone and facial structure, letting a person's essence show through.

85mm, 1/3200 of a second at f/1.4 and ISO 500, hand held; converted to black and white using Nik Silver Efex Pro.

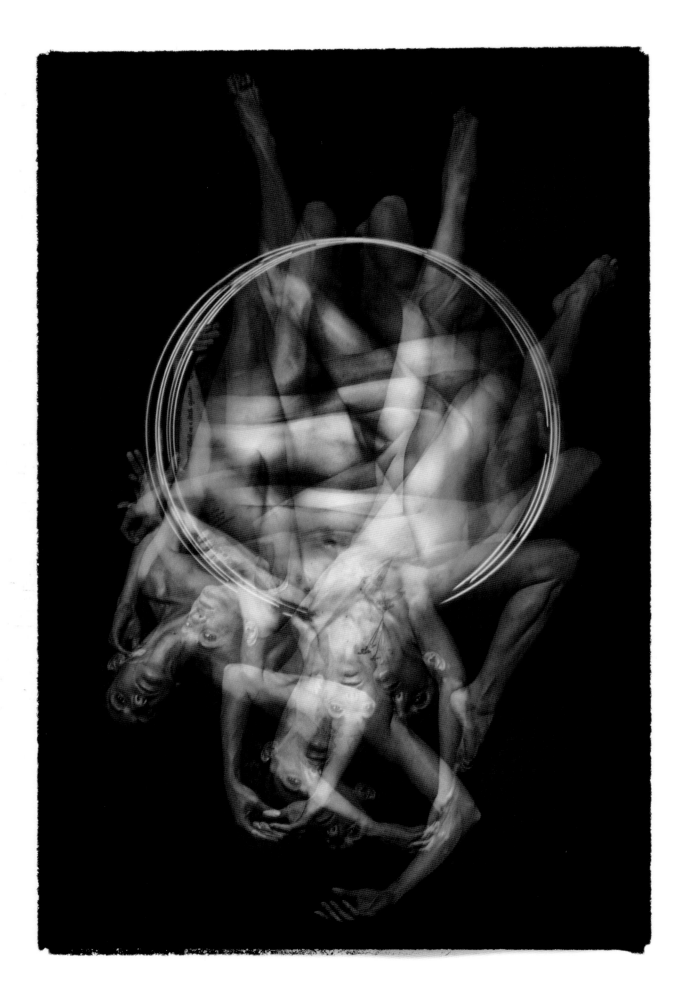

Black and white figure photography has a rich history that dates back to the beginning of photography. The ability to capture someone as a unique being in a moment of time is truly magical. One can appreciate the importance of black and white figure studies, as they have survived the test of time. Even with technological advancements and the movement from film to digital, black and white figure photography continues to have a place in portfolios and exhibits.

This is an image of one acrobatic model performing on an aerial ring known as a *lyra*. As the model moved from one position to another, I made five in-camera exposures using my camera's multiple exposure function. Each exposure used a studio strobe, and the technique takes advantage of the black studio background.

55mm, five exposures combined in camera, each exposure taken at 1/160 of a second at f/9 and ISO 100, hand held; converted to black and white using Photoshop, Nik Silver Efex Pro, and Topaz B&W Effects.

► Capturing the beauty and focus of people with my camera is enhanced by the black and white medium since the distraction of color is removed. Pre-visualizing in black and white takes practice and experimentation. You need to take the photos in order to discover what works and what doesn't.

When you work with people, it is important to talk to them and build a rapport. Finding out a little bit about them will inform your work—it will help you create the narrative for your photos as you work. As you come up with the story that defines your photos, you can use various lighting techniques to create an atmosphere that suits the subject you are working with.

This studio shot shown here seems simple enough: two models placed against a black background. However, there are subtle techniques at play. Before photographing I was careful to place the studio strobes off to one side, and then I slightly underexposed the capture to bring out the details in the models' different skin tones. This helps to emphasize the sensuous and tender quality of the image.

55mm, 1/160 of a second at f/8 and ISO 200, hand held; converted to black and white using Photoshop.

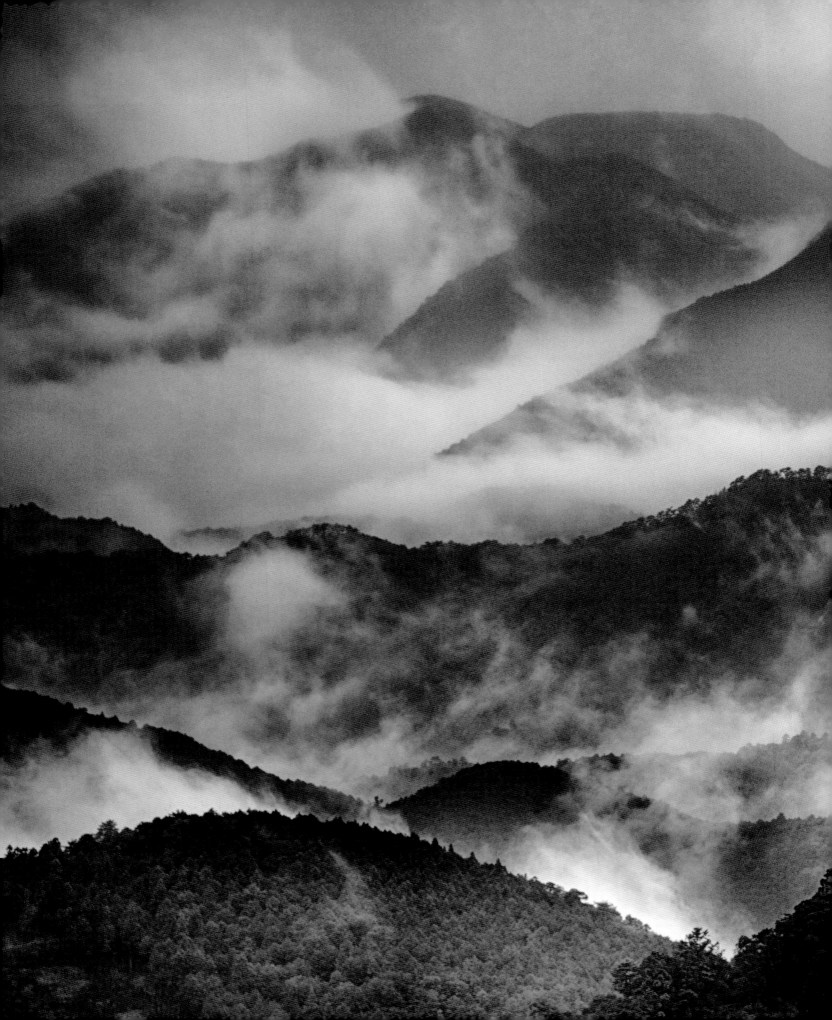

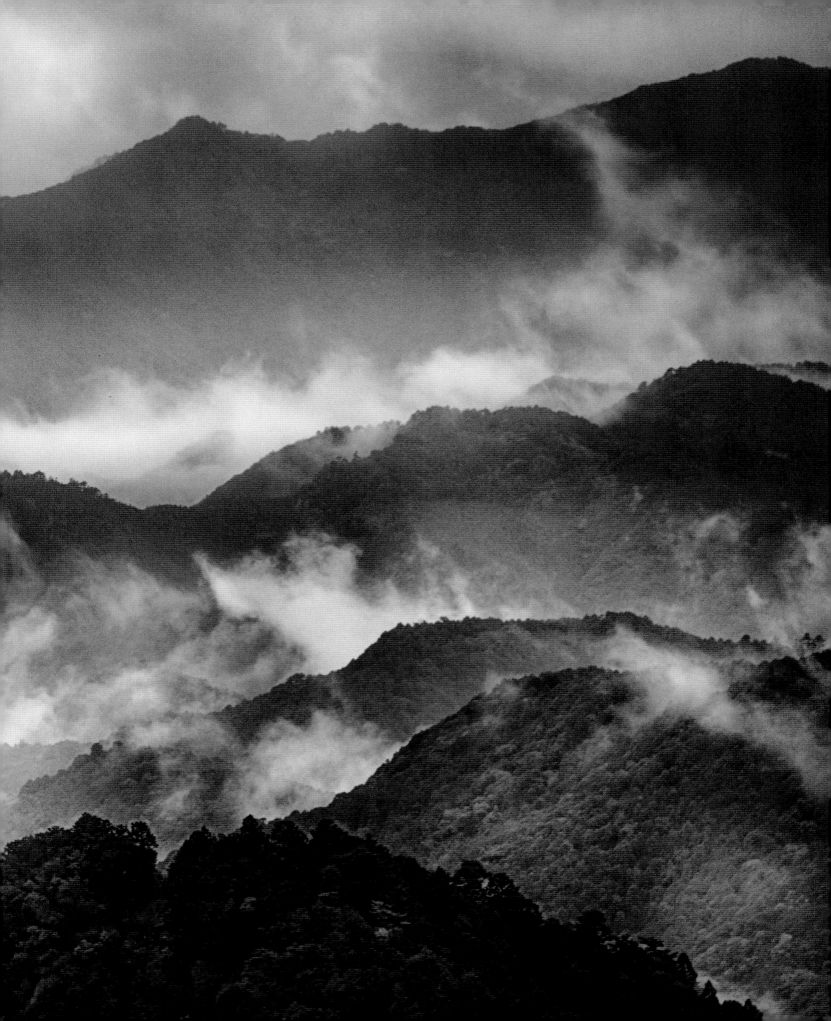

3: CONVERTING TO B&W

YOUR BLACK AND WHITE WORKFLOW

Suppose you have taken a wonderful image using best practices with your camera on a tripod and saved a RAW file. The thing you will need to know to present this file as black and white, once the RAW file has been processed, is how to convert it to monochrome.

We live in a highly interconnected world. So no question of technique—such as "How do I convert a RAW file to black and white?"—can be considered in a vacuum. Along with appropriate tools for performing the conversion, you will also need to understand how to fit this conversion into your personal workflow.

By workflow, I mean the process from beginning to end in which your vision is transformed into the reality of a photographic print or image on your computer. The workflow for a particular image doesn't have to encompass all aspects of this process, but you should know the options. Keep in mind that many workflow choices are essentially personal; it is reasonable to prefer to do things your own way.

That said, it is important to realize that there is a best-practices black and white workflow. This workflow begins with your vision and with seeing in black and white before you even capture an image. Next, it is ideal to capture

▲ PAGES 82–83 AND ABOVE: At 6 AM my alarm rang. I raised my head off the futon, pulled the screen aside, and peered out the window at a world of driving rain. I was staying at a country hot spring resort, so before starting up the trail I took a nice long soak, figuring as long as I was going to be wet, I might as well be warm *and* wet.

Pack cover in place and umbrella in hand, I started up the trail. At first the rain was heavy; then it subsided to a constant pitter-patter in the trees. Walking on a trail in the rain can be fun, but it does lead to melancholy reflections, particularly when you pass settlements that were abandoned hundreds of years ago, as is often the case on the Kumano Kodo pilgrimage trail on the Kii Peninsula of Japan.

Soon the trail started climbing toward a high pass, and I was blessed with a distant view of misty mountains as the storm began to clear.

300mm, 1/500 of a second at f/8 and ISO 200, tripod mounted; processed and converted to black and white using Photoshop.

▶ Kofuku-ji, a Buddhist pagoda temple with origins dating to 669 AD, was once one of the powerful Seven Great Temples of Japan. Today, it seems lost in the mists of time, and I used my iPhone capture to render an image that conveys this sense of nostalgia and poignancy.

iPhone camera app, processed in Filter Storm, Lo-Mob, and Snapseed.

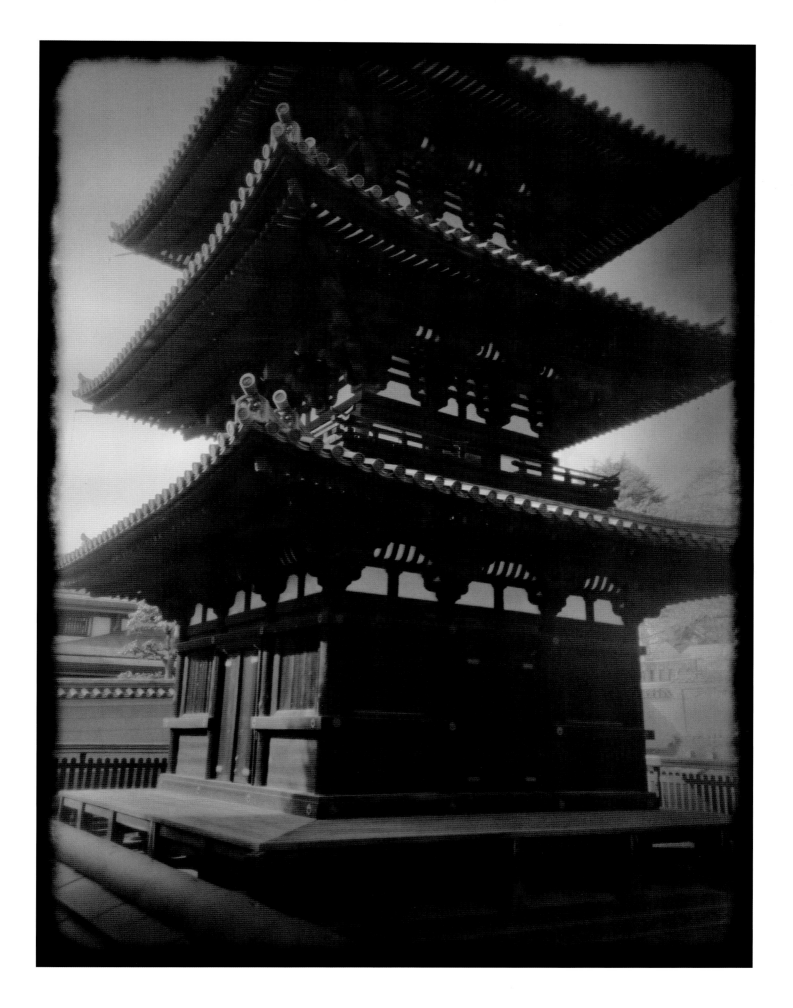

your images as bracketed exposures varying shutter speeds in the RAW format with a camera on a tripod.

Of course, there are exceptions, alternative workflows, and situations where an image is captured hand held and saved as a JPEG—for example, a photo taken with an iPhone.

But pursuing a normative best practices workflow (see pages 30–31), the next step would be to copy your image files to your computer, and then to start processing an image for its color values with black and white in mind.

The final steps in the workflow are to use a variety of tools and techniques to convert the resulting color image to black and white. This can be done using multiple techniques and layers—essentially so that each portion of your image can be translated to black and white as best suits that portion. In other words, the workflow gives you pinpoint control over how to convert all the areas of your image to black and white.

This chapter takes a look at the issues involved in your personal workflow, and how to accommodate personal workflow preferences within this context.

DISPATCHES FROM THE LAND OF THE RISING SUN

A small island archipelago without much in the way of natural resources, Japan has had an outsize impact on the history of the world, and its society embodies a number of paradoxes. This is a society with a great deal of reverence for tradition and hierarchy, yet it also has the ability to innovate very quickly.

The Japanese name for Japan in kanji is 日本, and these phonetic ideograms transliterate as "Nippon" or "Nihon." Nippon and Nihon can be translated to mean "the sun's origin," or "where the sun comes from." Thus, Japan has been romantically called the "Land of the Rising Sun."

Japan has a culture that embraces the latest in modern innovation, with crowded and bustling cities, and yet maintains a rural life that goes on in much the same way that it has for millennia.

Japanese aesthetic is careful and serene, with attention to both gesture and detail, and is capable of embracing both the bold, new (and sometimes ugly), along with techniques

◀ Visitors to Japan's ancient imperial capital of Nara quickly discover that the deer of Nara are beloved by visitors and natives alike. This is why they are portrayed in the attractive design on the manhole cover that I found on a Nara side street.

iPhone camera app, processed in Snapseed.

▶ In the gardens at Nara, an ancient imperial capital of Japan, I found the paradox of untrammeled nature arranged within distinct boundaries. Here within the formal gardens, the wild and informal aspect of nature was allowed full sway. There was beauty and passion that could be perceived when all was not orderly, but it was maintained with order, as can be seen in this ancient tree and reflection in the Isuien Garden, which dates from the Meiji Restoration of the 1860s.

180mm, four exposures with shutter speeds ranging from 1/6 of a second to 1/40 of a second, each exposure at f/10 and ISO 100, tripod mounted; exposures combined in Nik HDR Efex Pro and Photoshop, and then converted to black and white using Photoshop.

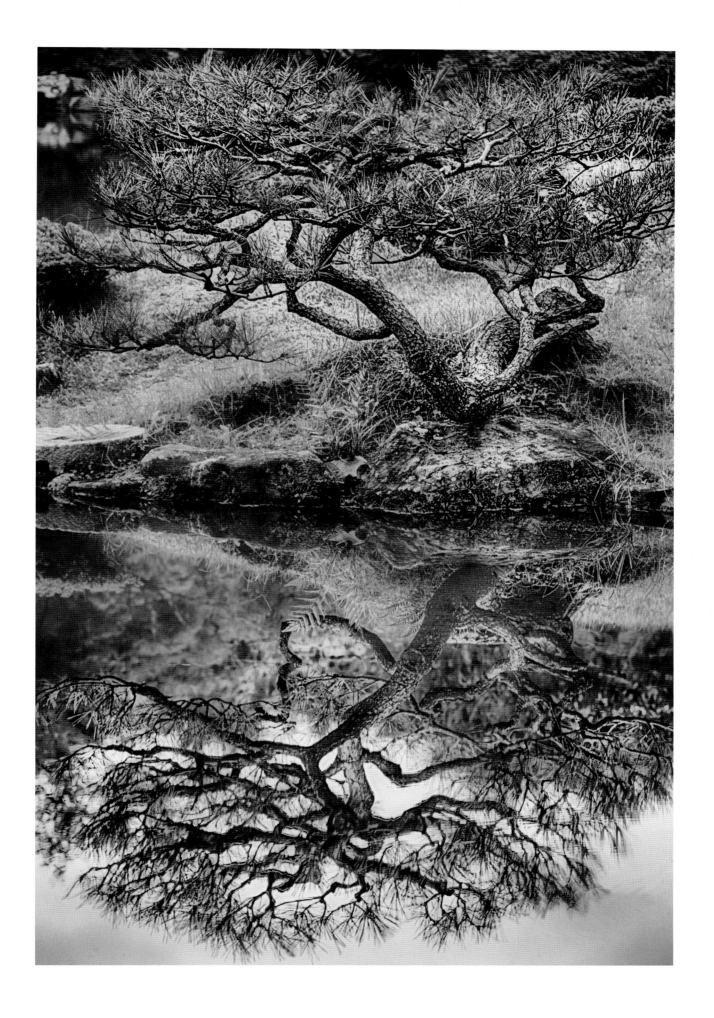

steeped in the traditions of ancient crafts. This is a society that is both intensely religious—mixing the apparently contradictory Buddhism and Shintoism as the national faiths—and is also defiantly secular.

Like Japan, modern black and white processing embraces both the good and the bad, the beautiful and the ugly of the latest digital technologies—and also of the traditions steeped in the past of film photography. To fully understand digital post-production in black and white, one needs to be aware of the history of photography. This is where many of the concepts of black and white post-production derive from, and also the nuts and bolts of digital workflow and processing.

This chapter shows you how to use the various techniques that are available for black and white conversion per se along a hierarchy from the easiest and least quality, to the most involved and best quality. You can take a look at the next section in this chapter, "JPEG vs RAW," starting on page 91, for more details about the

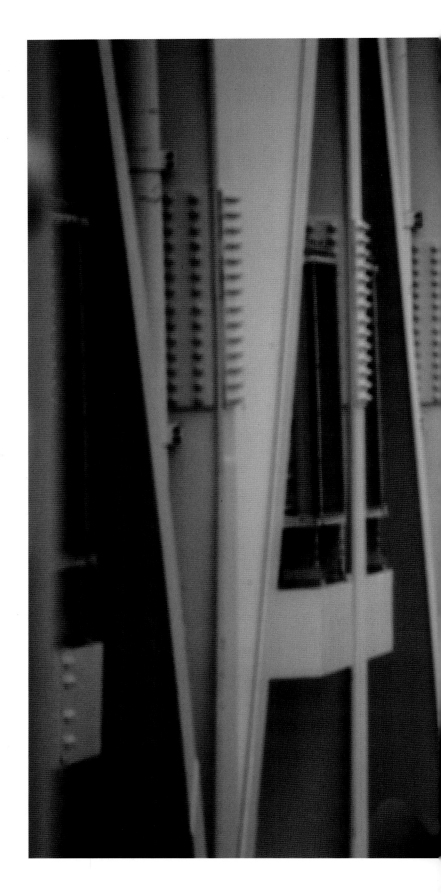

> ▶ In the 18th century, Tokyo—then known as Edo—was the world's largest city, with a population of more than one million. Today, Tokyo is still one of the world's great metropolises, sprawling over an almost unimaginable population and area with numerous "cities within the city," districts that are important in and of themselves.
>
> The Rainbow Bridge crosses northern Tokyo Bay between two of these districts, Shibaura and the Odaiba waterfront development in the Minato district.
>
> Walking across this graceful suspension bridge is an uplifting experience in every sense of the word. The graceful curves of the bridge take you high above the bustle of the city, while at the same time making the lines of modern Tokyo apparent. As I crossed the Rainbow Bridge with my camera in the dusk of a foggy day, I tried to align the curves of the bridge with the lines of an apartment complex in Odaiba in an image that uses selective focus to contrast the curves in the Rainbow Bridge with the linear spaces of the buildings beyond.
>
> *300mm, 1/200 of a second at f/5.6 and ISO 400, hand held; processed in Adobe Camera RAW and Photoshop, and then converted to black and white using Perfect B&W.*

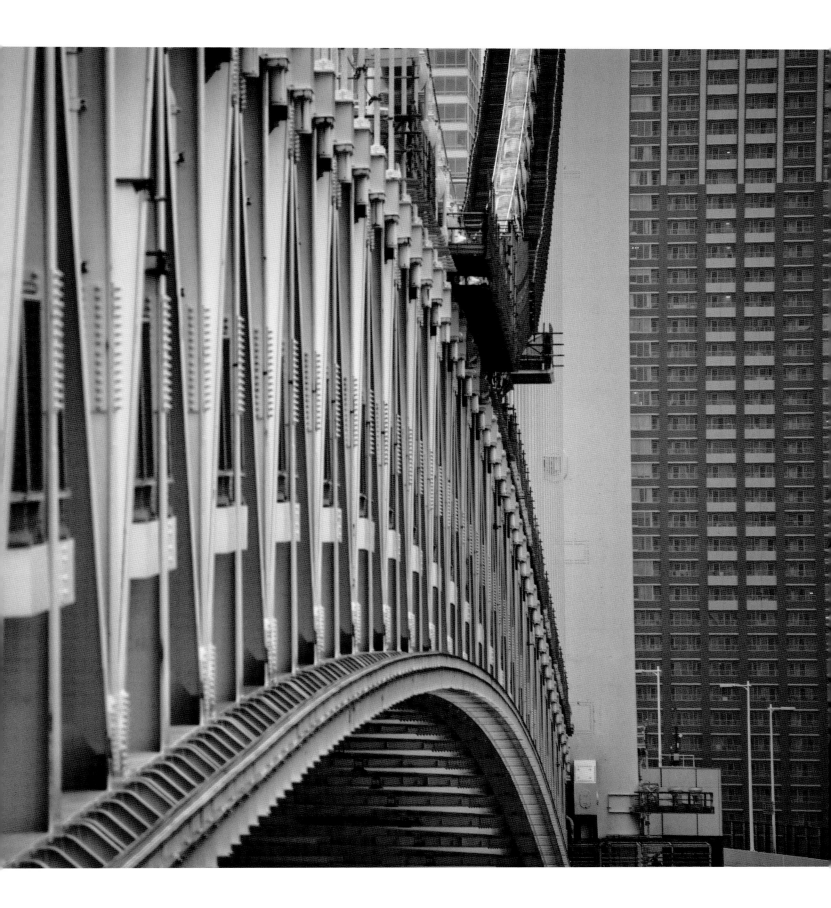

effort versus quality paradigm, and how you can use it to influence your post-production workflow.

In the previous paragraph, when I said "black and white conversion per se," what I meant is that each conversion technique is treated in isolation, as a thing unto itself. Generally, state of the art black and white conversion involves the effective use of multiple technologies, and putting individual black and white conversion methods together in a multi-modal fashion is explained in Chapter 4, starting on page 136.

Within the context of individual black and white conversion techniques, it is important for your work—as it is in the Japanese culture and aesthetics—to remember both the importance of the bold gesture, the overall look and feel, and the minute details that may only be apparent to the fine craftsperson.

In addition, my treatment of the various practical black and white post-production techniques places them within the historical context of black and white photography, both in concept and design.

Finally, each black and white conversion process needs to be seen in relationship to modern digital workflow, as practiced by a photographer, such as the workflow shown in the diagram on pages 30–31.

JPEG VS RAW

It's important to understand the difference between JPEGs and RAW files. JPEGs come out of your camera as a finished rendition of the camera's capture. They can be used as-is on a monitor, on the Internet, or for publication. Exposure values, white balance, and other settings are "baked in" to a JPEG file. This means that the photo you take with your camera is automatically processed by your camera's computer, converting the RAW capture into a JPEG file using internal camera settings. While you get a completed image file out of this process, you have no control over the conversion and how it is applied to an image.

In comparison, a RAW file consists of a "potentiality" that includes much more information about the exposure than a JPEG file. The information that is in a RAW file includes a range of possible exposures. In point of fact, a RAW file can be utilized to choose an exposure from the possibilities across a range that can be as large as 10 EV. Besides exposure information, almost any other aspect of the exposure that you can think of—most significantly, white balance—can be modified as you process a RAW file. In fact, the RAW file needs to be processed before it can be used, and the processing can take advantage of the greater set of information contained in the RAW file.

The advantages of a JPEG file are that it is "ready to go," highly compressed, and fast to work with. JPEG is an

◄ Katsushika Hokusai (1760–1849) was a Japanese artist, painter, and print maker of the Edo period. The Edo period, also known as the Tokugawa period, circa 1600–1868, was the time in Japanese history when society was ruled by the Tokugawa shogunate and the Daimyo—the 300 feudal lords who were the immediate vassals of the shogunate. The Edo period was an era of rapid economic growth and very strict social order, both fueled by the isolationist policies that kept Japan closed to the rest of the world.

As an artist and part of the so-called Ukiyo-e floating world, Hokusai lived life from a comparatively broad viewpoint. The Ukiyo-e functioned as a creative outlet in counterpoint to the rigid society at large. Hokusai's works were hugely popular during his lifetime, and in particular his views of Mount Fuji tied into a 19th-century domestic, recreational-travel boom in Japan.

100 Views of Mount Fuji is generally considered Hokusai's masterpiece. Mount Fuji or Fujisan (富士山) is one of Japan's Three Holy Mountains, and is the highest mountain in Japan. Fuji's snow-capped, symmetrical cone is visible from many places around Japan and has been an object of aesthetic and spiritual pilgrimage for centuries. Hokusai's work reflects the religious significance of Mount Fuji to Hokusai personally, and to the Japanese people.

My view of Mount Fuji is, of course, one you won't find in Hokusai's oeuvre, since airplane travel was still far in the future in the early 1800s. Sometimes I think that carefree photography with an iPhone camera amounts to the same kind of license to be creatively free that Hokusai had in the floating world.

iPhone camera app, processed in Lo-Mob and Snapseed.

8-bit format, and in some situations it is the best choice to work with because the rendering engine did its job well, or because "good enough" in terms of rendition is, well, good enough. Besides file size, the most compelling justification for working in JPEG is that it is fast and easy. Folks who want to spend their time behind the camera and not on the computer often gravitate to JPEG. Furthermore, some cameras, such as those in the iPhone, only do JPEG—so if you are using an iPhone camera, you have no choice except to work in JPEG.

The advantage of the RAW file is that it contains a great deal more information than a JPEG capture. This information can be used to create subtle and extended gradations of tone, rescue areas that are dark, fix some problems with lighting and color temperature, and much more. But RAW files need to be converted using Adobe Camera RAW (ACR), Lightroom, or another conversion program into a format that can be used in the world outside cameras. So the process of working a RAW file involves taking note, and possibly taking advantage of, the treasure trove of information contained in the RAW file, and also converting the image to a file format such as TIF, PSD, or JPEG that can be used in the real world.

This process of RAW conversion can be easy, and aspects of the conversion can be automated. On the other hand, a great deal of effort and many steps can go into a high-quality RAW conversion, with resulting file sizes and archives that are quite large.

It's important to understand that there is no single RAW file type. The camera manufacturers each have their own RAW formats, which are distinctive based on the proprietary image processing software that reads sensor results based on camera brands. These file formats include 3FR (Hasselblad), CR2 (Canon), ERF (Epson), MEF (Mamiya), NEF (Nikon), ORF (Olympus), PEF (Pentax), RW2 (Panasonic), and ARW (Sony), and are generally based on the TIFF format but contain individual differences.

One attempt to overcome the variations in the available RAW formats is the DNG file, promoted by an industry consortium. While it's fine to archive your RAW files in the DNG format, it's a mistake to assume that archiving a DNG file is the equivalent to archiving the original file that it is based upon.

So, should you photograph in JPEG or RAW? Some cameras, including the iPhone camera, don't allow you the choice—you can only work in JPEG. Otherwise, the choice basically depends on what you plan to do with your photos, with the decision falling along the effort versus quality graph on pages 94–95. Generally, the JPEG format is less work in post-production but doesn't yield as good results as a skilled RAW conversion. If I were taking many images that were going to be processed in essentially the same way, as comes up in many commercial photography assignments, I might shoot in JPEG. However, if my primary concern is to process each image for artistic quality, then I would definitely choose to photograph in RAW.

The good news: Almost all cameras that can capture in RAW also allow you to save files simultaneously as JPEGs. While this approach makes for twice as many files, and fills a little more space on your memory card, it does mean you can have the best of both worlds. You'll have JPEG files for immediacy, and for sharing with minimal effort, and RAW files for when a quality conversion is worth the effort.

EFFORT VS QUALITY

There's no hard and fast rule about what makes art. In many cases, simple black and white conversions from a JPEG-only camera such as the iPhone produce noteworthy imagery. But in terms of the quality and flexibility of the conversion to black and white itself, the sky is the limit in terms of the creative possibilities, and generally you get what you pay for. Put another way, no pain means no gain.

▶ Nanzenji is one of the Five Great Zen Temples of Kyoto, Japan. Wandering through the grounds at Nanzenji, I came across a huge red brick aqueduct, built in the 19th century and designed to carry water to Kyoto from Lake Biwa (it is still in use today). The mammoth nature of this structure seemed incredibly interesting to me, so I moved underneath the aqueduct with my camera and tripod to capture its supports, which seemed oddly out of place, almost like an ancient Roman engineering project in the heart of Japanese Zen.

28mm, 0.8 of a second at f/22 and ISO 100, tripod mounted; processed in Photoshop, and converted to black and white in Photoshop and Nik Silver Efex Pro.

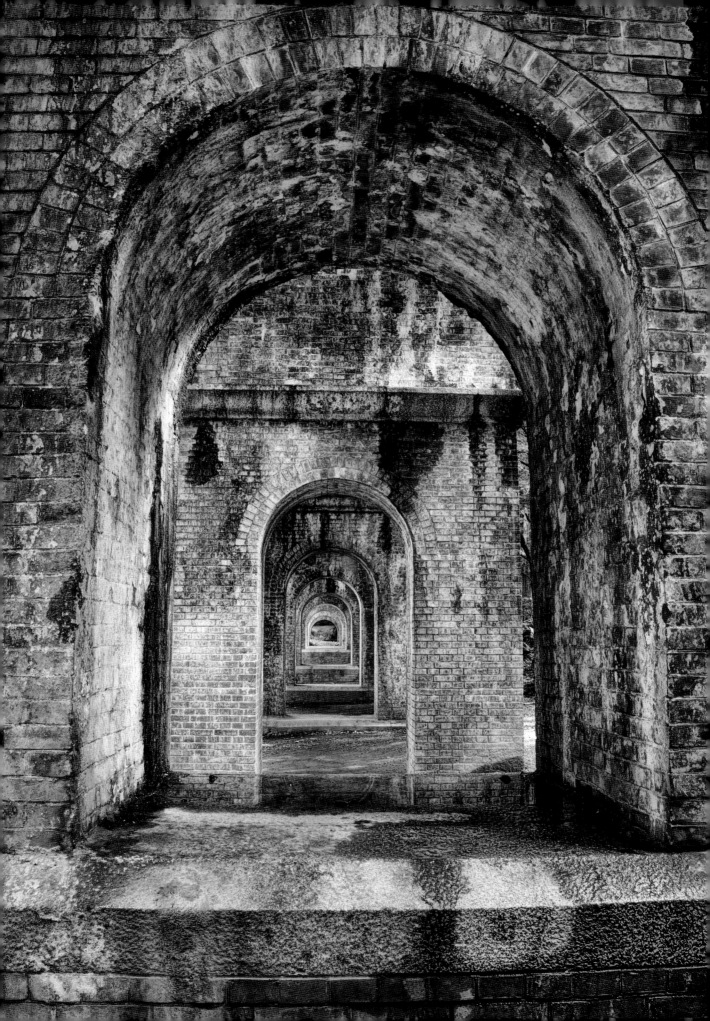

BLACK AND WHITE CONVERSION: EFFORT VS QUALITY

QUALITY of Finished Photograph

IN-CAMERA CONVERSION

In-camera black and white conversions, such as with the iPhone and many other cameras. Usually a copy of the original photo is made and saved in black and white to the camera's memory.

SIMPLE SOFTWARE CONVERSION

JPEG to JPEG using applications such as Google Photos, Photo (Mac), Picasa, Photoshop Elements, etc.

RAW TO GRAYSCALE CONVERSION

RAW conversion using ACR (grayscale option on the HSL/Grayscale tab).

.

Simple RAW conversion using Lightroom (HSL/Grayscale conversion).

REASONABLY COMPLEX SOFTWARE CONVERSION

More complex conversion using Lightroom and/or plug-ins such as Nik Silver Efex Pro.

.

Alternatively On1 Perfect B&W can be run as a standalone program.

EFFORT Involved to Make the Photograph

BASIC PHOTOSHOP CONVERSION

Photoshop black and white conversion using Adjustment layers and plug-ins such as Nik Silver Efex Pro and Topaz B&W Effects.

GOLD STANDARD: PHOTOSHOP MULTI-LAYER CONVERSION

RAW color capture processed multiple times for color in ACR, Lightroom, and Photoshop, and then converted to black and white using Lightroom, Photoshop, and plug-ins such as Nik Silver Efex Pro, Topaz B&W Effects, and On1 Perfect B&W.

.

These various black and white conversion techniques are combined in Photoshop using layers, masking, and opacity for pinpoint control.

EFFORT

Full-on quality black and white conversion does take some effort and time, but the efforts pays off in increased flexibility and creative control.

If you look at the graph shown to the left, you'll see a number of approaches ranked, going from left to right, on the basis of the amount of effort they take. The least effort is to press a menu item, or run an app, in a camera that does JPEG-to-JPEG conversions before the file is exported. The most effort is to perform a complicated conversion to color using the full information in a single RAW file, or a bracketed sequence of RAW files, and then to perform a black and white conversion of the color images using multiple conversion methods and options, controlling the application of the various methods using layering and masking.

There's no saying what's right or wrong here, and the choice is yours. But from the viewpoint of the quality of the conversion—which doesn't always correspond to the artistic quality of an image—the more work you put into it, the more your black and white imagery will get out of it.

▼ PAGES 96–97: The Tokyo Imperial Palace is the primary residence of the Emperor of Japan. It is situated in a large park-like area in the central Chiyoda Ward of Tokyo and contains many buildings including the palace, private residences for the imperial family, a museum, an archive, and offices. Not so long ago, the palace and its grounds were valued at more than all the real estate in the state of California. Wow!

The palace is built on the site of the old Edo Castle, which was built in 1457 and burned down in 1873. The remains of the stone platform that formed the base of the castle can be visited today, along with the moats and stone walls of the outer defensive perimeter defenses including the stone wall shown in this photograph.

The photo was first processed in color, and then converted to black and white using two layers, with each layer converted at a different exposure to maintain tonal consistency across the palace wall and its reflection in the moat.

85mm, 1/40 of a second at f/9 and ISO 200, tripod mounted; processed and converted to black and white in Photoshop.

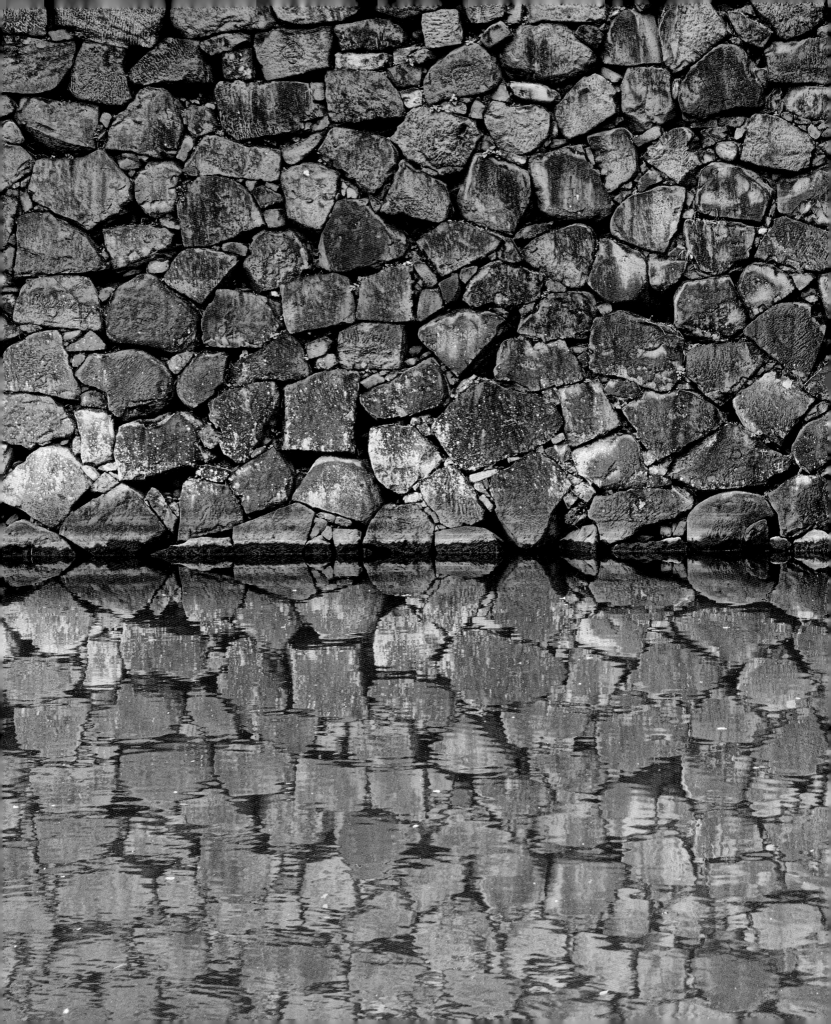

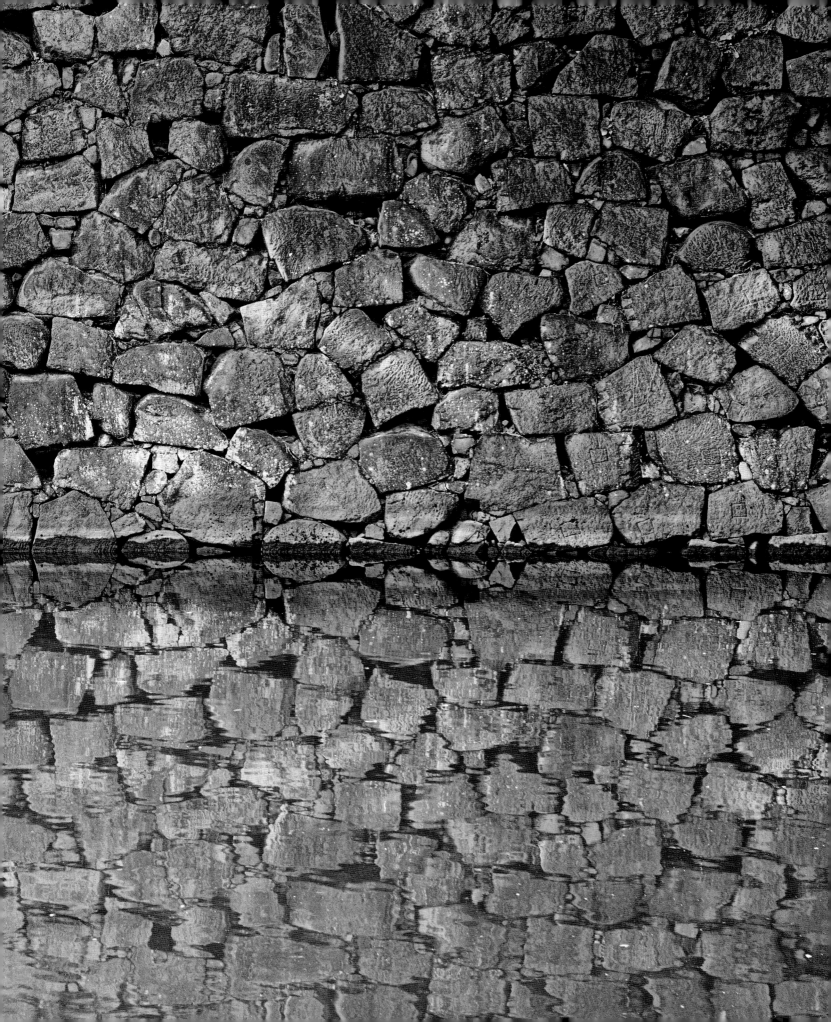

BLACK AND WHITE CONVERSION IN ADOBE CAMERA RAW (ACR)

Adobe Camera RAW, fondly known by the acronym ACR, is both part of Photoshop and separate. I know this sounds a little weird, but here's how it works: While ACR ships with Photoshop, and converting a RAW photo in ACR automatically opens Photoshop, ACR is notionally its own program, with separate dialogs and preferences.

Using ACR may just be the simplest way to convert a RAW file to black and white, as I'll show you in this section, although Lightroom can vie with ACR for simplicity depending on your preferences in user interface.

It important to know that ACR and Lightroom share the same underlying conversion technology. In other words, the RAW conversions and black and white imagery you get with either ACR or Lightroom are largely the same—it is only the route to get there that differs.

Depending upon how your computer has file applications associated, opening ACR with a RAW file can be as simple as double-clicking on the file in Finder (Mac), Explorer (Windows), or Adobe Bridge (cross-platform, ACR's companion as a Photoshop helper application, primarily intended as a file and folder navigator). If this doesn't work, you may need to right-click (or Control-click) on the RAW file, and then choose Photoshop from the Open With context menu.

▶ Exploring the temples near Kyoto, Japan, I came across this abandoned temple staircase, outmoded due to a more modern handicapped compliant access to the temple. The staircase was located in a small wooded area filled with ferns and dappled sunlight, which felt far from the hustle and bustle of the busy city.

As I contemplated the old staircase, I wondered who had climbed it—peasants, priests, royalty? What stories the stones could tell.

I wanted to photograph the staircase from above, so I climbed up a small hillside to gain height. I wanted my composition to show the stair diagonally bisecting the image frame.

32mm, 1/125 of a second at f/6.3 and ISO 400, hand held; processed and converted to black and white using Adobe Camera RAW.

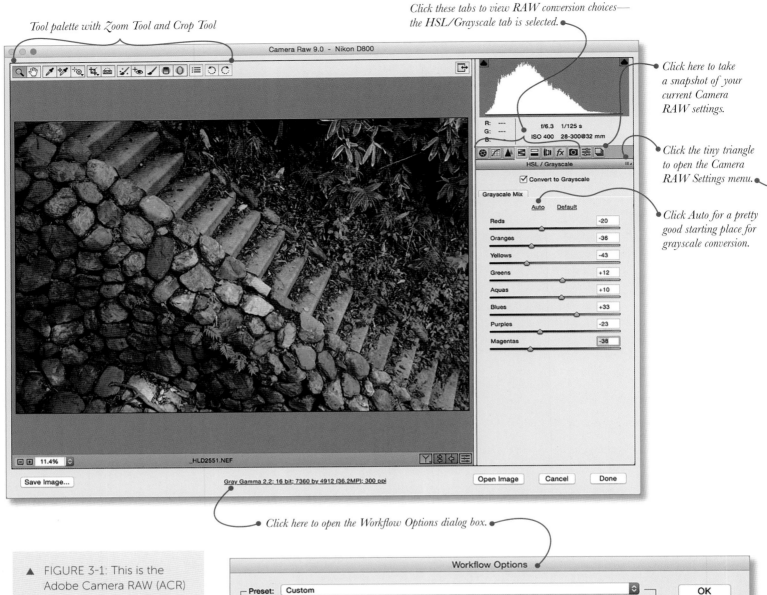

Tool palette with Zoom Tool and Crop Tool

Click these tabs to view RAW conversion choices—the HSL/Grayscale tab is selected.

Camera Raw 9.0 – Nikon D800

R: --- f/6.3 1/125 s
G: --- ISO 400 28-300@32 mm
B: ---

HSL / Grayscale

☑ Convert to Grayscale

Grayscale Mix

Auto Default

Reds	-20
Oranges	-36
Yellows	-43
Greens	+12
Aquas	+10
Blues	+33
Purples	-23
Magentas	-38

11.4%

_HLD2551.NEF

Gray Gamma 2.2; 16 bit; 7360 by 4912 (36.2MP); 300 ppi

Save Image... Open Image Cancel Done

Click here to take a snapshot of your current Camera RAW settings.

Click the tiny triangle to open the Camera RAW Settings menu.

Click Auto for a pretty good starting place for grayscale conversion.

Click here to open the Workflow Options dialog box.

Workflow Options

Preset: Custom OK

Color Space Cancel

Space: ProPhoto RGB Depth: 16 Bits/Channel

Intent: ☐ Simulate Paper & Ink

Image Sizing

☐ Resize to Fit: Default (36.2 MP) ☐ Don't Enlarge

W: 7360 H: 4912 pixels

Resolution: 300 pixels/inch

Output Sharpening

☐ Sharpen For: Screen Amount: Standard

Photoshop

☐ Open in Photoshop as Smart Objects

▲ FIGURE 3-1: This is the Adobe Camera RAW (ACR) application window. The HSL/Grayscale tab has been selected in this view of the program window, so the options it provides—such as the Convert to Grayscale check box and color sliders—are visible. You can click on the other tabs to see the amazing range of RAW conversion choices that this window has to offer. RAW photos contain a lot of data that you can use to adjust your images, including Exposure, Color Temperature, and White and Black Points.

Once your RAW image is open in ACR, you can convert it to black and white by choosing the HSL/Grayscale panel. This panel is accessed by clicking the fourth tab from the left in the row of available RAW conversion tabs. The ACR HSL/Grayscale panel is shown in Figure 3-1 to the left. Check the Convert to Grayscale box, and—*voila!*—your image converts to black and white.

You can adjust the ACR color sliders shown in Figure 3-1, on the far left, to set how the grayscale mix is determined. Actually, clicking the Auto link usually leads to a pretty satisfactory black and white conversion.

ACR is a work-person-like piece of powerful software without too much in the way of pretension. But a great deal of this power is found "under the hood," and how to access the full power of ACR is not always immediately obvious. If ACR is going to be part of your black and white work-flow, two hidden "features" you should know about are the Camera RAW Settings menu (Figure 3-2, above left) and the Workflow Options dialog box (Figure 3-3, far left, below).

To open the Camera RAW Settings menu, click the tiny triangle at the right of the HSL/Grayscale panel (this arrow is available on each RAW conversion panel). The Camera RAW Settings menu lets you perform important tasks like saving and loading custom RAW conversion settings that you create.

Another way to record your current ACR settings is to take a *snapshot*. You can use the snapshot feature to save settings as you work on a photo. If you do something you don't like, you can easily return to the previous settings saved in a snapshot. To create a snapshot, click the Snapshots tab located at the end of the RAW conversion tabs (the Snapshot tab is pointed out in Figure 3-1). In the New Snapshot dialog box that opens, type in a name for the snapshot, and then click OK. To restore a photo to a previous snapshot, click the Snapshots tab, and then choose the snapshot name from the list.

The Workflow Options dialog box shown in Figure 3-3 at the far, lower left is super important. To open it, click the text-type link at the bottom of the ACR window. While your settings in this dialog will depend upon what you are trying to accomplish, it is very important to keep in mind that this hidden dialog controls the color space and bit depth with which images are opened in Photoshop.

▲ FIGURE 3-2: The Camera RAW Settings menu is used to save and retrieve custom photo settings. That way, you can save a set of settings that work for one photograph, and then easily apply that same setting to other photos to give them a similar look, or to have the same starting exposure values. Save your custom setting by selecting Save Settings..., and then adding a descriptive name for the setting that will help you identify it later. Since I save all my RAW photo files by date, I usually include the date in the setting name so I can correlate the setting with the photos that I processed.

◄ FIGURE 3-3: The Workflow Options dialog box seems obscure, but it is *really* important. This dialog box controls the gamut of colors with which a RAW image is imported into Photoshop, along with the image bit depth and some other settings. The problem is that once you have lost color gamut, you cannot gain it back. So as a matter of workflow, it makes sense to bring an image into Photoshop with as wide a color gamut as possible, even if you will need to reduce the gamut later in your workflow.

Usually, choosing as wide a gamut as possible means selecting ProPhoto RGB using the Color Space: Space drop-down list. I normally recommend select-ing 16 bits using the Color Space: Depth drop-down list as is shown here because 16 bits provides more information than 8 bits, but it is more workable than higher bit depths such as 32 bit.

The good news is that once you have set this dialog the way you want it, your settings stay as the default. So, yes, you will need to open this dialog box the first time you use ACR, but you may never need to open it again!

BLACK AND WHITE IN LIGHTROOM

While the user interface in Adobe Lightroom is considerably more polished than the one in ACR, and the image management and workflow features are more advanced than those found in Adobe Bridge, it turns out that exactly the same technology underlying ACR is used in Lightroom—it's just that the program window you see as a user looks more finished.

The section shows you some of the straight-forward black and white conversion methods available in Lightroom for RAW conversions. You should know that Lightroom works with many third-party plug-ins, and I'll talk about that more later in this chapter. However, for a "gold-standard" multi-layered conversion, you will still need to bring your images as layers into Photoshop after they have been converted from the RAW in Lightroom, just as you would with ACR (more about this in Chapter 4).

▶ While Japan is usually (and accurately) portrayed as a very orderly society, it is less well known that there is a large underworld of homeless people in plain view in many of the larger cities.

You can see a homeless person on the left sitting on a bench, compositionally balancing the sculpture at the right. This photo was shot under a bridge on a major riverside boulevard in Tokyo, Japan.

Since I wanted to be sure to capture the silhouette of the homeless man, and because the area under the bridge was in deep shadow, I made sure to expose the image for the sunlight rather than the shadow. This choice meant that the sculpture under the bridge is intentionally dark, just as the homeless man is.

122mm, 1/125 of a second at f/10 and ISO 200, hand held, processed in Lightroom using the Basic Black & White treatment outlined on pages 94–95.

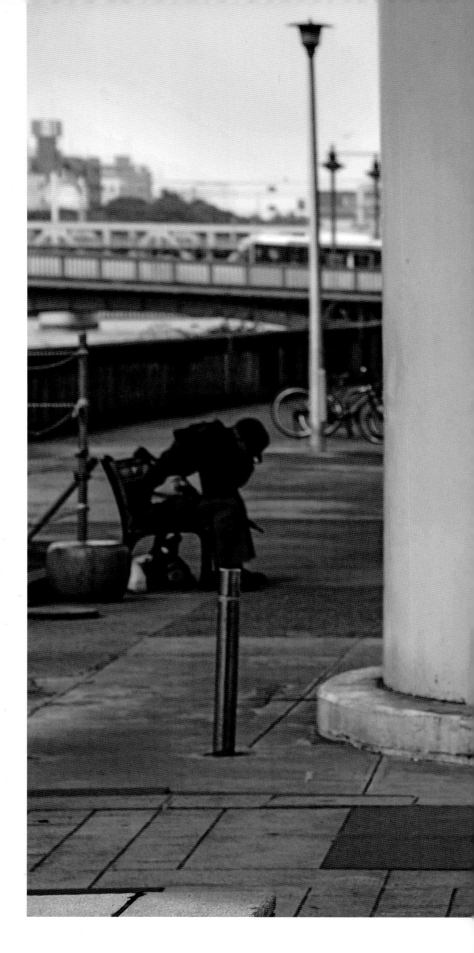

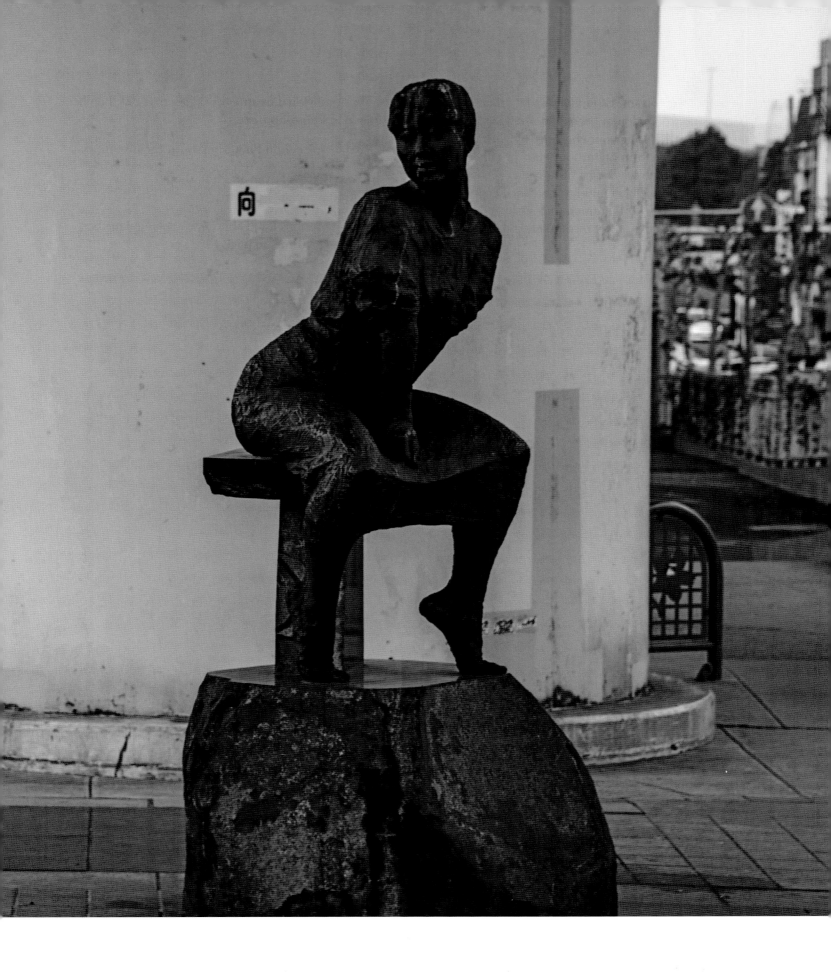

This last point is important. Essentially, images that are processed in Lightroom do not become standalone files until you export them using your choice of file format. To export your image file from Lightroom, start by choosing File ▸ Export, and then selecting a file format such as JPG, TIF, or PSD. To complete a multi-layered black and white conversion that starts with Lightroom processing of RAW imagery—along the lines of my recommendations in Chapter 4—you will need to:

- Export individual treatments as files that can then be edited in Photoshop, *or…*

- "Roundtrip" edit in Photoshop from Lightroom, *or…*

- Choose Edit As Layers in Photoshop from the Lightroom menu.

The last two options listed above are explained further in Chapter 4, starting on page 136.

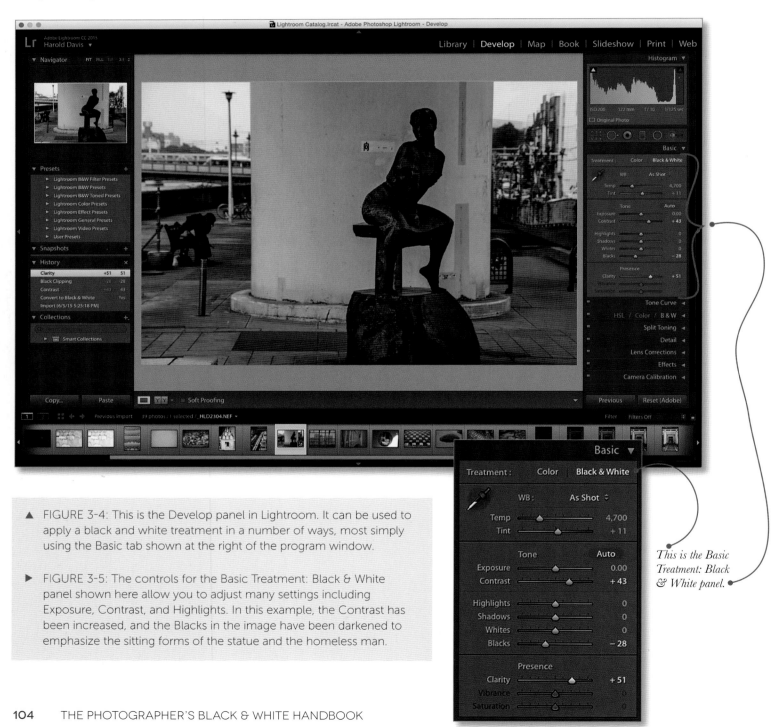

▲ FIGURE 3-4: This is the Develop panel in Lightroom. It can be used to apply a black and white treatment in a number of ways, most simply using the Basic tab shown at the right of the program window.

▶ FIGURE 3-5: The controls for the Basic Treatment: Black & White panel shown here allow you to adjust many settings including Exposure, Contrast, and Highlights. In this example, the Contrast has been increased, and the Blacks in the image have been darkened to emphasize the sitting forms of the statue and the homeless man.

This is the Basic Treatment: Black & White panel.

LIGHTROOM: BASIC BLACK & WHITE TREATMENT

The user interface for the Basic Black & White Treatment on the Develop panel in Lightroom gives some control over the results of the grayscale conversion, but not as much flexibility as other conversion methods.

To use the Basic Black & White Treatment, first use the Basic drop-down menu in Lightroom to choose Black & White from the Treatment panel. With the panel open (as shown in Figure 3-5), clicking the Auto button will give you an overall decent conversion. If you would like to tweak it, you can use the sliders to adjust Exposure, Contrast, Highlights, Shadows, Blacks, Whites, and Clarity.

In the example shown in Figures 3-3 through 3-5, I increased the contrast and the Blacks settings in the image to achieve the effect that I wanted, namely the silhouetted statue against the white pillar and the properly exposed external landscape.

Note that increasing the Blacks means adjusting the Blacks slider to the left, so that the numerical value it shows is, in fact, negative (in this case –28).

The controls on the ACR default panel are essentially the same as the controls on the Basic panel of the Lightroom Develop pane.

LIGHTROOM: HSL/COLOR/B&W TAB

One more step of flexibility than the Basic Black & White Treatment is to use Lightroom's HSL/Color/B&W control.

The HSL/Color/B&W control is found below the Basic and Tone Curve tabs on the right-hand side of the Lightroom Develop window. Click the tiny triangle to open the panel.

Just as in Adobe Camera RAW (ACR), to use the HSL/Color/Saturation control to convert an image to black and white, start by choosing the B&W tab (as shown circled to the right in Figure 3-6).

With the B&W tab selected, you can adjust the sliders to control the impact of each of the designated colors on the black and white mix. A good approach is to start by

using the Red slider to get a good general black and white look. Then, play with tweaking the other sliders to hone in on exactly the black and white look you are going for. The sliders work by allowing the individual color values to control the specific areas of the grayscale range during the black and white conversion.

The functionality is essentially equivalent to that of the HSL/Grayscale tab in ACR (see page 100). As with ACR, note that the conversion mix you are likely to get by clicking the Auto button is often quite good and one approach is to start with the settings generated by clicking the Auto button.

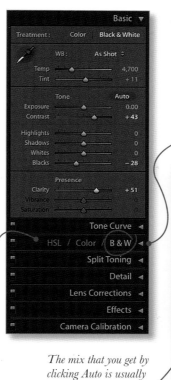

After clicking the tiny triangle to the right of B&W, the B&W Mix panel opens to show various adjustment sliders. You can use these sliders to get the black and white look you want. Starting with the Red slider will give you a good, basic black and white look.

The mix that you get by clicking Auto is usually pretty good.

▲ FIGURE 3-6: The Black & White Mix panel in Lightroom is found by clicking the B&W tab on the HSL/Color/B&W panel. The B&W tab provides controls similar to the ones found ACR, allowing individual channel inputs into the grayscale mix.

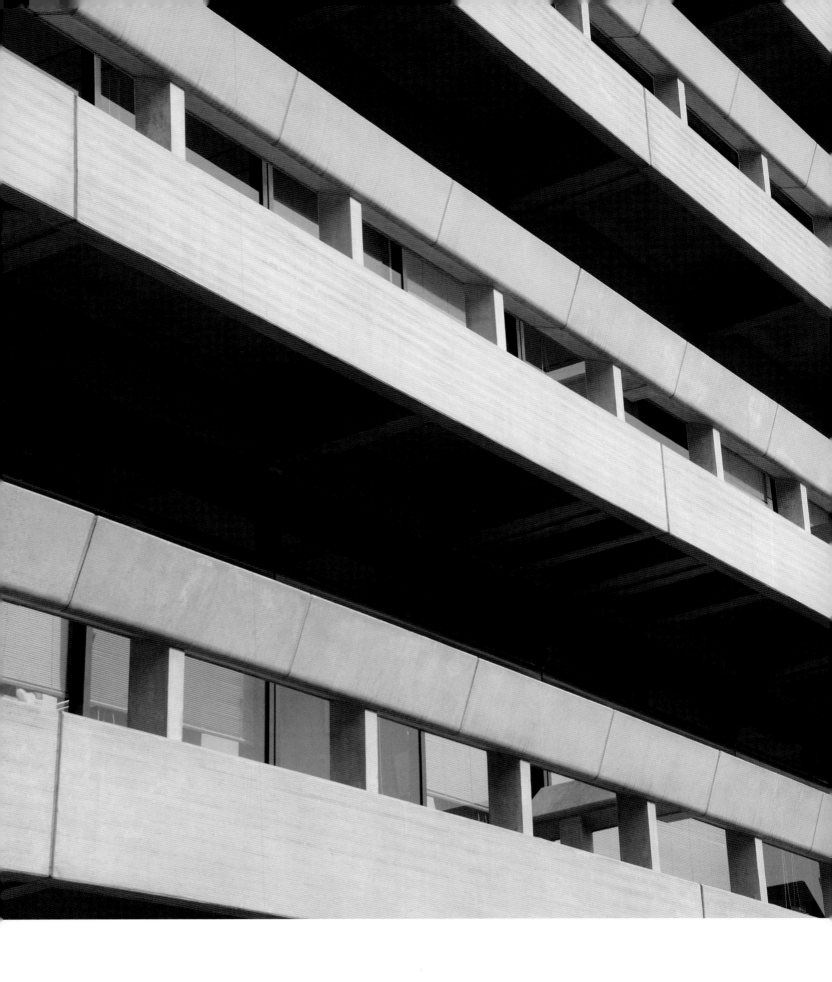

◄ Nara, Japan, was the imperial capital of Japan in 794 CE before the capital was moved to Kyoto. This means that Nara was an important city over a millennia ago when the unbroken line of the emperors, said to be descended from the gods, made Nara their primary seat. Recently, Nara celebrated its 1,300th anniversary of its ascension as Japan's imperial capital.

Wandering around the streets of modern-day Nara, it is easy to see two legacies of this venerable history. On the one hand, the parks of Nara are filled with elegant historic temples and traditional gardens.

On the other, it is clear that Nara is an important administrative center to this day, and the capital of the Nara Prefecture in the Kansai region of Japan. For example, I was struck by the modernistic lines of this municipal office building on a downtown street. Only a few blocks away are the famous Isuiein Gardens (see photo on page 87).

In general, one of the most interesting things about visiting Japan is witnessing the juxtaposition of the old and new. This dichotomy between the tradition and the modern exists cheek-by-jowl. An ancient Shinto cemetery may well be located adjacent to a contemporary skyscraper. In my experience, Nara truly exemplifies both the old and the new in Japan.

55mm, 1/160 of a second at f/16 and ISO 400, hand held; processed in Lightroom using the Black & White Mix dialog.

▲ I photographed this statue of Buddha in the garden outside Senso-ji, the oldest temple in Tokyo, dating from the 7th century. This temple is also known as the Temple of the Asakusa Kannon. The first temple in this location was founded in 645 CE.

According to legend, a statue of the bodhisattva Kannon was found in the Sumida River by two fishermen, who were brothers. The chief of their village recognized the holiness of the statue and acknowledged it by starting to turn his own house into a temple so the villagers could worship the Kannon.

On the day that I visited Senso-ji, the streets were crowded with celebrants, priests, tourists, and gawkers. I enjoyed having my fortune told on the temple grounds, and then stood in contemplation of the statue of Buddha. The hand gesture shown here is significant and has a special meaning. This is the Samadhi mudra, which shows balance of thought and tranquility, and invites meditation with a deep sense of oneness with the universe.

300mm, 1/80th of a second at f/5.6 and ISO 200, hand held; processed in Lightroom using the B&W Look 5 preset as a starting place for the black and white conversion.

LIGHTROOM: BLACK & WHITE PRESETS

Most likely, if you use Lightroom for your black and white conversions, you will want to experiment with Lightroom's built-in Black & White Presets. These presets present a great balance between ease of use, power, and flexibility. There's a lot more capability than with a Basic or HSL conversion without having to reach for a complex solution.

If the Black & White Presets in Lightroom are not enough for you, then the next step will be to use either a plug-in, such as Nik Silver Efex Pro (see page 123), Topaz B&W Effects (see page 124), or ON1 Software's Perfect B&W (see page 128).

As I explain later in Chapter 4, the gold standard for conversions is to use Photoshop layers to pick and choose, and mix and match, specific black and white conversions in combination. But, of course, this adds complexity to the conversion process, so many times the Lightroom presets will fit the bill with far less trouble.

Lightroom ships with quite a few presets. It's important to know that you can also create custom presets, which are added to the User tab. Essentially, these custom presets involve "recipes" based on settings of an existing preset.

Within the realm of Lightroom's Black & White Presets, you will find the following three categories:

- Lightroom B&W Filter Presets: These are conversion settings that mimic what would have happened in the chemical darkroom if you had used the designated filter on an enlarger.

- Lightroom B&W Presets: These are fairly conventional black and white treatments. Obviously, you will have to use trial and error to understand the visual impact of a treatment named (for example) "B&W Look 1."

- Lightroom B&W Toned Presets: In the chemical darkroom, toner such as sepia or selenium was added for visual effect to the "soup" used to develop prints; in the digital darkroom these presets simulate the image of chemical toning.

To apply a black and white preset to an image in the Lightroom Develop window, choose the preset you desire from the Presets tab, which is located on the left of the Develop window.

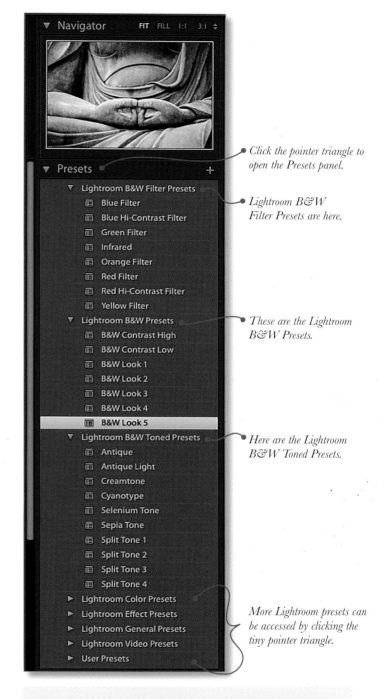

Click the pointer triangle to open the Presets panel.

Lightroom B&W Filter Presets are here.

These are the Lightroom B&W Presets.

Here are the Lightroom B&W Toned Presets.

More Lightroom presets can be accessed by clicking the tiny pointer triangle.

▲ FIGURE 3-7: The Lightroom Black & White Presets panel offers many options to get the monochrome look that you want. If you don't see the exact look that you are going for, you can use one of the presets as a baseline to get started. Select the preset that is closest to what you have in mind and then make adjustments using the various sliders, including Exposure, Contrast, Highlights, Shadows, etc.

BLACK AND WHITE IN PHOTOSHOP

To convert an image to black and white in Photoshop implies starting with a color image, likely derived from a RAW file processed for color through either ACR or Lightroom. There are a variety of methods for black and white conversion within Photoshop, shown here essentially in ascending order of both quality and complexity, starting with basic Photoshop conversions.

PHOTOSHOP: BASIC CONVERSIONS

First, it is important to understand that with the exception of a straight gray channel conversion, and dropping the color in LAB, which both work by simply dropping the color information, all Photoshop black and white conversion techniques lead to a technically color image.

Putting this in another way, the result of a black and white conversion in Photoshop is generally an image that *appears* black and white but is *actually* made up of color channels (if the image is in an RGB color space, these channels are the standard three R, G, and B channels). The color channels combine to create the appearance of black and white.

By the way, if you do drop the color information and are left with a one-channel (grayscale) image, you may need to reconvert the image back into color channels to make a quality print (depending on the output destination of your image). Interestingly, the result of converting to grayscale and then reconverting back to color remains black and white. You won't be able regain the color you've lost by reversing the process.

▶ Hiking down a mountain trail on the Kumano Kodo spiritual trail in rural Japan, I came upon the neat village of Hongū, with houses all with symmetrical tiled roofs, neatly arranged in a pattern.

This mountainous part of Japan, including Hongū, developed as a sacred place for Shugendo Buddhism starting in the mid-9th century. I thought that it was very striking to see a modern residential bedroom community in the context of the location very near sacred temples.

300mm, 1/80 of a second at f/8 and ISO 200, hand held; converted in Photoshop using Luminosity Blending Mode.

Grayscale: The simplest way to convert an image to black and white in Photoshop is simply to drop the color channels by choosing Image ▸ Mode ▸ Grayscale. While this technique is easy, it doesn't give you any control over how the conversion is carried out, and it may not lead to a satisfactory black and white image (it works best when your color image is fairly high contrast with a good distribution of lights and shadows).

Dropping the Color in LAB: To drop the color in LAB, first convert your image to the LAB color space by choosing Image ▸ Mode ▸ LAB. Next, in the Channels palette, delete the two color channels (a and b). The result will be pretty comparable visually to a straight grayscale conversion, although technically you will be left with a single alpha channel, rather than a grayscale channel.

While too crude a black and white conversion technique to be generally very helpful, you may wish to consider dropping LAB color if you are interested in working with LAB inversions as explained on pages 210–213, which can lead to some exciting special effects.

Hue/Saturation Adjustment: To convert a color image to black and white with a Hue/Saturation Adjustment, open the Properties panel, and then click the Hue/Saturation button. In the Hue/Saturations panel drag the Saturation slider all the way to the left (to −100) as shown below left in Figure 3-8. This will desaturate the image, giving it the appearance of monochrome.

Luminosity Blending Mode: Using the Layers panel, change your original color image from a default Background layer to a regular layer by choosing Layer ▸ New ▸ Layer From Background. Next, create a new layer by choosing Layer ▸ New, and then fill it with solid black. Move the solid black layer below the color image layer in the Layers panel as shown below right in figure 3-9. With the color image layer selected in the Layers panel, use the Blending Mode drop-down list in the Layers panel and select Luminosity; your image will convert to black and white. Provided that your original color image has a lot of contrast, this kind of black and white conversion can produce decent results.

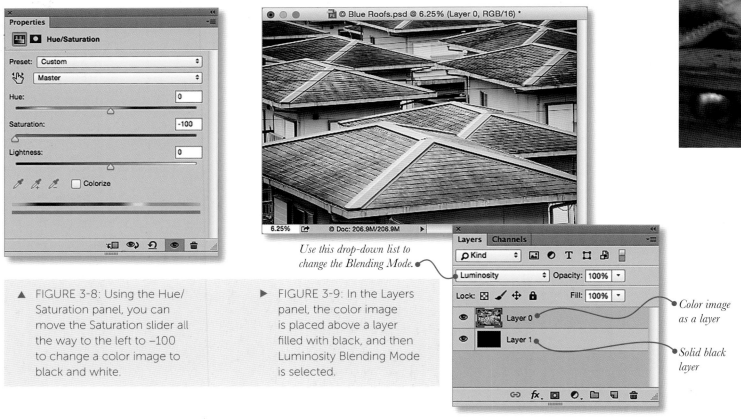

Use this drop-down list to change the Blending Mode.

Color image as a layer

Solid black layer

▲ FIGURE 3-8: Using the Hue/ Saturation panel, you can move the Saturation slider all the way to the left to −100 to change a color image to black and white.

▶ FIGURE 3-9: In the Layers panel, the color image is placed above a layer filled with black, and then Luminosity Blending Mode is selected.

For someone from the United States, browsing in a food market in Japan is an extraordinary experience. Many of these food markets are covered like the malls in the United States—but there the similarity completely ends.

Often enclosing a warren of tiny alleys and a maze of streets, Japan's food markets are always impeccably clean. Any kind of food item you can imagine, and many that you can't possible imagine, can be found in these markets. In fact, as one popular guide book puts it, there are items in many of these stalls that are definitely food, but are completely unidentifiable to foreigners.

These markets can be crowded with throngs of shoppers of all ages, ranging from salary men in suits to little old ladies in traditional kimonos and wooden clogs. One interesting aspect of browsing through the markets is that everyday items such as sandals and clogs often reside next to food stalls, such as the one I came across in a popular Tokyo covered market that was selling this basket of baby octopus.

170mm, 1/160 of a second at f/5.6 and ISO 200, hand held; processed using ACR and converted to black and white in Photoshop using gray channel conversion.

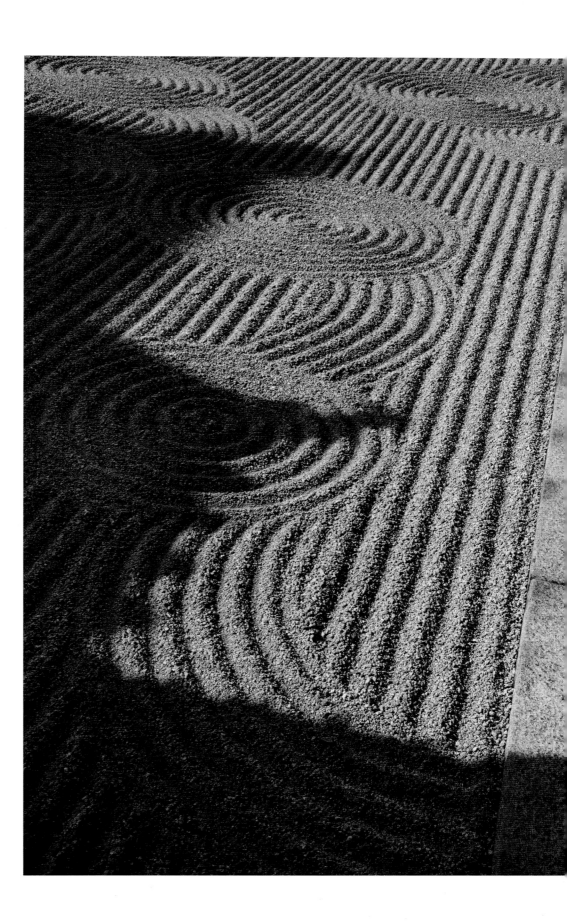

◄ Along the ancient Kumano Kodo spiritual trail in Japan, there is a vast silence, only broken by the sounds of the weather—wind whistling through the trees, mist falling on the leaves drop-by-drop.

It wasn't always this way. In years gone by, nobles from Kyoto made the pilgrimage and would often travel with many retainers. The remains of those days are still visible in the moss covered stairs, small abandoned settlements, and silent, empty tea houses.

As I walked the pilgrimage trail, the sense of silence and history permeated my thoughts, leading me to consider how I would show this ancient world in my photographs. Black and white was one answer, since it removes the distraction of color, and shows the essence of what lies beneath.

48mm, 1/15 of a second at f/8 and ISO 400, tripod mounted; converted to black and white using Photoshop.

▶ This Zen Buddhist temple on the outskirts of Kyoto has a garden of rocks that is raked daily. The pattern represents raindrops (the circles) and reflected clouds on a pool of water. So the Zen rock garden mimics what you might also see in a water garden. The roof line of the temple building is shown in the shadow in the image.

48mm, 1/400 of a second at f/14 and ISO 400, hand held; converted to black and white using Photoshop.

PHOTOSHOP: USING THE CHANNEL MIXER

The Channel Mixer allows you to select the contribution of each color channel to making a black and white mixture, using sliders that represent the channels. Historically, this has been one of the best methods of creating distinctive black and white imagery, and it still holds up fairly well to more modern approaches.

To convert an image to black and white, choose Window ► Adjustments to open the Adjustments panel. Then choose Channel Mixer on the Adjustments panel. Make sure the Monochrome box is checked, and then adjust the sliders to come up with the black and white look that you have in mind. The Channel Mixer makes it pretty easy to make smooth adjustments across the entire range of grays in an image.

Make sure you check the Monochrome box.

► Osaka, Japan, is one of the largest cities in the world. During Japan's Edo period (1603–1868), Osaka was known as the "nation's kitchen" because it was the center for the country's rice trade. Today Osaka is known for its cuisine and is still encouraging "kuidaore" (食い倒れ) which means "bringing ruin upon oneself by extravagance in food."

While waiting for a train connection in a train station on the outskirts of Osaka, I wandered out to the streets. Osaka is a city of contrasts—ancient castles and traditional-style Japanese architecture surrounded by modern apartment buildings and office towers. Walking past old and new, I found a patterned, modern apartment building with stairs rising in gray sculpted rows.

145mm, 1/60 at f/9 and ISO 400, hand held; converted to black and white using the Photoshop Channel Mixer.

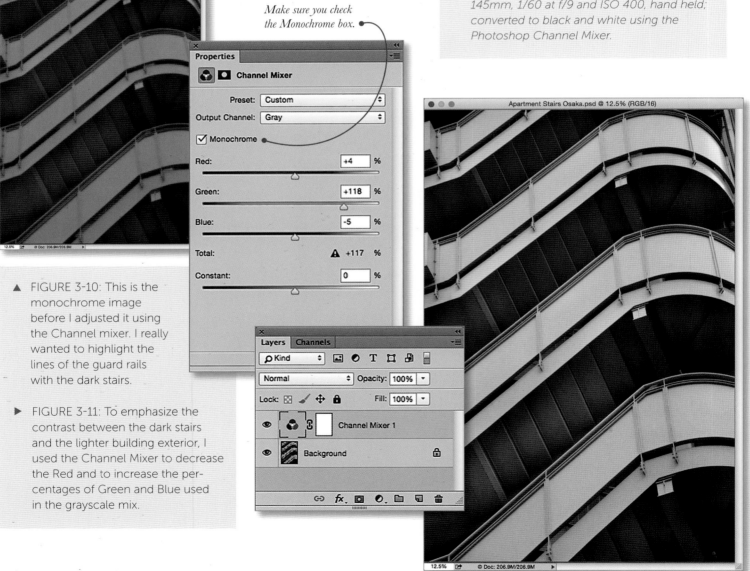

▲ FIGURE 3-10: This is the monochrome image before I adjusted it using the Channel mixer. I really wanted to highlight the lines of the guard rails with the dark stairs.

► FIGURE 3-11: To emphasize the contrast between the dark stairs and the lighter building exterior, I used the Channel Mixer to decrease the Red and to increase the percentages of Green and Blue used in the grayscale mix.

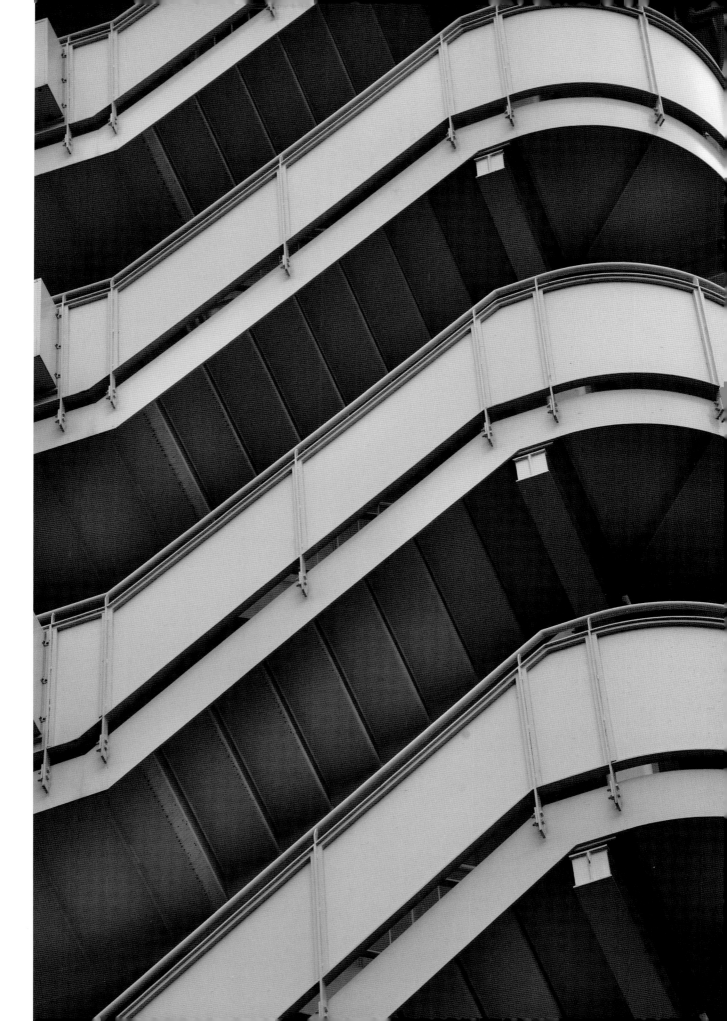

PHOTOSHOP: BLACK & WHITE ADJUSTMENTS

With Photoshop CS3 in 2007, Adobe added Black & White Adjustment layers. Black & White Adjustment layers are so flexible and easy to use that they've become one of the modern standards for monochromatic conversions, and it is hard to remember life before them. An Adjustment layer is a special kind of layer that only stores information about changes to the layer beneath it, rather than the entire information in a normal layer. The great advantage of this is that Adjustment layers take up much less file space than normal layers, and by definition cannot change the underlying layer.

If you look at the Layers panel in Photoshop, you will notice that when you use a Black & White Adjustment layer, Photoshop automatically puts the Adjustment layer above the image layer in the layer stack (see Figure 3-13).

▶ The hot springs resort of Yunomine Onsen nestles in valley basin in the Kii Peninsula of Japan, where it has provided respite to weary trekkers on the Kumano Kodo pilgrimage trail for at least a thousand years. It is the only hot springs that is formally registered as a UNESCO World Heritage Site.

Early one morning on my own pilgrimage, I woke to rain in this hot spring resort in the remote mountains of Japan. Rain was pattering on the windows at my rustic ryokan. After retrieving my hiking boots from the cubbies near the front door of the ryokan, I went outside to explore the misty and exotic environment.

The hot spring creek, belching steam and sulphur, ran down the center of the town, with paths, small roads, and bridges on either side of the creek. Onsens—hot baths—both public and private lined the banks of the creek with pipes of a variety of sizes carrying the hot water to yet more baths,

I made my way to a small bridge in the center of town. Shielding my camera from the rain, I turned to look at the weird scene of smoke, sulphur, and pipes in the early morning light.

The chill penetrated my rain shell, and after making a few photos, I retired to the hot bath at my ryokan.

28mm, 1/8 of a seond at f/8 and ISO 200; tripod mounted; converted to black and white in Photoshop using a Black & White Adjustment layer.

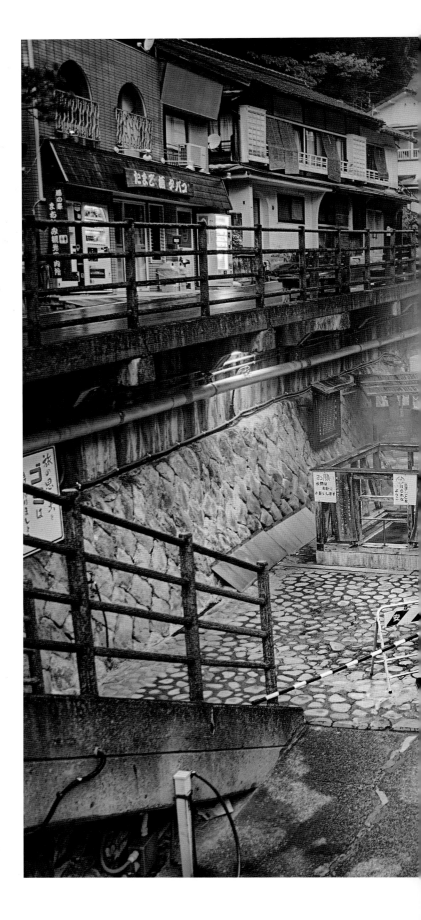

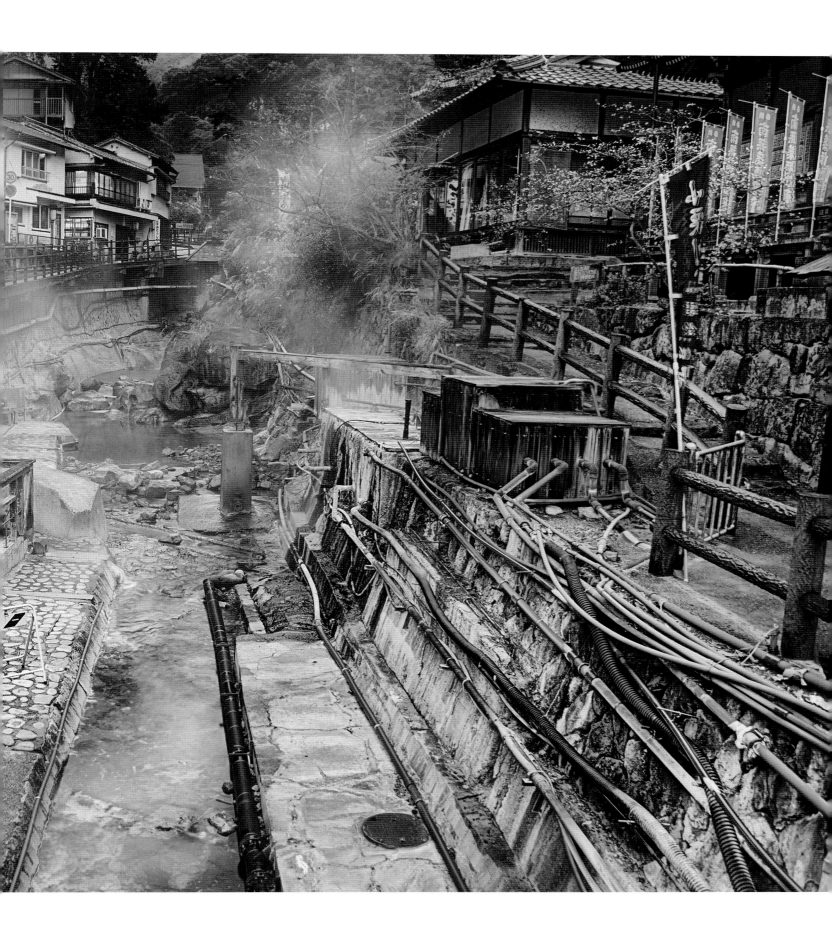

All adjustments that you make using the Black & White Adjustment layer are done on the Adjustment layer itself. Your color image is not changed in any way. This is really great for workflow because you can do lots of things with the Adjustment layer. For instance, you can:

- Edit the Black & White Adjustment layer at any time to tweak your settings.

- Use the layer mask attached to the Adjustment layer to paint out areas that you don't want to change.

- Delete the Adjustment layer if you decide you don't like it and start over without changing your image.

- Save it for use with other images, if you really like the look that the Black & White Adjustment layer gives to your image.

To convert to black and white using this method in Photoshop, choose Black & White from the Adjustments panel. To start with, the Black & White Adjustments panel will open with the Default preset selected (Figure 3-14).

Generally, clicking the Auto button on the Black & White Adjustments panel will yield a satisfactory middle-of-the-road black and white conversion. But a more flexible and artistic approach is to choose a preset from the drop-down list at the top of the palette.

The presets are named for simulated chemical darkroom filters that were placed on enlarger lenses in the days of film photography. So, if you are fortunate enough to have experience in the darkroom in the days before photography went digital, you will have a pretty good idea of what these presets are intended to do.

The general suggested workflow is to choose a preset that is close to the effect you'd like (for example, the Red Filter preset is shown selected in Figure 3-14), then use the color sliders to tweak the result.

▶ FIGURE 3-12: Start by clicking the Black & White Adjustment layer button on the Adjustments panel.

▼ FIGURE 3-13: A Black & White Adjustment layer will appear in the Layers panel.

Click this button to add a Black & White Adjustment layer.

You can click the Auto button to get started with a good black and white conversion.

▶ FIGURE 3-14: You can click the Auto button to get a good start on a black and white conversion; or select a preset from the drop-down list, and then use the color sliders to adjust the tones in your image.

▲ As I continued my trek on the Kumado Kodo, the end of one day's walking was at the Kumano Hongu Taisha. This temple has been the center of the Kumano Shugendo faith for more than a thousand years.

Coming into the temple complex, I saw this dragon presiding over the place for ritual purification. A priest showed me what to do: First, you take a scoop of water with your right hand and rinse your left hand. Then, with your left hand, you use the scooper to rinse the right. Next, you take a bit of water in your mouth, but don't drink it, and don't spit it back into the water source. Finally, you rinse the scooper's handle, clap twice, and bow. The dragon is there to make sure you get the steps right!

300mm, 1/100 of a second at f/8 and ISO 500, hand held; processed and converted to black and white using Adobe Camera RAW and Photoshop.

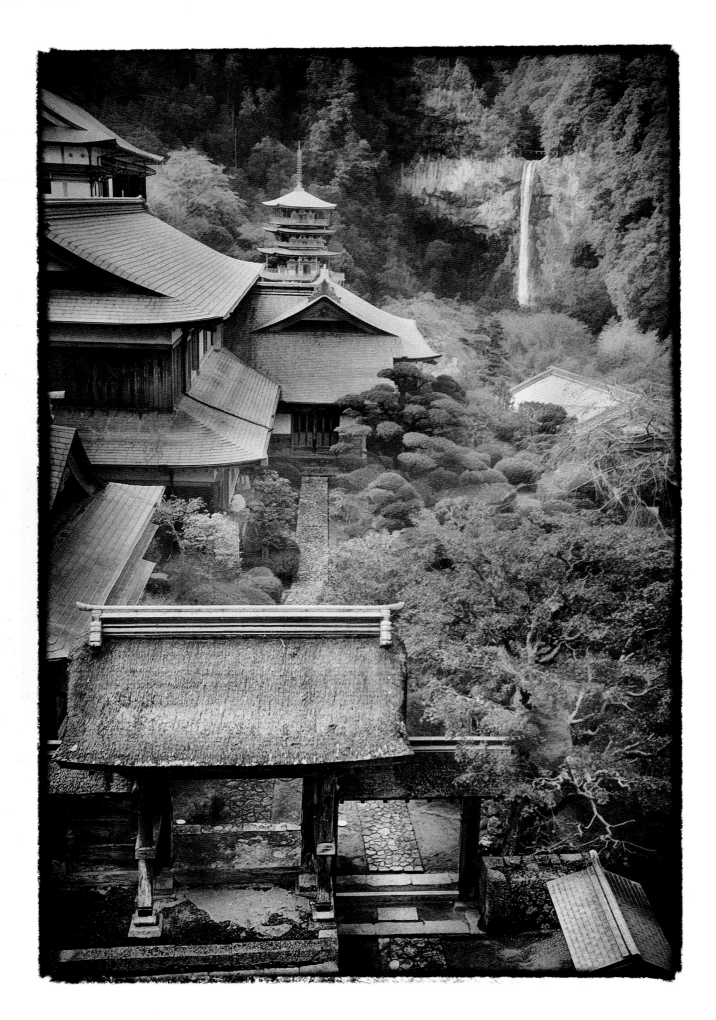

NIK SILVER EFEX PRO

Google's Nik Silver Efex Pro is a plug-in that runs with Photoshop (and Lightroom). This software provides a staggering variety of high-quality black and white conversion effects, and frankly even the default black and white conversion is pretty good. It is one of my very favorite black and white conversion programs. To open Nik Silver Efex in Photoshop, choose it from the Filters menu.

The best general way to approach this software is to first select a preset (Figure 3-15), then tweak the overall settings for the conversion, such as Brightness, Contrast, and Structure (Figure 3-16), and finally add special effects such as toning, vignetting, and borders. Note that once you have adjusted a preset to your satisfaction, you can save the preset as your own "custom preset"—which is a great convenience if you want to use the same settings multiple times.

Nik Silver Efex Pro provides a mechanism for localized (as opposed to global) adjustments, and this can be useful when you are converting an image quickly. However, my recommendation is to make your Nik Silver Efex Pro conversion on a separate Photoshop layer, and apply localization using Photoshop's masking and brush tools (see Chapter 4 starting on page 136).

You'll find more information about how to use Nik Silver Efex Pro to create special black and white effects in Chapter 5, starting on page 174.

◄ The three-story pagoda Seiganto-ji is part of the Kumano Sanzan temple complex in Nachi-san on Japan's inland sea at the end of the Kumano Kodo pilgrimage trail. This is a very special place, located near Nachi Falls, a site for nature worship going back millennia. The temple itself is a UNESCO World Heritage Site, and nominally Tendai Buddhist. As in many Japanese religious sites, the practitioners actually follow a syncretic combination of Shintoism and Buddhism. In the case of Kumano Sanzan and Seiganto-ji, the temple is one of the rare few whose dual heritage survived the Meiji restoration's forcible separation of the two religions, and the government establishment of Shintoism as the official state religion in the late 1800s.

40mm, 1/60 of a second at f/5.6 and ISO 200, tripod mounted; processed in Photoshop, and converted to monochrome using Nik Silver Efex Pro (Film Noir 1 preset).

Nik Silver Efex Pro comes with a library of presets. Choose the preset you like as a starting place for your black and white conversion.

Click on one of the presets to try it out.

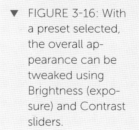

▶ FIGURE 3-15: In Nik Silver Efex Pro, there are many preset black and white conversions that you can use to get the look you want for your images. For the image shown to the left, I used the Film Noir 1 preset.

▼ FIGURE 3-16: With a preset selected, the overall appearance can be tweaked using Brightness (exposure) and Contrast sliders.

For this black and white conversion, I used the Film Noir 1 preset.

TOPAZ B&W EFFECTS

B&W Effects from Topaz Labs is a powerful black and white conversion program whose unique strength lies in the special effects presets that are organized to simulate many film darkroom printing techniques, for example Selenium and Platinum. It runs as a Photoshop or Lightroom plug-in (with some additional software from Topaz you can also run it as a standalone without either program). To launch Topaz B&W Effects in Photoshop, choose Filter ▸ Topaz Labs ▸ BW Effects.

Generally, the workflow process for B&W Effects is similar to that of other black and white conversion filters: You choose a preset based on your idea for the conversion, then tweak the preset, and add finishing touches.

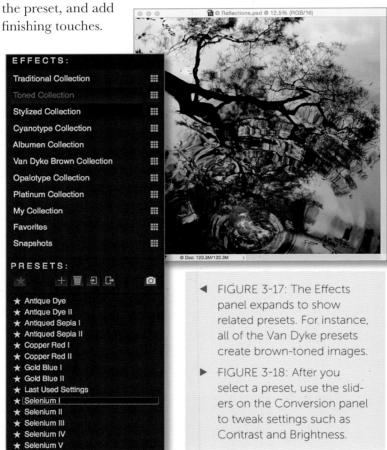

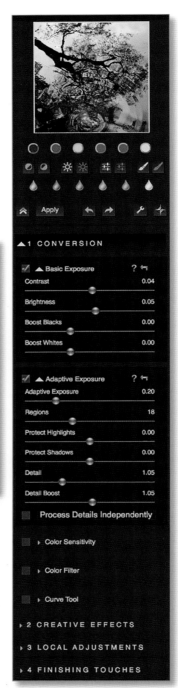

◄ FIGURE 3-17: The Effects panel expands to show related presets. For instance, all of the Van Dyke presets create brown-toned images.

▸ FIGURE 3-18: After you select a preset, use the sliders on the Conversion panel to tweak settings such as Contrast and Brightness.

▸ Wandering in a temple garden in Kyoto, I saw this reflection and koi in a pool, and quickly made a photograph showing the trees, ripples and the reflections—all coming together the way the garden designer had intended!

56mm, circular polarizer, 1/60 of a second at f/9 and ISO 800, hand held; processed in Photoshop and converted to black and white using the Selenium I preset in Topaz B&W Effects.

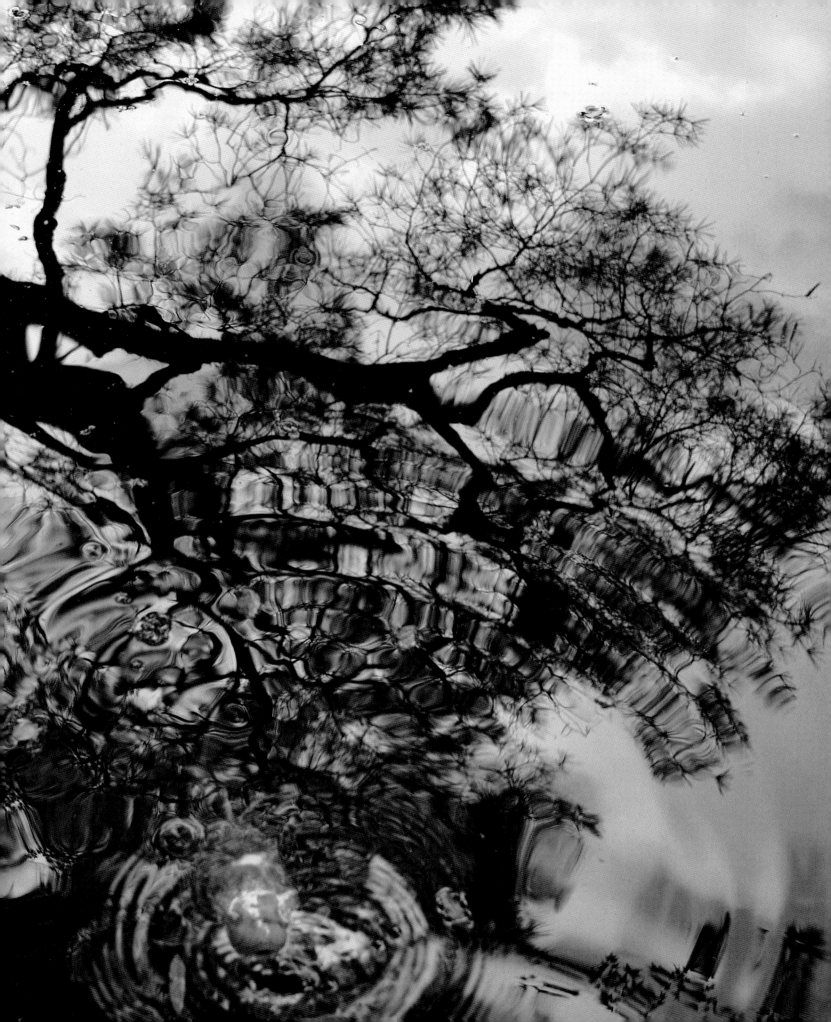

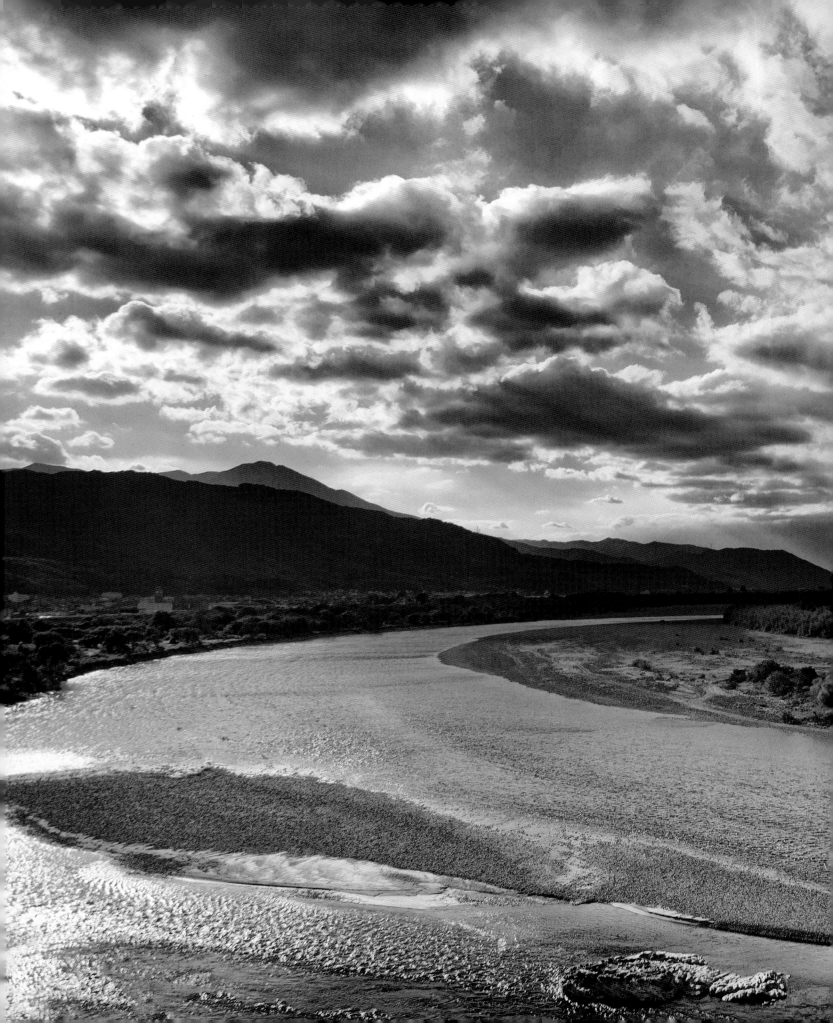

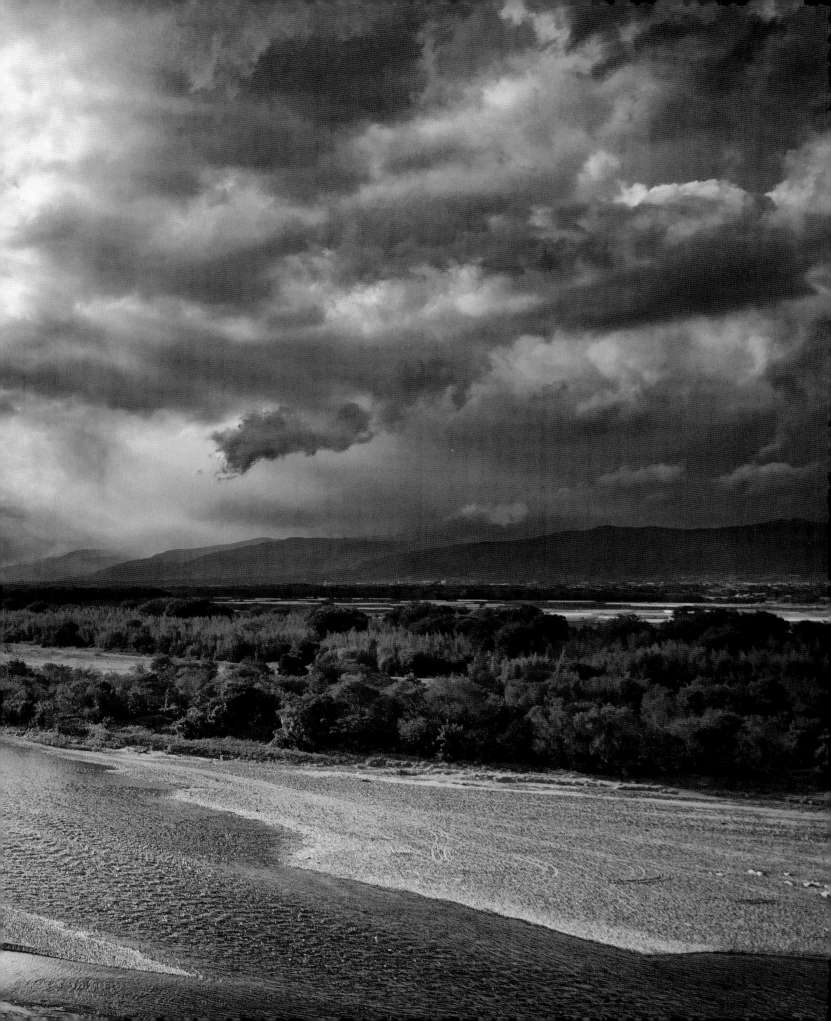

PERFECT B&W

Perfect B&W from ON1 Software runs as a Lightroom or Photoshop plugin—or as a standalone program via the Perfect Suite. It comes with many presets that can give you vintage effects. To open Perfect B&W from within Photoshop, choose File ► Automate ► Perfect BW. (Unlike competing conversion programs, it is not found on the Filter menu.)

With Perfect B&W running, choose a preset on the left-hand side of the window to select a monochrome look that you are interested in. Then use the sliders on the right side of the window to tweak it as necessary.

For example, the landscape showing the Yoshino River in Japan, above right, was converted using the elegant "Ansel in the Valley" preset (Figure 3-19), often a good choice for dramatic landscapes. After converting the image using the preset, I made several adjustments, including Brightness, Detail, and Red using the various sliders (Figure 3-20). The final black and white version is shown on pages 126–127.

After you select a preset, you can use these sliders to adjust the black and white conversion.

ON1 Perfect B&W comes with many preset libraries organized in tabs that reflect the history of photography.

◄ FIGURE 3-19: Many of the Perfect B&W presets are modeled on vintage black and white looks. All you need to do is click a preset to try it out.

► FIGURE 3-20: After selecting a preset that gives you the look that you pre-visualized, use the sliders to adjust various aspects of the conversion. Color filters simulate the results they would have had in the film darkroom; for example, applying a Red filter will make clouds more dramatic.

▲ PAGES 126–127: From high on a bluff, I photographed the Yoshino River in Tokushima Prefecture on Shikoku Island in Japan. The photo shows the wide sweep of the Yoshino near its outlet in the ocean. This photograph made the landscape seem vast and almost empty, which is a bit deceptive as a closer look would disclose homes, shops, and temples in almost every nook and cranny near Tokushima, the largest city on Shikoku Island.

28mm, 1/500 of a second at f/8 and ISO 200, hand held, processed in Photoshop and converted to black and white using the "Ansel in the Valley" preset in Perfect B&W.

► High on a mountain pass on the Kumano Kodo pilgrimage trail in Japan, the weather opened up so I could photograph the scene of distant mountains. I made a number of compositions with my high-resolution cameras in the RAW format (see pages 82–83 and 132–133), and also this JPEG using my iPhone. This relatively low-res mobile phone image doesn't have the range of a high-res photograph. But it does have a unique quality all its own—due to creative anachronism: This is a new technology used to create an image that in some respects seems quite antique.

iPhone camera app, 8-bit JPEG, processed in Lo-Mob.

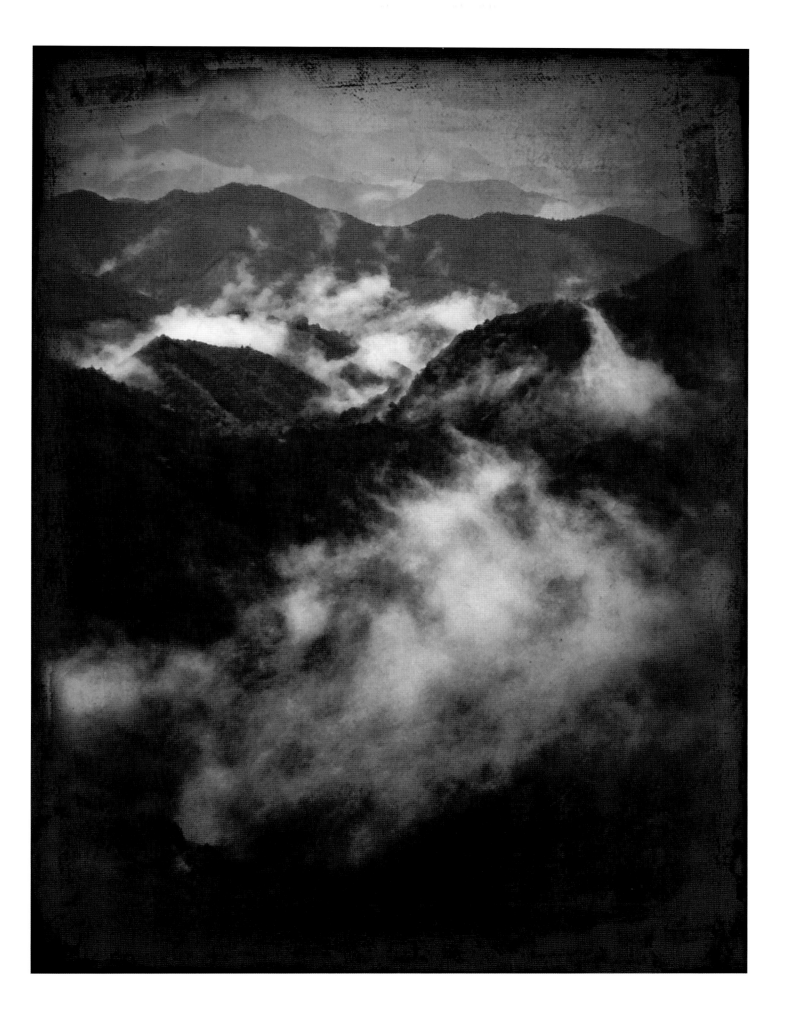

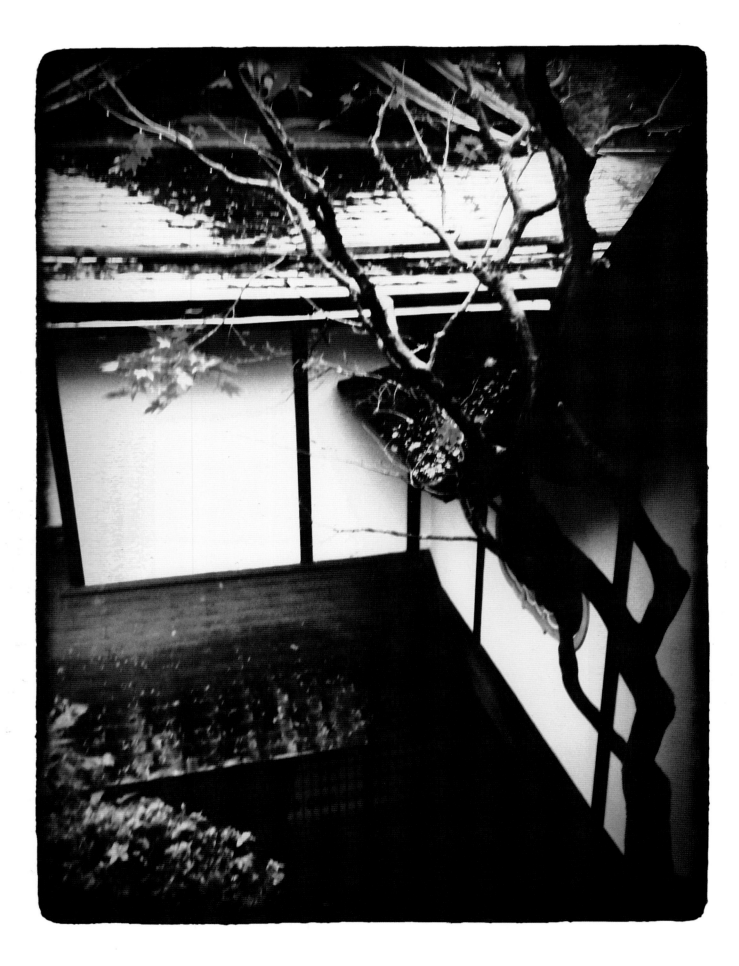

◄ I spent several autumn days as a guest at a Buddhist monastery in Koya-san in the mountains of rural Japan. This kind of temple lodging is called a *shukubo* (宿坊). Combining things that are more in my normal experience in order to describe the *shukubo*, it was part youth hostel and part resort hotel, with everyone sleeping on the floor in rooms divided by paper screen partitions. There were guided meditations morning and night, and pretty gardens.

A cold rain had been falling for most of the day, and the trick was to stay warm and dry. Paper walls do not make for great insulation! If you are interested, this *shukubo* heats with kerosene (yes, it smells bad), and also with a secret electric heater under the low table for one's feet. The breakfast and dinner served to the guests at Koya-san, was the same simple vegetarian fare that the monks ate.

iPhone camera app, processed in Snapseed.

▼ As I explored the grounds of the Shoren-in Buddhist temple in Kyoto, Japan, I found many ancient trees. This Buddhist temple, also known as the Awata Palace, was built in the late 13th century.

These temple gardens were quiet and dignified, and the trees showed their connection to the Earth. Wandering in this temple was a remarkably peaceful experience. It is a bit off the beaten tourist track in Kyoto, so there were few tourists and only a few Japanese visitors.

Some of the camphor trees are more than 800 years old. The roots of this tree, photographed in the mist of a twilight hour in autumn, exemplifies this connection.

98mm, with three exposures at 2, 4, and 6 seconds at f/32 and ISO 200, tripod mounted, processed in Photoshop and converted to black and white using the "Straight Up" preset in Perfect B&W.

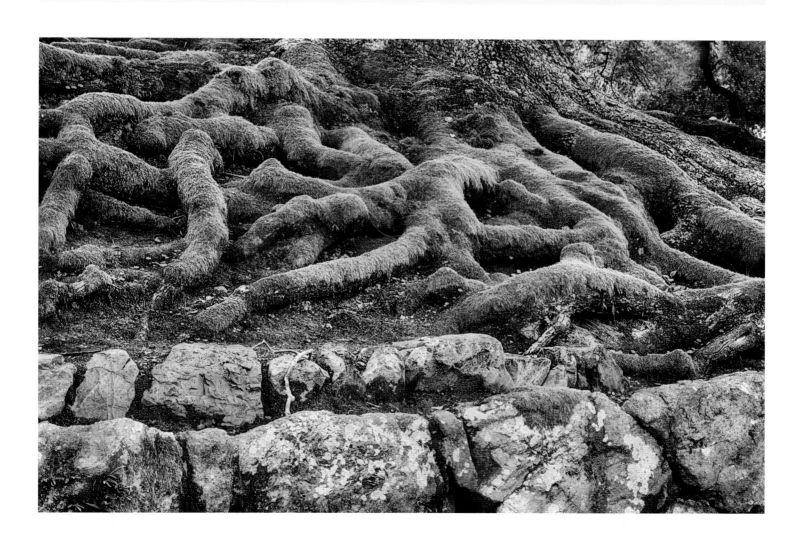

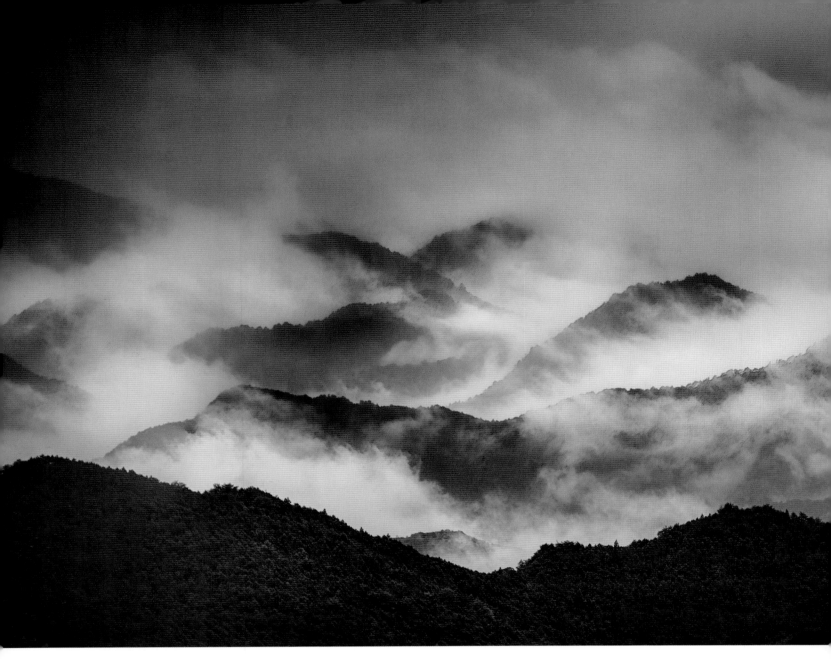

ONWARD AND UPWARD

This chapter has presented many options for black and white conversion of a single-layered image. In most cases these conversion techniques work well, and with the right image, some of the techniques can produce world-class black and white imagery.

However, it is important to keep in mind that any single-layered black and white conversion technique is a compromise. To rephrase this for clarity, if you only use one monochromatic conversion technique, it is unlikely that your conversion will be the best choice for every part of your image. The reason any single black and white conversion technique is a compromise is because different parts of an image need different treatments in conversion. No one conversion technique provides the visual appeal that all portions of an image requires. The only way to get around this is to selectively apply multiple conversions.

In other words, one black and white conversion technique may be good, but many conversion techniques are usually better. The gold standard for selective black and white conversions is to create a layer stack in Photoshop using a variety of actual conversion techniques, such as Photoshop and third-party filters and adjustments, at differing opacities, and in some cases masked. The mechanics and workflow for this process are explained in the next chapter.

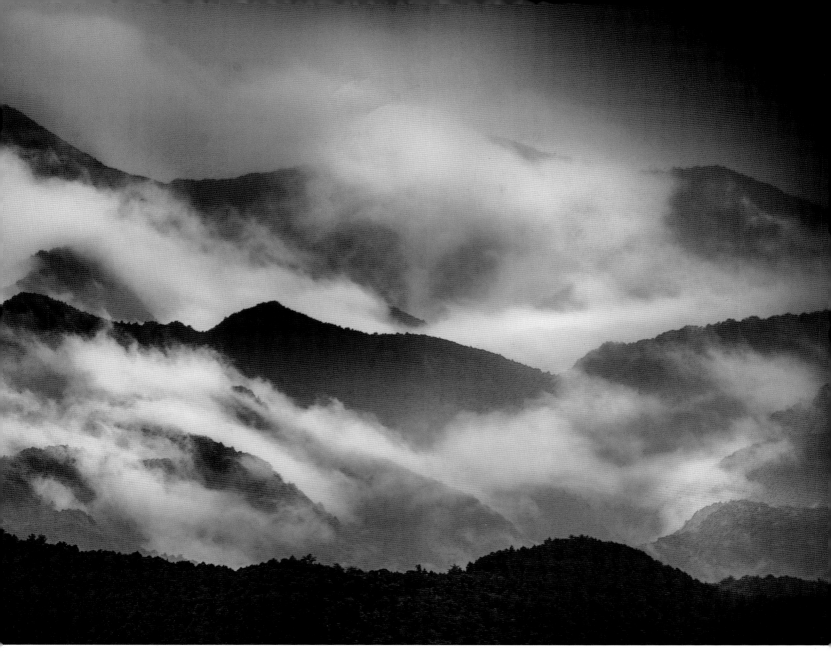

▲ As I walked the Kumano Kodo spiritual path in rural Japan, each day's weather was different—some days sunny and warm, others misty, and some days rainy. But following the path meant going out and trekking, no matter what the weather.

Hiking through a steady, cold rain, I paused at a lookout about half a mile before reaching Hyakken-gura, my next dry resting place for the night. Peering out from beneath my umbrella, I saw the wide vista of the Kumano Sanzen Roppyaku Po, which translates to "view of 3,600 peaks of Kumano." I could see through the pine trees to a distant landscape where the cloud cover seemed to be breaking up. The view seemed to call for a panorama, so

I mounted my camera on my tripod. As the wind gusted, rain splattered my face and my camera lens and tripod, so it was pretty hard to make notes to keep track of the positioning of the frames in the panorama. I had to work hard to keep myself—and more important—my camera dry. As I wiped the rain off my glasses and out of my eyes, I realized that the weather was a part of the spiritual scenery that makes the Kumano Kodo so special. After all, you can't capture a clearing storm unless you are out in the weather to begin with.

This is a high-resolution panorama, shot in 10 separate sections with my 36MP Nikon D800. The final, full-size processed file measures 12,256 x 4,747 pixels at 300 ppi.

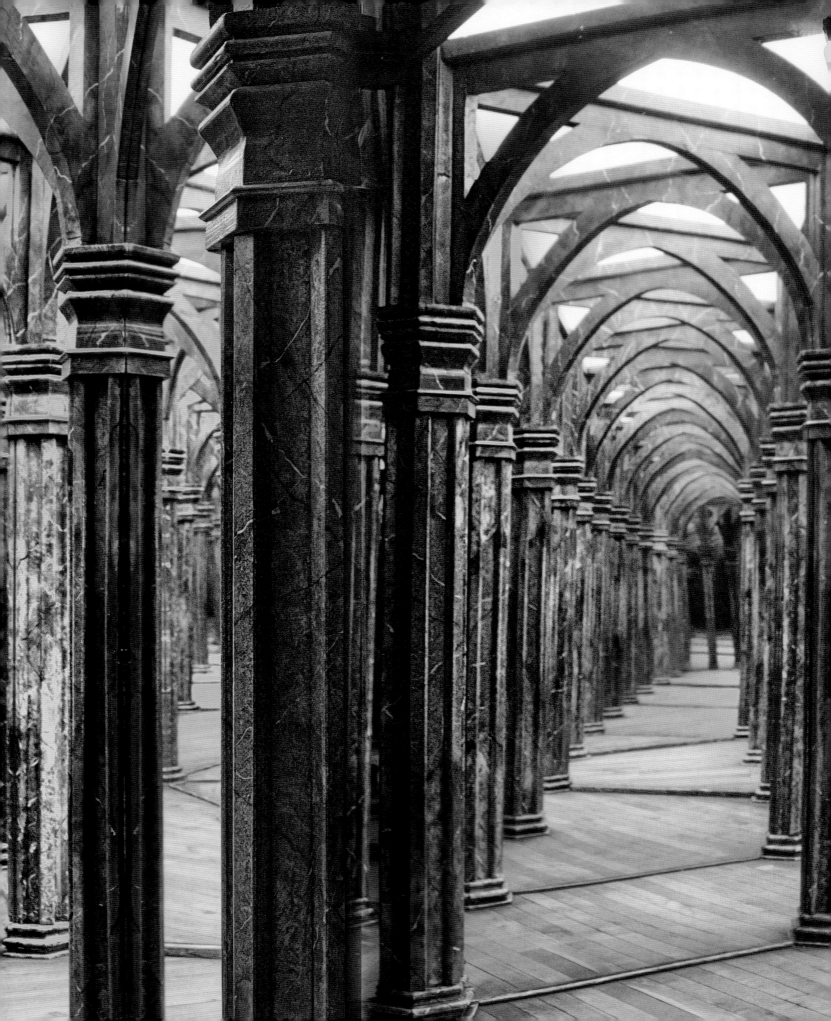

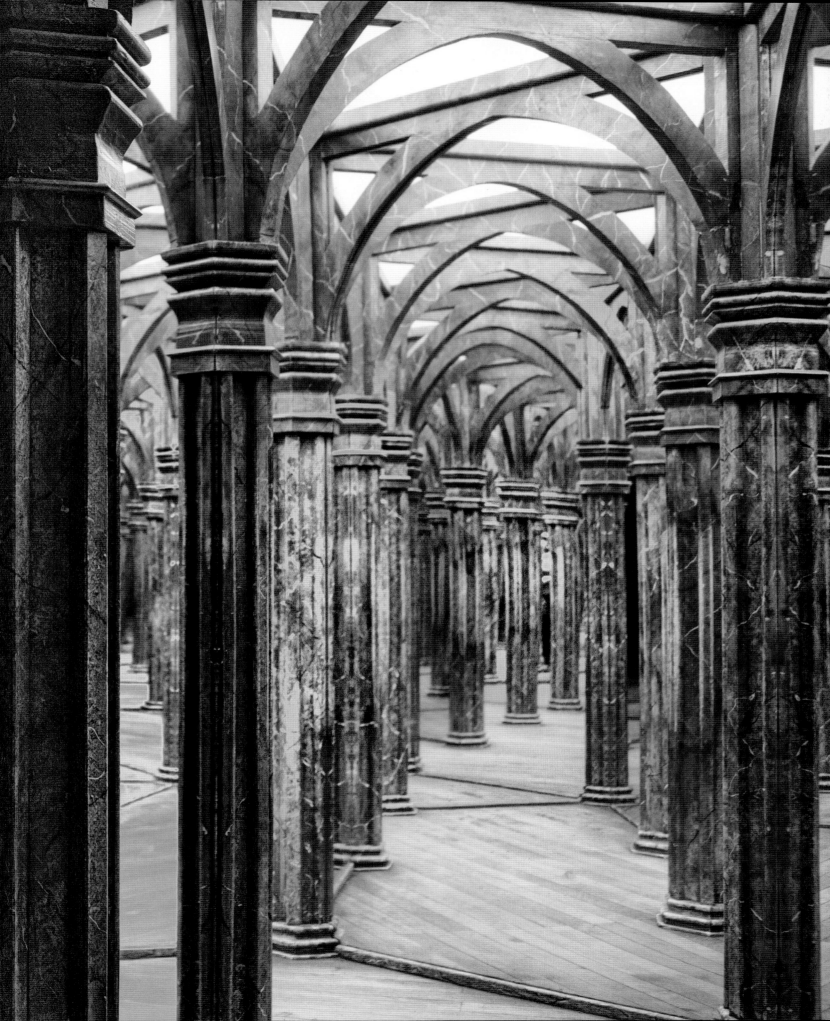

4: EXTENDING TONAL RANGE

FROM COLOR TO BLACK AND WHITE

For the most part, the quality of black and white imagery is enhanced by extending the tonal range as much as possible, so that whites are the whitest whites, and blacks are the darkest blacks. There are a number of different points during the black and white workflow where the tonal range—sometimes also called dynamic range—can be enhanced (turn to the chart on pages 30–31 for more about this). But with a digital image, the easiest place to extend the tonal range is at the beginning: in the photography, or when the image is in color, before it has been converted to black and white.

This chapter guides you through the best photographic and post-production techniques that you can use to extend tonal range, starting with multi-RAW processing, and roughly organized from start to finish assuming you are using the best-practices workflow illustrated in the chart on pages 30–31.

To start with, you'll learn how to process a RAW image more than once—"multi-RAW" processing—using Adobe Camera RAW (ACR) or Lightroom. Once you have multi-RAW processed your image and are working in Photoshop, your next

▲ PAGES 134–135 AND ABOVE: Prague, the largest city in the Czech Republic, is a fun and friendly metropolis that is wonderful to visit, but on a recent trip there was something that made me feel I was being watched—and not necessarily in a kind way. This is a city with a long magical tradition, the city in which the golem came alive, the site of the martyrdom of Jan Huss, of an unholy reign of Nazi terror, and of the silence and collaboration of officialdom in the Soviet era.

On a foggy day, I wandered in Petřín Park in the so-called Little Quarter above the city, following signs to "the labyrinth." The labyrinth turned out to be a fun house maze and hall of mirrors, adjacent to a diorama of the history of the defense of Prague against the Swedish in 1648. I waited until the labyrinth seemed to be empty, carefully held my camera so it didn't capture my own reflection in the mirrors, and made this photo. But where was my reflection, and what was the odd breathing I could hear from behind the mirrors?

32mm; 1/40 of a second at f/4.5 and ISO 2,000, hand held; multi-RAW processed and converted to black and white in Photoshop, and finished using Topaz Simplify.

▶ On any given weekend, the streets of Prague are likely to be filled with partygoers who are looking to get intoxicated with the utmost efficiency. And how better than the infamous drink that may have led Vincent van Gogh to severe his own ear? Likely designer-brewed absinthe no longer has the toxic properties of the historical beverage, but where would the fun be if a drink didn't involve some wormwood and the element of risk?

iPhone capture, processed using HDR in the camera app, and converted to black and white in Lo-Mob.

step will be to combine the different tonal versions you have created using layers and masks. After the layers are combined to your satisfaction, you can then use various Photoshop tools to enhance the tonal quality of your image.

Another approach to extending tonal range that is explored in this chapter is to create a bracketed sequence of photos, and then combine the RAW sequence either using hand-layering (also sometimes called "hand-HDR"), or with HDR software. A variant of using HDR software is to go directly to monochrome (skipping the color portion of the workflow) by choosing a monochrome HDR preset within the automated HDR software. You can see this workflow shortcut in the modified chart below indicated by the pink arrow. When it works, it works well—but of course it is not for all images.

Finally, the chapter concludes by showing you that mix-and-match may be the best conversion tactic of all for extending range—there's no reason why all these techniques can't be used on individual layers within a Photoshop layer stack.

▶ From a distance the facade of the Schwarzenberský Palác appears to be clad in three-dimensional, pyramid-shaped stonework. Looking more closely, the three-dimensional effect is actually an illusion, akin to trompe l'oeil. The illusion is created using patterns called *sgraffito* that have been incised on the flat walls of the palace.

The Schwarzenberský Palác was originally built for the influential Lobkowicz family by the Italian architecht Agostino Galli in the 16th century. The palace is in the Italianate style rather than Bohemian. Passing through several families, eventually the Schwarzenbergs, a leading Habsburg family, bought the palace in 1719. Today, the palace houses the Czech National Gallery collection of Baroque art.

180mm, 1/400 of a second at f/9 and ISO 200, hand held; processed twice in ACR with the two versions combined in Photoshop using a gradient; converted to black and white using Photoshop and Nik Silver Efex Pro.

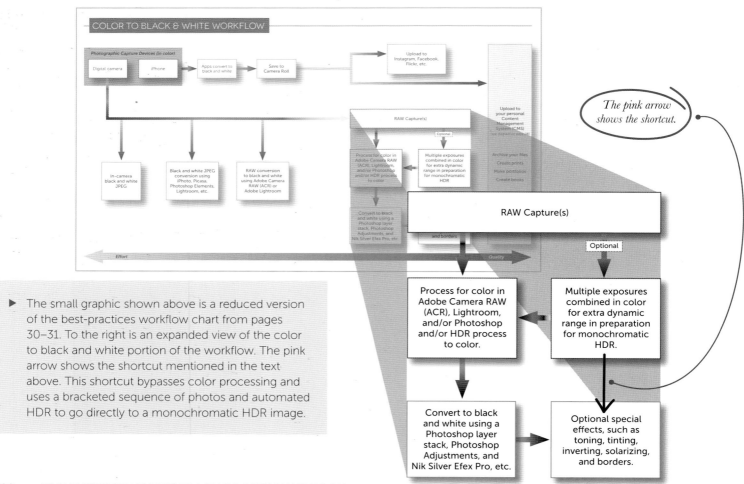

▶ The small graphic shown above is a reduced version of the best-practices workflow chart from pages 30–31. To the right is an expanded view of the color to black and white portion of the workflow. The pink arrow shows the shortcut mentioned in the text above. This shortcut bypasses color processing and uses a bracketed sequence of photos and automated HDR to go directly to a monochromatic HDR image.

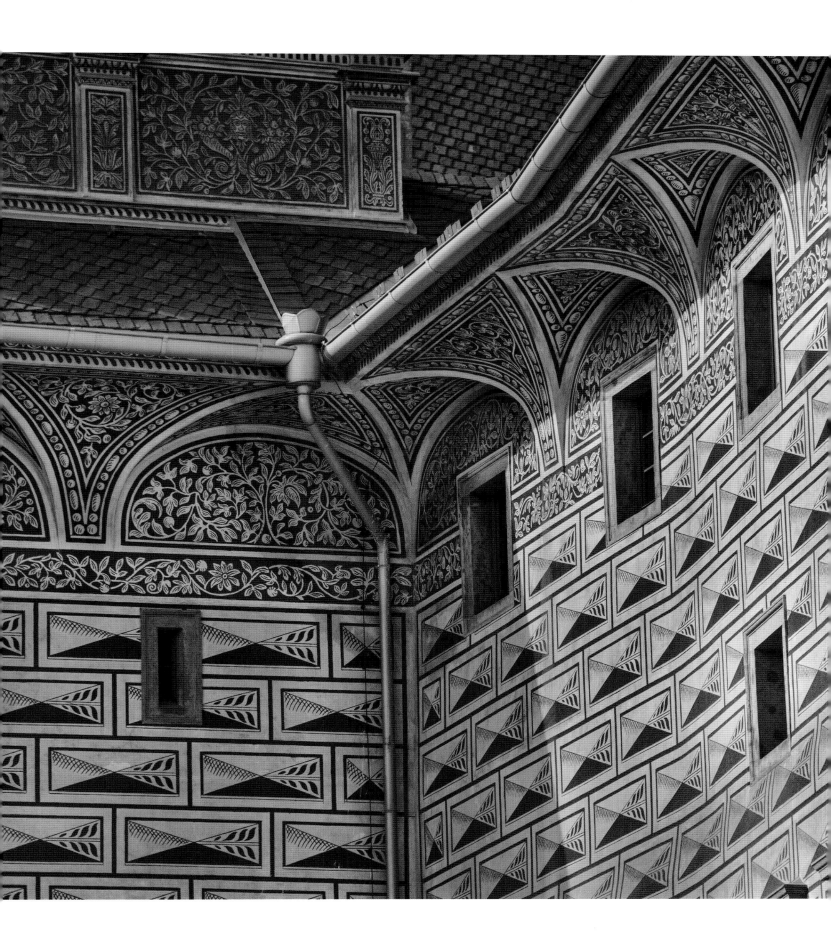

MULTI-RAW PROCESSING VIA LIGHTROOM

Adobe Lightroom is the favorite program many photographers use to organize and process their work. While "under the covers" the RAW file processing engine used by Lightroom is the same as that used by ACR, the user interface is quite different.

To multi-RAW process an image in Lightroom, first start by developing one version in Lightroom. Next, make a virtual copy of the first version by selecting Photo ▶ Create Virtual Copy. Adjust the virtual copy as appropriate. Finally, export the original and the virtual copy to Photoshop by choosing Photo ▶ Edit In ▶ Open As Layers In Photoshop. Note that you can export single images to Photoshop (and combine them to create a layer stack in Photoshop), or you can multi-select the images and export them as an aligned layer stack in one fell swoop.

As you may know, Lightroom itself has some pretty good tools for applying selective adjustments to an image without bothering with layering up in Photoshop—using the Adjustment Brush and the Graduated Filter tools. Once again, under the covers these Lightroom tools are trading on the power of the information hidden in a single RAW file. If Lightroom's RAW adjustment tools will give you the tonal range you need, that is great—but managing layers and layer masks remains the most powerful and flexible way to extend the tonal range in an image once you master the process of working with layers in Photoshop (see pages 149–151).

▶ The arcade of pedestrian bridges across Nekazanka Street in downtown Prague today decorate a bustling and attractive area of art galleries and department stores. These bridges and buildings were designed by Osvald Polívka, an Austrian-born Czech architect, with styles that include 1890s new-Renaissance and later Art Nouveau elements.

28mm, 1/200 of a second at f/13 and ISO 400, hand held; processed twice in Adobe Lightroom with the two versions combined in Photoshop; converted to black and white using Photoshop and Nik Silver Efex Pro.

▶ FIGURE 4-1: To change the "exposure" of a RAW file processed in Lightroom, first make a virtual copy of the processed file, and then adjust the exposure of the virtual copy using the slider at the right side of the Lightroom window. You can also make other tonal adjustments including Highlights, Shadows, Whites, and Blacks.

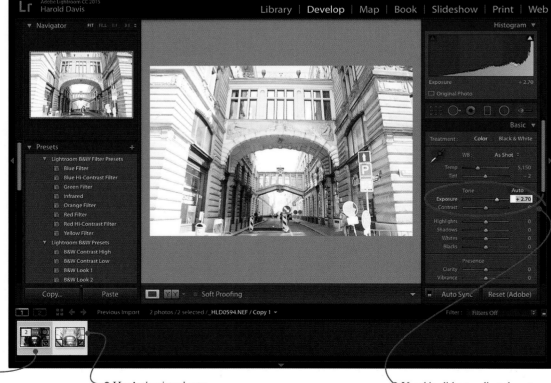

This is the original RAW file.

Here's the virtual copy.

Use this slider to adjust the exposure.

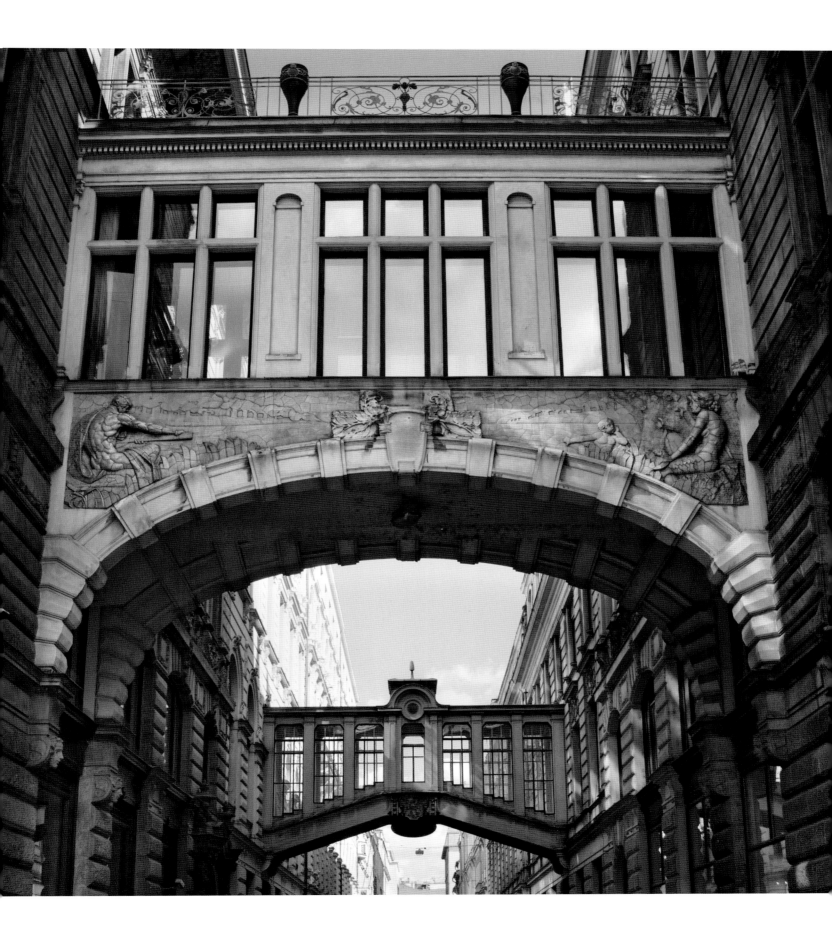

MULTI-RAW PROCESSING WITH ADOBE CAMERA RAW (ACR)

The idea behind multi-RAW processing is deceptively simple: Since there are many potential exposures baked into a single RAW file, why not take several of these exposures—for example, one lighter and one darker—and use them to extend the dynamic range from light to dark in the resulting image?

The devil, as they say, is in the details, and multi-RAW processing can be harder to pull off with a seamless look than one might think. But this technique can work very well when using a tripod is impossible or undesirable. Ultimately, the possibility of multi-RAW processing is a

large part of the appeal of working in RAW rather than in JPEG.

The general multi-RAW steps are to process a single image file several times using a different exposure setting each time. You can do this using tools such as Adobe Camera RAW (ACR) or Lightroom. The next step is to align the differently processed image files as layers in Photoshop and combine the layers using Photoshop tools such as layer masks, the Brush Tool, and the Gradient Tool.

It's easy to begin the ACR multi-RAW process from Adobe Bridge (an organizing program that ships with Photoshop). Simply double-click the thumbnail of the RAW file to process it in ACR the first time. Use the sliders in ACR to set the exposure of the process. Click OK to open the first processed version in Photoshop.

Next, go back to Bridge, and double-click the thumbnail again. This time, use the sliders to engage new settings for the second processed version, and click OK to open this second version of the image in Photoshop. You can go back to Bridge and repeat these steps as many times as you'd like. From here, you'll put these images together as layers using layer masks in Photoshop (see page 150).

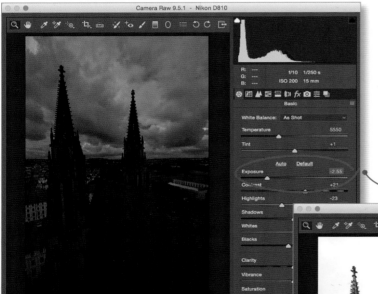

This first RAW processing uses an Exposure Value of −2.55.

The second RAW processing uses an EV of +1.45.

▲ FIGURE 4-2: This RAW image of Saint Vitus Cathedral in Prague will be processed twice using ACR. Here the image is being processed to expose for the clouds and sky at −2.55 EV.

▶ FIGURE 4-3: Here the Saint Vitus Cathedral RAW file being processed a second time—this time exposed for the patterned roof at +1.45 EV.

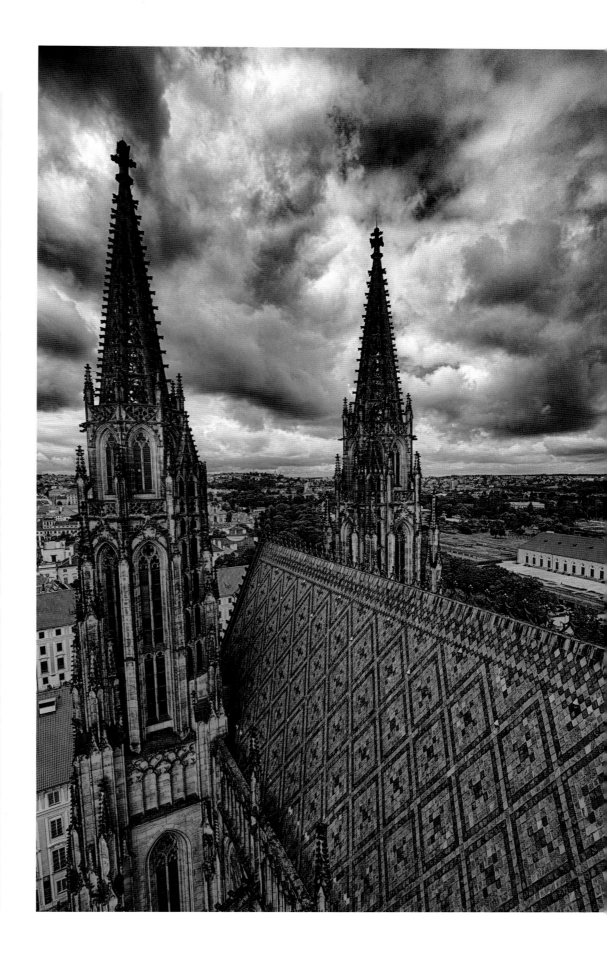

▶ Work on Saint Vitus Cathedral, in the heart of Prague Castle, began in 1344, but wasn't fully completed until the 20th century. This famous cathedral houses the Czech crown jewels as well as the tomb of "Good King" Wenceslas.

Faced with the climb up the 287 stairs of the southern Bell Tower adjacent to Saint Vitus Cathedral, I decided to leave my tripod behind. But this left me in a bit of a quandary when I saw the beautiful patterned roof of Saint Vitus against a cloudy, bright afternoon sky.

Looking down at the scene over a low stone wall, I decided to use an extreme wide-angle lens (15mm) to enhance the natural drama and perspective of the scene.

Fortunately, since I was shooting RAW files and using multi-RAW processing, I could create a single, average exposure, and then adjust for the bright sky and darker foreground later in post-processing.

15mm, 1/250 of a second at f/10 and ISO 200, hand held; processed twice in ACR with the two versions combined in Photoshop using a gradient; converted to black and white using Photoshop and Nik Silver Efex Pro.

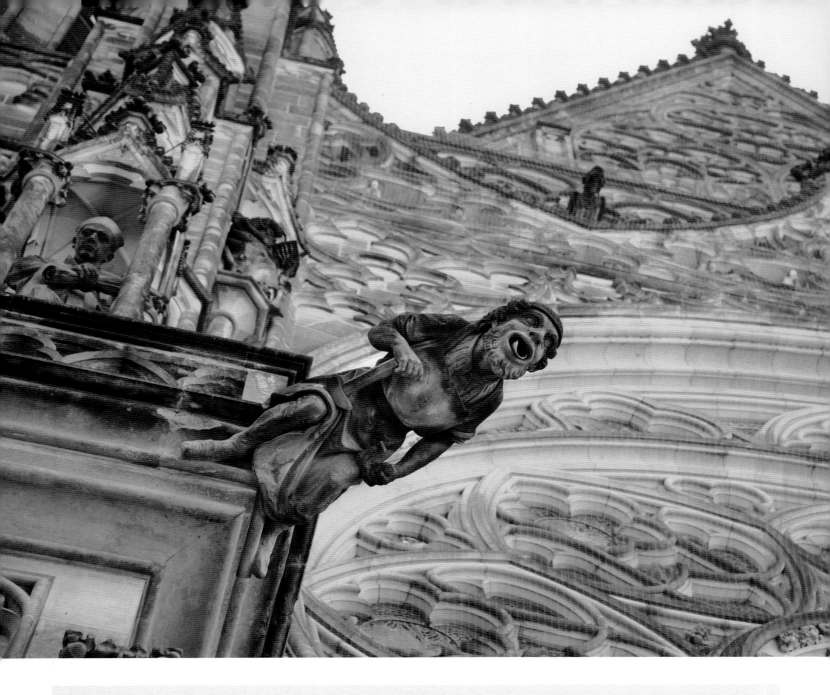

▲ Gargoyles on many cathedrals are carved stone statues that represent grotesque lions, monkeys, dragons, and people, put there to protect the cathedral from evil spirits. Many of the gargoyles also show the spirit's moment of damnation as a warning to the faithful. If you were inside the church, you were safe; if you were outside, you were right where the evil one could get you. Gargoyles also have a practical function as downspouts to keep the rain off the sides of the cathedral. In this case, the lead spout is shaped like the gargoyle's tongue.

As I looked at this gargoyle on Saint Vitus Cathedral and pre-visualized this image, I saw that time had aged and darkened the gargoyle, creating an exposure problem: If

I exposed for the gargoyle, the cathedral walls would get blown out; but if I exposed for the cathedral, the gargoyle would be too dark. The solution was to use multi-RAW processing in ACR at my computer—I processed two versions of the color image, a lighter version exposed for the gargoyle and a darker version exposed for the cathedral. Then I combined them in Photoshop using layers, a layer mask, and the Brush Tool. After that, I converted the image to monochrome.

116mm, 1/100 of a second at f/5.6 and ISO 200, hand held; processed twice in Adobe Camera RAW with the two versions combined in Photoshop; converted to black and white using Photoshop.

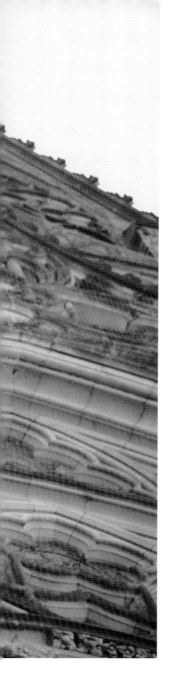

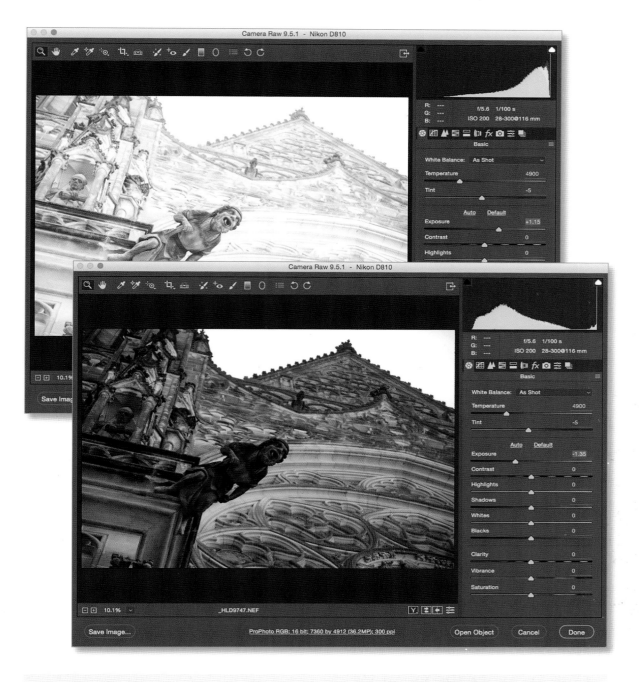

▲ FIGURE 4-4 (TOP): The first version of the gargoyle image was processed in ACR to expose for the gargoyle itself. So I moved the Exposure slider to the right until I felt that the gargoyle details were really visible (+1.15 EV). Notice that since this version of the image was brighter, the histogram shown in the ACR window moved to the right as well. With multi-RAW processing there's no need to worry about the other parts of the image being blown out in this version. The areas that are too light won't be visible in the final version of the color image.

▲ FIGURE 4-5 (BOTTOM): Here the gargoyle image has been processed in ACR for the background (−1.35 EV). Since I moved the Exposure slider to the left into negative territory, the histogram shown in the ACR window has also moved to the left.

While this example shows the same image processed twice, you can process an image any number of times, creating custom versions that are exposed for important areas of your photo. From there, you can combine the different versions using layers and layer masks in Photoshop (see page 151).

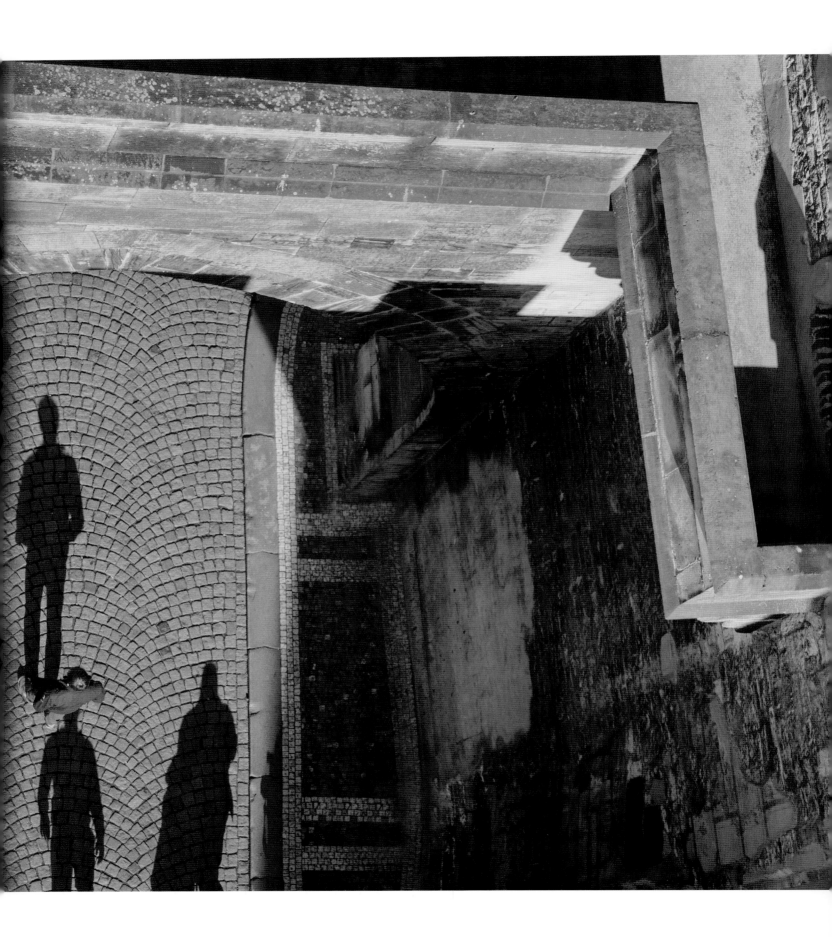

MULTIPLE LAYERS AND MASKING IN PHOTOSHOP

The rubber meets the road with multi-RAW processing when the different exposures—each created from the same RAW image file—are combined in Photoshop. From a technical perspective, the individual files that are opened in Photoshop are called "documents." Each document becomes a layer, so instead of two single-layered documents, when you multi-RAW process an image twice, you have one document with two layers. So the first step in Photoshop is to combine your separate documents into a

▲ PAGE 146: The Vltava River, also known as the Moldau, is sometimes called the national river of the Czech Republic. The names derive the old Germanic words for "wild water." The river has been dammed many times, and you might think that its wildness has been tamed, but winter ice storms and spring flooding remain an enduring concern. The massive logs shown in this photo are intended to protect the Charles Bridge from whatever nature decides to throw at it.

48mm, 1/60 of a second at f/13 and ISO 320, tripod mounted.

PAGE 147: Wheels within wheels, the reality of Prague's bicycle-riding present meets the past in this bike rack shown against the background of patterned stone work, typical in older Bohemian architecture.

45mm, 1/80 of a second at f/20 and ISO 400, hand held

Both: Multi-RAW processed in ACR and Photoshop; converted to black and white in Photoshop and Nik Silver Efex Pro.

◀ One of the cool things about visiting Prague is all the towers one gets to climb. One of the first towers I climbed was the Old Town Bridge Tower on the Old Town side of the famous Charles Bridge over the Vltava River. From the top of the tower, there is of course a stunning view of river and city, but what interested me most was the view straight down at the pedestrians and their shadows. The point of this image for me is the way it upends normal visual anticipation of perspective and visual orientation.

68mm, 1/125 of a second at f/13 and ISO 400, tripod mounted; multi-RAW processed in ACR and Photoshop; converted to black and white in Photoshop and Nik Silver Efex Pro.

single multi-layered document (unless you already exported from Lightroom as a layer stack). Precise alignment of the layers is essential, or the resulting image won't look sharp.

There are two ways to align layers together in Photoshop. The first is to choose the Move Tool from the Tool panel. With the Move Tool selected, hold down the Shift key. Click within the source image (the one going on top in the layer stack). Drag the source image over the target image (the one going on bottom). Let go of the Shift key, then let go of the mouse. The two images will be perfectly aligned as layers (see page 150).

Sometimes managing the Move Tool and the Shift key together may be a little cumbersome, so you may be pleased to learn that you can align two documents as layers using familiar menu items: With the source document active, choose Select ► All, followed by Edit ► Copy. Next, click on the target document to make it active, and choose Edit ► Paste. That's it! Now the two documents are aligned as layers, with the target the bottom layer.

In a layer stack with blending set to normal at 100% opacity, all that is visible in the final image is the top layer. But in order to take advantage of multi-RAW processing, the layer beneath must be selectively exposed. To accomplish this, a layer mask is added to the top layer, by selecting Layer ► Layer Mask from the Photoshop menu.

A Hide All layer mask is black, and hides the layer it is associated with. A Reveal All layer mask is white, and reveals the layer. The mnemonic to make this easier to remember is, "Black conceals, and White Reveals"—at least when it comes to the layer that the layer mask is working with. Layer masks are the ultimate in flexibility, and there are a number of different ways to work with them that ultimately lead to the same end results. But perhaps the easiest way to go about things is to hide—with a black, Hide All layer mask, the topmost layer. Then the parts of the top layer that one wants can be selectively painted in.

The Gradient Tool is what you use to paint in a portion of a layer when you want a smooth, even blend from one part of an image to another—for example, from a dark foreground to a brighter sky. However, if you only want certain, very specific areas to be painted in, such as in the image of the gargoyle, then the Brush Tool will give you control of exactly how much is painted in, and at what opacity.

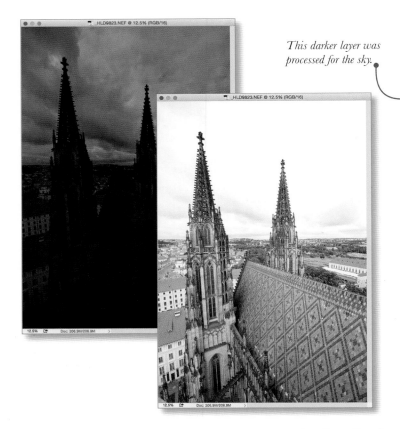

This darker layer was processed for the sky.

This layer is lighter and was processed for the church roof.

▲ FIGURE 4-6: After processing the Saint Vitus Cathedral roof twice in ACR, once in a darker version for the clouds and sky, and a second time for the church roof, in Photoshop I copied and pasted the sky image into the document containing the roof image. This gave me two layers, one on top of the other, as shown in the Layers panel above.

▶ FIGURE 4-7: The next step for this multi-RAW processed image was to add a layer mask to the Clouds & Sky layer in Photoshop, and then use the Gradient Tool to draw a black to white gradient on the layer mask. This had the virtue that the white area covered by the layer mask revealed the upper portion of the Clouds & Sky layer (letting the sky show), and the black area covered by the layer mask hid the lower portion of the Clouds & Sky layer (letting the roof from the Church Roof layer show). The gray area of the layer mask made for a smooth transition between the two layers. You can see the finished image on page 143.

Here's the Photoshop Gradient Tool.

Layer mask with black to white gradient

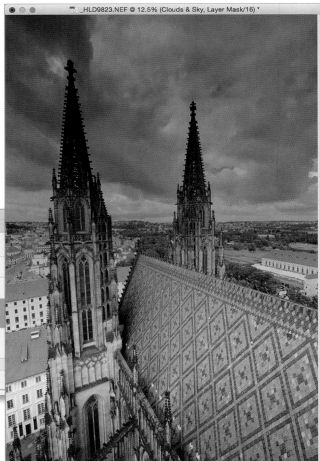

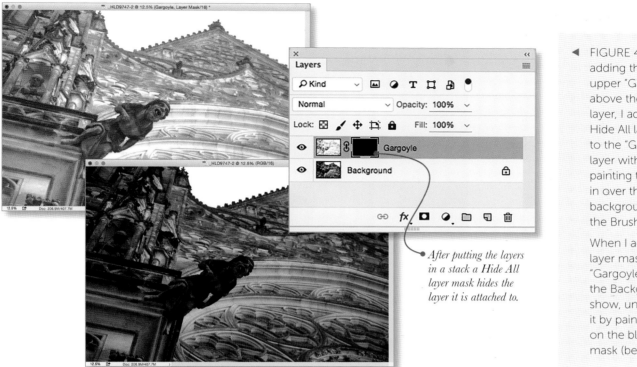

After putting the layers in a stack a Hide All layer mask hides the layer it is attached to.

◀ FIGURE 4-8: After adding the lighter upper "Gargoyle" layer above the Background layer, I added a black Hide All layer mask to the "Gargoyle" layer with the plan of painting the "Gargoyle" in over the darker background using the Brush Tool.

When I added the layer mask, it hid the "Gargoyle" layer, letting the Background layer show, until I revealed it by painting in white on the black layer mask (below).

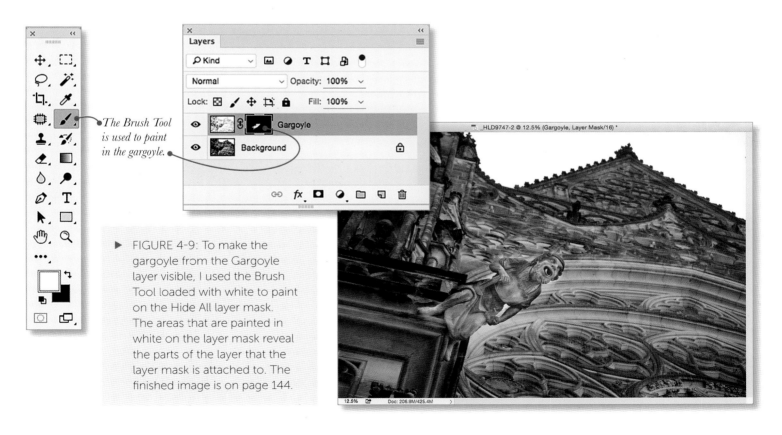

The Brush Tool is used to paint in the gargoyle.

▶ FIGURE 4-9: To make the gargoyle from the Gargoyle layer visible, I used the Brush Tool loaded with white to paint on the Hide All layer mask. The areas that are painted in white on the layer mask reveal the parts of the layer that the layer mask is attached to. The finished image is on page 144.

With Prague's grand castles and elegant squares overflowing with happy visitors and marquee shopping, it is easy to forget that this is also the city of Franz Kafka. Metamorphosis happens in Prague, whether it is a human turning into a bug, or the curved shapes of a nearly empty street altered in the reflection in a traffic mirror. The outer world is unaltered, but inside the metamorphosis the lone pedestrian wanders down a twisted street toward an uncertain end.

Wandering around in the old streets near Prague Castle early in the evening, I spotted this traffic mirror across the street and realized that it could be aligned to be compositionally interesting in juxtaposition to the buildings in the background.

Looking through my viewfinder, the image didn't quite jell and I realized that it needed an additional element, such as a pedestrian. I waited, crouching, on the opposite side of the street. The first few people to go by did not fit the composition because I was looking for someone to be walking away from the camera toward the arch that can be seen in the distance, refracted in the mirror. My knees were definitely feeling creeky as I crouched when this woman wrapped in a winter coat came along and I took the picture.

To bring out the mirror, which is central to this composition, I processed a second, lighter version of the image just for the mirror.

90mm, 1/160 of a second at f/10 and ISO 400, hand held; multi-RAW processed in ACR and Photoshop; converted to black and white in Photoshop.

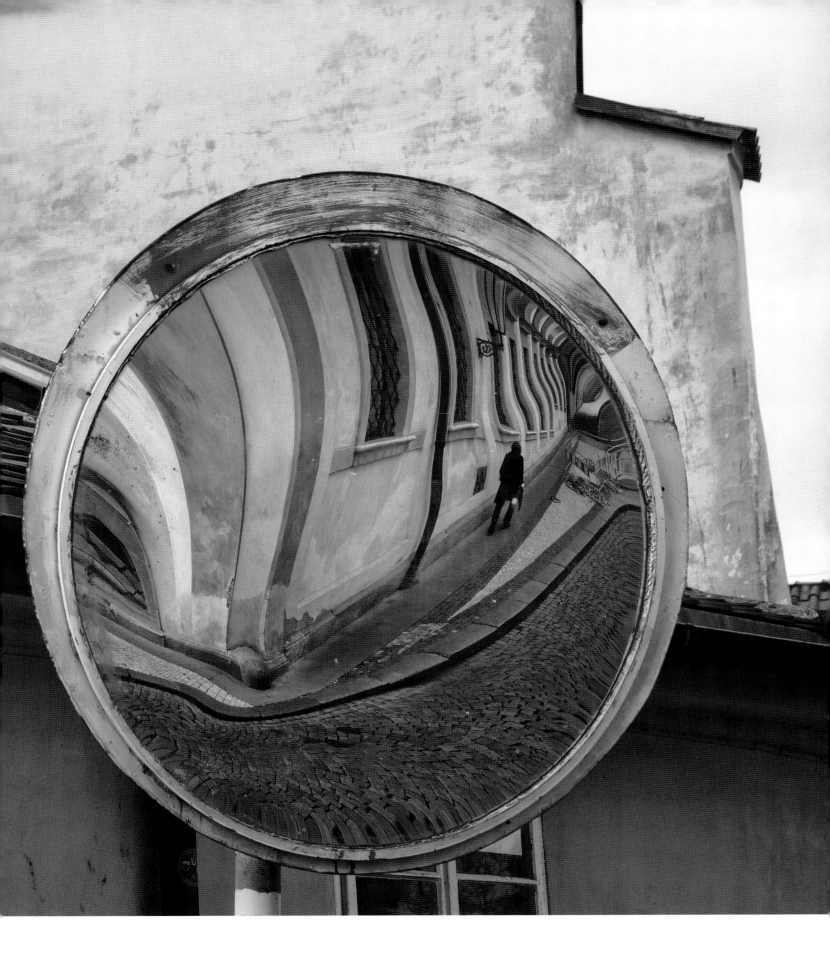

EXTENDING CONTRAST AND RANGE IN PHOTOSHOP

There are many possible ways to extend contrast and dynamic range in Photoshop. A key insight is that these are usually best applied before the black and white conversion stage of the workflow. So you are essentially adjusting a color image to have the greatest range from light to dark, and also (depending on the image) increasing contrast, either selectively or overall.

One of the easiest ways to extend the range is to use a Brightness/Contrast Adjustment layer. To do this, make sure the Adjustments panel is open. Choose Brightness/Contrast from the panel (Figure 4-10, below). Next, in the Properties window, use the sliders to increase or decrease contrast. For example, you might want to increase the brightness of the light parts of an image.

You can use the layer mask that comes along with your Adjustment layer to selectively apply the adjustment; for example, by applying a gradient.

Note that it is possible to have multiple Adjustment layers on a single image, so Brightness/Contrast adjustments together with the appropriate masks can be used to make bright areas brighter, and dark areas darker.

▶ Reinhard Heydrich was the second-in-command of the Nazi SS, and respected by Hitler as one of the most efficient and effective members of the Nazi regime. Heydrich was charged with enhancing the Czech industrial contribution to the Nazi war machine, and did his best in a terrible reign of terror, earning him the moniker "The Blond Beast." Heydrich was eventually assassinated by two members of the Czech underground, who had been parachuted into Czechoslovakia in a suicide mission by the Czech government-in-exile in Great Britain. The patriotic assassins met their end in an incredible barrage of firepower in a church crypt.

Although somewhat faded, like this rose in a plastic bottle, flowers still mark the memorial to the victims of Heydrich on the busy Prague street where the church crypt is located.

To capture the nostalgia and sadness of the place and what it memorializes, as well as the faded nature of the flower and bottle, I photographed the image wide open for shallow depth-of-field, and converted the image to black and white, processing back in a little splash of color in the dried-up rose.

135mm, 1/200 of a second at f/4 and ISO 400, hand held; multi-RAW processed in ACR and Photoshop; converted to black and white in Photoshop, with selective color added back in using a Photoshop layer.

Click here to add a Brightness/Contrast Adjustment layer to your layer stack.

▶ FIGURE 4-10: After adding a Brightness/Contrast Adjustment layer and using the adjustment sliders in the Properties panel, drag a black-to-white gradient on the Adjustment layer's layer mask. This will blend the Adjustment layer in with the Background layer below.

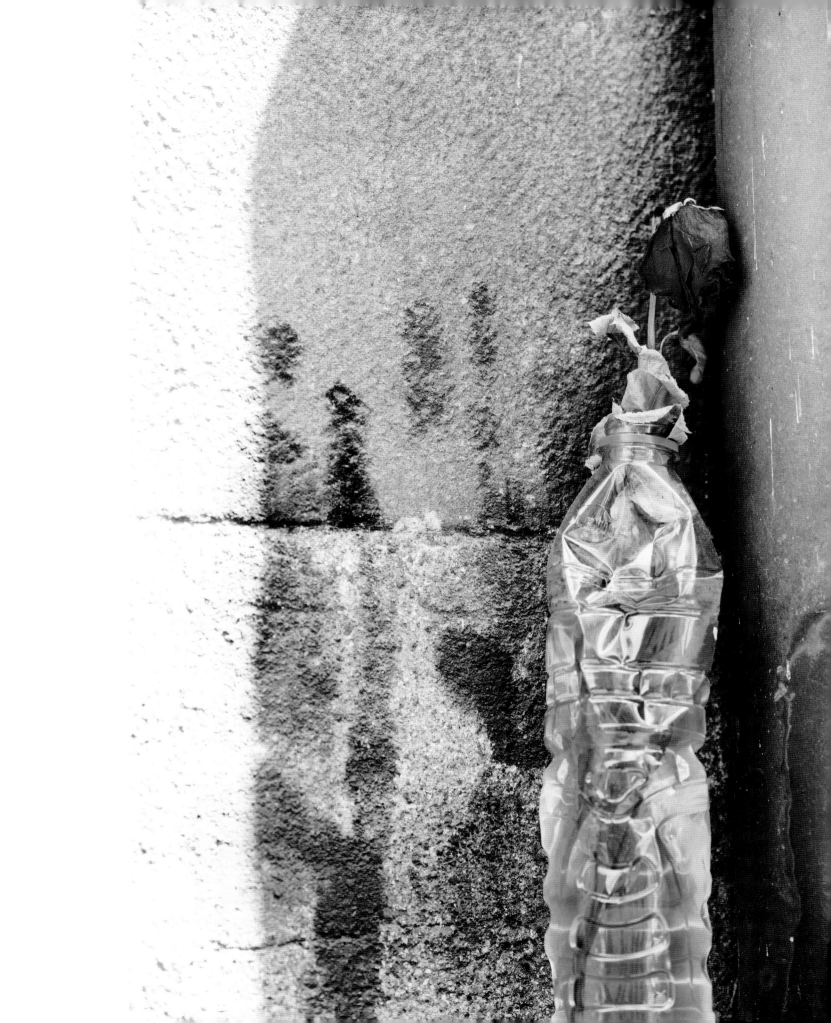

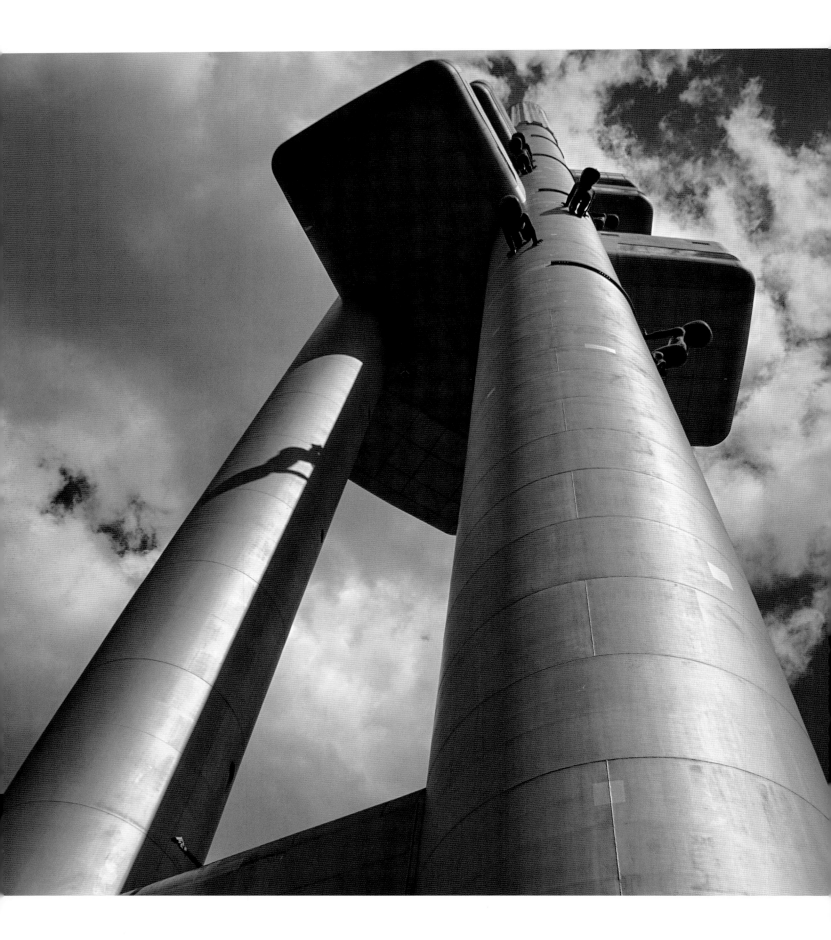

BLENDING MODES

Keeping in mind that even, or particularly, when the ultimate goal is black and white, the most effective extension of dynamic range occurs when the image is still in the color portion of the workflow, it is worth taking a careful look at the power of blending modes.

From a technical perspective, a blending mode defines the formula that is used to combine a pixel on one layer with a pixel in the same position on the layer below it. In the Normal blending mode at 100% opacity, the formula is that the upper pixel is 100% shown. I think of this as like looking down on a stack of pancakes from the top.

You don't need to understand the formulas behind blending modes to use them; you do need to have a sense for what the blending modes do. To use a blending mode, the Background layer has to be blended with *something*—often it is blended with itself.

For example, in the photo of the Žižkov Television Tower, clearly the sky was too bright, and the underneath of the tower where the sculptures of the babies can be seen was too dark.

◀ The Žižkov Television Tower is the tallest building in Prague, and dominates the cityscape because it can be seen almost no matter where you are. An example of communist-era architecture, today the tower is mocked by those living in Prague, with nicknames like "Baikonur" after the Soviet space launch facility in Kazakhstan, "Pershing" after the U.S. ICBM, some more political, like "Jakešův prst" (Jakeš's finger, after a particular Secretary General of the Czechoslovak Communist Party), and more. When it was built in the 1980s, vocal criticism was impossible, but sub rosa the tower was lambasted for its "megalomania," its "jarring" effect on the Prague skyline, and for destroying part of a centuries-old Jewish cemetery situated near the tower's foundations.

The somewhat surrealistic sculptures of babies crawling up and down the tower are by David Černý, and were added as a permanent art installation in 2001.

28mm, 1/1000 of a second at f/8 and ISO 400, hand held; multi-RAW processed in ACR and Photoshop; converted to black and white in Photoshop and Nik Silver Efex Pro.

To fix the brightness in the clouds, I duplicated the layer with itself, and applied the Multiply blending mode (which darkens) to the duplicate layer. Next, I added a Hide All layer mask. Using the Brush Tool loaded with white, I made sure the layer mask was selected and then painted in the areas of the clouds I wanted to darken.

To make the shadowed areas of the tower less heavily dark, I duplicated the background again, and put the duplicate layer into Screen Blending mode (which lightens). Next, I added a Hide All layer mask to the screened layer, and once again used the Brush Tool to lighten the shadow areas under the tower platform.

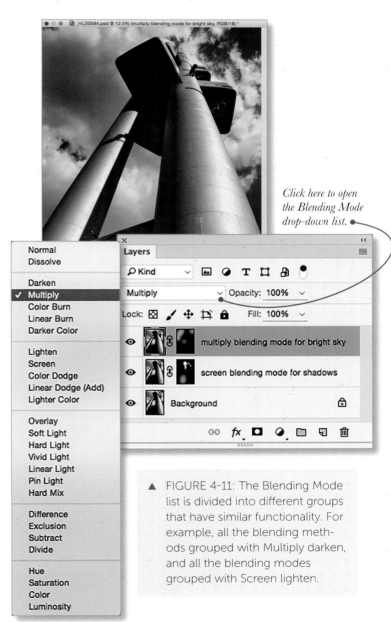

Click here to open the Blending Mode drop-down list.

▲ FIGURE 4-11: The Blending Mode list is divided into different groups that have similar functionality. For example, all the blending methods grouped with Multiply darken, and all the blending modes grouped with Screen lighten.

LAB COLOR FOR CONTRAST ENHANCEMENT

As you may know, you can choose from a number of color spaces within Photoshop. These color spaces use channels to model the gamut of colors in a given image. Choosing the LAB color space allows you to work only on the black and white information in a color image, which can have a striking impact on the apparent contrast within an image before it is converted to black and white. For more information about LAB color, see page 210.

Note that this LAB technique is best used for enhancing contrast levels, not actually extending the dynamic range of an image, and is applied while the image is still apparently color, because the enhanced contrast in the color image can be used to create vivid black and white conversions.

First, convert your image to LAB by choosing Edit ► Convert To Profile (Figure 4-12). Next, in the Channels palette make sure the L channel is selected. Finally, choose Image ► Adjustment ► Curves.

With the Curves window open, make sure the Lightness channel is selected in the drop-down box. The next step is to steepen an Input-Output curve, by drawing the ends of the graph in, and by reconfiguring the curve itself to a sideways 'S' shape. When this curve is applied to the image, it will appear as if there is greater visual separation between lights and darks.

Note that it is always a good idea to apply this curve adjustment to a duplicate layer. In other words, duplicate your layer before choosing the adjustment curve. That way, if you want adjustment to apply only to parts of the image, you have the flexibility to do so using a layer mask.

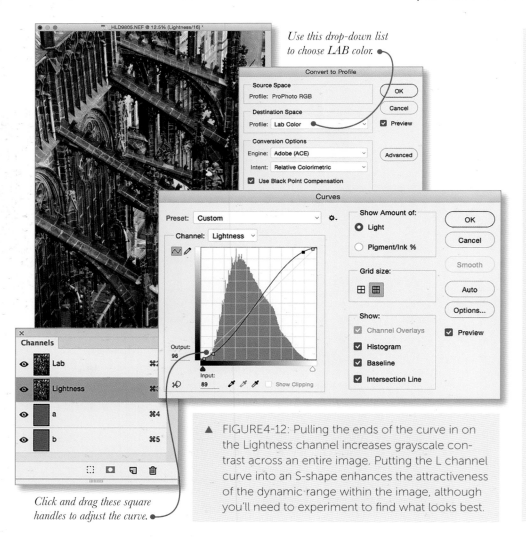

Use this drop-down list to choose LAB color.

Click and drag these square handles to adjust the curve.

▲ FIGURE4-12: Pulling the ends of the curve in on the Lightness channel increases grayscale contrast across an entire image. Putting the L channel curve into an S-shape enhances the attractiveness of the dynamic range within the image, although you'll need to experiment to find what looks best.

▶ The great challenge of the Gothic period of cathedral architecture was to develop vast, soaring interior spaces without apparent support other than the perimeter walls and galleries. To meet this challenge, starting in the 13th century, flying buttresses were used to take the load from the vast interior vaults and bear the weight down to the ground.

This photo shows the system of flying buttresses bearing the weight of the high walls of Saint Vitus Cathedral from above. Somehow, the intricate system of flying buttresses, while designed from an engineering viewpoint, is also attractive. Looking at the image in post-production, I decided that the only way to convey the architectural cohesion amid the intricacy would be by converting the photo to black and white, and also enhancing the contrast in the image's dynamic range.

105mm, 1/50 of a second at f/13 and ISO 200, hand held; multi-RAW processed in ACR and Photoshop; converted to black and white in Photoshop and Nik Silver Efex Pro.

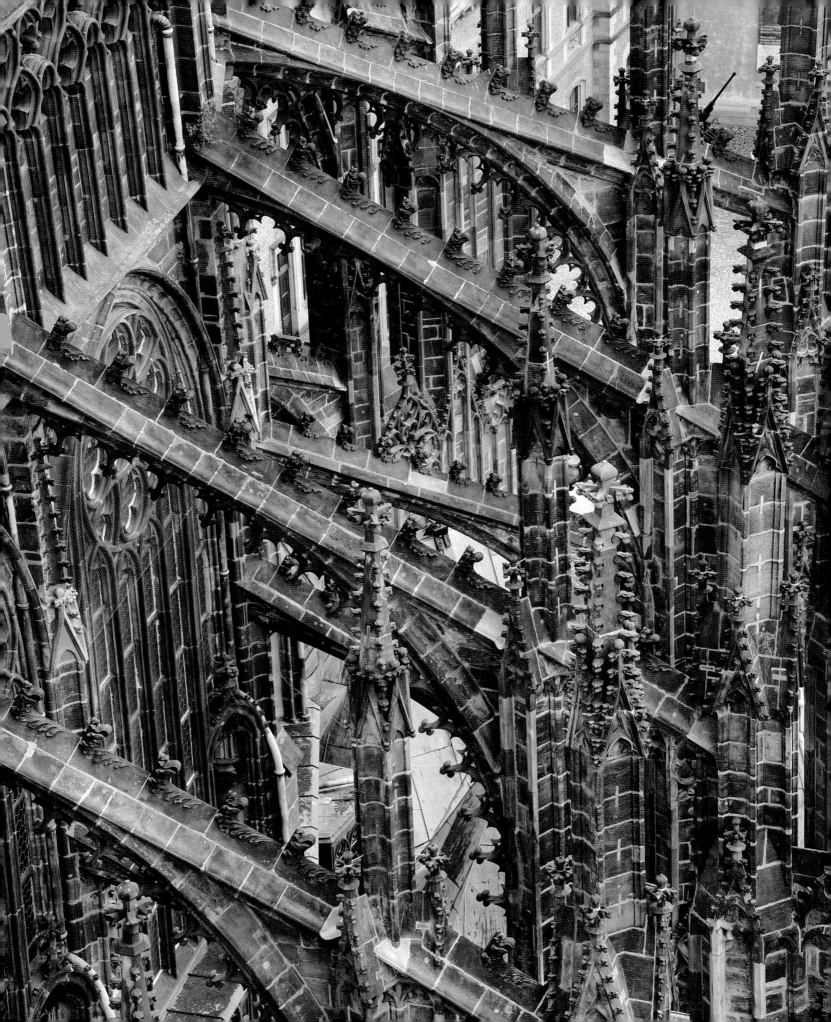

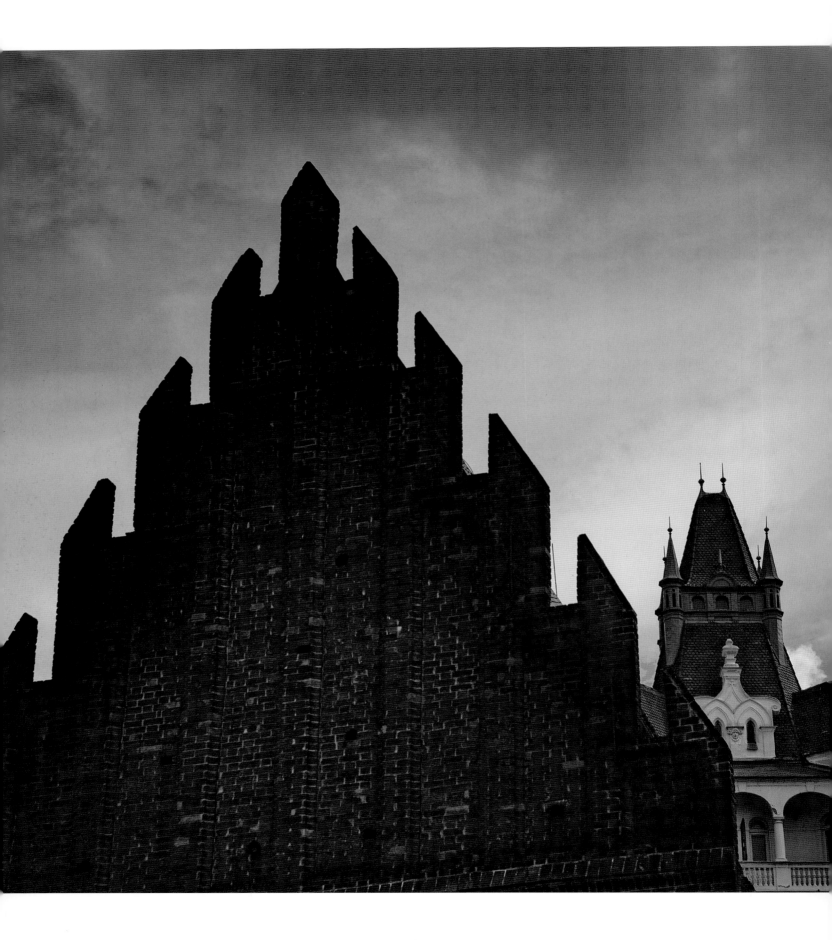

BRACKETED SEQUENCE PHOTOGRAPHY

If one photograph is good, then more than one photo is likely better. This is a facetious comment, but it is true that there is more information form a technical viewpoint in two digital captures than in one. There is a great deal of information in a single RAW exposure, but if you bracket exposures—meaning make multiple exposures that vary their exposure values—you can get even more usable dynamic range information to use in your finished image.

Bracketed photos can be combined by hand using layers and masking, in a process similar to multi-RAW processing sometimes called Hand High-Dynamic Range processing, or Hand-HDR. A sequence of bracketed photos can also be processed by an automated HDR program, such as Nik HDR Efex Pro, or the auto HDR capabilities built into Lightroom and Photoshop. The capabilities of each of these HDR software programs are roughly similar, and which you should use depends upon your workflow and personal taste.

Note that one very good reason for shooting a bracketed sequence has nothing to do with HDR. It may turn out that one of the bracketed exposures you've made is far superior to the rest. Often, this is not the exposure that you think it's going to be, and in the case of this kind of surprise, it is almost invariably not your camera's idea of the best exposure.

It is recommended to shoot bracketed sequences on a tripod, and vary shutter speed for each exposure by one EV for a total of ten exposures. In most situations ten exposures covers the range from light to dark that you are attempting to photograph. It tends to be more effective to bracket shutter speed than aperture, because with aperture you run into the possibility of changing each individual image due to variations in depth-of-field.

Note that some photographers prefer to use their in-camera auto-bracket program, rather than manually adjusting shutter speeds between the exposures in the sequence (see the sidebar below).

◄ One of the most striking things to me about the Prague skyline are the irregular crenellations of the towers and fortifications that are found all over the city. Some of these architectural details belong to famous buildings such as the Powder Tower and Prague Castle. Others are found on anonymous structures like this peaked roof, which probably dates from the Middle Ages.

When I noticed the shape of this roof and decided to make an image, I knew that if I took an exposure that averaged the building into the sky, neither the sky nor the building would look very good—the sky would be blown out and the building would be too dark. So I decided to take advantage of the exposure range inherent in a single RAW file by exposing for the sky, knowing that the building would be radically underexposed.

I "rescued" the overly dark building by processing the RAW file a second time in ACR, making it lighter so some of the detail in the brickwork became apparent. I combined the two layers using a layer mask and the Gradient Tool, so the sky would be interesting and the building was not just a black silhouette.

62mm, 1/1600 of a second at f/8 and ISO 200, hand held; multi-RAW processed in ACR and Photoshop; converted to black and white in Photoshop.

SHOOTING BRACKETED SEQUENCES ON A TRIPOD VS HAND HELD

Shooting bracketed sequences hand held is an interesting variation on normal bracketed HDR sequential photography, and it can work well, if you keep a couple of things in mind. First, since there will be variations between the framing of the images in the sequence, you will not be able to create a typical Photoshop layer stack and expect the layers to be in alignment. You will need to rely on the auto-alignment feature of the HDR software to create the processed version of your image. For example, in Nik HDR Efex Pro, this is accomplished by checking the auto-align box.

To succeed with hand held bracketed sequences, you need to set your camera to burst mode (to minimize the time and movement between frames) and use the built-in auto-bracket program (available on some but not all cameras). Image stabilization if it is available in your camera or lens should be used. Keep in mind that the auto-bracket program may select shutter speeds that are too slow for sharp hand-held photography, in which case you will be unable to use these frames in your final image without introducing blur from camera shake.

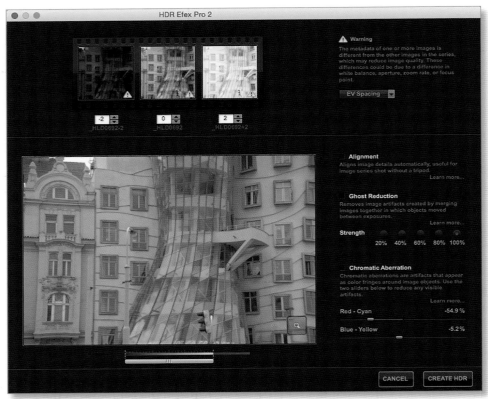

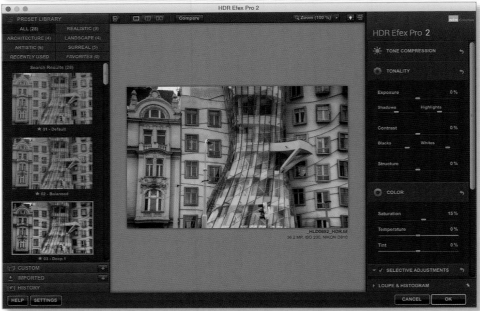

▶ The "Dancing House" and "Fred and Ginger" are the names that locals gave to this building from the 1990s. It was designed by Czech architect Vlado Milunić in partnership with Frank Gehry. Built on the location of a house destroyed in the 1945 bombing of Prague by the U.S., "Fred and Ginger" rests uneasily next to its Baroque, Gothic, and Art Nouveau neighbors. Somewhat symbolic of the Velvet Revolution, the building has never been a great success, either culturally or financially, but it is certainly fun to photograph.

So, why black and white? The building is visually interesting next to its staid neighbors in color as you can see in Figure 4-13 and Figure 4-14. But what happens when it is presented in black and white is that the striking color differentials between the blue windows and stone facades disappear. One is left with textural differences that present a contrast between the reflective surface of the dancing glass and the solidity of the flat, matte stone. It is this visual contrast that creates a subtle composition that repays an in-depth look more than the superficial color rendition, and also best highlights the architectural uniqueness of this under-appreciated Frank Gehry structure.

92mm, three exposures shot at shutter speeds from 1/250 to 1/1000 of a second, each exposure at f/6.3 and ISO 200, tripod mounted; sequence processed in Photoshop and Nik HDR Efex Pro; converted to black and white in Photoshop and Nik Silver Efex Pro.

▲ FIGURE 4-13 (TOP): The opening screen in Nik HDR Efex Pro shows the images that will be combined and their exposures in EVs. You can also choose to enable Alignment, Ghost Reduction, and Chromatic Aberration correction.

FIGURE 4-14 (BOTTOM): The workflow in an auto HDR program is roughly the same no matter which program you choose. Once the images have been pre-processed in the program, you choose a preset that provides the overall look-and-feel, and then tweak aspects of the preset such as Exposure and Saturation.

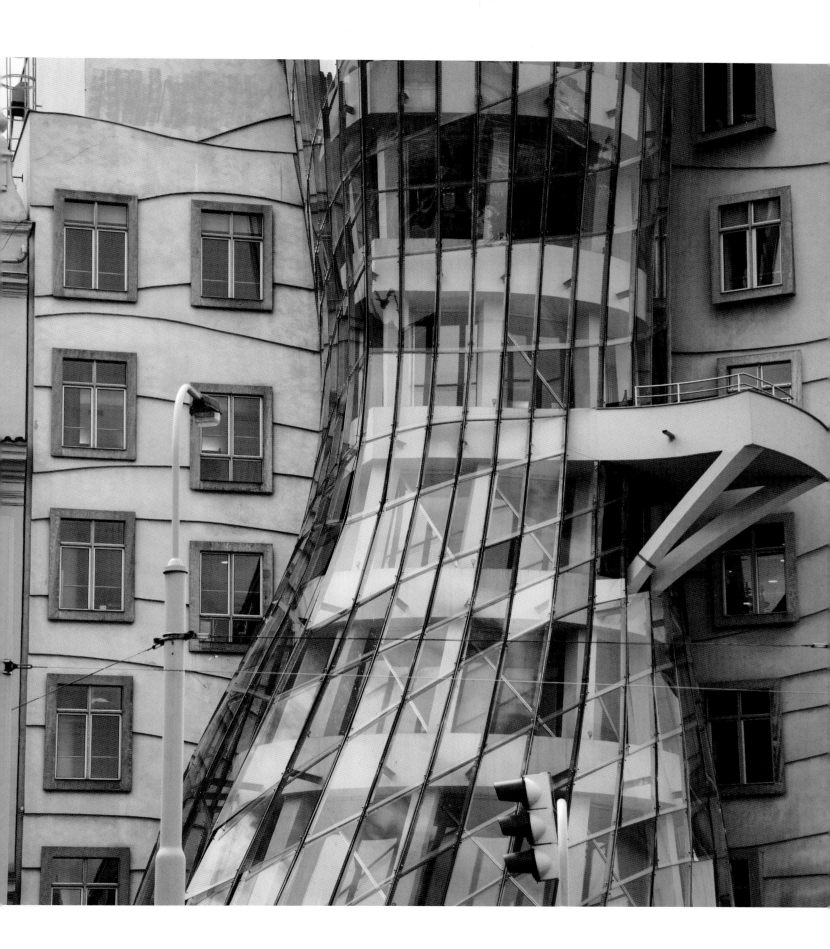

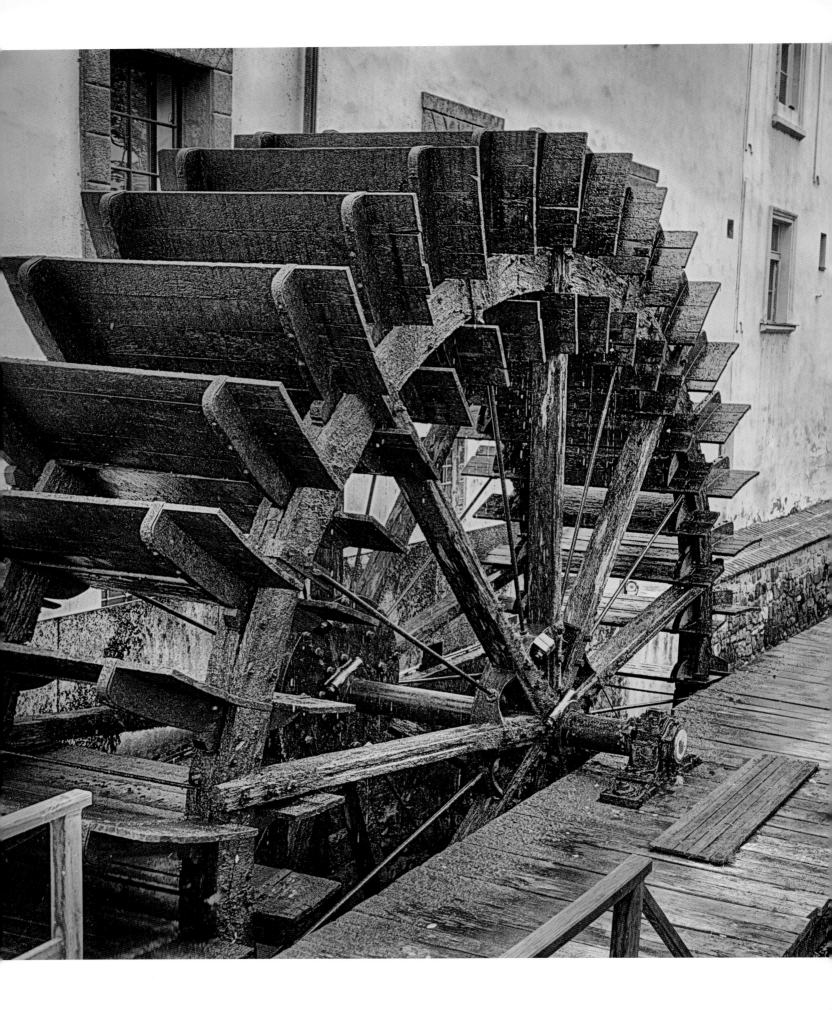

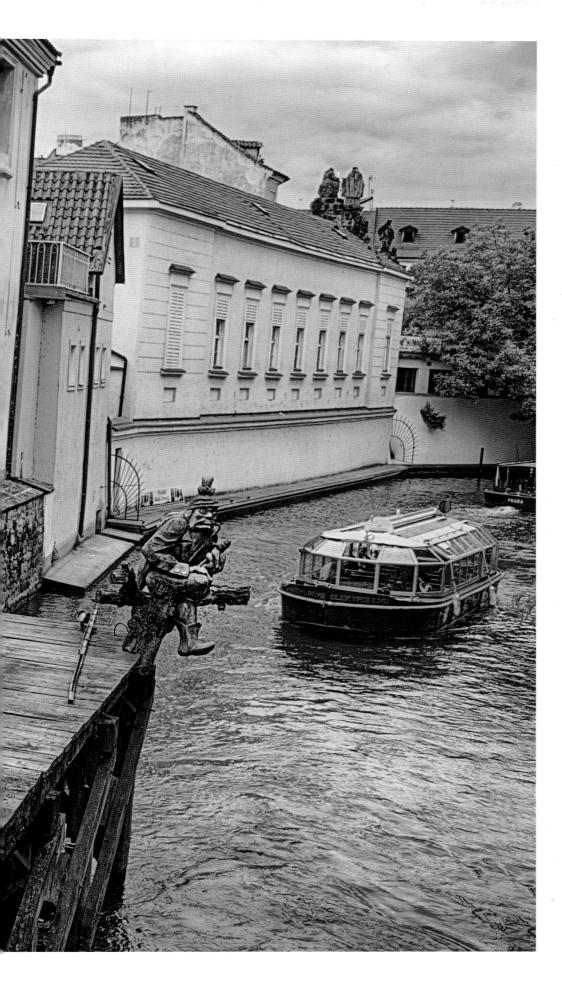

◀ This water wheel at the Velko-prerovsky Mill near the Charles Bridge in central Prague is the sole survivor of the many mills that once lined the Čertovka, or, in English, Devil Channel. The channel takes its water from the Vlatva River. It was built in the 12th century by the Order of the Knights of Malta.

The water wheel is guarded by the devil, or goblin, you can see straddling a log out over the water. It is rumored that the water goblin lives in the river with other creatures of the underworld.

Walking around the corner from the John Lennon Wall, I was surprised to see this fellow guarding the mill race. I knew that I wanted to photograph the scene, but it was going to be difficult because the sides of the small bridge I was standing on were topped with a fence of vertical iron bars. There was really nowhere I could stand to set up my tripod and get a good shot.

Instead, I placed my camera on the low wall and pointed the lens through the bars. Holding the camera as steady as I could, I made nine exposures to capture the entire dynamic range of the scene.

38mm, nine exposures shot at shutter speeds from 1/6 of a second to 1/800 of a second, each exposure at f/6.3 and ISO 400, hand held; photographed using auto-bracketing and burst mode; nine-image sequence processed in Photoshop and Nik HDR Efex Pro; converted to black and white in Photoshop and Nik Silver Efex Pro.

MONOCHROMATIC HDR PRESETS

One scenario that extends the dynamic range of the final image and converts easily to black and white is to shoot a bracketed sequence, and then to combine the sequence using an HDR program such as Nik HDR Efex Pro. You can choose one of the monochrome presets to create a black and white image without having to pass through the color processing stage. This is an approach that makes the most sense when you are not using a tripod because you don't have the luxury of easy alignment in post-production.

The resulting black and white image will have nice dynamic range, assuming you shot a full bracketed sequence. However, it is not flexible in terms of how different areas of the image are processed, and also not all situations are right for bracketed photography (a subject in motion is one example that likely will not work well photographed this way).

There are many situations in life in which using a tripod is simply not practical. Tripods may not be allowed in venues as varied as museums, castles, and on public transit. Some cities don't allow tripod use without a license. And even if a tripod is allowed, you may not feel like lugging it around. So when a tripod is forbidden, impractical, or undesirable, and when you want to go to black and white, consider shooting a bracketed sequence and combining it in post-production using a monochromatic HDR preset.

▶ I've never seen such a veritable cacophony of spires in a European city as in Prague. These wonderful spires, or towers, help to impart Prague's unusual and distinctive flavor. What is it about upright towers reaching for the sky that appeals to the engineers among humanity?

Prague boasts more towers you can climb than is generally the case. Each tower has a circular spiral staircase, seemingly hewn out of the stone. It can be very interesting encountering a party coming the other direction in one of these small, claustrophobic staircases!

Carrying a tripod seems like asking for trouble, which is why this is a good place for hand-held bracketed sequence photography, assembled using an HDR preset.

190mm, four exposures at shutter speeds ranging from 1/400 to 1/8000 of a second, each exposure at f/10 and ISO 200, hand held; photographed using auto-bracketing and burst mode; exposures combined in Nik HDR Efex Pro, and converted to monochrome using a Nik HDR Efex Monochrome preset.

THE PHOTOSHOP LAYER STACK AS GOLD STANDARD FOR BLACK AND WHITE CONVERSION

Images vary, and some are more complex to convert from RAW, process in Photoshop, and convert to black and white than others. Perhaps the most important thing is the part of the process that is sometimes called pre-visualization. Before you even think about the technical conversion process of creating a high-quality black and white image, you should consider the kinds of imagery that work best in black and white (Chapter 1) and how to find these images in your own work (Chapter 2).

Once you are comfortable with black and white imagery and have integrated it into the kinds of photography you like to do, it is true that each image deserves the attention that it is entitled to when it comes to processing. This is a little like printmaking in the chemical darkroom: The work was only partly done in the negative, and a great deal of creativity went into each black and white print.

The situation is actually more complicated and richer when it comes to digital black and white as compared to film black and white. This is because each portion of a black and white image can be processed in its own way and to its own requirements. It is possible to both subdivide processing into a kind of grid, and also to stack different processing methods sequentially, so that they all have an impact on the final result. Burning, dodging, and the zone system all tended in this direction but without nearly the power or flexibility that is inherent in digital post-production.

In this chapter, you've seen a number of different scenarios for opening RAW files, processing, and black and white conversion, each of which can be regarded as a separate step. The good news is that many images do not require intricate work at all these steps (and may not require much detailed work at all). The other good news is that almost any kind of conversion you can pre-visualize in black and white can be accomplished, although it may take some effort. Keep in mind that if something is worth doing, it is worth doing right.

Let's summarize the best practice for digital black and white. The first step is to process a RAW file into Photoshop, via ACR or Lightroom. This process can be augmented by multi-RAW processing. The result is a color layer stack in Photoshop (Figure 4-15).

An alternative that can be combined with RAW or multi-RAW processing is to create a bracketed sequence of images, either on or off tripod, and process these by hand or using automated software into layers in a color Photoshop stack (Figure 4-15).

The next step is to work with the image in color in Photoshop, resulting in a second layer stack. The idea here is to optimize for color and clarity with black and white in mind, so color may be exaggerated to this end (Figure 4-16). This is also the stage of the process in which the image gets retouched for minor flaws and cropped to enhance the composition.

Finally, a third layer stack is created (Figure 4-17) when the color image is converted to black and white using Photoshop and third-party conversion programs. This can be a simple one-step affair or as complex as you like, with a great deal of variability in terms of the software and processes used. The result can be a stack with many layers and layer masks, and varying opacities.

Of course, to use the black and white image for reproduction or printing, the final layer stack needs to be archived and the layers merged down into a one layer file. This single-layer file can be used to create a master for printing, and it can also be used as the basis for a JPEG of the image for display on the Web.

▼ PAGES 170–171: Going up the tower in Prague's Old Town Square, I expected to photograph the wonderful and wacky medieval cityscape of crooked roofs, passages, and Gothic towers. Sure, this was great grist for the photographic mill—but what really appealed to me about the location was the interior spiral ramp. This interior area was bisected by a passenger elevator. So looking down to the center of the ramp presented an almost futuristic experience, which was completely unexpected in the context of this 14th-century building.

15mm, 1/60 of a second at f/2.8 and ISO 2000, hand held; multi-RAW processing using ACR and Photoshop; color processing using Nik Viveza, Nik Color Efex Pro, and Topaz Adjust; converted to black and white using Nik Silver Efex Pro and Photoshop.

▶ FIGURE 4-15: After using ACR to process two versions of the photo—a darker version for the wood ramp and a lighter version for the elevator and windows—I combined them in Photoshop using a black Hide All layer mask and the Brush Tool loaded with white (page 151).

▶ FIGURE 4-16: My next step was to work on making the colors and dynamic range of the image as deep and rich as possible. Sometimes the colors can be over-exaggerated. By extending the dynamic range and color of the image, I knew that this would create a vibrant black and white conversion.

▶ FIGURE 4-17: After saving the finished color version of the image, I merged down all the layers and started a new layer stack. This stack started with the color version on the bottom and worked its way up through the black and white conversion with various enhancements that I brushed in using layer masks and the Brush Tool.

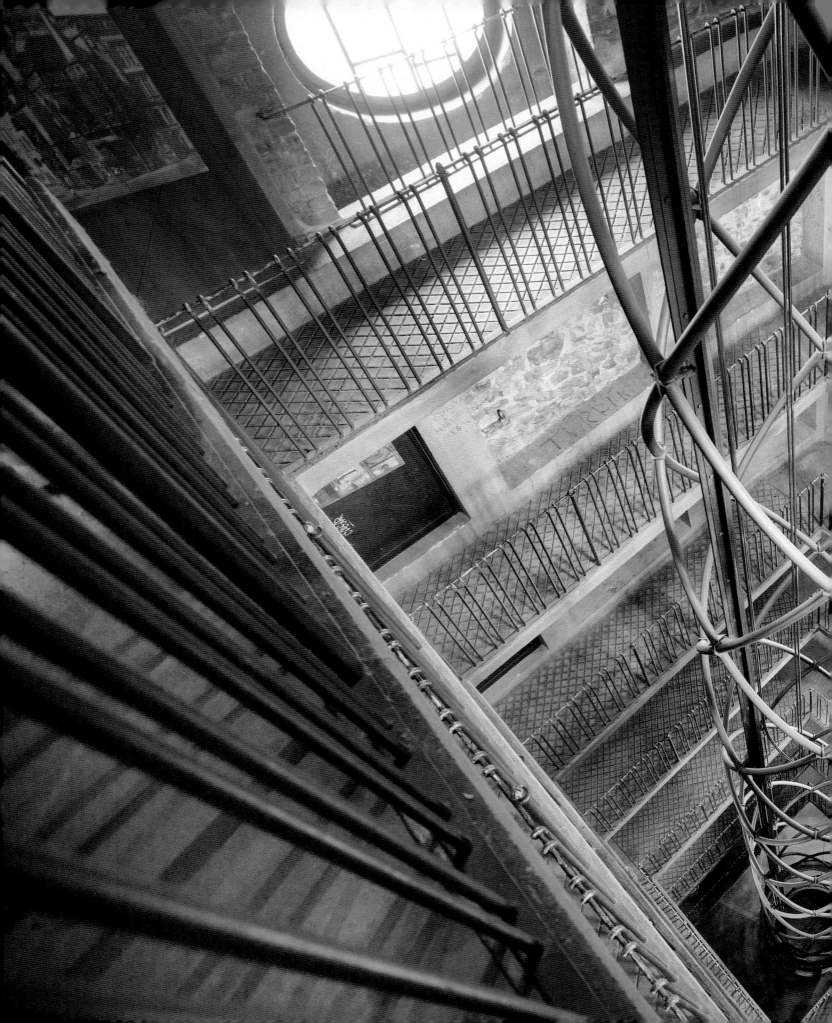

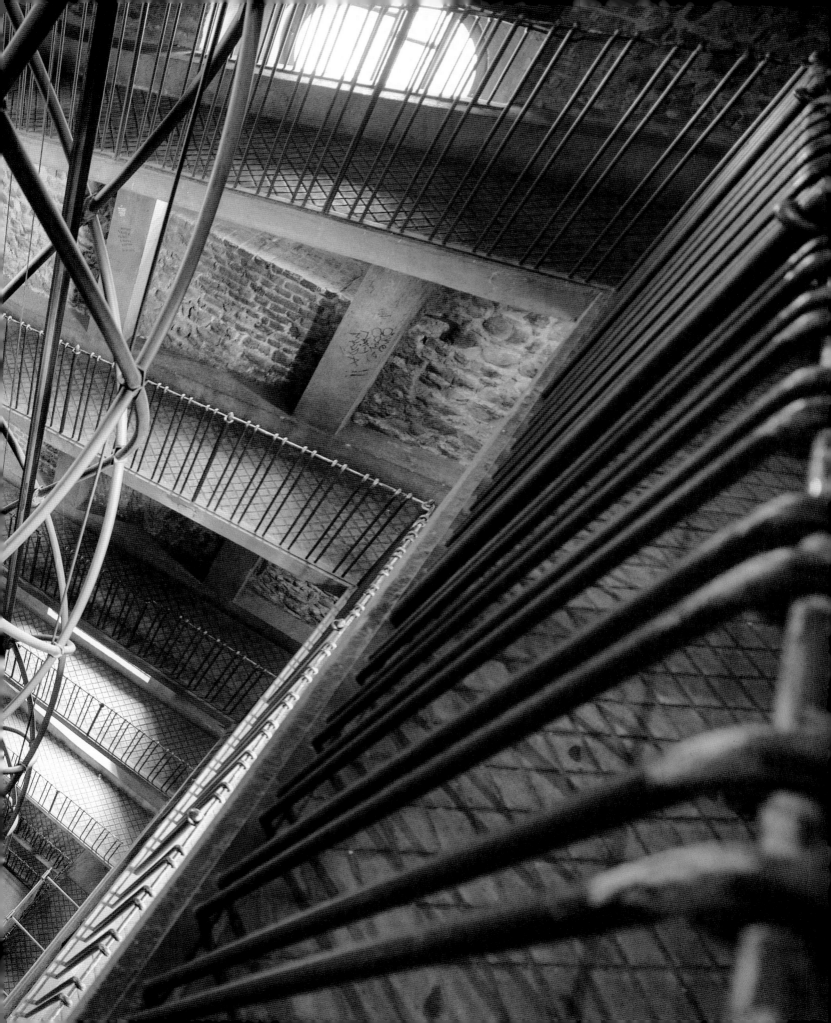

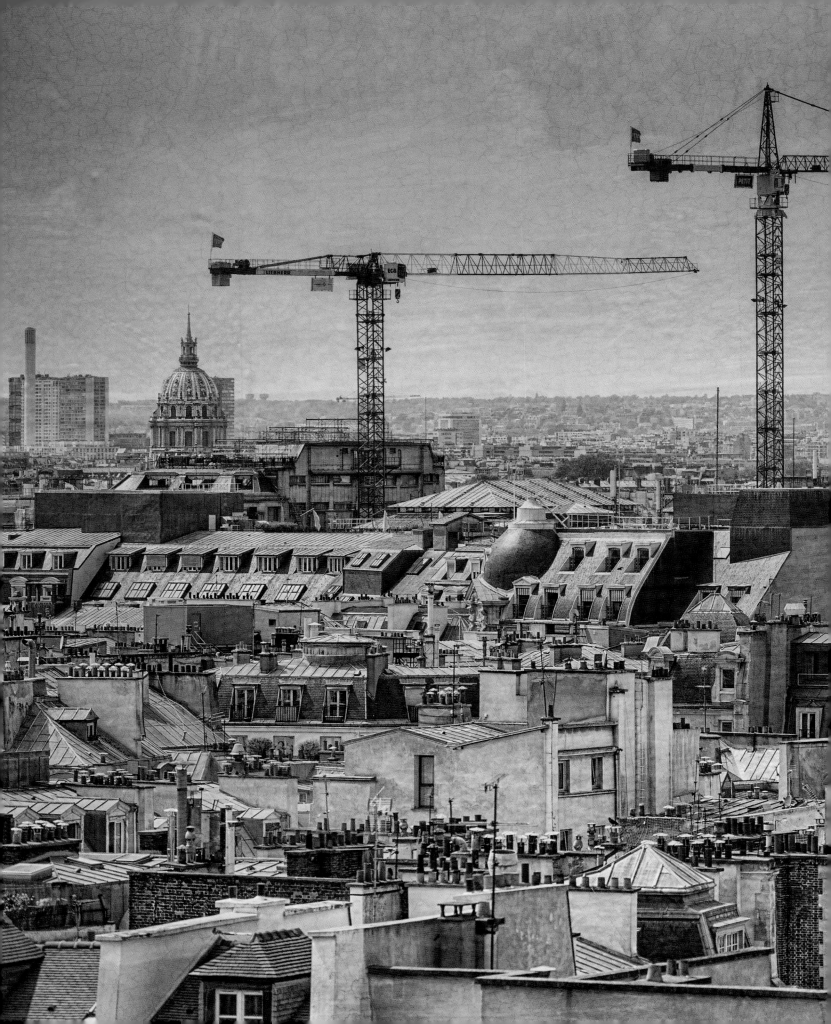

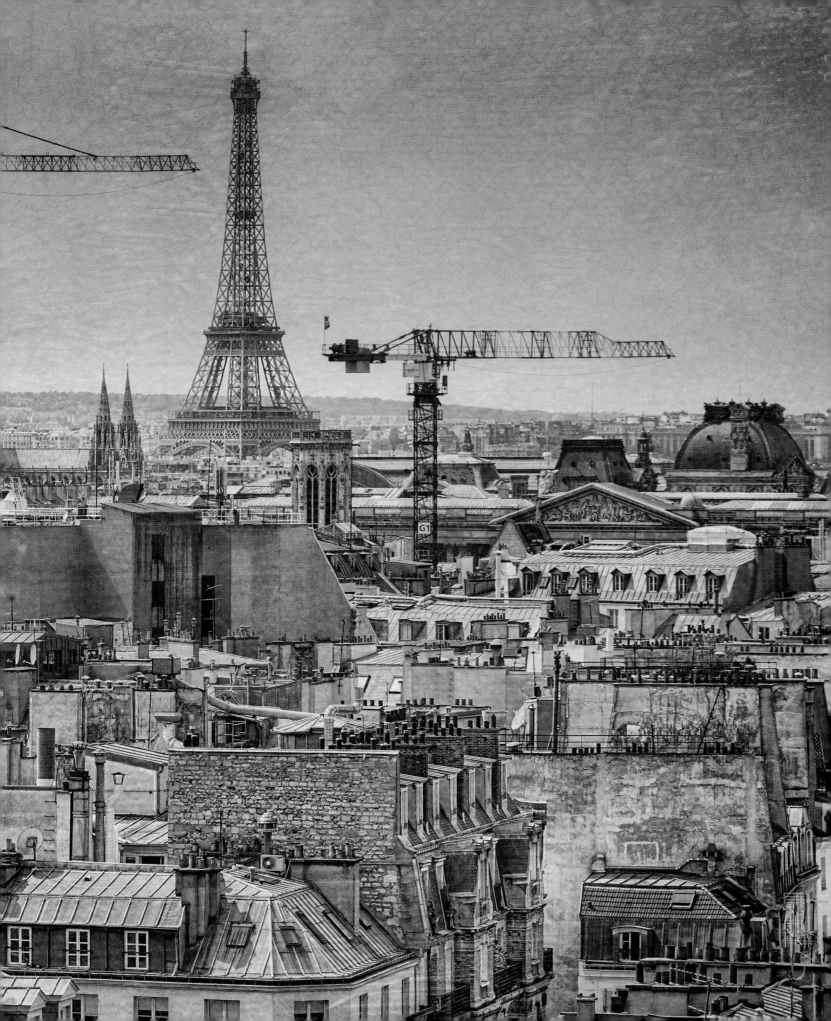

5: CREATIVE B&W EFFECTS

FINISHING THE IMAGE

Sometimes an image speaks for itself. For some imagery, and some photographic artists, no more may be required than simple processing and a straightforward black and white conversion.

But many, if not most, images need a bit more. Ansel Adams famously likened photography to a musical composition, and spoke of the photo being the score and the print being his performance. Many of Adams' stunning images wouldn't have been very impressive as photographed without the maestro's great printmaking skills. The same thing applies to digital photography, with post-production processing being the "performance"—and often crucial to great image making.

It's important to know how to use a camera and to start with the best photographic image possible. Some issues—such as those related to composition—are best resolved in camera, while others can be successfully addressed at various points along the workflow. Overall, it's fair to say that good post-production skills often make the difference between mundane and magnificent photos.

This chapter presents "special effects" that can be used to finish a black and white image. Note that

▲ PAGES 172–173 AND ABOVE: Paris, France, is at its core an ancient city, with its early medieval roots in two small islands in the Seine River that could be easily defended from invaders such as the Vikings. The city grew, with one of the first universities in Europe founded in the 1200s. The Parisian meme, of old with the new, and ancient buildings surrounded by new construction, started early and has continued to this day.

This photograph of the Paris skyline is from May, 2016, and was processed to convey the sense of Paris as a city always in transition, with the old buildings, the Eiffel Tower, and construction cranes all in the same breath.

135mm, 1/6400 of a second at f/4 and ISO 100, hand held; multi-RAW processed in ACR and Photoshop, and finished using Photoshop, Nik Creative Efex Pro, Nik Viveza, Topaz Adjust, and Topaz Simplify; three texture files added to finish color version; converted to black and white using Nik Silver Efex and a Van Dyke preset in Topaz B&W Effects.

▶ This image is of Les Deux Magots, a watering hole in the heart of the Saint-Germain-des-Prés district in Paris, France, beloved by Ernest Hemingway and literati and glitterati ever since Hemingway's era.

Recently wandering past with only my iPhone camera in hand, I noticed the waiter in an old-fashioned apron "skirt" looking just like photos from bygone times in Paris. Before this vision from the past vanished, I snapped the picture.

iPhone camera app, processed in Snapseed, Mextures, and Lo-Mob.

some special effects can be accomplished in the camera or simulated in post-production. An example is IR (infrared) photography using IR-modified cameras; this chapter explains several flavors of post-production IR simulations but doesn't cover the use of IR-modified hardware (a substantial topic in and of itself). Likewise, a simulated pinhole effect is discussed, but building a pinhole camera is not.

Generally, and somewhat peculiarly, many special black and white effects are referred to by the terms used in the film darkroom. What once was accomplished using enlarger settings and chemistry is now accomplished with specialized software.

Finally, while the goal of these special effects is to use them to finish black and white images, it is important to understand that some recipes can also be applied—or are even best applied—during the color portion of the workflow, before the imagery has been converted to black and white.

LIGHTING AND MONOCHROMATIC PHOTOS

I often tell my workshop participants that one cannot photograph an actual object placed in front of a camera—one can only capture the light reflected or emitted by the object. This is a truism of physics. But while many photographers will agree with the statement that photography is about capturing light, the implication—that we should look at light, not objects, when evaluating the potential for making an interesting photo—is often ignored.

How your subject is lit—whether you arrange the lighting or it is natural because the light was "just there"—is crucial to the success of any photo. The most important aspect of the art and craft of working with light is perceptual. It's necessary to learn to be able to pre-visualize the impact of lighting—and relatively small changes in lighting—on a final image.

The primary subject of this chapter is that way you can use post-production—specifically the tools available in Photoshop and its third-party plugins—to manipulate the appearance of lighting in your black and white images. But before turning to that topic, it makes sense to spend a little time with the conceptual and more general issue of lighting and black and white photography.

As F. Scott Fitzgerald said about the difference between rich and poor folks, color is different from black and white. With color, there are more variables. Light with a given quality can interact and appear differently depending on what is being photographed. Two objects, right next to each other in the same photo, can reflect different color temperatures, even though they are lit the same way. The infinite gradations of light intensity, color temperature, and tone correspond to the normal way we see the world and provide a rich and subtle palette for nuanced imagery.

The strengths of black and white tend to lie elsewhere. Light still plays a crucial role in monochromatic compositions. But its role is usually anything other than subtle. Essentially, the only way lighting is rendered in a black and white image is in the differences between light and dark.

The idea that any photograph is "reality" is of course not true. But with black and white photography, the illusion that must be created is so obviously a construct—because we see the world in color and not in monochrome—that care must be taken to either suspend disbelief in the viewer or to create a statement that is inherently powerful in its own right.

▶ The ancient streets on the Left Bank of Paris surrounding the Place Saint Michel are invariably crowded with people—students, tourists—no matter the hour of day or night. My idea in capturing this image was to create a time exposure in which the hordes of people seemed ghost-like, and therefore lighter, with the processing intended to create a darker, low-key effect for the background.

The trickiest thing about making this photo actually involved the hordes of people. My tripod was set up in tight quarters, and it was difficult to make a long exposure without being bumped. I also needed an interval with a bit of space between the camera position and the leading row of pedestrians. So I tucked into a small side alley (which didn't smell so sweet but worked well to keep the camera from being jostled) and waited until the spacing of the crowd seemed right.

35mm, 15 seconds at f/9 and ISO 100, tripod mounted, processed in ACR and Photoshop; converted to black and white in Nik Silver Efex Pro with platinum toning added in Topaz B&W Effects.

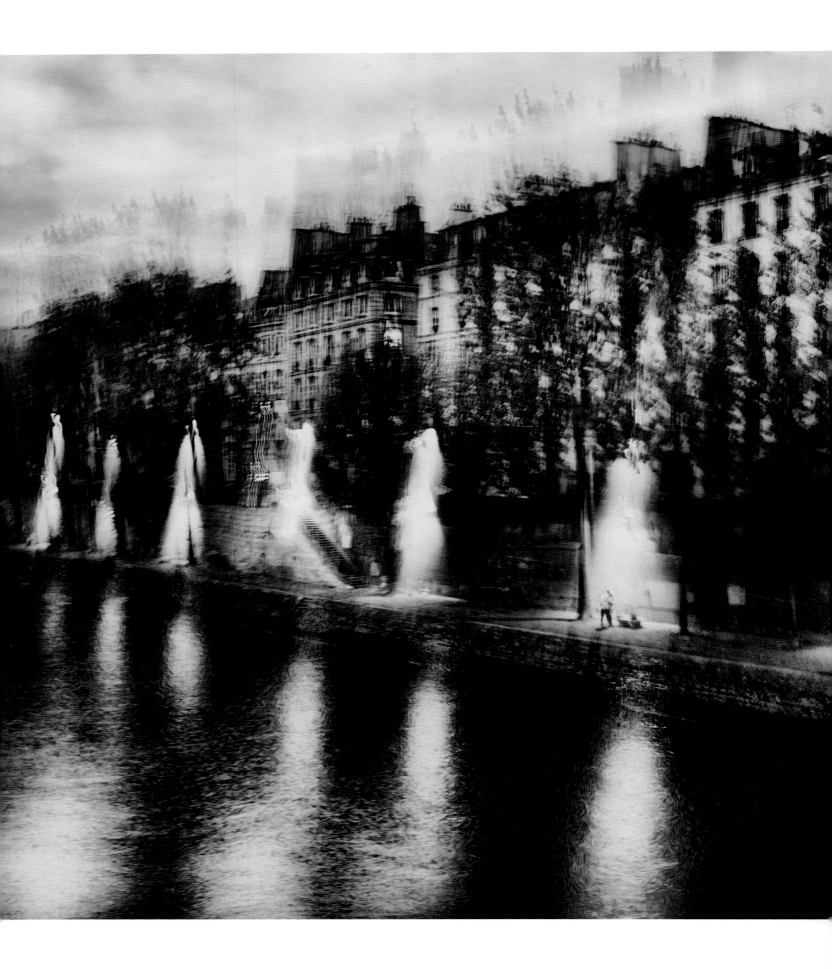

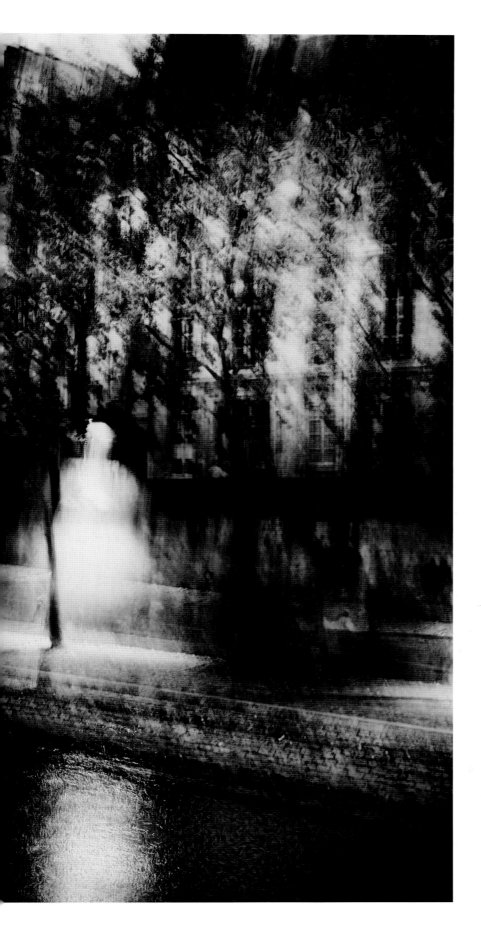

Monochrome favors bold boundaries and abrupt transitions from light to dark. When I see a subject that shows this kind of strong, abstract demarcation—particularly if color doesn't play a vital role in the composition—I start thinking, "black and white." I also aim my post-production workflow, both in the color and black and white phases, to aid the power of these demarcations.

Since a digital monochromatic image is essentially a simulation that involves repurposing a full color capture, working with light in black and white should take place in six stages:

1. Recognizing, or setting up, a black and white composition (see Chapter 2, *Finding Black & White*, starting on page 38).

2. Making an exposure (or more than one to extend dynamic range; see pages 136–169). Many of the photos I've used in this book, taken together with their captions that include camera settings and processing information, are intended to help give you a starting place for your own creative black and white exposures.

◀ On a late November wet afternoon, as dusk turned to sodden night, I wandered the banks of the Seine River with my camera. Paris is always romantic, and perhaps at no time so much so as during a late autumn afternoon. While the flowers of spring are not in bloom, love is in the air in a quiet, melancholy way.

My idea with this image was to render the street lights as an important graphic element of the scene, so I intentionally used a long exposure and introduced camera motion into the composition, then processed to exaggerate the impact of this lighting.

35mm, 4 seconds at ISO 50, hand held; processed in ACR and Photoshop, special effect added in Nik Analog Efex Pro; converted to black and white using Nik Silver Efex Pro High Contrast and Antique Plate presets.

3. Processing an image captured in color—usually from one or more RAW files (see *From Color to Black and White*, starting on page 136).

4. Applying creative special effects to the way your photo (and its lighting) appears in color.

5. Moving from color to black and white, the subject of Chapter 3, "Converting to B&W," starting on page 84.

6. Applying special effects to the black and white image, the subject of this chapter. Note that there is often some flexibility about where in the workflow the special effects that I show you can be used; many can equally well be applied during the color portion of the workflow.

The special effects shown in this chapter can be used as ideas for reference, as possibilities to bear in mind when you conceptualize a black and white image, or simply as recipes for enhancing your existing work.

HIGH KEY

As I explained on pages 60–67, not all subjects are appropriate for high-key photography. When you find a good high-key subject, you should plan to overexpose.

Once more, learning to pre-visualize the entire process—in-camera exposure, RAW conversion, color enhancement, and black and white conversion—will yield the most dividends.

As a reminder, when photographing with high key in mind, look for bright, white, well-lit subjects that can be rendered in subtle shades of gray and do not require strong contrasts.

Overexpose by as much as four or five f-stops (+4 EV or +5 EV), but if possible include bracketed versions that are more normally exposed. Since each successively smaller f-stop lets in half of the light of the previous f-stop, a 4 f-stop overexposure means increasing the shutter speed by a factor of 2^4 (or 16) if you keep the f-stop constant.

For example, at f/16 if the exposure according to your camera's light meter is 1 second, then 16 seconds might be the right shutter speed for a successful high-key effect.

If you bracket, you'll maximize the chances of getting the right exposure, even if you don't need all the exposures.

You can use multi-RAW processing to emphasize the high-key effect (see pages 140–148 for more about multi-RAW processing). Once in Photoshop or Lightroom, you can use exposure adjustments and other techniques to brighten an image (turn to pages 154–156 for info about extending contrast and range in Photoshop).

One technique in Photoshop that adds a high-key effect is to add a white layer over your image. You then selectively paint using a gradient or a brush over areas you want to lighten. To get started with this method, open the image you want to lighten in Photoshop. Then open the Layers panel and click the Create A New Layer button at the bottom of the palette to add a transparent (empty) layer on top of the layer stack. (Turn to pages 149–153 for more about layers).

Next, Press D and then X to make sure the Foreground color is set to White in the Tool panel.

Using the Paint Bucket Tool, fill the new layer with white. Your image will disappear, but don't be alarmed! It will be right back in the next step.

With the white-filled layer selected in the Layers panel, choose Layer ► Layer Mask ► Hide All to add a black Hide All layer mask to the layer. This hides the all-white layer, making the image on the layer below visible.

> ► On a wet and dark autumn day, I photographed in the garden at Rodin's museum. The dark bronze casts of Rodin's famous sculptures, such as *The Thinker* shown here, were streaked with rain. Originally conceived as a part of Rodin's mammoth *The Gates of Hell*, *The Thinker* works well on its own, particularly when raised high on a plinth.
>
> I knew that if I exposed the image "normally," I would lose all the gorgeous detail in the sculpture, so I "overexposed"—by 4 EVs, in other words a factor of 16x—to create a normal seeming, or even slightly high-key, image that would have seemed very dark with a normal exposure.
>
> *300mm, 1/60 of a second at ISO 2000, hand held; processed and converted to black and white in Photoshop.*

With the layer mask selected in the Layers panel, use the Gradient Tool to draw a gradient on the layer mask to partially reveal the layer, or use the Brush Tool (set to roughly 10% opacity) to paint on the layer mask. This will make the areas you paint on seem more high key and "transparent"—by adding white to them. (For more about painting on a layer mask, turn to pages 149–153.)

Finally, with the white layer selected in the Layers panel, click the Opacity box to use the slider associated with the overall layer to create a pleasing high-key effect.

Another possibility when creating a high-key black and white image is to convert the image to black and white using a method that tends to lighten the image. For example, if you convert to black and white using a Black & White Adjustment layer in Photoshop, try selecting the Maximum White preset. Or, if you are working with Nik Silver Efex Pro, use one of the High-Key presets as a starting place for your high-key image.

▶ On the outskirts of Paris, at the last stop in the #1 Metro line, lies La Défense, the largest special-purpose business district in Europe. Fifteen of the world's fifty largest companies are headquartered here. New skyscraper construction is ongoing. Anyone who thinks that France is a cute, cuddly, and archaic country should check out La Défense—where the architectural homage to aggrandizement, capitalism, and perhaps crypto-fascism is unabashed.

In the direct line of sight of the distant Arc de Triomphe, the giant cubist arch at La Défense not so much complements the Arc de Triomphe as attempts to trivialize it. The white marble steps climb abruptly upward toward the government offices within the vast space enclosed by the hollow cube. They are slippery when wet, as it was when I visited one morning in a light, cold rain.

To make this image, I exposed for the very white stairs, intentionally selected an aperture for shallow depth-of-field (f/5.6). I focused closely on the stairs in the extreme foreground, allowing the businessman climbing the stairs in the background to become out of focus and an anonymous silhouette.

150mm, 1/500 of a second at f/5.6 and ISO 200, hand held; processed and converted to black and white in Photoshop, with a white gradient applied in post-production to lighten the image.

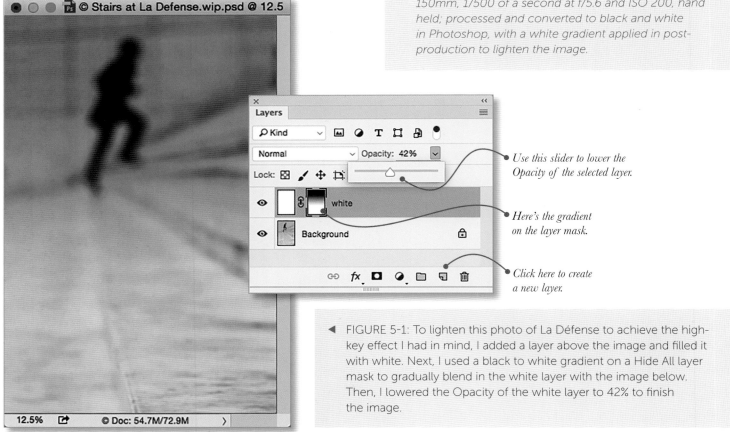

Use this slider to lower the Opacity of the selected layer.

Here's the gradient on the layer mask.

Click here to create a new layer.

◀ FIGURE 5-1: To lighten this photo of La Défense to achieve the high-key effect I had in mind, I added a layer above the image and filled it with white. Next, I used a black to white gradient on a Hide All layer mask to gradually blend in the white layer with the image below. Then, I lowered the Opacity of the white layer to 42% to finish the image.

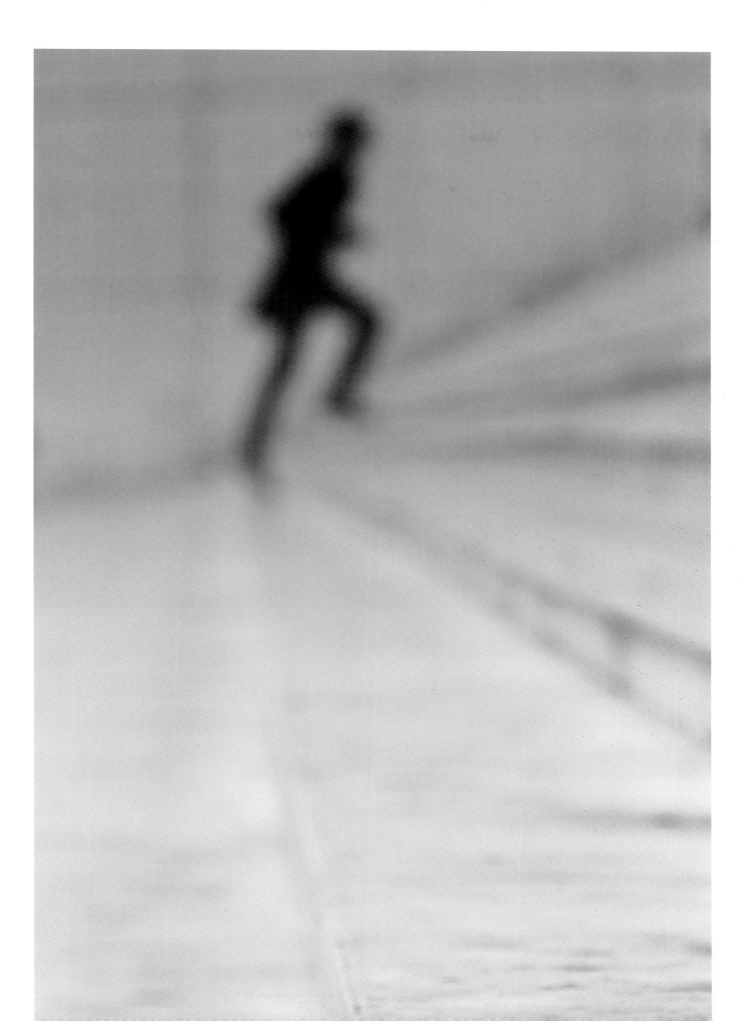

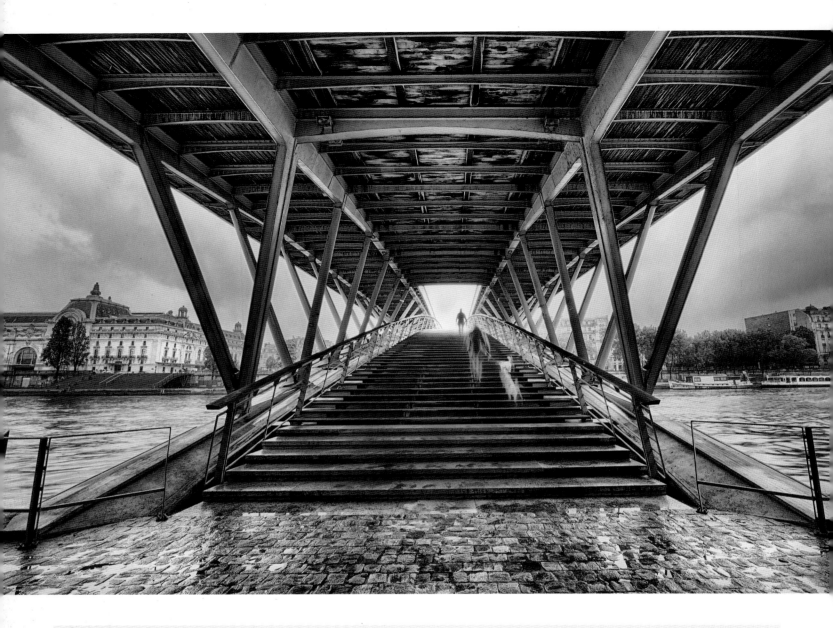

▲ On a rainy spring day, I was photographing under the bridges in Paris, trying to keep my camera dry. The bridge shown in this image is the Pont Solferino, a pedestrian bridge over the Seine. My position was with the Tuileries at my back, looking across the river at the Musée d'Orsay on the left.

The image is composed from a bracketed sequence of five shots. The HDR blending caused the people in motion climbing the stairs to "ghost"—at least in this case, an interesting effect.

15mm, six exposures at shutter speeds ranging from 6 seconds to 1/60 of a second, each exposure at f/22 and ISO 100, tripod mounted; exposures processed and combined in Nik HDR Efex Pro, and converted to black and white in Photoshop using a Black & White Adjustment layer with the Maximum White preset selected.

▶ The two natural islands in the Seine in Paris are Île de la Cité and the Île Saint-Louis. Inhabited since the time of Julius Caesar, Île de la Cité is the heart of Paris. Notre Dame Cathedral was built here starting in 1136 on a sacred pagan site from Roman times.

On a foggy, wet day I explored the islands in the Seine. Photographing this view of the Île de la Cité from Île Saint-Louis, I enjoyed the extraordinary feeling of being in this part of Paris at the water's edge. Later, as I processed the image for a high-key feeling, it brought out the details in the tree and leaves, and created a scene with very Parisian ambiance.

35mm, 1/200 of a second at f/4 and ISO 100, hand held; processed in ACR and Photoshop, and converted to black and white in Nik Silver Efex Pro, using the High Key preset.

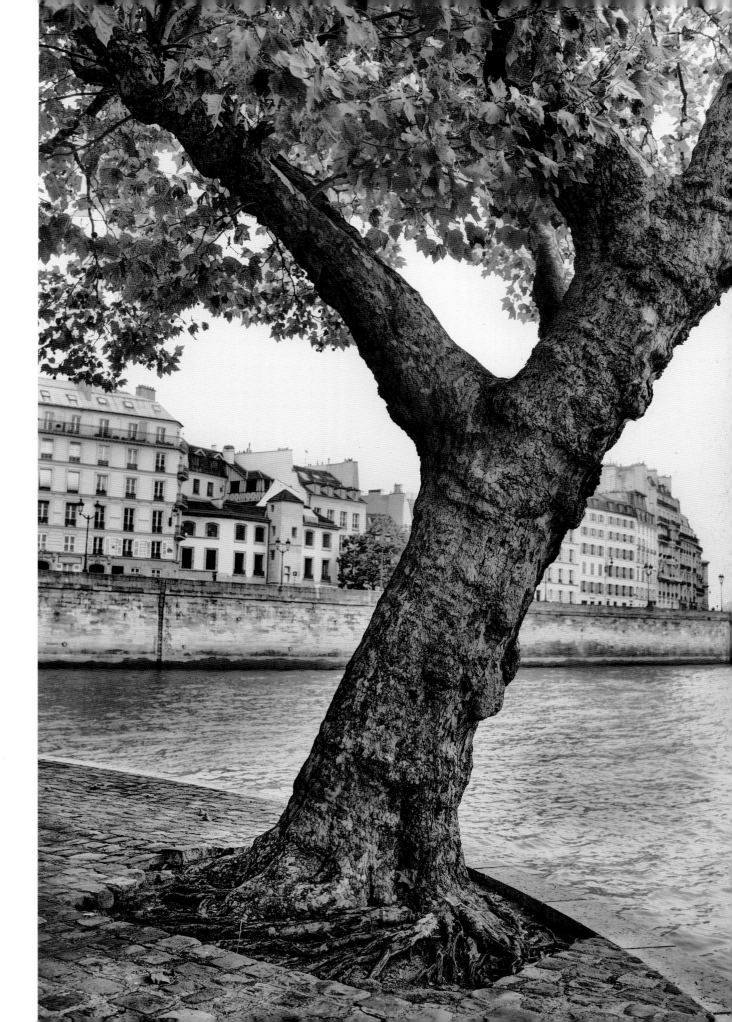

LOW KEY

Low-key images, as I explained on pages 60–67, are predominantly very dark. The point of these dark compositions is often to contrast the important areas that are lit with the blackness that surrounds them. It's human nature to associate dark negative spaces (so-called because the space is empty) with an aura of power and mystery—so low-key compositions can be inherently very powerful.

Another feature of low-key photographs is they are effective at isolating the key elements of a composition and removing extraneous details. You can hide a great deal of clutter behind a curtain of dense black.

When shooting with low key in mind, look for the exact opposite of what you'd try to find with high key. In other words, good low-key subjects are dark and black. The best low-key subjects are intermittently lit. Lighting often shows a chiaroscuro effect, meaning that there is mottled lighting with an extreme contrast between light and dark areas.

Effective use of low-key lighting involves underexposing the overall scene. That way, the highlighted areas, which are what you are really interested in, will be properly exposed, and you can correct the dark areas.

There's no substitute for trial and error, and for checking your captures using Live View or your camera's LCD. Since you are only interested in selective areas of the composition, with a willingness to let the rest go very dark,

be sure to examine the parts of the photo that matter rather than relying on an overall impression.

I often process the RAW conversion to emphasize the darkness that you'd like to have surrounding the lit areas of the composition (see pages 98–101 for more about RAW processing).

A related technique is to create a black layer in Photoshop that you can use to darken background areas, thus emphasizing the lighted areas. To do this:

1. Choose Layer ▸ New ▸ Layer to add a transparent (empty) layer at the top of your layer stack (see pages 149–153 for more about layers).

2. Press D to set the Foreground color to Black in the Tool panel.

3. Select the Paint Bucket Tool from the Toolbox.

4. With the transparent layer selected in the Layers panel, click on the image window with the Paint Bucket Tool to fill the layer with black. When the layer fills with black, your image will disappear. Don't be alarmed; the image will be back in the next step.

5. Choose Layer ▸ Layer Mask ▸ Hide All to add a black Hide All layer mask to the all-black layer. This hides the all-black layer and makes the image layer below visible once more.

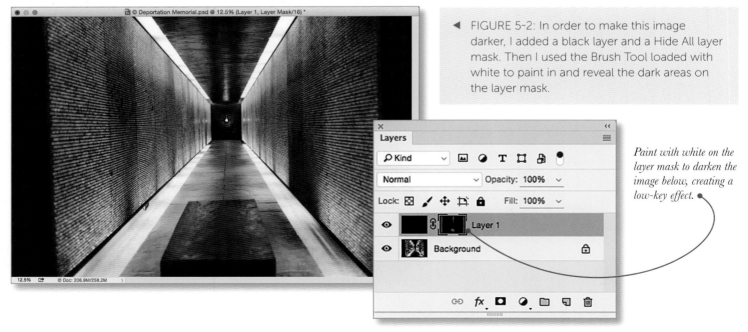

◀ FIGURE 5-2: In order to make this image darker, I added a black layer and a Hide All layer mask. Then I used the Brush Tool loaded with white to paint in and reveal the dark areas on the layer mask.

Paint with white on the layer mask to darken the image below, creating a low-key effect.

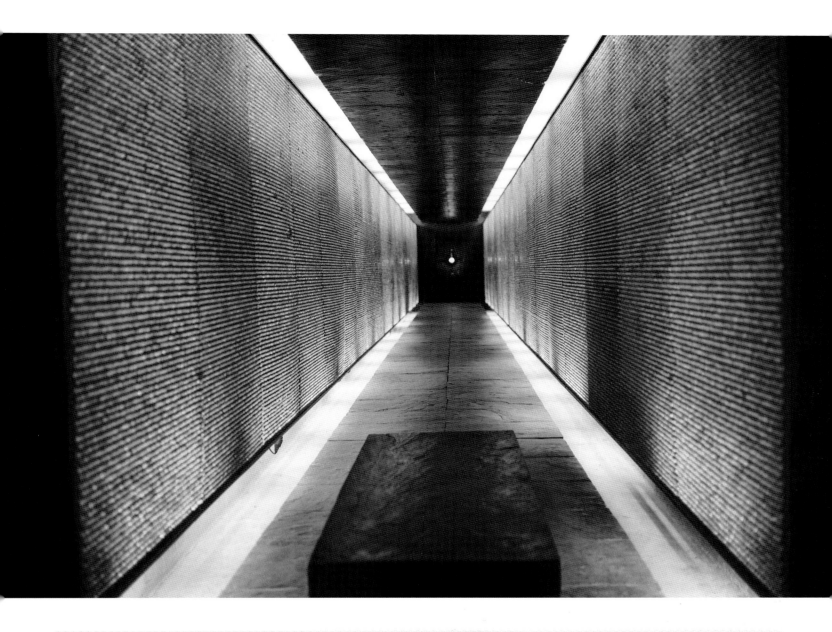

▲ Millions of visitors crowd into the Île de la Cité in Paris to visit tourist attractions such as Notre Dame Cathedral and Sainte-Chapelle. Just a few blocks away from the crowds, on the southeastern tip of the island, surrounded by the flowing, muddy waters of the Seine, is the Mémorial des Martyrs de la Déportation.

Scarcely visited, the Mémorial des Martyrs de la Déportation is a memorial to the roughly 200,000 people who were deported from France to the Nazi concentration camps during World War II with the collaboration of the French government. The bulk of these 200,000 people were Jewish, and of course most of them were murdered and never returned. It is estimated that 60,000 to 70,000 were children.

The photo shows the crypt, with a lit star for each of the 200,000 deported, with a raised platform in front containing the ashes of a few unknown victims from the concentration camps.

I intentionally processed the image so that is dark and low key, in keeping with the somber and solemn subject matter.

35mm, 1/200 of a second at f/1.4 and ISO 500, hand held; converted and processed in Photoshop, with a black layer brushed in to create a low-key effect.

6. Select the Brush Tool from the Toolbox. Set the Brush Tool's opacity to 50%.

7. Make sure the Foreground color is set to white and then paint on the layer mask in the areas you want to make darker. You can vary the opacity setting of the Brush Tool as you work.

When you finish adding black, remember to archive your layered document, and then merge it down.

Another way to create low-key imagery in post-production is to convert to black and white using a method that tends to darken your image. For instance, you could use:

- The Maximum Black preset on the Black and White Adjustment panel

- The Low Key preset in Nik Silver Efex Pro

- The High-Contrast Red preset or filter available in a number of conversion programs

▶ Photographing the Pyramide after dark in the grand courtyard of the Louvre is always an amazing experience. The shapes of the Pyramide become an abstraction, and are an interesting contrast in their modernity with the ornate structure of the grand old palace of the French kings on either side.

15mm, 30 seconds at f/22 and ISO 200, tripod mounted; processed in ACR and Photoshop, and converted to black and white using Nik Silver Efex Pro with the Low Key preset.

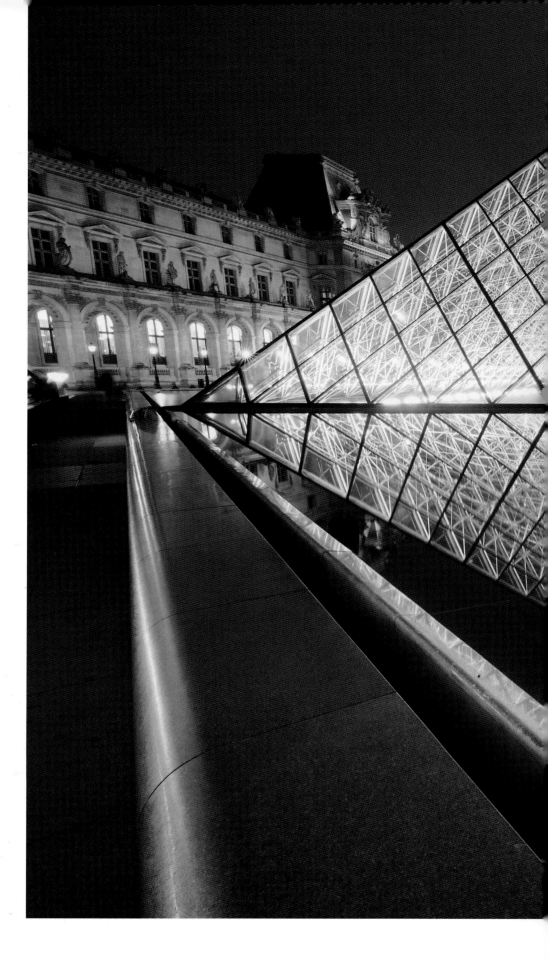

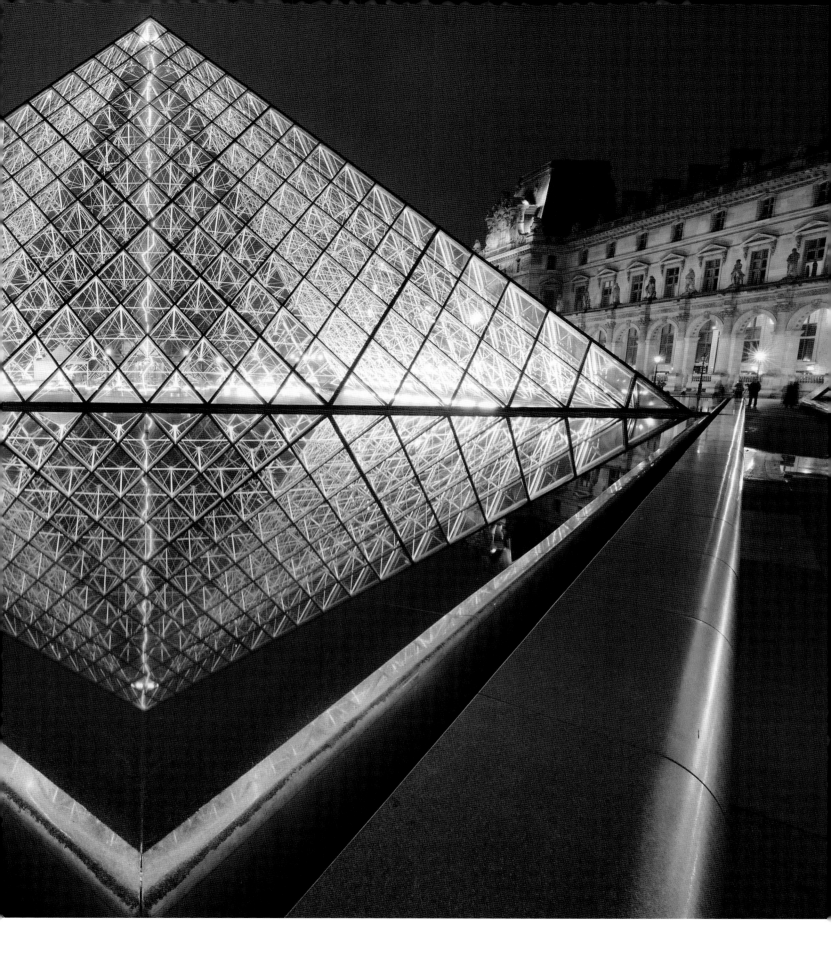

TONING, TINTING, AND SPLIT TONING

Black and white is black and white, right? Not so! In several senses this is not exactly true—which is why "monochrome" may be better terminology than black and white. From a technical perspective your digital black and white image is almost certainly a color file. From an aesthetic viewpoint, there has always been a tremendous level of color variation in prints that folks think of as black and white.

From the very beginning of photography, black and white has actually meant the light brown of sepia toning, gray caused by the chemical selenium, the blue of the cyanotype process, and so on—the single, monochrome color on a scale with white. Historically, toning was the result—or by-product—of the chemical process used to make a print, although artistic choice may also have been involved when a toned effect was actively sought after.

In other words, black and white means monochrome, but black and white images can, and often do, involve tonality beyond the grayscale range.

In the digital world, there are many easy ways to apply a color patina to a black and white image. With digital photography, all "tinting" and "toning" choices are virtual—applied digitally—and intended to add to the visual appeal of a black and white photo. There's no reason to add color to a digital black and white photo other than to increase the visual appeal of the photo.

Toning and tinting may have been technically achieved in different ways in the chemical darkroom, but in the digital darkroom there isn't any significant technical difference between the two. Both are processes that add color to some or all of a black and white photo. The visual distinction is that toning is associated with the look-and-feel of archival prints, and most toning choices are at least notionally intended to keep to color choices that might plausibly have been seen in toned, old prints.

Obviously, there are many ways to add a color overlay (a tint or tone) to a monochromatic image. Note that I recommend as a best practice converting to black and white as a separate step—and only once you have a black and white image, adding the tint or tone on a duplicate layer. The advantage of this is that you can easily control the strength of the tint or tone via the opacity of the layer that it is on, rather than having the strength of the effect bound up with the overall black and white conversion.

Here are some of the ways to add a simple, uniform tone or tint to your image:

- In Adobe Camera RAW (pages 98–101) choose the Split Toning tab. Enter the same values for highlights and shadows.

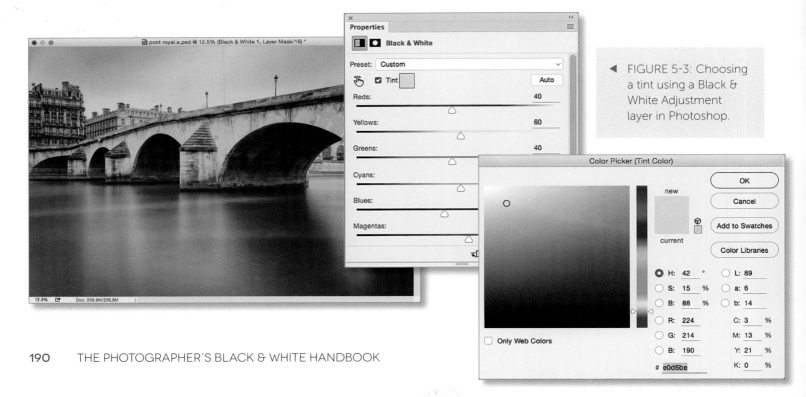

◀ FIGURE 5-3: Choosing a tint using a Black & White Adjustment layer in Photoshop.

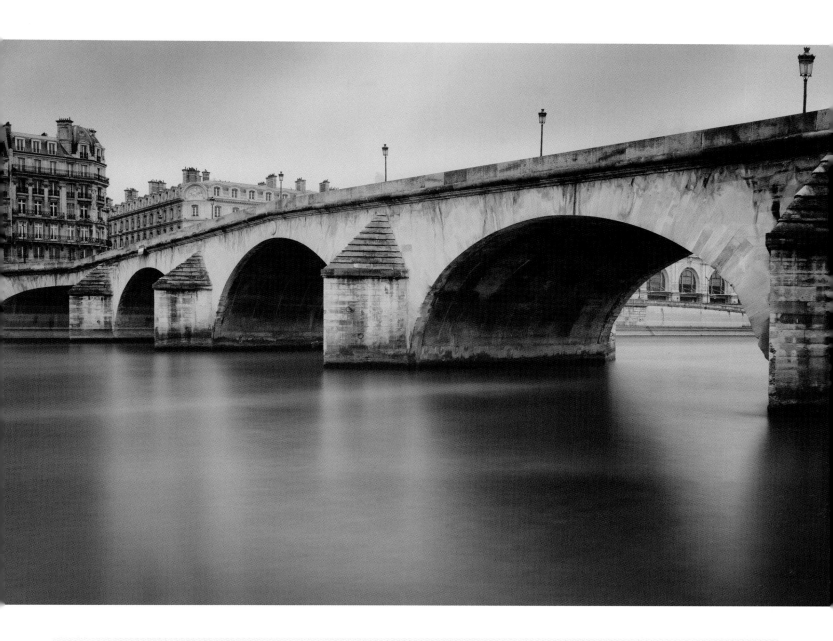

Spring in Paris means that sometimes it rains, which can make the city all the more romantic. On an early spring day, I took advantage of the moody light to photograph along the Seine River. From time to time rain squalls hit, and my camera and I would run for cover under one of the bridges.

The Pont Royal is one of the oldest bridges in Paris. Originally, in the 1600s, a wood toll bridge was built on this location to connect the Left Bank and the Right Bank. This bridge replaced a ferry that had been offering crossings for time immemorial. In 1683, the old wooden Pont Royal was partly burnt and in 1684 it was carried away by heavy flooding.

Louis XIV to the rescue! In the waning years of the 17th century, the Sun King financed a new stone bridge, giving it the name Pont Royal.

Finding myself along the quayside near the Pont Royal, I stopped to look at this old bridge. The stone construction and bright overcast day seemed perfect for a black and white composition. I used a long exposure (two minutes) to flatten the moving water and give an old-fashioned appeal to this shot of the Pont Royal.

35mm, circular polarizer, +4 ND filter, 120 seconds at f/13 and ISO 100, tripod mounted; processed in ACR and Photoshop, with a tint added using a Photoshop adjustment.

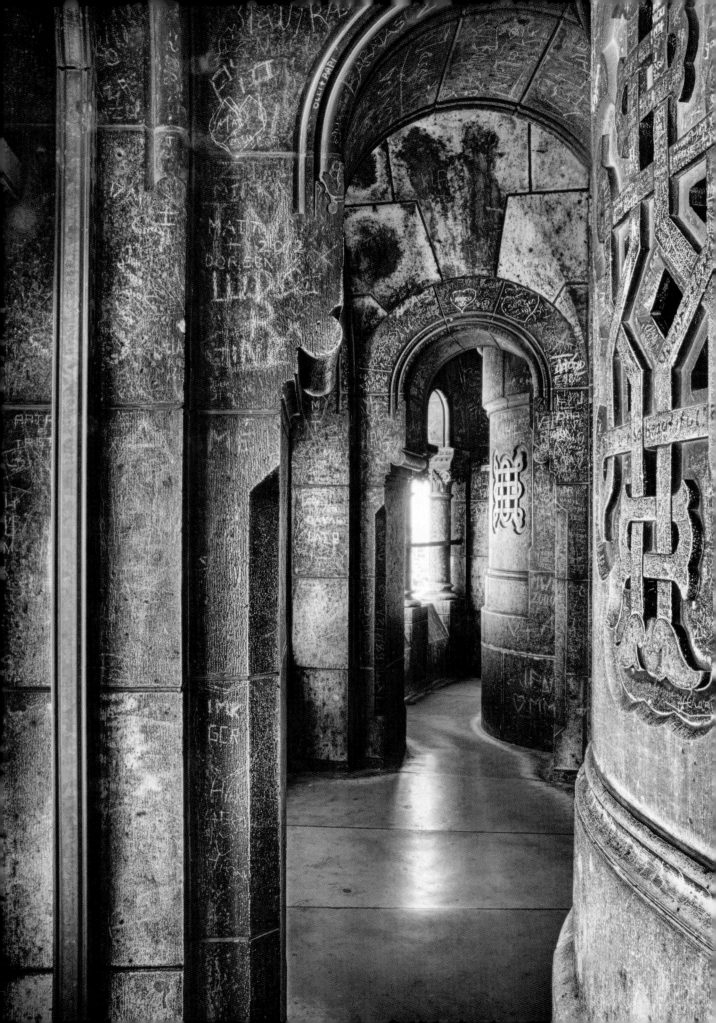

- In Adobe Lightroom (pages 102–109) use the Split Toning tab with the same values set for highlights and shadows.

- In Photoshop, place a layer filled with your tone or tint color above the layer containing your photo, and then adjust the opacity and blending mode until you achieve the desired effect.

- In Photoshop, add a Hue/Saturation Adjustment layer to your photo, with the Colorize box checked.

- In Photoshop, add a tint to a Black & White Adjustment layer.

TINTING USING A PHOTOSHOP BLACK & WHITE ADJUSTMENT LAYER

Perhaps one of the easiest ways to add a tint to a photo is to use the Tint option in Photoshop's Black & White Adjustment layer Properties panel (see Figure 5-3 on page 190).

First check Tint, and then select the color of the tint from the Color Picker window by clicking on the Tint swatch in the Properties panel. Remember that for added control and flexibility the black and white conversion should be done first and separately, before a tint is added.

◀ La Basilique du Sacré-Coeur de Montmartre sits high on a hill overlooking Paris. Controversial from long before the start of construction, the design of Sacré-Coeur was a response to the supposed "moral decline" of France in the century following the French revolution, with the more proximate cause the defeat of France in the Franco-Prussian War of 1870.

While the church itself is visited by millions of people a year, Sacré-Coeur gets surprisingly little traffic up in the passage that circles the grand dome. Perhaps the narrow and twisting stairs—all 280 of them—inhibit guests. The views of Paris are superb.

22mm, eight exposures at shutter speeds between 1/20 of a second and 3 seconds, each exposure at f/22 and ISO 200, tripod mounted; exposures processed in Nik HDr Efex Pro and Photoshop, and converted to monochromatic using Photoshop, Topaz Adjust, and Nik Silver Efex Pro; split toning added in Perfect Black & White, Nik Silver Efex Pro, and Topaz B&W Effects.

TONING AND SPLIT TONING USING NIK, ON1, AND TOPAZ

Tones are tints (or color overlays) associated with the color derived from chemical monochromatic processing in the past. You can pretty easily choose a tint that is similar in tonality to colors that might have been used for toning, or you can choose to tone using the choices in conversion programs such as Nik Silver Efex Pro. In Silver Efex, toning settings are limited to color choices that simulate actual chemical toning, and are labeled with a reminder of the chemical process that might have generated the color.

"Split toning" is the process of toning various parts of an image differently. Within Photoshop plugins including Topaz B&W Effects, On1 Perfect B&W, and Nik Silver Efex Pro, split toning is selected on the basis of one tone for the paper and one tone for the silver. To follow this metaphor, you should understand that "paper" is essentially referring to the white areas in the image, and silver refers to the darker areas that have been "developed" over the paper.

If you are prepared to go to a bit more trouble than using the split toning in one of these plugins, it is possible to slice and dice the split in your toning almost any way you'd like to. For an example of the possibilities, see "Split Toning Using Color Range Selection in Photoshop" on page 194.

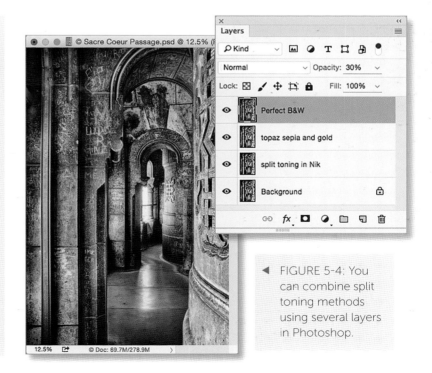

◀ FIGURE 5-4: You can combine split toning methods using several layers in Photoshop.

SPLIT TONING USING COLOR RANGE SELECTION IN PHOTOSHOP

My color image of the picturesque rooftops of one of the oldest sections of Paris (Figure 5-5) has been widely reproduced. So, when I converted it to black and white, I thought about how to enhance the image further. The strategy I selected was to use Color Range selection to select midtones (and darker) so I could apply one tint to the roofs in the image (a tone from Nik Silver Efex simulating the cyanotype process), and a warmer tone (based on simulating the sepia process) to the lighted fronts of buildings and other architectural details. You should note that the two different tonal ranges within the image were also processed individually in the black and white conversion process.

To start in Photoshop, I copied the image onto a new layer. That way, I would be working on a copy, not the original. Then, I chose Select ▸ Color Range. In the Color Range dialog box that opened, I chose Midtones from the Select drop-down list, and then expanded the range that had been selected by moving the black Range slider to the left to adjust the color range selected by including more dark tonal values in the selection. The areas that would be selected are shown in black in Figure 5-5.

Next, I clicked OK in the Color Range dialog box to create the complicated selection shown in Figure 5-6. With the selection active, I clicked the Make Mask button in the

Layers panel to create a layer mask from the selected areas, as you can see in Figure 5-7.

Since I knew I would want all tonal values to be "in play" and toned, I also created an inverted layer mask by duplicating the layer containing the layer mask. With the original layer mask selected in the Layers panel, I then chose Image ▸ Adjustment ▸ Invert. The result was a layer mask with the opposite impact of the original layer mask: What was revealed in one mask would be hidden in the other, and vice versa (Figure 5-8). Note that the Color Range Selection dialog also allows you to invert this selection, which would be a workflow alternative to inverting the layer mask itself.

With the pieces in place, I was now able to assemble my hand-split-toned monochromatic image (Figure 5-9). First, I duplicated the color image and generically processed it to black and white using a Photoshop Black & White Adjustment layer. Then I duplicated the original color version twice, processing the two layers differently in Nik Silver Efex Pro, one for the roofs with a High Contrast preset and cyan toning, and one for the whiter areas using a Full Dynamic Range preset and sepia toning. I used the layer masks I had created to make sure that each toned version was applied only to the color range that I intended.

I was glad to have each of the tonally processed versions on separate layers, because that way I was able to take down overall opacity of each of the layers to create my final version.

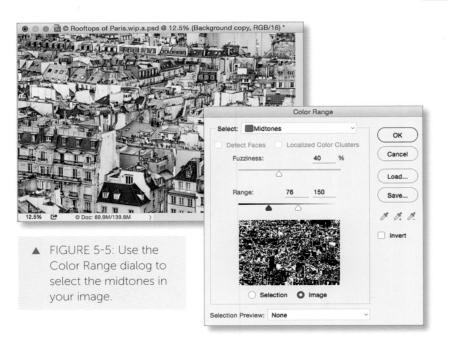

▲ FIGURE 5-5: Use the Color Range dialog to select the midtones in your image.

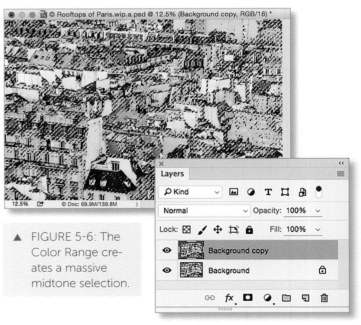

▲ FIGURE 5-6: The Color Range creates a massive midtone selection.

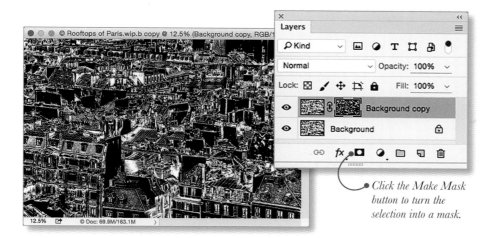

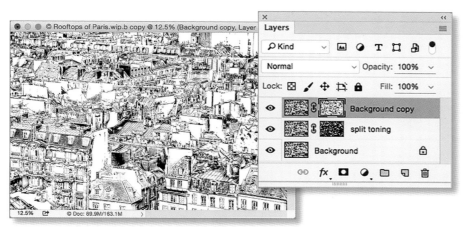

◄ FIGURE 5-7: After clicking the Make Mask button at the bottom of the Layers panel, the selected midtone areas were turned into a layer mask.

To show you what the mask looks like, I selected it in the Layers panel and made it visible here in the image window.

When working with a layer mask, remember that the black areas hide the portions of the layer that the mask is associated with.

◄ FIGURE 5-8: Since I wanted to be able to individually tone the high-tone areas of the image, I inverted the midtone layer mask shown in Figure 5-7 to create a new layer mask.

The result was a layer mask that revealed the areas in the image that other mask would hide and vice versa.

Another way to do this would be to use the Color Range dialog to invert the selection by clicking the Invert check box in the dialog. (You can see the Invert check box in Figure 5-5.)

◄ FIGURE 5-9: Once I had my midtone and high-tone layer masks ready to go, I was able to put together the hand-split-toned image. First, I duplicated the Background layer and converted the image to monochrome using a Black & White Adjustment layer. Then, I used Nik Silver Efex Pro to individually process the two layers with the mid-tone and high-tone layer masks. For one layer I used a Cyanotype preset and for the other I used a Sepia preset.

Click the Make Mask button to turn the selection into a mask.

▼ PAGES 196–197: There's nothing more romantic in my opinion than the jumble of fantastic roofs, dormer windows, and chimneys that can be seen in the older parts of Paris. By converting this image to black and white, my idea was to capture the lines, shapes, and endless variety that can be found from the perspective above the "City of Light."

90mm, 1/320 of a second at f/9 and ISO 200, hand held; processed in ACR and Photoshop; converted to black and white using a Photoshop Black & White Adjustment layer; toning added for midtones to dark tones using Nik Silver Efex Pro High Contrast Preset with Cyanotype, and toning added to light tones using Full Dynamic preset with Sepia (both toning effects at partial opacity).

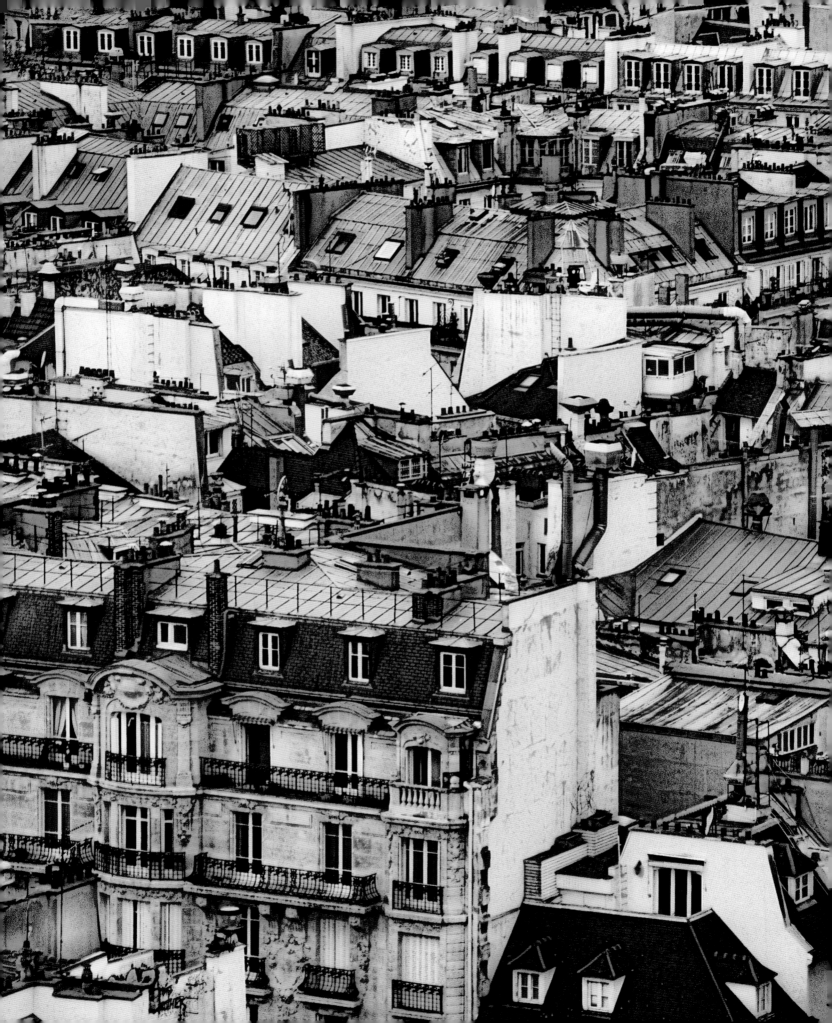

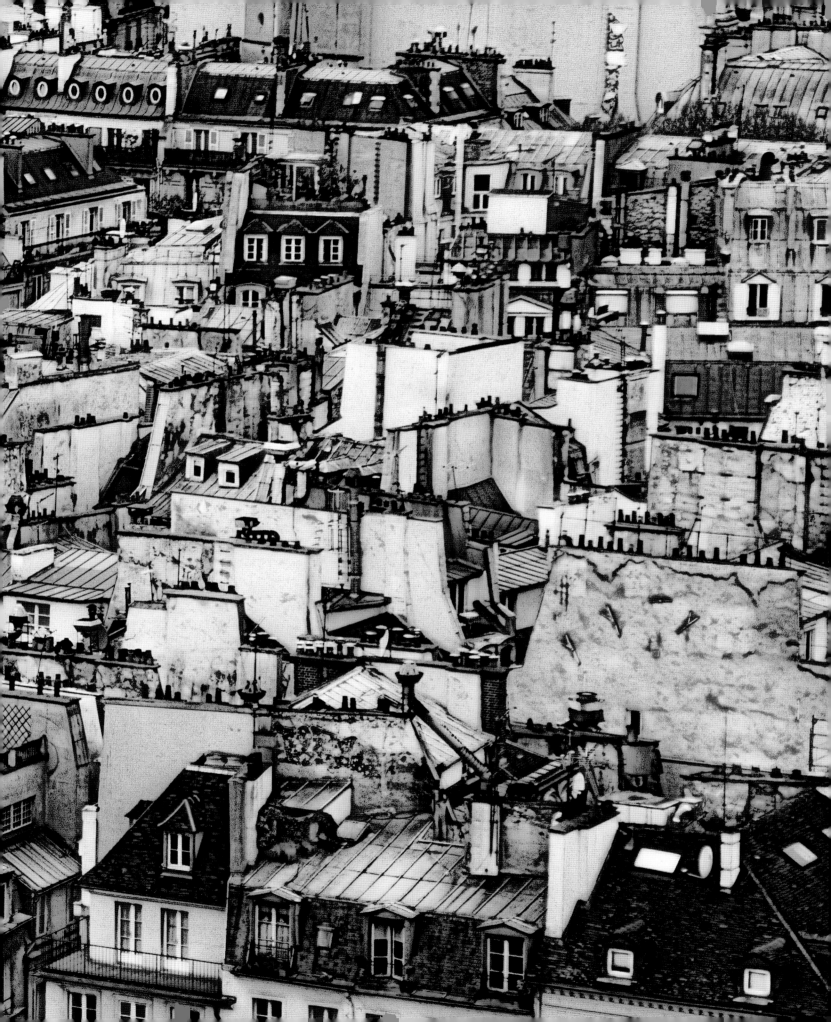

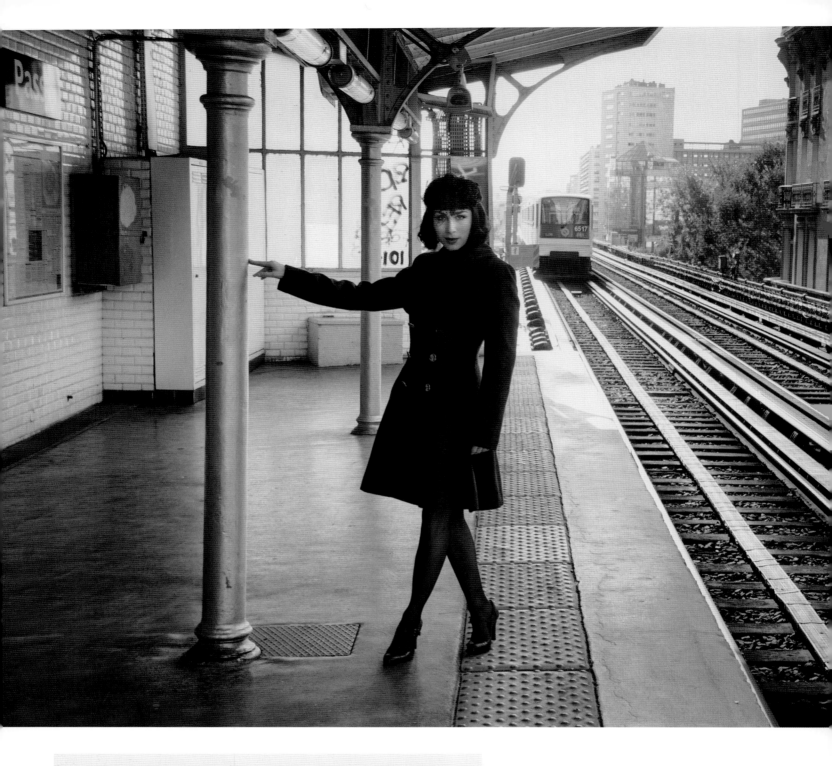

▲ With this photograph of a model at the Passy Station on the Paris Metro,
I tried to create an image that was glamorous but somewhat reflective
of Parisian life. In other words, I was not looking for a photo in front of
the Eiffel Tower. We wandered through streets and alleys and stopped
for refreshments in a café. Finally, I posed the model at this Metro stop
and waited for an incoming train to snap the photo.

*34mm, 1/160 of a second at f/6.3 and ISO 200, hand held using fill
flash; processed and converted to monochrome in Photoshop, with a
tint added using Nik Silver Efex Pro.*

▲ When making in-camera multiple exposure portraits I usually keep the camera on a tripod in a single position. However, with this image I tried something different. This is a hand-held in-camera multiple exposure, with the captures made at a variety of focal lengths and from different positions. Using this technique, I was able to capture front and back views of the model, both in a single image.

Various focal lengths, eight in-camera multiple exposures using Autogain, each exposure 1/160 of a second at f/9 and ISO 250, hand held using studio strobes; processed and converted to monochrome in Photoshop and Nik Silver Efex Pro, with a tint added using Nik Silver Efex Pro.

SELECTIVE COLOR AND HAND PAINTING

Added color selectively back into a color image that has been converted to black and white, and painting with color directly on a black hand white image (hand painting), are two techniques sometimes collectively known as "colorization." Whichever technique is used, images should be colorized with care because it is easy to stretch the bounds of good taste. Undoubtedly a powerful way to call attention to important portions of the right image (the portions that have been recolored), misused colorization can border on—or go way past the border of—kitsch.

In Steven Spielberg's mostly monochromatic film *Schindler's List* there's one small bit of color: a girl in a red coat. We are able to follow the girl because of the color of the coat she's wearing. This visual device—using selective color—works in *Schindler's List* because it is somewhat restrained. In other words, it's easy to create a selective color effect in an otherwise monochromatic image—but it is seldom an effective creative choice because it can often seem unnatural and over the top. When you do try it, don't overdo it.

Hand-colorization was often used in the past before there was such a thing as color photography. The most common use was in portraiture, and sometimes hand-painting or tinting was also seen in landscapes. The technique used was to literally paint with pigment directly on a monochromatic print. As you might suspect, since modern applications of colorization are creative anachronisms that echo the modalities of the past, the technique is best applied to imagery that has an antique component, or a resemblance to the images that were colorized in the past.

When the colorization process involves painting the color image back in over a black and white version, then the result is a partially saturated image, with colors that have been selectively muted or removed. From this perspective, the process of adding selective color can actually be viewed as one of desaturating. If you have a color version of a monochromatic image, it's easy to sandwich the color and monochromatic versions together. You can then add selective color by masking out the color and then selectively painting small areas of it back in.

Usually there are many ways to accomplish any task in Photoshop. Another approach to selectively adding color back into an image that works well, provided you have the Photoshop History states of the image handy, is to paint over the black and white version of the image with the History Brush, after selecting a history state using the History panel from when the image was in color.

If you want to paint color on an image (rather than applying selective color back in), I suggest doing this on a duplicate layer, so that you can have the flexibility to adjust the overall layer opacity at a later point.

To add a selective color effect to my photo of Giverny shown to the right, I first made a duplicate of the image, and then converted it to black and white. Next, I copied the original image as a layer back over the black and white version. Then, I added a Hide All black layer mask, and selectively painted in the areas I wanted to colorize using the Brush Tool as shown in Figure 5-10. To finish, I used a white layer with a layer mask and the Brush Tool to lighten the edges of the image in an oval pattern, as you can see in Figure 5-11.

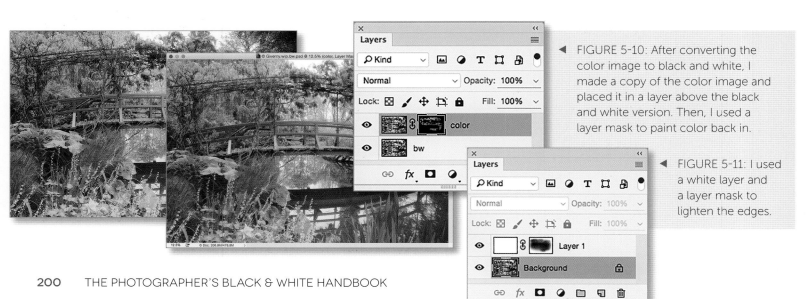

◄ FIGURE 5-10: After converting the color image to black and white, I made a copy of the color image and placed it in a layer above the black and white version. Then, I used a layer mask to paint color back in.

◄ FIGURE 5-11: I used a white layer and a layer mask to lighten the edges.

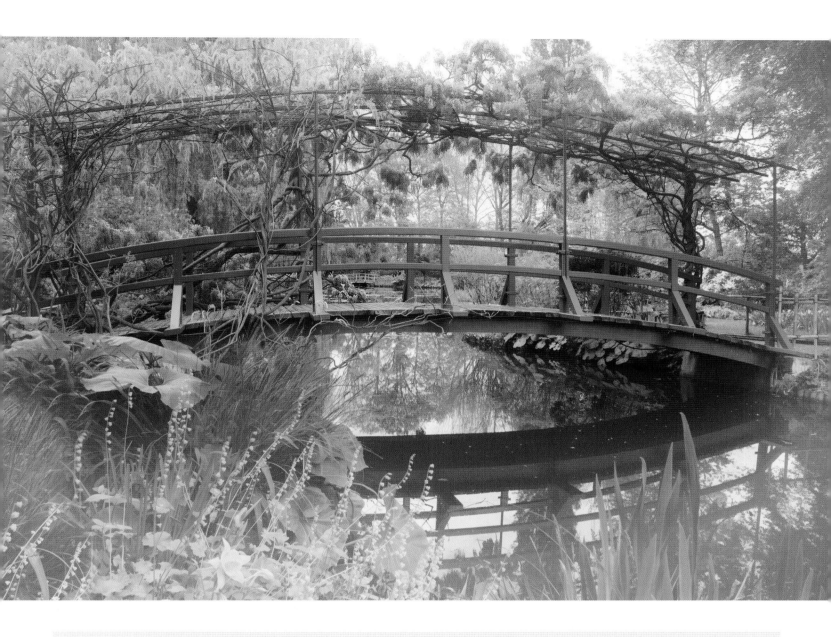

When I first aspired to be an artist, Claude Monet and his famous water lily paintings were incredibly important to me. I spent hours in the Museum of Modern Art in New York studying the giant panels that were on display at that time. So it has been a great privilege to be able to photograph in Monet's gardens in Giverny, France, a number of times in the past few years. (Giverny is located about an hour outside of Paris.)

The famous gardens are divided in two by a road and connected by an underpass. Monet's house, studio, and a fairly conventional flower garden are on one side. Monet created the water garden on the other side by damming a local creek, which his neighbors didn't particularly appreciate.

The water gardens and its bridges are famous art history iconography, and of course, are brilliantly colorful. To make a somewhat different view of this incredible place, it made visual sense to me to present a mostly desaturated view of the gardens, with the color in the bridges and wisteria selectively painted back in. After all, visitors to Monet at his home in Giverny back in the late 1800s might have made a colorized black and white print as a souvenir.

28mm, 1 second at f/22 and ISO, tripod mounted; processed in Photoshop and converted to black and white using Nik Silver Efex Pro; selective color added back into the image using Photoshop; a white layer was applied at 12% opacity to finish processing and add a hint of lightness.

SOFT AND SELECTIVE FOCUS

Soft focus is when an entire image is blurred or out-of-focus and appears soft. *Selective focus* is when only a specific portion of an image is in focus. *Selective soft focus* refers to an image that is generally soft focus, except for certain specific areas, such as the center of the image or a person's face in a photo.

Traditionally, soft and selective focus effects have been achieved in-camera, using hardware. To get a soft look, you can intentionally throw a lens out of focus or introduce motion blur. You can also add something soft in front of your lens, such as a filter coated with Vaseline, or even (as was traditional in Hollywood films of the 1930s) a nylon stocking.

Selective focus is generally achieved by focusing carefully, and using a wide-open lens for minimum depth-of-field. This requires knowing how to manually focus your lens (there can be more to the craft of manually focusing than you might expect), how to set your aperture, and an appreciation for the optical qualities of your lens. Tele- photos have much shallower depth-of-field compared to wide-angle lenses and are therefore much better at creating selective focus images. In addition, certain specialty lenses such as those made by Lensbaby can be used to add selec- tive soft focus, where the image is out of focus and blurry except a central, user-controlled "sweet spot."

While the camera remains the best place to create many kinds of soft-focus and selective-focus imagery, it is easily possible to add soft-focus and selective-focus effects in post-

production. Post-production addition of a selective blur is particularly appropriate when you've used shallow depth- of-field in-camera but need more of a soft look in the areas that are not in focus.

The general technique is to duplicate the background layer, and apply the blur effect to the duplicate layer. Next, add a Hide All black layer mask to the blurred layer. Paint on the layer mask, using a white brush, to reveal the areas you want blurred. Finally, adjust the overall opacity of the layer that includes the blur to obtain the desired effect.

You should know that there are quite a few Photoshop and third-party filters that can be used to create blurring, soft-focus, and selective-focus effects. Some of the ones I use are shown in the table below. It's worth taking the time to see which filter works best with your specific image.

I photographed the portrait of the model shown to the right with my lens wide open (at f/1.4), so the image was pretty nicely selectively focused to start with, as shown in Figure 5-12. But I felt a little more selective focus would enhance the image. To achieve this, I duplicated the Back- ground layer (as you can see in the Layers panel in Figure 5-12), and added a Photoshop Iris blur, being careful to preserve the focus on her face (Figure 5-13).

Once the Iris blur was applied, I had a layer stack with the blur on the topmost layer. I took a moment to make sure that the blur wasn't overdone (which could be corrected by lowering the opacity of the "Iris blur" layer) before merg- ing down the layers and creating the final version that you can see on page 205.

SELECTED BLURS AND RELATED EFFECTS

FILTER	COMMENTS
Iris Blur, in Photoshop: Filter ▸ Blur Gallery ▸ Iris blur	This blur filter creates an effect most like a camera lens out-of-focus blur. Can be used to create a selective focus effect using a layer mask.
Path Blur, in Photoshop: Filter ▸ Blur Gallery ▸ Path blur	This is the blur filter that can be used to simulate a motion blur.
Nik Color Efex Pro: Classical Soft Focus	Closest to Hollywood 1930s soft-focus look.
Nik Analog Efex Pro: Lens Distortion	Bokeh, zoom, rotation, and motion blur effects.
Topaz Lens Effects	Great creative blur and "sweet spot" emulation.
Topaz Simplify: BuzSim	Classical and sweet overall softness.

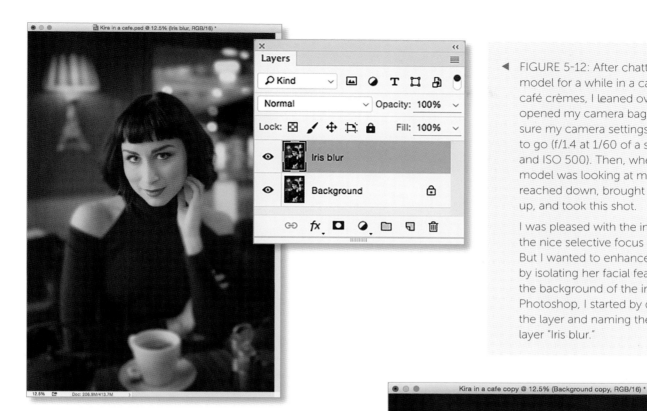

FIGURE 5-12: After chatting with my model for a while in a café over our café crèmes, I leaned over, quietly opened my camera bag, and made sure my camera settings were ready to go (f/1.4 at 1/60 of a second and ISO 500). Then, when the model was looking at me intensely, I reached down, brought my camera up, and took this shot.

I was pleased with the image and the nice selective focus on her face. But I wanted to enhance the portrait by isolating her facial features from the background of the image. So, in Photoshop, I started by duplicating the layer and naming the duplicate layer "Iris blur."

FIGURE 5-13: To apply the Iris blur to the model's face, in Photoshop I selected Filter ▸ Blur Gallery ▸ Iris blur. I clicked on her eye where I wanted the point of focus. Then I dragged a circle around the area I wanted to keep in focus. The idea was to make sure that the rest of the image was blurred using the Iris blur, which mimics a real out-of-focus lens set to its maximum aperture for minimum depth-of-field. You can see the finished portrait on page 205.

▲ The idea for this photo was to isolate the typewriter key used to type French accents, because it looks like a little funny face. To achieve this goal I kept the circumflex (^) key sharp, while letting everything else in the image go out of focus.

The underlying narrative thrust of this photo is about what it feels like to be alone. This is somewhat unusual in that typewriter keys are often seen as the kind of unified army of office work. So it tickled me to create an image about individuality using a typewriter key.

I wanted to present the photo with an antique look, so once I'd processed the black and white version I added a sepia tone layer with reduced opacity.

200mm macro lens, 1.3 seconds at f/4.5 and ISO 100, tripod mounted; processed and converted to black and white using Photoshop, tint added using a Photoshop Adjustment layer.

▶ Paris is known as the City of Light, and also for its cafés and beautiful women. Bringing these three together, it was fun to make this portrait in a café near the Eiffel Tower in the City of Light. (This is the model also shown on page 198.)

My idea in making this portrait was to try to isolate the subject from the background, and also to create an image that seemed old-fashioned—almost as if I were making a portrait of Anaïs Nin or another prominent figure from the legendary past of Paris. To achieve my purpose, I was a little devious. We didn't specifically work on making a photo. Instead, we sipped our café crèmes and chatted. As she was looking at me intensely, I pulled up my camera and took the photo before she knew what was happening.

35mm, f/1.4 at 1/60 of a second and ISO 500, hand held; processed and converted to black and white in Photoshop with tone added in Nik Silver Efex Pro; selective focus blur added using the Photoshop Iris Blur filter.

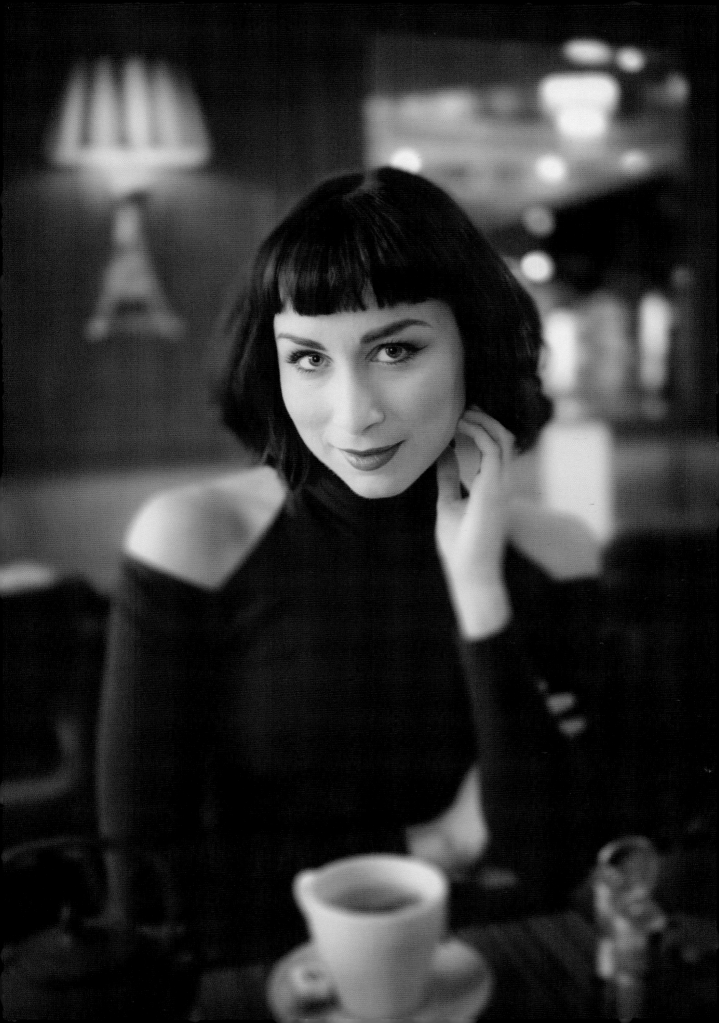

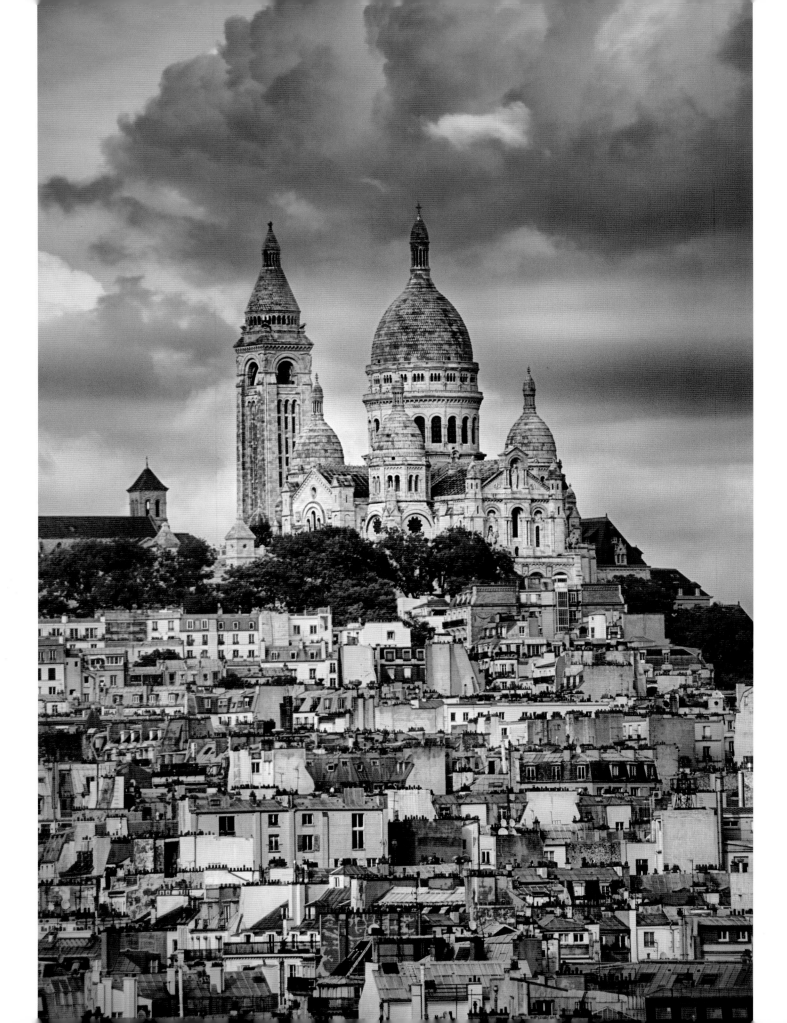

PINHOLE CAMERA EFFECT

The first cameras were pinhole cameras. Pinhole cameras don't have a lens. Instead of a lens, light passes through a tiny hole; the light passing through this hole forms the image inside the camera. A *camera obscura* is a large pinhole camera where light passes through a tiny hole—the smaller the hole, or aperture, the sharper the image—and is projected on the back wall of an otherwise dark room. The projected image is upside down, but perspective and other characteristics are preserved, so a *camera obscura* can be used to create detailed drawings that are accurate representations of scenes.

The first *camera obscura* was created by Arab physicist Ibn al-Haytham in the 11th century. In the West, the optics of the pinhole effect were understood as early as the 15th-century Renaissance, and were described by Leonardo da Vinci and others. The use of the optical pinhole effect in the *camera obscura* was one of the key discoveries leading up to the invention of photography; if you get the chance, don't miss the opportunity to visit one.

Today, it is possible to purchase pinhole cameras, or to make them from a kit. *Camera obscuras* are fairly easily constructed from shoe boxes, tin cans, and even odder materials. What's a little more difficult is to figure out how to capture on a sensor the image projected on the rear wall of the *camera obscura* by the pinhole aperture. You can punch a small hole in the body cap of a DSLR, but then you'll need to extend the body cap using a tube so that it is slightly removed from the body. This configuration also directly exposes the sensor of your camera to dust particles coming through the pinhole—so at-home pinhole photography may have been easier in the film era.

In any case, if you analyze pinhole photography of the past, it's fairly easy to determine the general characteristics of the genre. A pinhole photo, depending of course on the diameter of the aperture that was used to make it, has great overall depth-of-field, but definitely lacks sharpness and is overall quite soft (because it was made without a lens). The edges tend to be darker, and the center of a pinhole image is definitely bright. To simulate these characteristics in Photoshop, I started with an image that was completely in focus (because it was at one focal point, infinity), and by its nature had a somewhat antique look. My photograph of Montmartre and the Basilica of Sacré-Cœur was taken from a rooftop deck in central Paris.

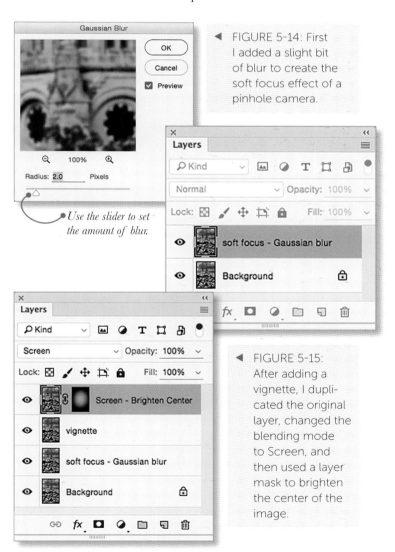

◄ FIGURE 5-14: First I added a slight bit of blur to create the soft focus effect of a pinhole camera.

Use the slider to set the amount of blur.

◄ FIGURE 5-15: After adding a vignette, I duplicated the original layer, changed the blending mode to Screen, and then used a layer mask to brighten the center of the image.

◄ High on Montmartre, La Basilique du Sacré-Cœur dominates the surrounding topography. It's not until you look at Montmartre from a distance—this view through a telephoto lens (200mm) is an example—that you understand exactly how exotic this part of Paris is, and how Montmartre is truly different from the more cosmopolitan and European parts of the city.

200mm, six exposures at shutter speeds ranging from 1/125 and 1/2500, each exposure at f/8 and ISO 200, tripod mounted; exposures combined in Nik HDR Efex Pro and converted to black and white using Nik Silver Efex Pro; simulated pinhole effect added using Photoshop layers and masking.

The first step in Photoshop was to blur the photo slightly to add the soft look characteristic of the pinhole by adding a slight amount of Gaussian blur (Figure 5-14, page 207). Next, I used the Custom tab of the Lens Correction dialog (opened using Filter ▸ Lens Correction) to add a dark vignette to the edges of the image. My final step was to add a duplicate layer in screen mode to the top of the layer stack. I added a Hide All layer mask, and used the Brush Tool to paint the center so it was brighter (Figure 5-15, page 207).

Another approach to adding a Pinhole effect is to use a preset. Each of the major third-party Black and White Lightroom and Photoshop plugins has one or more Pinhole presets. It's worth experimenting with these to find the ones you like (Figure 5-16).

Starting with my image of a gargoyle high on the façade of the Cathedral of Notre Dame, I experimented with adding the Pinhole presets from Nik Silver Efex and Topaz B&W Effects, with the results you can see to the right.

▶ A gargoyle is a carved grotesque, with (sometimes) the practical function of serving as a downspout for rain, and often the emotional purpose of warding off evil spirits. The world's most famous gargoyles are those on the Cathedral of Notre Dame de Paris—which, however, are probably as much due to the Gothic romanticist architect Viollet-le-Duc as they are to historical antiquity. When Viollet-le-Duc reconstructed Notre Dame in the 1860s, it was tumbling down and virtually abandoned. Violett-le-Duc's renovation was strongly inspired by Victor Hugo's novel *The Hunchback of Notre Dame*—a work of fiction not particularly based in historical realities.

Whatever the historical authenticity of the Notre Dame gargoyles, they are a marvelous subject for photography, and a "must see" on any visit to Paris.

82mm, 1/400 of a second at f/10 and ISO 200, hand held; processed in ACR and Photoshop and converted to black and white in Photoshop, with Pinhole presets from Nik Silver Efex Pro and Topaz B&W Effects added.

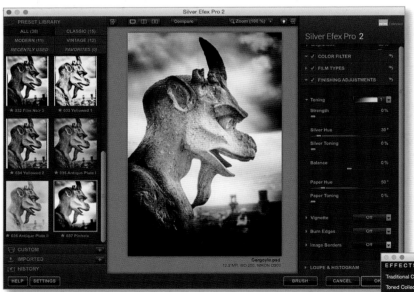

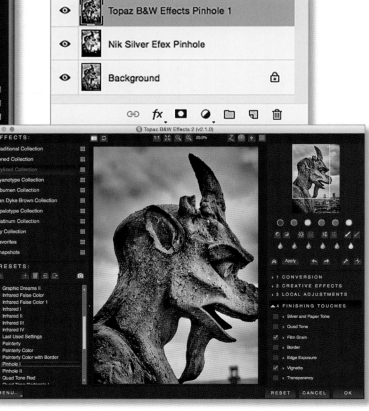

▲ FIGURE 5-16: I really enjoyed layering these Pinhole presets from Nik Silver Efex Pro and Topaz B&W Effects. First, I copied the Background layer and then I used Nik Silver Efex to choose the 037 Pinhole preset. Next, I copied the Background layer again and applied the Topaz Pinhole I preset to that layer. Then I adjusted the opacity setting for both the Nik and Topaz layers until I got the look I was after.

LAB INVERSIONS

A *color model*—which operates on a *color space*, or aggregate of all possible colors in the model—is the mechanism used to denote the colors we see in the world. You are probably familiar with two of the most common color models, RGB and CMYK. The RGB—Red, Green, and Blue—color model is used to display photos using the RGB color space on a monitor.

On the other hand, the CMYK—Cyan, Magenta, Yellow, and Black—color model is primarily used for printing books, magazines, and other materials.

You may not know as much about the LAB color model and related color space, which is structured in three channels:

- The L channel contains luminance information. Luminance is another way of referring to the black and white data in a photo. In the Photoshop Channels palette, the L channel is called the Lightness channel.

- The A channel provides information about greens and magentas.

- The B channel provides information about yellows and blues.

COLOR SPACE DIAGRAM

▲ FIGURE 5-16: This diagram shows the approximate relative extent (gamut) of commonly used color spaces. The LAB color space includes colors that cannot be rendered or reproduced.

I'm not going to go into the details of the theory of LAB, which has a great many applications in creative use of color. But it is worth noting that the size of the LAB color space, also referred to as the LAB *gamut*, is greater than the gamut of the RGB or CMYK color spaces (see Figure 5-16). In other words, there are colors that can be specified in LAB that are not within the domains of the other color spaces.

With all these colors, LAB is to some extent impractical, in the sense that a LAB image cannot be printed or displayed. In other words, after you've finished playing in LAB, to get serious and do anything with your image you'll need to convert to back to another color space.

In terms of black and white photography, the low-hanging fruit that LAB provides is the ability to *invert* an image, meaning to switch black for white, and white for black. An image to which an invert adjustment has been applied is called an *inversion*.

This is an effect a great deal like the work in a chemical darkroom: Most black and white film was negative, and the print made from the negative was positive. The ability to invert an image is like being able to make a negative image from a positive image.

The ability to easily accomplish the inversion is dependent on two features of LAB:

- Black and white information is completely separate from the color information.

- The channels in LAB are opponent, meaning each channel contains the range that includes opposite values. For example, if the L channel includes pure black, it will also include pure white.

To invert an image and swap blacks for whites, and white for blacks, first convert the image to LAB (Figure 5-17). Next, make sure only the L Channel is selected, but all channels are visible in the Channels panel (Figure 5-18). Choose Invert from the Adjustments menu (Figure 5-19). You may wish to apply a Curves adjustment to the L channel to make the inversion more visually striking, and to increase the contrast between blacks and whites (Figure 5-20). Finally, make sure all three channels are selected before you convert back to RGB or CMYK (Figure 5-21).

▲ FIGURE 5-18: Start by selecting the Lightness channel in the Channels panel.

◄ FIGURE 5-19: Select Image ► Adjustments ► Invert to invert the Lightness channel.

▲ FIGURE 5-17: Start by converting your image to the RGB color space. Select Image ► Mode ► Lab Color, and then choose Lab Color from the Profile drop-down list in the Convert to Profile dialog box.

Make sure Lightness is selected.

▲ FIGURE 5-20: If you want to add more contrast, choose Image ► Adjustments ► Curves.

Drag the handles to adjust the curve.

▲ FIGURE 5-21: Before you convert back to RGB or CMYK, make sure all the channels are selected.

The three large portals of the Cathédrale Notre Dame de Paris are decorated with statues that tell the story of the saints and depict the afterlife both heavenly and diabolic. Beneath the statuary are two extremely heavy wooden doors that are decorated with the ironwork filigree shown in these images. My idea in making these images was to emphasize the incredible level of craftsmanship, even in the tiny details of the hardware.

120mm, 1/500 of a second at f/9 and ISO 250, hand held; processed in ACR and Photoshop and converted to black and white in Photoshop (above); inverted using LAB color in Photoshop (right).

SOLARIZATION

Solarization in film photography was a process that swapped blacks and whites. In the chemical darkroom, solarization—also called the *Sabattier effect* after French photographer and scientist Armand Sabatier, who described the effect in 1862—was achieved by re-exposing an already exposed negative or print to light before development was finalized.

The most typical way of creating a solarization effect in the chemical darkroom, namely turning on the light partly through the process of developing a print, was never terribly precise. Nor, despite the apparent similarity to the LAB L-Channel inversion, was the intent ever to completely swap dark and light tonalities, rather to create a kind of fusion blend involving reversal.

Since solarization reverses—or, more accurately, partially reverses—dark and light tones, this effect works well for images in which the contrasts between blacks and whites are an important part of the overall composition. If you have a high-contrast, very "designer-like" image with strong whites and blacks, it may be a good candidate for solarization.

In this section, I'll show you four different ways to simulate the solarization effect in the Photoshop darkroom:

- Using a double LAB inversion

- Applying a downward curve adjustment in RGB

- Using the Photoshop Solarize filter

- Using the Nik Color Efex Pro Solarize filter

Of these techniques, the double LAB inversion and the curve adjustment lead to a color result, the Photoshop Solarize filter creates a black and white image, and the Nik Color Efex Solarize filter produces results in either color or black and white, depending on which option you select.

Assuming that your goal is to create a black and white image—which is, frankly, most typically appropriate for solarization effects—as a matter of workflow you need to pay attention to your color image prior to the solarization and aim to increase contrast. If you've used a solarization process that produces a color result, your final image will be impacted by how you convert to black and white.

On the other hand, if you've bypassed the color solarization step and gone directly to black and white, you may want to add a little black and white from a non-solarized conversion process back in. There are so many different solarization options, and, the results of these processes can be so radically different, that it really pays to play and experiment to see which results you like most.

SOLARIZING USING DOUBLE LAB INVERSIONS

An LAB L-Channel inversion swaps blacks for whites and whites for blacks (for more on LAB, and LAB inversions, see pages 210–213). Since this is clearly related to a simulated solarization effect, it makes sense to use LAB as one of the ways to solarize.

First, duplicate the image on a new layer (Figure 5-22), and then convert your image to LAB as shown in Figure 5-17 on page 211. In the Channels palette, with the L-Channel selected, choose Image ▸ Adjustments ▸ Invert as shown in Figures 5-18 and 5-19 on page 211.

I've found that one gets the best simulated solarization effect by applying a second LAB inversion to the image, this time to all three LAB channels as you can see in Figure 5-23 to the right.

Don't forget to convert the image back to RGB after you've applied the second LAB inversion. You can then convert your image to black and white, using your favorite conversion method (a Photoshop B&W adjustment is shown in Figure 5-24.

▲ FIGURE 5-22: Copy the image layer before starting.

▲ FIGURE 5-23: Select
all the channels in
the Channels panel
and invert the layer
a second time. Don't
forget to convert
back to RGB before
continuing.

▼ FIGURE 5-24: Use
a Black & White
Adjustment layer to
convert the image
to monochrome.

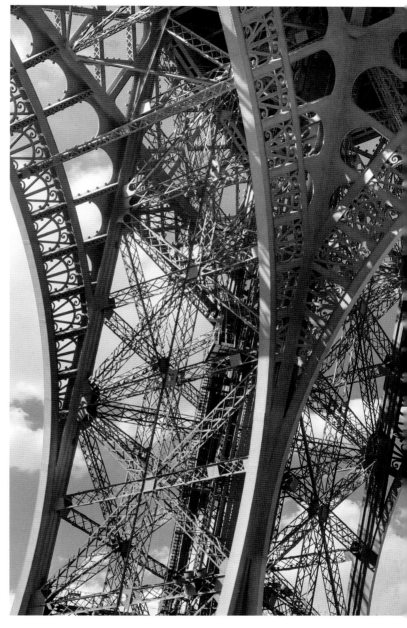

▲ When Gustav Eiffel designed and constructed his tower
in 1889 as the entrance to the World's Fair, it was in-
tended as a temporary structure. Today, the Eiffel Tower
is the most visited paid monument in the world and
represents Paris iconographically. Climbing the stairs of
the tower, I was able to take my time viewing the iron
filigree, and to realize how good a thing it was that the
tower had not been pulled down as planned.

*28mm, 1/320 of a second at f/9 and ISO 200, hand
held; processed in ACR and Photoshop; solarized using
a double LAB inversion in Photoshop.*

SOLARIZING USING CURVE ADJUSTMENTS

A Curve adjustment maps the lights and darks in the image into a new combination of lights and darks, so it is not surprising that this tool can be used to create a simulated solarization.

With the Curve adjustment window open (Figure 5-26), the first step is to click on the center of the curve to create a fixed point. Next, pull the right-hand side of the curve down to the baseline. This will create an inverted 'V' shape in the curve histogram, and pull the image into a simulated solarization. Don't forget to convert the color image to black and white for the best appearance.

PHOTOSHOP SOLARIZE FILTER

There's good news and bad news about the Photoshop Solarize filter. The good news is that it is absolutely easy to use. The bad news is that there is no flexibility, and no options; you simply get a black and white solarization.

To use the Photoshop Solarize filter, open your image in Photoshop and copy the image in a new layer (that way you have the unsolarized original). Then, choose Filter ► Stylize ► Solarize.

► FIGURE 5-28: Another architectural view of the Eiffel Tower structure.

► FIGURE 5-29: The Solarize filter is really easy to use.

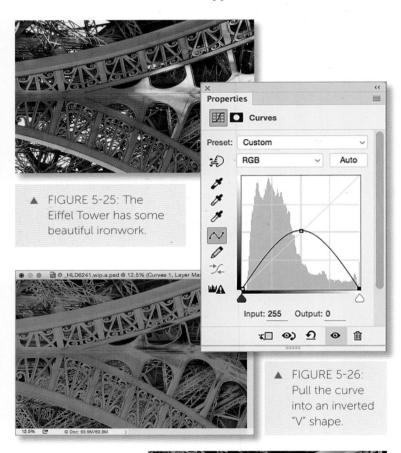

▲ FIGURE 5-25: The Eiffel Tower has some beautiful ironwork.

▲ FIGURE 5-26: Pull the curve into an inverted "V" shape.

► FIGURE 5-27: The finished image after the conversion to black and white.

► FIGURE 5-30: This conversion is quick but doesn't let you select any options.

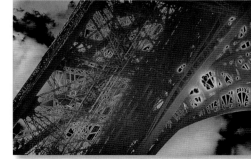

NIK COLOR EFEX PRO SOLARIZATION FILTER

The Nik Color Efex Pro Solarization filter provides the easiest, and arguably the most powerful, way to create simulated solarizations.

To use the filter, start Nik Color Efex Pro. Choose Solarization from the list of filters on the left, and then select one of the twelve Methods—six in color and six in black and white—as shown in Figure 5-32.

◄ FIGURE 5-31: Looking up, the structural view of the Eiffel Tower's ironwork is really nice against the bright sky.

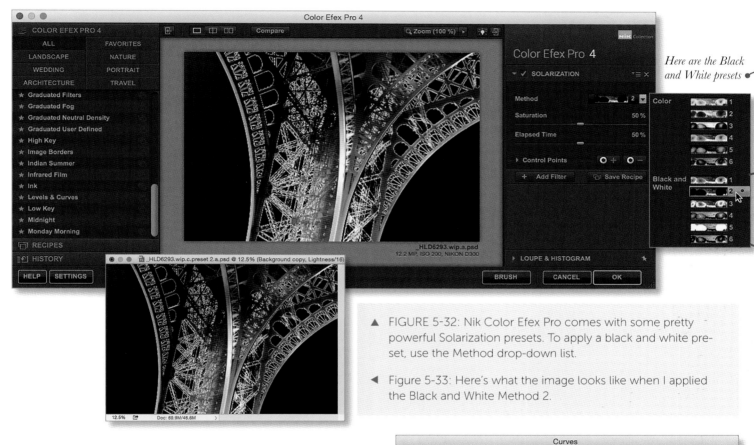

Here are the Black and White presets

▲ FIGURE 5-32: Nik Color Efex Pro comes with some pretty powerful Solarization presets. To apply a black and white preset, use the Method drop-down list.

◄ Figure 5-33: Here's what the image looks like when I applied the Black and White Method 2.

► FIGURE 5-34: After applying Black and White Method 5, which produces a very light result, I applied a curve to the Lightness channel in LAB to make the blacks darker.

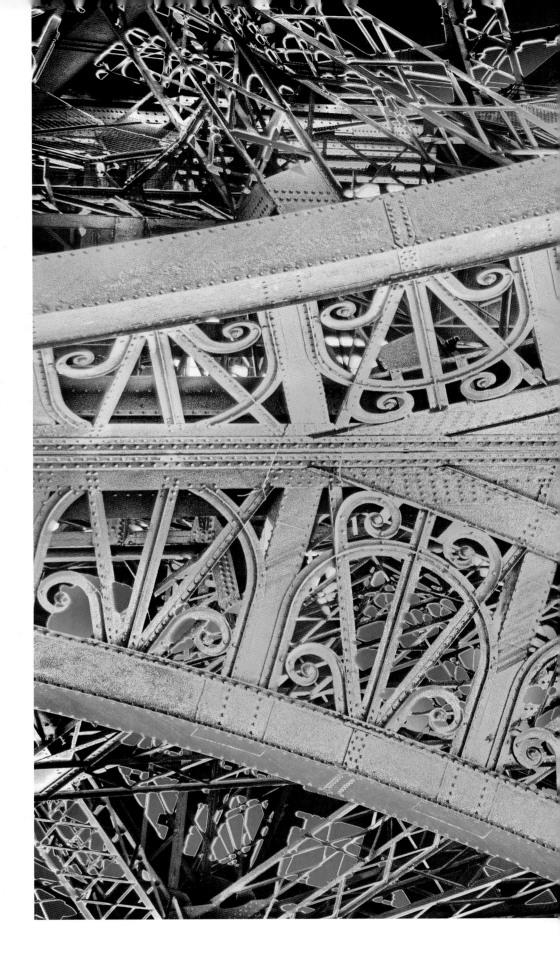

One way to avoid some of the lines at the Eiffel Tower is to walk up the first 66 floors (you can take an elevator the rest of the way from the second deck). This is not as bad a climb as it sounds, as there is no rush going up and great views. This photo was taken from roughly ten flights up the Eiffel Tower, where the stair still is winding within one of the three columns of the base. As you can see, a slow, exploratory walk up the Eiffel Tower is the best way to get a good look at the construction of this extraordinary monument.

It's worth keeping in mind that the Eiffel Tower was not particularly popular when it was planned. The proposed tower was a subject of controversy both because it was feared that it wouldn't be structurally stable and because of the aesthetics. Prominent artists, including de Maupassant, Gounod, and Massenet, all threw their prestige in against the tower. Which all goes to show that you can write great short stories or compose great music, and not know diddly about what makes great architecture or engineering.

56mm, 1/100 of a second and f/5.6 at ISO 200, hand held; processed in ACR and Photoshop; "solarized" using Nik Color Efex Pro Solarization filter, Black and White 2; solarization layer combined with Nik Silver Efex High Contrast preset.

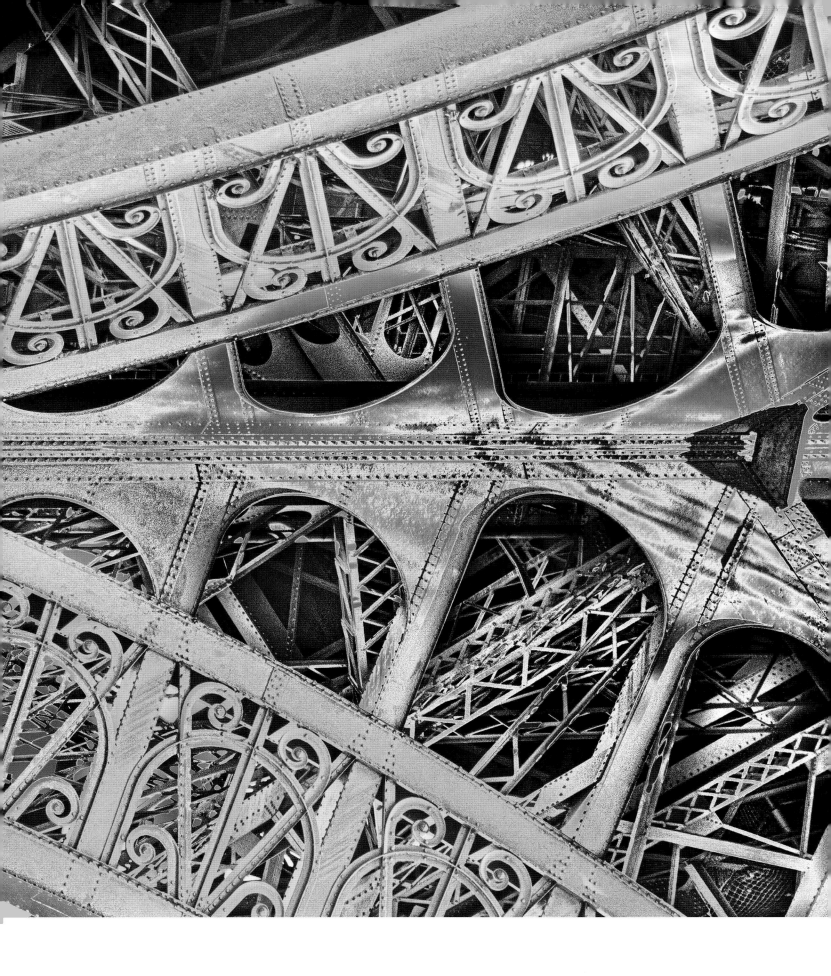

SIMULATED INFRARED

Infrared radiation (IR) is electromagnetic radiation with a wavelength that is longer and a frequency that is shorter than that which produces visible light. Capturing imagery using IR has forensic and scientific applications. But there are no production consumer IR cameras available. While it is fairly easy to have an older model digital camera retrofitted for IR photography, it's also possible to simulate infrared photography in the digital darkroom. Personally, I've never been a great fan of colored IR photography, because the colors look so unnatural, and not (in my opinion) unnatural in a good way. But black and white IR, whether actual or simulated, can be quite visually compelling.

SIMULATED IR USING A PHOTOSHOP BLACK & WHITE ADJUSTMENT LAYER

You can simulate a mild infrared effect in Photoshop by applying a black and white adjustment. Choose Infrared from the drop-down preset list in the Black & White Adjustments window. Note that the Photoshop Infrared preset works best if you start with a color version of your image—rather than an image that has already been converted into black and white. This is true in general for simulated IR conversions, because the color information helps that software understand how best to make the image appear as if it were actual (rather than virtual) IR. An example of simulated IR conversion using the Photoshop preset is shown on page 222.

IR SIMULATION WITH NIK COLOR EFEX PRO

With the Nik Color Efex plugin installed, it is easy to apply a simulated infrared effect. In Photoshop, choose Filter ► Nik Collection ► Color Efex Pro. Next, from the filter list in Color Efex choose Infrared Film (Figure 5-35). You can see the finished image on page 221.

You should note that the Color Efex Infrared filter provides a drop-down list with nine IR conversion methods. It's worth experimenting with these to see which you like best. If you choose a color conversion method, you can also convert to black and white in a subsequent step.

Sometimes one part of an image looks great in simulated infrared, but another part not so much. The solution is to process the image twice, once for simulated infrared, and once more conventionally.

For example, with the view of Paris rooftops and the Eiffel Tower shown on page 223, I liked the very infrared look in the foreground, but not the way the IR simulation rendered the distant view of the Eiffel Tower and the sky. So I processed the foreground using simulated IR with Nik Color Efex Pro, and then combined that version with a more conventional black and white conversion for the sky and tower. I then combined the two using layers and a gradient.

▲ FIGURE 5-35: After selecting Infrared Film from the preset list (on the left), use the Method drop-down list (circled on the upper right) to select an IR conversion method.

▶ Wandering along the right bank of the Seine River, I noticed a graceful row of trees hugging a high wall. I stopped to create an impressionistic view of the scene using a motion blur.

28mm, 3/10 of a second at f/22 and ISO 50, hand held; processed in Photoshop with simulated Infrared Film Method 1 applied using Nik Color Efex Pro.

There's nothing more typically Parisian than a row of gracious old trees in a park, with benches for enjoying the view and watching people pass by. To capture this feeling, I used a long hand-held exposure, intentionally adding a motion blur to the image for an impressionistic feeling.

35mm, 4 seconds at f/4.5 and ISO 50, hand held; processed in Photoshop and converted to monochrome using a Photoshop Black & White Adjustment layer set to the Infrared preset.

Infrared conversions often render green foliage as white (like the trees in this image). But when I processed this image I also wanted to show the distant view (and Eiffel Tower) more naturally, so I used a gradient to blend the conventionally converted black and white background view with the IR version of the foreground.

35mm, 1/30 of a second at f/20 and ISO 200, tripod mounted; processed in Photoshop with simulated Infrared Film filter in Nik Color Efex Pro applied to the foreground.

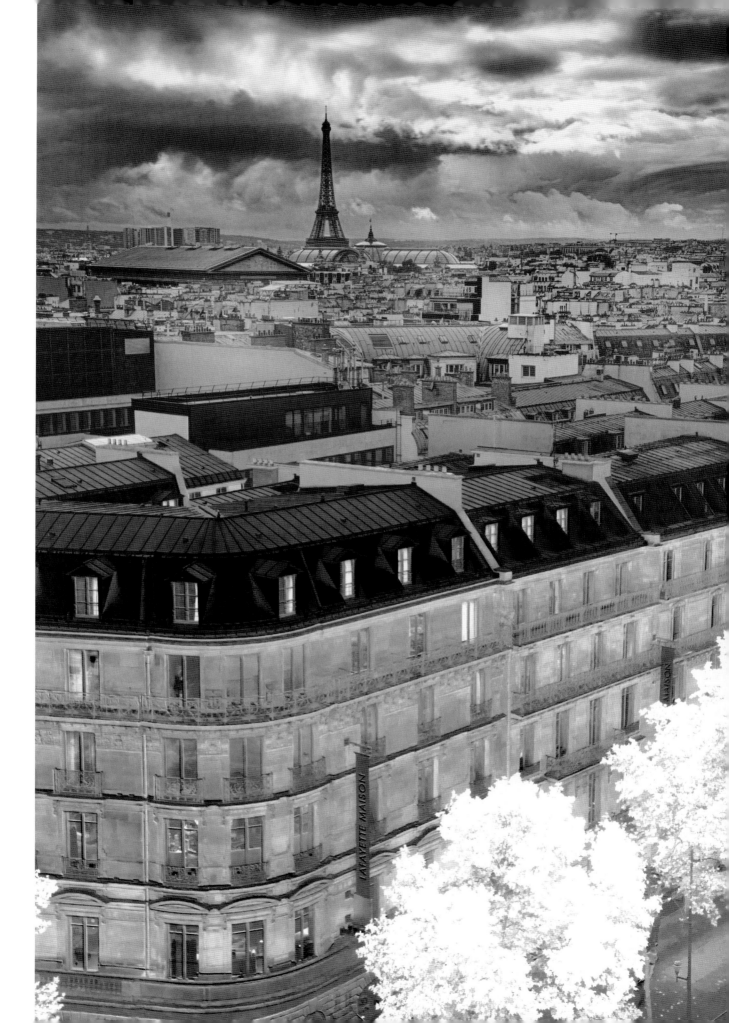

ARTFUL BLACK AND WHITE EFFECTS WITH TOPAZ

Topaz Labs produces a number of plugins that work with Photoshop and Lightroom. The Topaz software is particularly known for its effective painterly and artistic effects, in addition to the B&W Effects software used for black and white conversion, which is detailed on pages 124–127.

With the word "painterly" color comes to mind. But interestingly, there are several black and white filters hidden away within these otherwise colorful Topaz plugins. A selection of these "hidden" filters that you may wish to experiment with are shown in the table below.

Generally, my advice is to use these filters with care to add a little spice to your black and white images.

You almost never want to use them full strength because they can take over your image. One strategy is to always apply the effect to a duplicate layer, and then reduce the opacity of that layer, thereby reducing the strength of the effect.

These near-monochromatic filters can also be very helpful in creating unique black and white photographic effects. Once you apply one (or several) filters to your image (remember that you can always use layers and masking to blend several effects as shown on pages 149–151), you can complete the black and white conversion using the methods described in Chapter 3.

For other examples of images in this book that have benefited from a touch of Topaz, take a look at pages 74–75, 177, and 209.

◄ FIGURE 5-36: You can see the original photo in the view box at the upper right of the Topaz Glow window. When I selected the Elysium filter, the result was a black and white image with intense darks and lights that really brought out the lines and shapes. Since I was applying this to a duplicate layer, I was able to reduce the ferocity of this filter using the Layer panel's Opacity slider.

SELECTED BLACK & WHITE WITH TOPAZ

TOPAZ PLUGIN	BLACK & WHITE FILTERS
Topaz Adjust	Grunge Me BW, Sketch Pencil
Topaz Glow 2	Elysium, Heavy Metal II
Topaz Impressions 2	Charcoal, Sketchwork III
Topaz Simplify	BuzSim, Black and White, Oil Painting Black and White, Wood Carving

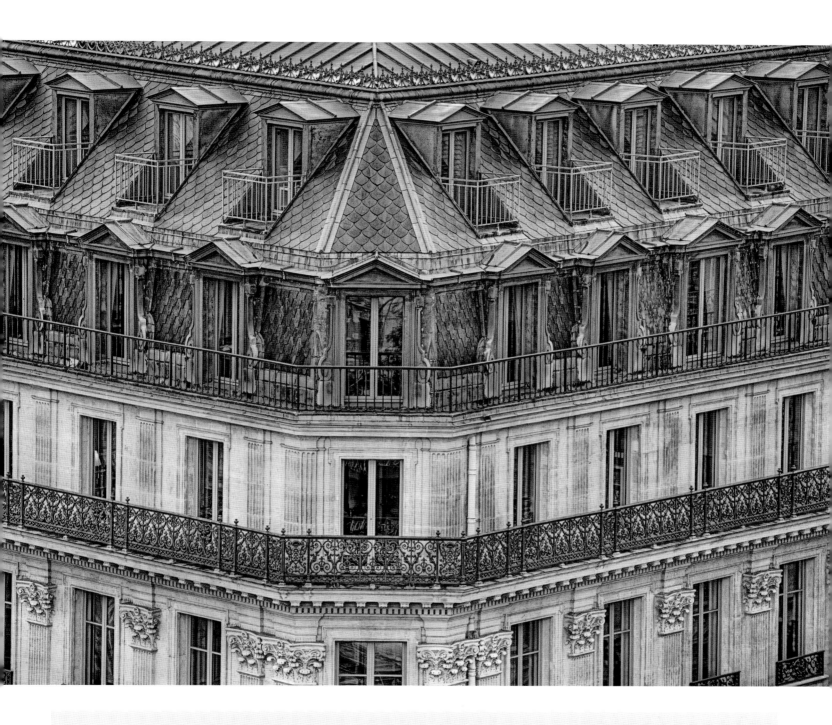

▲ To the frustration of Ancien Régime kings and Napoleonic emperors, the common people of Paris were completely capable of revolution using any means at hand including cobblestones when the times called for it. Putting down the revolts of the Parisians was complicated by the narrow, winding medieval streets of the old capital.

Napolean III finally decided to put an end to this situation and engaged Baron Haussmann to plow wide boulevards through swaths of the city, leaving only the Marais in the First Arrondisement intact. Troops could march with their cannons, many abreast, up and down these new streets, and regular Empire-style apartment buildings went up along them to house the newly rising class of bourgeoisie.

135mm, 1/200 of a second and f/8 at ISO 200, hand held; processed in Photoshop, with Topaz Simplify Wood Carving filter added.

ANTIQUE, VINTAGE, AND FILM EFFECTS

There are a raft of antique, vintage, and film effects that you can add to black and white images using third-party plugins. These effects will not be suitable or appropriate for all images, so the best advice is to experiment. Many of these effects are named after simulations of antique and vintage chemical processes and (in some cases) specific older cameras.

Appropriateness is largely going to depend on the subject matter and nature of your image, as well as the feeling you want to convey—modern architecture may not work as well in an antique treatment as a romantic, older castle.

Since many of the antique, vintage, and film effects involve backgrounds, textures, and borders, your intended presentation of the image should also be considered when choosing one of these effects. In other words, think about how good the effect will look when printed, and whether you plan to print the image in a way that works visually with the effect that you've chosen.

While the elements that go into these effects may be visually complex, applying them using Lightroom and Photoshop plugins is not. The table below shows where to find some of my favorite finishing effects within the Photoshop ecosystem. You can find a number of my images that use these effects in *The Photographer's Black & White Handbook*; for example, on pages 134–135, 192, and 227–229.

◀ FIGURE 5-37: On1 Perfect B&W 19th Century Processes filters really cover the gamut of different antique film techniques. You can play around with these filters and use them to add a touch of antique to your photos.

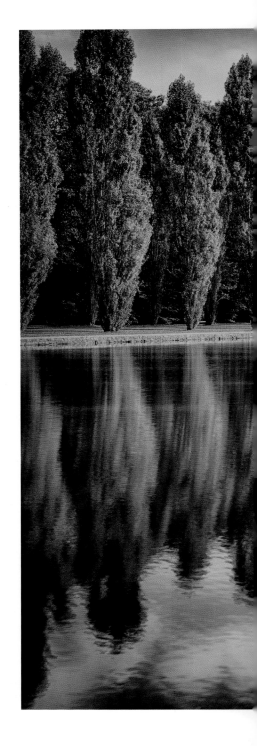

SELECTED VINTAGE EFFECTS

PLUGIN SOFTWARE	ANTIQUE, VINTAGE, OR FILM EFFECTS
Nik Analog Efex Pro	Classic Camera, Vintage Camera, and Wet Plate in the Camera Toolkit
Nik Silver Efex Pro	Film Noir, Antique Plate, and Pinhole presets
Perfect B&W	19th Century Processes and TrueFilm tabs
Topaz B&W Effects	Traditional Cyanotype, Van Dyke Brown, Opalotype, and Platinum collections

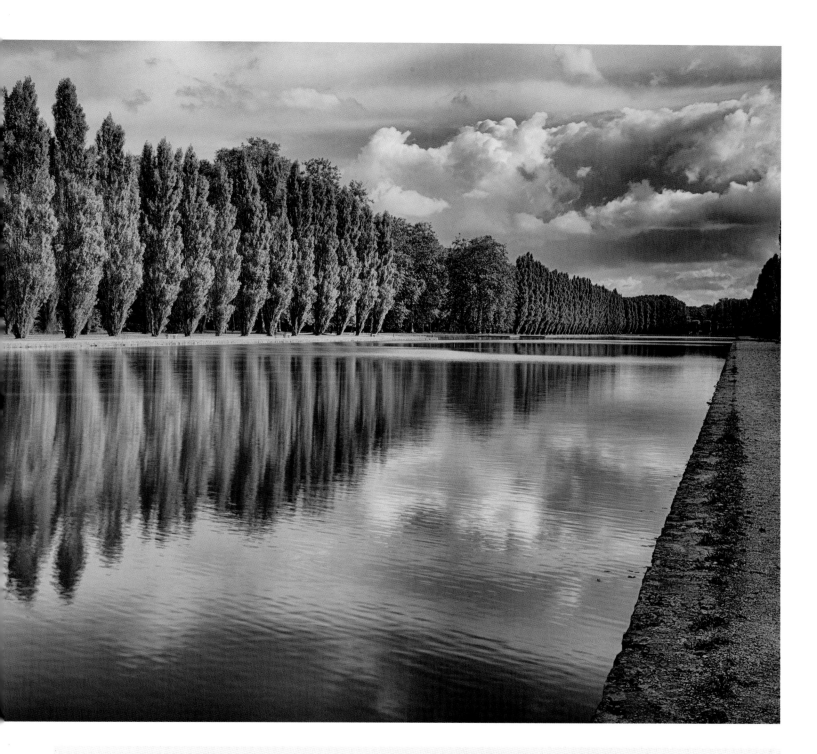

▲ The Parc de Sceaux, a lesser-known creation of André Le Nôtre, lies on the periphery of Paris near the bedroom community of Bourg-la-Reine. André Le Nôtre was the Frederick Law Olmsted of France. Like Olmsted, Le Nôtre is the essential landscape designer of his country. In Olmsted's case, much of the inspiration came from park-like wilderness, such as the floor of Yosemite Valley, while Le Nôtre's creations—including the gardens at Versaille, Fountainebleau and the Tuileries—are formal, and involve long vistas with aisles of sight running to the vanishing point, as well as very regular and symmetrical shapes both small and large.

I looked for an effect that complemented the formal and essentially antique nature of the subject matter, and added a Classic Camera preset from Nik Analog Efex.

35mm, 1/30 of a second and f/16 at ISO 100, tripod mounted; processed in Photoshop with Classic Camera 2 preset from Nik Analog Efex applied.

▲ The underlying photography in this image consists of two separate captures of trees reflected in a puddle that I made in the Parc de Sceaux in suburban Paris, France, with the camera on a tripod. One photo was made when the water was still, so the reflections of the trees were very clear. The other was made from the same position when it was windy, so that much of the image consisted of motion blur. Both were shot for as much depth-of-field as possible at f/22.

After combining the two photos in Photoshop, I applied the Calotype Glass Negative preset from Perfect B&W's 19th Century Processes tab. The Calotype preset digitally simulates an early photographic process invented by William Henry Fox Talbot that exposed a silver iodide coated substrate to light. The simulation shown here would have been of a print made from a calotype glass negative, rather than the negative itself.

200mm, two exposures with different points of focus, each exposure at 4/5 of a second at f/22 and ISO 100, tripod mounted; processed in Photoshop, simulated Calotype effect added in Perfect B&W.

▶ I photographed this sunflower on a light box in my studio, then processed it using techniques that I have developed for high-key floral photography. When processed in its color version, this leaves an image with maximum translucency and a pure white background.

Looking at the image, I decided to convert it to black and white and also tried a number of simulated historical effects. This version has a simulated ambrotype effect added, essentially an irregular border and a tint applied to a high-key image. If you are interested, historically, the ambrotype process involved printing on glass using a variation of the wet-plate collodion-glass process—so viewing an ambrotype meant looking at a reflective glass print, often in a velvet case. I know the viewing experience of looking at my image of a sunflower is not exactly like looking at an ambrotype, but nonetheless this creative anachronism does bring up visual associations with the historical process.

55mm, 1/2 of a second at f/16 and ISO 64, tripod mounted; processed in Photoshop with simulated Ambrotype effect added in Perfect B&W.

BORDERS

Adding a border to an image can add a nice finishing touch—particularly when you are going to make a fine art print—whether your intention is to create a sleek, modern image with an industrial edge or something more along the antique line as shown to the right. You'll also find some other border examples on pages 15, 19, and 122.

How you plan to print an image should impact your choice of border, since printing itself often produces borders that should be complemented by your border selections.

Depending on the black and white conversion technique you've chosen, a border may already be included (this is most common with simulated antique or film conversions). If not, a custom border can be added to any black and white conversion when you are using Silver Efex Pro, Perfect B&W, or Topaz B&W Effects:

- In Silver Efex Pro, choose a Border Type from the Image Borders drop-down list in the Finishing Adjustments tab.

- In Perfect B&W, turn on the Borders toggle. Next, choose a Category, Border, Blending, Opacity, and Size.

- In Topaz B&W Effects, expand the Finishing Touches panel and check the Borders box. Next, select a Border Type from the drop-down list, and then use the slider to assign a size.

▶ On May Day, a national holiday in France, the fountains were going full force in the Parc de Sceaux near Paris. Since it was a holiday weekend, the park was full of people, who showed up as "ghosts" in this bracketed exposure sequence, combined using HDR. I removed most of the ghosts in post-production, but if you look closely, you'll see that I left a few ghosts to wander in this enchanted garden.

70mm, two exposure sequences (one fast—a three exposure sequence to stop motion at ISO 320 and f/8, with exposures ranging from 1/80 to 1/500 of a second; one slow—a four exposure sequence at ISO 50 and F/32, with exposures ranging from 1.3 seconds to 1/6 of a second), tripod mounted; exposures combined and processed in Photoshop and Nik HDR Efex Pro, and then converted to black and white in Nik Silver Efex with a Type 11 Border added.

PRINTMAKING

Creating beautiful prints of one's work is one of the most important goals for photographers—at least those who aspire to being artists. This is perhaps even truer when the work is in black and white rather than color. While the tools of printmaking have changed with the advent of digital photography and high-end pigment inkjet printers, this remains at its best a demanding and artisanal handcraft. The topic of print making is a large one, certainly beyond the scope of this book (and perhaps worthy of its own title). But if you keep this overview in mind, you'll get started down the right road with printing.

CREATING A MASTER FILE

In the workflow chart on pages 30–31, I indicate that the goal of a black and white digital workflow is to create a master file. It's important to safely archive this master file, keeping it agnostic as to issues such as printer, paper, and even print size.

After you've archived the master file, the idea is to create a separate file for each different printer, paper, and size combination that you use to make a print. This has the advantage that once you find a paper, size, and settings you like you can easily replicate your print without having to "reinvent the wheel" each time. Since your master file has remained untouched, you have it available if you decide next time tio experiment with printing your image in a very different way.

PRINTERS AND PRINTING INK

Printers and inks designed to reproduce a high dynamic range will be more likely to give you satisfactory black and white prints. The two leading manufacturers of high-end printers are Canon and Epson. Canon's high-end printers use Lucia pigment inks (with 12 inks for high-end Canon printers), and Epson's high-end inks are called Ultra-Chrome HDR (with 11 inks for high-end Epson printers). These two sets of ink are essentially comparable.

Both Canon and Epson inks when used properly in a high-end printer on an appropriate paper can yield a top-notch fine art monochromatic print. The ink set for the high-end Canon is worth mentioning in the context of black and white, as it includes five inks specifically designed for grayscale reproduction in the Canon ink set (the Epson equivalent has four monochromatic inks).

Both Lucia and UltraChrome HDR inks are highly regarded for longevity and archival stability.

PAPER

Some images look better on certain papers, and other images look better on other papers. The best bet is to experiment with your paper choices, and see what works best with your specific photo.

That said, it is worth bearing mind that brighter paper can reproduce a higher tonal range, and therefore brightness in a substrate is one of the characteristics one should consider in evaluating the paper for suitability for black and white printmaking. It's not intuitively obvious why a brighter paper can reproduce a broader dynamic range, so think of it this way: The brighter the paper is, the more it can reproduce very white whites, but you can still cover it with black. Duller paper on the other hand can still reproduce fully dark blacks, but won't be able to show high-key portions of an image with as much luminosity. To fully render my black and white images, I look for a paper with an ISO Brightness rating of 92% and up (check the data sheet that comes with the paper for this information).

The caveat here is that sometimes it makes sense to print on less bright paper for aesthetic reasons. If you want a watercolor look, then you'll want a paper with a water-color-like surface, and it is unlikely to reproduce with as much tonal separation as a more photographic paper.

The high-end paper companies—such as Cason, Hahnemuhle, and Moab—have sample books available that are generally free, and sample packs you purchase at a nominal cost to try a variety of papers. Personally, I am partial to the Moab Paper line of papers; however, in full disclosure, Moab is a sponsor of mine. Be that as it may, you can find a great deal of information about printing on the Moab blog, moabpaper.com/blog.

ICC PROFILES

An ICC profile is a file that can represent the color gamut for a particular paper and printing device—for example, a particular printer when loaded with a specific paper. A good ICC profile intended for a specific substrate and printer is a must for fine art printing—and should be available for online download from the paper vendor for most quality printers. Using an ICC profile, and a monitor profiled using a color photospectrometer, are both essential for quality printmaking with consistency.

Instructions for installing ICC profiles in Adobe Photoshop can be found in many places on the Internet. One good source is Moab paper at http://moabpaper.com/profile-use-and-installation/.

The general principle is to work in as wide a color gamut as possible for as long as possible. At the end of your workflow, as I mentioned, you save a master copy of the file, and use a duplicate to experiment with the impact of printing on different papers. This impact can be simulated (also called "soft proofing") in Photoshop on your profiled monitor by using the Edit ► Convert To Profile panel. The ICC profile for your specific paper and printer is selected, just as you would convert between RGB and LAB.

If you don't like what you see in terms of color shifts in perceptual values after switching to the ICC profile for your paper, then you can try another paper (with a different profile)—or adjust the image itself to get the profiled image closer to your concept of what it should look like.

PROFILING YOUR MONITOR

The point of profiling your monitor is to have a steady point of reference, so when you evaluate an image as it appears with a particular printer-and-paper profile you have an apple-to-apples comparison. Profiling is accomplished by placing a color photospectrometer, such as the ColorMunki from X-Rite, www.xrite.com, in front of your monitor (usually it hangs down on the connecting cord that syncs with your computer), then following the steps recommended by the software that ships with the spectrometer.

You can find a good overview of the steps to take in a profiling workflow at www.dpbestflow.org/color/monitor-calibration-and-profiling. Consumer versions of the Color-

Munki are generally available for less than $100, although you may wish to get a more expensive profiler if you have multiple monitors (and computers) that you work with.

DISPLAYING PRINTS FOR PRESERVATION

It makes no sense to go to a great of effort to create a beautiful fine art print on archival paper using archival inks, and then to display the print without taking good care of it. A properly cared for print can last hundreds of years, but this requires careful storage, or if you want to display your print, framing using acid-free, archival materials, with as little touching the actual print as possible. Special "corners" can be used to hold the print in place.

It also is important to protect a print that is displayed from UV radiation, which is present in sunlight. This is accomplished using special glass or plexiglass that has been treated to reduce UV.

Generally, if you ask a quality framer for "conservation" or "museum" framing your print will be protected, but of course this kind of framing is expensive.

The Library of Congress has published some useful guidelines on framing works on paper for long-term preservation at www.loc.gov/preservation/care/mat.html.

▲ PAGES 232–233: I photographed this model in black lingerie on a black seamless paper background using studio lighting. My idea was to create an image that played with positive and negative space by contrasting the black background and lace with the light skin tones of the model.

To further emphasize the contrast between black and white, I prepared a second version that flipped black for white and white for black using a LAB Lightness channel inversion and solarization. The impact is to create an alternative negative space universe, where the skin tones are dark and the lingerie is white.

55mm, 1/160 of a second at f/9 and ISO 250, hand held; studio strobe lighting, photographed on a black background; processed in ACR and Photoshop, and converted to black and white using Nik Silver Efex Pro (page 232); inverted using LAB with solarization in Nik Color Efex Pro (page 233).

RESOURCES

If you'd like to learn more about my work, please check out my website, digitalfieldguide.com, and my blog, digitalfieldguide.com/blog. You'll find my upcoming workshops and events listed at digitalfieldguide.com/learning/workshops-events.

The Photographer's Black & White Handbook has touched on a number of topics that are beyond the scope of this book to cover in detail.

Here's where you can go for some more information in my other books:

- For working with Photoshop, and LAB color in particular, *The Photoshop Darkroom* (Focal Press).

- Extending dynamic range, and multi-shot sequence processing: *Creating HDR Photos* (Amphoto) and *Monochromatic HDR Photography* (Focal Press).

- Working with Photoshop filters and plugins, and creating painterly photographic images: *The Way of the Digital Photographer* (Peachpit Press).

- The "vision thing"—how to become a better photographer: *Achieving Your Potential As a Photographer* (Focal Press).

The great Muhammad Ali once said, "Impossible is not a fact. It's an opinion. Impossible is not a declaration. It's a dare. Impossible is potential. Impossible is temporary. Impossible is nothing." This is nowhere more true—at many levels—than in the contemporary art and craft of digital photography. As Yoda says, "Do or do not, there is no try." So now it's your turn. Go out, make pictures, make art, and enjoy yourself!

SOFTWARE IN THIS BOOK

Adobe Camera RAW (ACR), Bridge, Lightroom, and Photoshop are products of Adobe Systems Incorporated, www.adobe.com, and available in a monthly subscription as a "photographer's bundle" or as part of the Adobe Creative Cloud product.

Nik plugins run from within Lightroom and Photoshop, and are available from www.google.com/nikcollection/. The Google Nik software discussed in this book includes Color Efex Pro, HDR Efex Pro, and Silver Efex Pro.

Perfect B&W is a product of On1, Inc., www.on1.com, and runs either as a standalone, or as a plugin within Lightroom or Photoshop.

Topaz plugins run from within Lightroom and Photoshop, and are available from www.topazlabs.com. The Topaz Labs software discussed in this book includes Topaz Adjust, Topaz B&W Effects, and Topaz Simplify.

Adobe Camera Raw (ACR): Used to convert RAW files into files that Photoshop can open.

Ambient light: The available, or existing, light that naturally surrounds a scene.

Aperture: The size of the opening in the iris of a lens. Apertures are designated by f-numbers. The smaller the f-number, the bigger the opening, and the less depth-of-field.

Blending mode: Determines how two layers in Photoshop will combine.

Bracketing: Shooting many exposures at a range of settings. It often works better to bracket shutter speed rather than aperture.

Brush Tool: Used to paint on a layer or layer mask in Photoshop.

Channel: In Photoshop, a channel is a grayscale representation of color (or black) information. In RGB color there are three channels: Red, Green, and Blue.

Chiaroscuro: Moody lighting that shows contrasts between shadows and brightness.

CMYK: Cyan, Magenta, Yellow, and Black. The four-color color model used for most offset printing.

Color space: A color space—sometimes called a color model—is the mechanism used to display the colors we see in the world, in print, or on a monitor. CMYK, LAB, and RGB are examples of color spaces.

Composite: Multiple images that are combined to create a new composition.

Depth-of-field: The field in front of and behind a subject that is in focus.

DSLR: Digital single lens reflex camera.

Dynamic range: The difference between the lightest tonal values and the darkest tonal values in a photo.

EV (Exposure Value): Denotes any combination of aperture, shutter speed, and ISO that yields the same exposure. −1 EV means halving the exposure, and +1 EV means doubling the exposure.

Exposure: The amount of light hitting the camera's sensor. Also the camera settings used to capture this incoming light.

Exposure histogram: A bar graph displayed on a camera or computer that shows the distribution of lights and darks in an image.

f-number, f-stop: The size of the aperture, written f/n, where n is the f-number. The smaller the f-number, the larger the opening in the lens; the larger the f-number, the smaller the opening in the lens.

Focal length: Roughly, the distance from the end of the lens to the sensor. The sensor's position is also called the *focal plane*. The location of the focal plane (the distance from which focal length is measured) is indicated on most camera bodies with a special symbol, ⊖. The horizontal line in the symbol indicates the position of the focal plane, used for determining the focal length when it is needed precisely.

Gradient: A gradual blend, often used when working with layer masks in Photoshop.

Grain: Texture found in photographic film and prints due to the residue of small grains of metallic silver left over from chemical developing. Grain can be simulated in a digital photo.

Grayscale: Used to render images in a single color from white to black. In Photoshop a grayscale image has only one channel.

Hand-HDR: The process of creating an HDR image from multiple photos at different exposures without using automatic software to combine the photos.

HDR: Extending the dynamic range in an image using techniques including multi-RAW processing, hand-HDR, and automated HDR software.

High key: Brightly lit photos that are predominantly white, often with an intentionally "overexposed" look.

Histogram: A bar graph that represents a distribution of values. An exposure histogram is used to display the distribution of lights and darks in an image.

Hyperfocal distance: The closest distance at which a lens at a given aperture can be focused while keeping objects at infinity in focus.

Infinity (∞): The distance from the camera that is far enough away so that any object at that distance or beyond will be in focus when the lens is set to infinity, regardless of aperture.

Infrared (IR) photography: Captures made using infrared rather than normal, visible light.

ISO: Scale used to set a camera's sensitivity to light.

JPEG: A compressed file format for images that have been processed from the original RAW file.

LAB color: A color model consisting of three channels. The Lightness (L) channel contains luminance (black and white) information, the A channel contains magenta and green, and the B channel holds blue and yellow.

Layer: Photoshop documents are composed of layers stacked on top of each other.

Layer mask: Masks are used to selectively reveal or hide layers in Photoshop.

Low key: Dimly lit photos that are predominantly dark, often with an intentionally "underexposed" look.

Monochrome, monochromatic: Black and white. A monochrome image is presented as nominally consisting of tones from white to black even when the underlying file actually contains color channels. Digital "black and white" images can be tinted or toned, and so may vary from straight grayscale.

Multi-RAW processing: Combining two or more different versions of the same RAW file to extend the dynamic range and create a more pleasing final image.

Pinhole camera: A camera that uses a literal, very small hole as the lens to capture an image. Also called a *camera obscura*, one of the earliest capture mechanisms in use.

Pre-visualization: Seeing how an image will come out after capture and processing before making an exposure.

RAW: A digital RAW file is a complete record of the data captured by the sensor. The details of RAW file formats vary between camera manufacturers.

RGB: Red, Green, and Blue. The three-color color model used for displaying photos on the Web and on computer monitors.

Shutter speed: The interval of time in which the camera shutter is open.

Solarization: Reverses, or partially reverses, blacks and whites. In film photography, using re-exposure to make partially developed material lighter, simulated in digital photography; also known as the Sebattier effect.

Split Toning: Toning with two colors. Often one toning color is applied to highlights and the other to shadows.

Tinting: Adding color to a monochromatic image.

Tonal range: The range of color and light and dark values in an image.

Toning: In the chemical darkroom, toner such as sepia or selenium was added for visual effect. In the digital darkroom, toning simulates the impact of chemical toning.

A

Adams, Ansel, 18, 174
Adjustment layers
 Black & White, 182
 Brightness/Contrast, 154
Adobe Bridge, 98, 142, 236
Adobe Camera Raw (ACR), 28,
 92, 136–139, 142–145, 145,
 168–169, 190, 236
 black and white conversion in,
 98–101
 HSL/Grayscale tab, 100–101
 settings menu, 101
 Snapshot tab, 101
 Split Toning tab, 190
 vs Lightroom, 102
 Workflow Options dialog, 101
Adobe Creative Cloud, 236
Adobe Lightroom, 10, 28, 32,
 92, 98, 136–140, 142, 161,
 168–169, 180, 193, 236
 Adjustment Brush Tool, 140
 B&W Presets, 108–109
 B&W Toned Presets, 109
 Black & White Basic Treatment,
 104–105
 Black & White Mix panel,
 105–106
 black and white, in, 102–109
 Develop panel, 104
 exporting as a layer stack, 149
 file export, 104
 Graduated Filter Tool, 140
 HSL/Color/B&W tab, 105
 multi-RAW processing, 140
 opening as layers in Photoshop,
 140
 roundtrip to Photoshop, 104
 Split Toning tab, 193
 virtual copy
 creating, 140
 exporting, 140
 vs ACR, 102
Adobe Photoshop, 10, 28, 98, 102,
 136–138, 142, 149–157,
 161, 168–169, 176,
 180–182, 193–199, 236
 basic conversion, 110–113
 Black & White Adjustments,
 118–121, 182, 193–195
 High-Contrast Red Filter,
 188
 Maximum Black preset, 188
 Maximum White, 182
 presets, 120
 black and white conversion, in,
 110–121
 blending modes, 157
 categories, 157
 dynamic range, extending
 with, 157
 Multiply, 157

 Normal, 157
 opacity of, 157
 Screen, 157
 Brightness/Contrast Adjust-
 ment, 154
 Brush Tool, 142, 151, 157, 169,
 182, 188, 200, 202
 Channel Mixer, 116–117
 Color Picker, 193
 Color Range dialog, 194
 contrast, extending, 154
 curves, 158, 210
 Gradient Tool, 142, 149, 150,
 182
 grayscale, in, 112
 History Brush, 200
 History panel, 200
 History states, 200
 Hue/Saturation Adjustment,
 112, 193
 ICC profile, 235
 Infrared preset, 220
 Invert adjustment, 194–195
 LAB color, defined 110
 LAB color, dropping color, 112
 layer masks, 120, 144, 149,
 150–151, 168–169, 186,
 200
 Hide All, 149, 151, 157,
 169, 186, 200, 202
 Reveal All, 149
 layers, 123, 132, 144
 creating new, 180
 opacity, 168–169, 200
 stack, 168–169
 Layers panel, 118, 180–182
 Lens Correction dialog, 208
 Luminosity blending mode, 112
 Make Mask button, 194
 Move Tool, 149
 opacity, 168–169
 Paint Bucket Tool, 180, 186
 panorama, 27
 plug-ins, 176
 Red Filter, 120
 Solarization filter, 216
 split toning, 194–197
 Tint swatch, 193
 Tool panel, 149
ambrotype, simulated, 228
antique effects, 226–229
Autogain (in multiple exposures),
 199

B

backgrounds, 226–229
black and white, 14–26
 adjustments, 118–121, 182,
 193–195
 Adobe Lightroom, and,
 102–109
 antique effects, 226–229

 border, adding, 28, 230–231
 colorizing, 200–201
 composition, 41, 44–45, 46
 contrast, and, 21
 converting to, 84–133, 168–169
 effort vs quality, 92–95
 in ACR, 98–101
 creative effects, 174–231
 film effects, 226–229
 finding subject matter, 38–81
 grain, adding, 28
 in Photoshop, 110–121
 lighting, and, 176–180
 night photography, and, 74–77
 patterns, and, 23
 photographing people, 78–81
 presets in Photoshop
 High-Contrast Red Filter,
 38, 188
 Maximum Black, 188
 Maximum White, 182
 pre-visualization, 45
 selective color, adding back in
 200–201
 solarization, virtual, 28,
 214–219
 special effects, 28
 split toning, 190–199
 tinting, 14, 190–199
 tonal range, extending, 136–171
 toning, 28, 190–199
 workflow, 26–34, 30–31, 84–86,
 86
black and white printing. *See*
 printing
blending modes, 157
 categories, 157
 drop-down list, 112
 Luminosity, 112
 Multiply, 157
 Normal, 157
 opacity, setting, 157
 Screen, 157
blurs, 202, 208
 Blur Gallery, 202
 BuzSim (Topaz Simplify), 202
 Classical Soft Focus (Nik Color
 Efex Pro), 202
 Gaussian, 208
 Iris blur, 202–205
 Lens Distortion (Nik Analog
 Efex Pro), 202
 Lens Effects (Topaz), 202
 Path Blur, 202
borders, 28, 226–229, 230–231
bracketing, 63, 161–165
 sequence, 161–165
 shutter speed versus aperture,
 161
Brush Tool, 142, 151, 157, 169,
 182, 188, 200, 202
burning, 168

 border, adding, 28, 230–231
 colorizing, 200–201
 composition, 41, 44–45, 46
 contrast, and, 21

C

calotype, simulated, 228
camera obscura, 207
Canon printers, 234
Channel Mixer, 116–117
CMYK, 26, 210
color
 implied, 23, 45
 model, 210
 opponent, 210
 space, 210
 converting between, 158
 diagram, 210
 gamut, 210
 LAB color, 158
colorizing, 200–201
ColorMunki, 235
composition
 black and white, 41, 44–45, 46
 formal, 23
content management system
 (CMS), 28, 31, 32
contrast, 68–72
 black and white, and, 21
 extending in Photoshop, 154
 extreme, 45
converting to black and white,
 84–133
creative effects in black and white,
 174–231
curves, 158, 210
 LAB color, using in, 158
 L channel, and, 210
 solarizing with, 216

D

depth-of-field, 202–205, 207
desaturating, 200
digital asset management (DAM),
 32–33
DNG file format, 92
dodging, 168
dynamic range, 45

E

effort versus quality in black and
 white conversion, 92–95
Epson printers, 234
exposure
 bracketing, 63, 161–165
 determining, 179

F

film effects, simulating, 226–229
filters (for camera lens)
 neutral density, 25, 68
 red, 34
finding black and white subjects,
 38–81
focus
 selective, 202–205
 soft, 202–205

formal composition, 23
framing (in composition), 41, 46, 55, 56
framing for preservation, 235

G

gamut, in color spaces, 210
ghost reduction, 184
Gradient Tool, 142, 150, 182
gray, shades of, 68–72
 in Photoshop, 112

H

hand-HDR processing, 138, 161
hand held vs tripod, 161, 168
hand painting, 200–201
HDR (High Dynamic Range), 138, 161–167
 automated, 161
 by hand, 138, 161
 monochromatic, 138, 166
 panorama, 27
high key, 8, 41, 60–64, 180–185
History Brush, 200
History panel, 200
HSL/Grayscale tab in ACR, 100–101

I

ICC profile, 235
implied color, 45
infrared, simulated, 220–223
intervalometer, 74
Inversion adjustment (in LAB), 194–195, 210–213
iPhone, 10, 86
iPhone apps
 Filter Storm, 84
 Lo-Mob, 38, 46, 84, 91, 128, 136, 174
 Mextures, 174
 Snapseed, 84, 86, 91, 131, 174
IR (infrared)
 camera vs simulation, 176, 220
 Infrared filter (Nik Color Efex Pro), 220–223
 Photoshop Infrared preset, 220
ISO, 73
ISO brightness rating (paper), 234

J

JPEG, 86, 91–92, 168
 to JPEG conversion, 95
 versus RAW, 91–92

L

LAB, 110, 158, 210–215
 contrast enhancement, and, 158
 double inversion (solarization), 214–215
 dropping color, with, 112
 inversions, 210–213
 L channel inversion, 214–215
 profile, converting to, 158
layers. See Photoshop, layers

layer masks. See Photoshop, layer masks
Layers panel, 118, 180–182
Lensbaby, 202
lighting
 black and white, and, 176–180
Live View, 186
low key, 8, 41, 60–64, 186–189
Lucia pigment inks, 234
Luminance (L channel), 210

M

master file in printing, 234–235
MEF (Mamiya) RAW file format, 92
mixed-key, 60
Moab Paper, 234
monitor profiling, 235
monochromatic HDR, 138, 166
multi-RAW processing, 136–138, 142–145, 145, 149–151, 161, 168–169, 180

N

narrative, in photography, 8
negative space, 41, 46, 53–55, 56, 59
neutral density filter, 25, 68
night photography, 74–77
Nik Analog Efex Pro, 226
Nik Color Efex Pro, 236
 Infrared filter, 220–223
 Solarization filter, 217–220
Nik HDR Efex Pro, 28, 161, 162, 236
 alignment, 162
 chromatic abberation correction, 162
 ghost reduction, 162, 184
 Monochromatic presets, 166
 workflow, 162
Nik Silver Efex Pro, 10, 123, 182, 193, 226, 236
 Border Type, 230–231
 Cyanotype preset, 195
 Full Dynamic Range preset, 194–195
 High Key preset, 182
 High Contrast preset, 194–195
 Low Key preset, 188
 Pinhole preset, 208
 Sepia preset, 195

O

overexposure, intentional, 180

P

Paint Brush, 142, 151, 157, 169, 182, 188, 200, 202
Paint Bucket Tool, 180, 186
panorama, in Photoshop, 27
patterns, 49, 56–59
 black and white, and, 23
people, photographing, 78–81
Perfect B&W, 128, 193, 226, 228, 236

Borders toggle, 230–231
Photographer's Ephemeris, The (TPE), 77
pinhole camera effect, 207–210
portraits in black and white, 78–79
positive space, 46, 53
pre-visualization, 23–25, 28, 45, 73
printing, 234–235
 ICC profile, 235
 ISO brightness rating, 234
 master file, creating, 168, 234–235
 workflow, 234–235
ProPhoto RGB, 101
PSD file format, 92

R

RAW, 26, 28, 84, 86, 91–92, 95, 136–138, 140, 142–145, 149, 161, 180, 186
 versus JPEG, 91–92
Red filter (for camera lens), 34
RGB, 26, 110, 210
 ProPhoto, 101

S

Sabattier effect, 214
selective
 color, 200–201
 focus, 202–205
 soft focus, 202–205
soft proofing, 235
solarization, 214–219
 curve adjustment, with, 216
 Nik Color Efex Pro, using, 217–220
 Photoshop filter, 216
 virtual, 28
split toning, 190–199
 color range selection, using, 194–197
sweet spot, 202

T

textures, 226–229
TIFF, 92
tinting, 190–199
tonal gradations and range, 45
 extending, 136–171
toning, 28, 190–199
Topaz Adjust, 224–225, 236
Topaz B&W Effects, 124, 193, 208, 226, 236
 Borders box, 230–231
 Finishing Touches, 230–231
Topaz Glow, 224–225
Topaz Impressions, 224–225
Topaz Simplify, 136, 224–225, 236
tripod vs hand held, 161, 168

U

UltraChrome HDR inks (Epson printer), 234

W

workflow, 26–34, 84–86, 138, 179, 180. 234–235
 color to black and white, 30–31

Z

zone system, 168

PHOTO LOCATIONS

Czech Republic, Prague, 135–171
France
 Bourges, 29
 Bourg-la-Reine, 226–227, 228, 230–231
 Cahors, 24–25
 Dordogne River, 26–27
 Giverny, 201
 Lot River, 20–21
 Montpazier, 15
 Paris, 172–197, 205–225
 Rocamadour, 16-17
 Saint-Cirq-Lapopie, 19
 Sainte-Croix-de-Beaumont, 12–13, 34–35
Japan
 Hongu, 110–111, 121
 Kii Peninsula, 2–3, 82–83, 114, 129, 132–133
 Koya-san, 130
 Kyoto, 93, 98–99, 113, 115, 124–125, 131
 Nachi-san, 122
 Nara, 85, 86, 87, 106–107
 Osaka, 117
 Tokushima, 126–127
 Tokyo, 88–89, 96-97, 102–103, 108
 Yunomine Onsen, 118–119
United States
 Arizona
 Antelope Canyon, 50–51, 52
 New River, 74–75
 California
 Alabama Hills, 36–37
 Berkeley, 4–5
 Bishop, 64–65
 Death Valley, 44
 Eureka Dunes, 42–43
 Oakland, 62–63
 Point Reyes National Seashore, 54–55, 66–67, 68–69
 Route 66, 39
 San Francisco, 76–77
 White Mountains, 40–41, 70–71
 Maine, 10–11, 236
 Nevada, 58–59
 Oregon
 Astoria, 60–61, 72
 Columbia Gorge, 48